MOBILIZING METAPHOR

DISABILITY CULTURE AND POLITICS

Series Editors: Christine Kelly (University of Manitoba)
and Michael Orsini (University of Ottawa)

This series highlights the works of emerging and established authors who are challenging us to think anew about the politics and cultures of disability. Reconceiving disability politics means dismantling the strict divides among culture, art, and politics. It also means appreciating how disability art and culture inform and transform disability politics in Canada and, conversely, how politics shape what counts as art in the name of disability. Drawing from diverse scholarship in feminist and gender studies, political science, social work, sociology, and law, among others, works in this series bring to the fore the implicitly and explicitly political dimensions of disability. *Mobilizing Metaphor: Art, Culture, and Disability Activism in Canada* is the inaugural volume in the series.

DISABILITY
CULTURE AND
POLITICS

MOBILIZING METAPHOR
Art, Culture, and Disability Activism in Canada

Edited by Christine Kelly and Michael Orsini

UBCPress · Vancouver · Toronto

25 24 23 22 21 20 19 18 17 16 5 4 3 2 1

Printed in Canada on FSC-certified ancient-forest-free paper (100% post-consumer recycled) that is processed chlorine- and acid-free.

Library and Archives Canada Cataloguing in Publication

 Mobilizing metaphor : art, culture, and disability activism in Canada / edited by Christine Kelly and Michael Orsini.

(Disability culture and politics)
Includes bibliographical references and index.
Issued in print and electronic formats.
ISBN 978-0-7748-3279-3 (hardback). – ISBN 978-0-7748-3280-9 (pbk.). –
ISBN 978-0-7748-3281-6 (pdf). – ISBN 978-0-7748-3282-3 (epub)

 1. People with disabilities and the arts – Canada. 2. People with disabilities – Political activity – Canada. 3. People with disabilities in art. 4. Political activists – Canada. I. Kelly, Christine, 1982-, editor II. Orsini, Michael, 1967-, editor III. Series: Disability culture and politics

NX180.H34M62 2016 704'.087 C2016-904098-4
 C2016-904099-2

Canadä

UBC Press gratefully acknowledges the financial support for our publishing program of the Government of Canada (through the Canada Book Fund), the Canada Council for the Arts, and the British Columbia Arts Council.

This book has been published with the help of a grant from the Canadian Federation for the Humanities and Social Sciences, through the Awards to Scholarly Publications Program, using funds provided by the Social Sciences and Humanities Research Council of Canada.

UBC Press
The University of British Columbia
2029 West Mall
Vancouver, BC V6T 1Z2
www.ubcpress.ca

Dedicated to Santa Vescio Orsini, 1944–2016

Contents

Illustrations

Acknowledgments

Edited collections are so much more than the sum of their parts. *Mobilizing Metaphor* is the product of a conversation we had about what was missing in the field of critical disability studies in Canada. We had this discussion at one of our first meetings, when we didn't know each other very well. The discussion evolved over time into a workshop and ultimately this collection. It feels strange to acknowledge each other, but our friendship is the foundation of our work.

We would like to thank our stellar cast of contributors, which includes disability activists, artists, and senior and emerging scholars from across the country. We were honoured to work with such a talented and diverse group, who are passionate about art, disability, and politics in different ways. From the moment we invited them to contribute, they have been steadfast in their commitment to seeing this project to completion.

We would also like to acknowledge the generous financial support of the Social Sciences and Humanities Research Council of Canada. Many of the contributors to this volume presented drafts of their chapters at a workshop we held at the University of Ottawa in March 2014, and this event could not have taken place without the substantial funding provided through the SSHRC Connection Grant Program. The final publication of the collection is supported by the Awards to Scholarly Publications Program, a program that is essential to nurturing and promoting scholarly works in Canada. Thanks are also due to the University of Ottawa's Faculty of Social Sciences

for additional financial support, and to Sophie Letouzé for help with the SSHRC application.

A special acknowledgment is due to Tanya Titchkosky and Rod Michalko, who attended and contributed to our fall workshop. Tanya accepted with enthusiasm the task of rapporteur, which meant listening to all of the conference presentations and identifying common themes. Tanya kindly agreed to write the closing chapter for our collection, which weaves these themes and reflects deeply on the myriad ways in which we can mobilize metaphor in the name of disability activism. Tanya also acted as a patient and creative sounding board for us as we reworked the book's title and settled on *Mobilizing Metaphor*.

At the University of Ottawa, Ashley Bickerton provided logistical support for the workshop, Christopher Leite shared expertise and attention to detail in preparing early versions of the collection, and Simone Parniak was an exemplary editorial assistant in the final preparation of the book. Thanks are due, as well, to the indefatigable administrative support of Margot Charbonneau and Natacha Lemieux at the Institute of Feminist and Gender Studies.

Our sincere thanks to our editor, Emily Andrew, for shepherding this project to the finishing line and for believing in critical, interdisciplinary work. UBC Press is a beacon for scholars working at the intersections of disciplines, and has consistently produced remarkable work. UBC Press's Ann Macklem, who guided us through the production process, was a model of patience and took care of every final detail. Sincere thanks, as well, to the anonymous reviewers of the manuscript; each reviewer provided detailed, thoughtful, and engaged comments. Artist jes sachse is not only a contributor to this collection: jes's *Freedom Tube* installation inspired us and graces the cover of the book. Finally, artist Persimmon Blackbridge allowed us to use her phenomenal sculptural work, *Lace Wood Doll*, as inspiration for the logo of the Disability Culture and Politics series. We are indeed surrounded – and grounded – by art that provokes and inspires.

Chrissy would like to thank her former colleagues in the Institute of Feminist and Gender Studies for their interest and friendship. Her new colleagues in Community Health Sciences at the University of Manitoba, including Deb McPhail, Kate Sibley, Kerstin Roger, and Stephen Moses have been generous and curious. Support from cherished colleagues in the imaginary "Canadian disability studies department" that operates via social media, email, and at conferences continues to inform her scholarship. She acknowledges the steadfast encouragement from her parents, Katie, Chris,

and Brandon and the motley Winnipeg family who quickly filled up the weekends upon moving here. This work would not be possible without the ongoing emotional, but mainly culinary, support from Dale and the imaginative and continual distractions from Ian.

Michael would like to acknowledge his friends and colleagues who listened to his endless bellyaching. They include Corrie Scott, Olena Hankivsky, Patrizia Gentile, his in-laws Mary and Robert Gordon, brother Sam and family, Jennifer Kilty, Pauline Rankin, Francesca Scala, Audra Simpson, Miriam Smith, Jenn Wallner, and Luc Turgeon. Most of all, he is indebted to Victoria, Emma, and Lucca for their consistent love, and to his parents and Aunt Mary for always being his number one fan.

MOBILIZING METAPHOR

Introduction
Mobilizing Metaphor

CHRISTINE KELLY and MICHAEL ORSINI

What's in a straw? For disability artist jes sachse,[1] the straw is both a useful aid and object brimming with cultural and political meaning. *Freedom Tube* is an art installation composed of ten thousand red and white straws arranged in what sachse describes as "a waterfall[-]like curtain, a foot from the ground to encourage approach, which is not something disability does" (Fisher 2015). *Freedom Tube* was given its name following a conversation sachse had with fellow disability artist Eliza Chandler, in which they discussed how straws were not just a mundane part of daily life for many disabled people, but an essential item for access.[2] The term "freedom tube" became an inside joke, a shorthand for a vibrant disability culture, and the tangible presence of straws a signpost that welcomes and celebrates different embodiments. Describing the work, sachse explains:

> It was like one of those moments you have in life where, someone gives you this new phrase and all of a sudden you get this montage in your head and boom boom: I am seeing every time I've ever seen a disabled person use a straw, like this guy I can recall seeing drink pints of beer out of a straw[,] and all of a sudden it became this phrase that transformed this object for me as something I normally associated with kind of my daily ritual – just one of the myriad of little accommodations I do for myself without thinking[,] and it became this icon in my head, it was kind of pulsating. (Fisher, 2015)

sachse's homage to disability culture can be contextualized in their public presence, where sachse offers wide-ranging social and cultural commentary through social media, lectures, and blog posts on topics including income support, international and virtual crip communities, and daily experiences of mental and physical difference, among others. *Freedom Tube* is part of a larger agenda of disability justice grounded in the assumption that disability cultures and aesthetics can and do transform situated and lived experiences of difference.

Disability is situated amid competing representations, undelivered policy promises, and the harsh reality of material inequality. Despite the growing public presence of disability studies, politics, and art from the 1970s onward, disability continues to be depicted in highly reductive terms in mainstream literature, film, and television. Typically, these representations rely on tropes of overcoming and pity and characters played by non-disabled actors to ease the audience's discomfort about physical and mental differences. Yet at the same time, we are witnessing a proliferation of new visions and intricate cultural representations of disability by artists such as sachse.

Alongside these cultural battles of representation, living with a disability continues to be linked to material disadvantage, and worldwide austerity measures have reduced public spending meant to address these disadvantages. Disabled people are active agents in resisting and shaping this landscape, and our collection enters at this complex intersection of agency, representation, and material change. We ask: What is the role of disability art, which doesn't always have concrete demands, when there are pressing activist struggles to mount in legal and policy spheres?

On the policy front, austerity measures are perhaps among the most pressing concerns for disability activists. On May 7, 2014, a group of people gathered at an Ottawa community centre to hear Ellen Clifford, a disabled activist from Disabled People Against Cuts (DPAC), a UK-based direct-action group that has been a vocal opponent of austerity policies.[3] The group gained worldwide attention during the 2012 Paralympic Games when it protested the sponsorship presence of Atos, a company contracted by the UK government to implement austerity measures (Lakhani and Taylor 2012). The DPAC protests highlighted a disjuncture between the promises of disabled achievement, overcoming, and accessibility heralded at the Paralympics and the daily reality of unemployment and poverty for many people with disabilities. In an age of austerity, people with disabilities live under constant threat of losing social benefits. People with disabilities and chronic illness must undergo medicalized, suspicion-driven "professional" assessments

primarily designed to balance government spending rather than to ensure the protection, or even survival, of disabled people.[4]

At the Ottawa event, Clifford (2014) recounted the history of DPAC and shared shocking examples of how the cuts were implemented. She reminded the audience that, at times, such policy changes can be directly linked to the suicide and death of disabled people. Or, as Dan Goodley, Rebecca Lawthom, and Katherine Runswick-Cole (2014, 982) explain, "If labour is slow death, living as a disabled person in 2014 might mean a quick one." Indeed, in 2013 over 80 percent of the global population was affected by austerity measures (Ortiz and Cummins 2013). Yet Clifford's key message was "if they thought disabled people were going to be easy targets, DPAC has proven them wrong."

In 2014 the Ontario government attempted to "reassess" the Ontario Disability Support Program (ODSP), which echoed the austerity program in the United Kingdom. Largely in response to a Raise the Rates campaign led by direct-action, anti-poverty coalition activists (including people with disabilities), the medical reviews were halted. In fact, in a complete shift, the 2015 and 2016 provincial budgets actually provide increases to ODSP recipients.

Alongside the radicalized efforts to enact social change, subvert neo-liberal policy agendas, and improve the material conditions of people with disabilities, we are also witnessing an unprecedented moment for disability arts in Canada. The same week as the DPAC event in 2014, May 4–10, SPiLL, a non-profit Canadian arts organization, hosted a week-long artist retreat for Deaf artists in Gatineau, Quebec, the first event of its kind in Canada. In this collection, Paula Bath shares a first-hand community perspective of this event. At the SPiLL open house on May 9, each presentation was simul-taneously interpreted into French, English, American Sign Language, and Langue des signes québécoise (Quebec Sign Language). Over the week, a group of fifteen artists from across Canada outlined and signed an ambi-tious manifesto that interweaves their existence as a political collective with their individual artistic creations, even when the artwork does not explicitly address themes of accessibility, language rights, or deafness.

Disability art, much like disability, is difficult to define, and the defin-itions are often contested. Rose Jacobson and Geoff McMurchy (2010, 1) define disability arts as "a vibrant and richly varied field in which artists with disabilities create work that expresses their identities as disabled people" and distinguish the history of disability art from the Deaf arts and De'VIA arts.[5] This definition centres on the notion that disability art is by people with disabilities and is about disability. Yet disability scholars have

challenged the binary distinction between disabled and non-disabled as well as the very premise of identity-based politics (McRuer 2006; Schalk 2013). Kristin Nelson (this volume) explores the challenges associated with requiring individual artists to claim disabled identities and politics to be included in the category of disability art. Further, Rachel Gorman (2013) argues that the ability to claim politicized identities such as mad pride, disability pride, or Deafness relies on recreating racial and class inequalities and hierarchies of impairment. Indeed, how should we situate disability activism alongside cross-cutting identities that might merge racial, class, and disability identities without subsuming one of the categories?

We must also consider how the legacy of colonialism has worked to produce "states of injury" (Brown 1995) among Indigenous peoples, and the colonial repositioning of disability. In seeking to bring disability activism into a productive dialogue with Indigenous activism, we experienced significant challenges locating individual contributors who might reflect on these issues. An acknowledgment that none of the chapters deals specifically with these issues is not an excuse, but a recognition that there is a greater need to reflect on how disability activism, however multi-vocal and multi-faceted, has failed to sufficiently address how Indigenous bodies are marked by a colonial system of oppression that must be theorized independently of the focus of state-sponsored violence against disabled bodies (Greensmith 2012).

We highlight Clifford's talk, SPiLL's artist retreat from spring 2014, and the absent-presence of Indigenous perspectives to demonstrate the shifting landscape for disability activism that incorporates radical action and growing artistic communities, while continuing to exclude specific politicized identifications and histories. Despite the difference in tactics and even membership, both radical activism and disability art operate in the realm of meaning making and culture. Drawing on a disability justice framework and challenging aesthetic notions of what constitutes beauty, Mia Mingus (2011) writes, "There is magnificence in our ugliness. There is power in it, far greater than beauty can ever wield." Instead of a commercialized call that "all bodies are beautiful," Mingus starts from the premise that some bodies, particularly disabled and poor bodies, are continually deemed ugly. Historically, this ugliness was formalized into laws colloquially known as the "ugly laws" in the United States, which sought to prevent disabled and impoverished bodies from appearing in public spaces (Schweik 2009). As the shorthand name implies, these laws were about determining and controlling the concept of "ugly" while also being in themselves an ugly idea. The ugliness of being dragged from a wheelchair during an anti-austerity rally or

demanding multilingual interpretation in artistic contexts does not reclaim beauty in a vague, commercialized manner but disrupts the representational status quo around disability. "The ugly" also challenges politicized communities to interrogate practices of exclusion and demands a broader and more nuanced world of art and representation, including the exclusions of disability politics. Importantly, the disability justice framework evoked by Mingus and the turn toward the ugly emerge from centring the experience of disabled people of colour, refusing to simplify questions of identity, and do not shy away from critiquing the limitations of disability politics and scholarship.

Against this backdrop, we present a collection of essays exploring Canadian disability activism in its many forms. Our collection features contributions from artists and activists with disabilities, disability scholars, and many who cross these categories. Through this collection, we argue that disability activism in Canada is at once bold and vibrant in its diversifying tactics, but also fracturing in response to new economic and social realities. This collection considers the potential of seeing art as an integral element to broadening accounts of Canadian disability movements, an element that represents a lived practice of Mingus's (2011) disability justice framework. This is not to say, however, that disability justice is the best or only mode of disability activism; rather, it helps us to appreciate the role of art and radical mobilizing in renewed, nuanced accounts of Canadian disability activism. And we should be careful, as well, in positioning disability identity and activism as somehow subsuming identities that are experienced through an intersectional lens that recognizes the multiplicity of oppression, one that is not always reducible to disability identity or status.

Indigenous and racialized individuals who experience disability may intervene in ways that upset any neat ordering of identities or that might seemingly resist naming disability or impairment directly. Forms of colonial violence, from the painful legacy of residential schools through to the crisis of missing and murdered Indigenous women, work to disable Indigenous bodies, even if the disabling nature of these acts of violence is rarely imagined as such. Instead, Indigeneity itself is reproduced as a pathology, as an affliction that is somehow synonymous with the act of being Indigenous (see Million 2013). There are also some difficult resonances between practices in residential schools and those in large-scale institutions for people with intellectual disabilities and psycho-social disabilities. In these ways, we hope that some of the reflections on disability activism discussed here resonate with Indigenous people who are in the forefront of thinking

about what it means to live and act in a world marked by colonialism and dispossession.

Acclaimed Indigenous artists such as Rebecca Belmore have, through performance, video, and other artistic forms, intervened in reimagining the Indigenous woman's body as a site for collective resistance against everyday colonial violence and trauma. While Belmore does not address disability directly in her work, themes of embodiment abound in her artistic practice and culminate in efforts to resist outside naming that is often required in disability politics. One of Belmore's first and better-known works, a performance titled *Artifact 671B*, found the artist seated immobile in –22°C weather for two hours on the frozen ground outside the Thunder Bay Art Gallery to protest an exhibition organized by the Glenbow Museum in conjunction with the 1988 Winter Olympics in Calgary. As Belmore explains in an interview, however, it is frustrating for Indigenous artists to be asked to speak for all Indigenous people: "One thing that does puzzle me is this idea that my work is only concerned with identity politics ... I was recently asked during a visit if I ever get tired of always having to represent my people. I joked that I have never run for the position of 'chief.' Seriously, how do non-aboriginal people view themselves? That is my question" (quoted in Nanibush 2014, 217). The absence of Indigenous perspectives in disability studies is troubling and invites further reflection, but Belmore's work highlights how "identity politics" are also a by-product of a form of colonialism that forces individuals to assume tokenistic or spokesperson roles, something she strongly rejects.

Including artistic, radical, and cultural interventions within accounts of Canadian disability movements helps to broaden the parameters of disability activism in ways that are more inclusive of complex embodiments and reflective of historically-situated contexts, such as the overlapping traumas associated with settler colonialism. The historical erasure of Canadian disability experience and disability histories occurs within a context that cannot be separated from the grievous harms of state-sponsored violence against Canada's Indigenous inhabitants. In addition, it helps to "mobilize metaphor" by challenging the assumption that metaphor operates only in non-material realms. The chapters in this collection speak to a need to challenge the material–non-material divide, especially as it pertains to the performative potential of artistic expression to fashion new worlds of disability experience. *Mobilizing Metaphor* also represents alternative modes of knowledge production and seeks to disrupt the epistemic privilege granted to written, rational, and evidence-based forms of articulation.

Broadening the Parameters of Disability Activism in Canada

Scholarly literature on Canadian disability movements presents a picture of policy-based, cooperative, and state-focused activism that predominantly operates through non-profit organizations (Hutchison et al. 2007). A number of historic successes have followed in this tradition in Canada, including the oft-cited struggle to ensure the inclusion of mental and physical disability in the Canadian Charter of Rights and Freedoms (Peters 2003). Individual advocates and representatives of disability organizations often participate in policy consultations (Barnartt 2008; Stienstra 2003), such as the establishment of the Accessibility for Ontarians with Disabilities Act (Kitchin and Wilton 2003). The history of policy involvement has led scholars to characterize Canadian disability activism as "non-confrontational" (Chivers 2007) and preferring to employ "lobbying" tactics (Carroll and Ratner 2001). Further, historic accounts of Canadian disability activism tend to emphasize the development and activities of non-profit organizations (Driedger 1989; Lord 2010; Lord and Hutchison 2007; Neufeldt 2003). Michael Prince (2012, 11) argues that Canadian disability activism is a valuable counter-narrative to neoliberalism and argues that the disability movement "is not an anti-capitalist movement nor is it anti-globalization."

This style of activism and social change continues in Canada, where, in some cases, advocates and disability organizations work cooperatively with governments to achieve policy goals. Recent examples of successes include the development of and public education about the Accessibility for Ontarians with Disabilities Act from 2005 onward and Canada's role in developing the United Nations Convention on the Rights of Persons with Disabilities. The Charter of Rights and Freedoms also continues to play an important role in promoting and achieving change for people with disabilities through high-profile cases. Lisa Vanhala (2011, 64–67) documents over thirty-nine cases from 1985 to 2007 in which the four disability organizations in her study appeared before the Supreme Court of Canada in various capacities. There are more examples from other organizations excluded from Vanhala's analysis, especially organizations addressing mental illness. At the provincial level, a historic class-action settlement in 2012 against the Ontario government acknowledged the harms and misguided approaches of large-scale residential institutions (Crawford Class Action Services 2014). This settlement represents an important development in deinstitutionalization against a backdrop where large-scale institutions continue to operate in other Canadian provinces and Alberta actually reversed its decision in fall 2014 to close the Michener Centre. Without question, Canada has a lively

and ongoing history of pursuing advances in disability rights through the court system. We should not discount the clear, measurable, and important history of disability activism in policy and legal arenas. Yet Lisa Vanhala (2011) admits that many of the key legal victories at the Supreme Court of Canada have not been implemented consistently by various levels of government, demonstrating the limitations of legal gains.

When held up against a historical record of vibrant, robust forms of legal organizing, one might assume that the present moment is characterized by a retreat from disability activism. But this is to misread the current situation: such a view is possible only if one assumes a particularly narrow understanding of what constitutes disability activism and engagement (Kelly 2013). In addition to anti-poverty mobilizing by groups like DPAC, individual disabled protesters have a visible and troubled presence in broad-based radical movements. Sunaura Taylor, Marg Hall, Jessica Lehman, Rachel Liebert, Akemi Nishida, and Jean Stewart (Taylor et al. 2016) share firsthand accounts of their involvement with various Occupy movements across the United States in 2011. The authors share moments where Occupy encampments demonstrate at least some initial acceptance and awareness of disability issues, but also moments of physical, social, and economic inaccessibility. Nishida's account in this collaborative chapter emphasizes the importance of people with disabilities joining Occupy movements. She writes, "We go to [Occupy Wall Street] to represent our community, especially those who cannot be there physically for various reasons; to show diversity within the 99%; to inform and educate people about ableism; to welcome disabled people who do not know about the community; and to be with each other" (ibid., 25). Intersectional movements are gaining awareness of disability politics and the necessity of including disabled people in efforts toward social justice. In Canada, disabled people also played an important role during the Occupy movement, and Melissa Graham and Kevin Jackson (this volume) share a first-hand account of organizing the annual Disability Pride March that originated during Occupy Toronto. Disability activists were also involved in the 2012 Quebec student movement (Blouin Genest, this volume). Reading about legal and policy successes related to disability in Canada can discursively erase, or at least distance, the work of individual activists engaged in broad-based, grassroots movements. Jen Rinaldi and nancy viva davis halifax (this volume) highlight the disjuncture between policy and legal successes and the world of disability art through what they term a "poetry of witness," which disrupts conventional framings of disability. In sharing her experiences with the Red Wagon arts

collective, halifax observes the limitations of legal interventions, which are presumed to ameliorate material inequalities faced by people with disabilities more than poetry, art, or even radical activism do. She writes: "I am present for decades, witnessing the ordinary, iterative, neglected suffering – the lack in the amount and nutritional value of food over days and months extends into years; the inability to purchase tampons, deodorant, or tokens for travelling is not a Charter concern" (Rinaldi and halifax, this volume). Art, and more disruptive forms of collective politics such as Occupy, hold potential and forge change in ways that move beyond policy and the courtroom.

Mobilizing Metaphor

Disability and Deaf arts in Canada are stronger than ever, with the Canada Council for the Arts releasing an equality strategy in 2012 to expand the arts; a robust renewal of the Abilities Arts Festival, now an explicitly disability-led organization called Tangled Art + Disability; the inclusion of disability art exhibits in museums and local art festivals such as Artsweek Peterborough; and the growing popularity of specific disabled artists. While the world of disability and Deaf art is growing, it remains underrepresented in scholarship on Canadian disability movements. For example, an important report on Canadian disability arts, titled *Lights ... Camera ... Attitude!*, is absent from other literature documenting the disability movement (Abbas et al. 2004). This appears to be a unidirectional problem, however, as an account by Jacobson and McMurchy (2010) about disability and Deaf art in Canada properly situates these artistic communities within broader discussions of disability activism. It is clear then that many of the artists see themselves and their work within a politicized disability framework, even if conventional ways of thinking about disability politics marginalize their contributions.

Indeed, many disability artists see themselves as activists and engage in what Rosemarie Garland-Thomson (2009, 193) calls "visual activism," where people with disabilities put "themselves in the public eye, saying 'look at me' instead of 'don't stare.'" In the chapter by Carla Rice, Eliza Chandler, and Nadine Changfoot (this volume), both the creative process and the resulting digital stories by women who embody difference constitute political makings and foster an "aesthetic community." Further, Rice, Chandler, and Changfoot situate the digital story project within a disability justice framework. As mentioned above, disability justice is an emerging cross-issue, radical, and transformative approach that moves beyond rights-based and

independent living discourses. Mingus (2011) explains, "I am not fighting for independence, as much of the disability rights movement rallies behind. I am fighting for an interdependence that embraces need and tells the truth: no one does it on their own and the myth of independence is just that, a myth." Jeffrey Preston (this volume) uses his co-created webcomic *Cripz* as a political *détournement* to disrupt myths of disability perpetuated in mass media. The political acts imagined through the characters in *Cripz* extend into confrontational politics in the forms of chairmobbing and stairbombing.

Including examples of arts-based and radical activism in accounts of disability politics challenges the assumption that metaphor and affect do not operate in material ways. While Nirmala Erevelles (2011, 119) critiques feminist scholars within and outside of disability studies for the "overreliance on metaphor at the expense of materiality," this collection asks whether attention to metaphor and affect precludes tangible, material change in historical contexts. Is it irresponsible to focus on cultural or artistic interventions when there are concrete political struggles rooted in the retrenchment of the welfare state and its impact on people with disabilities? And how do we reconcile cultural and artistic production with more conventional forms of disability activism and mobilization, or should we even attempt to bridge these worlds of activism? Jay Dolmage (2014, 100) argues, "A cultural turn does not deny the materiality of disability, yet it troubles the origins and sedimentations of this materiality." The relationships among material realities, embodied experiences, and emotion – especially emotions that are generated through creating and engaging with art – are difficult yet essential to explore.

Arlie Hochschild (1983) attended to emotion long before the "affective turn" in critical theory, highlighting the ways in which female flight attendants were required to engage in emotional labour through controlling and projecting emotions to produce specific responses in customers. Hochschild's widely cited work demonstrates that managing emotions is a form of gendered labour and that emotional work produces measurable outcomes in large corporations in the form of profit. The assumption that the emotions of customers must be tended to in order to produce profit undergirds the logic of customer service that is a hallmark of the private sector, and has migrated beyond to influence the public sector broadly. More directly related to visual art, Sarah Brophy and Janice Hladki (2014, 6) make a compelling case that "the cultural and political salience of visual autobiographies inheres in how they generate and critically mobilize affect for pedagogical

purposes." There is ample support for challenging the imagined distinction between a world of art and emotion from the worlds of politics and tangible action. But this holds only if we accept that emotion and politics are discrete concerns.

The emotional turn has been felt throughout several social science and humanities fields (see Ahmed 2004; Bondi, Davidson, and Smith 2005; Goodwin, Jasper, and Polletta 2001; Gould 2009; Massumi 1995, 2002; Nussbaum 2001, 2004). Although this literature addresses a myriad of topics, a central theme relevant to the study of disability activism concerns the need to destabilize the separation of emotion from reason, wherein art and radical activism are presumed to emerge from emotional, "irrational" motivations (Flam and King 2005; Goodwin, Jasper, and Polletta 2001; Gould 2009). It is common nowadays, however, to refute claims that emotions and rationality stand apart, uncoupled from one another (Damasio 2005). Rather, reason and emotion are seen as mutually co-constituted. Once we accept that we can think *with* emotions, that emotions don't get in the way, it opens a space for affective ways of imagining and enacting disability art and politics. There is also a burgeoning literature on the role of emotions and affect in social movement activism, some of which disrupts notions of rationality that have characterized the study of contentious politics (see Flam and King 2005).

Emotions are often structured by social conventions and culture. Complex moral emotions such as compassion, disgust, fear, and anger "express explicit principles that we hold, or mere intuitions that we have never fully articulated" (Jasper 2006, 17). As Jasper explains, they reveal that we attach moral weight to our ability to express certain emotions. So we might feel shame, for instance, about our desire to express outrage or anger. Affects are non-conscious but registered experiences of bodily energy and intensity that respond to stimuli (Massumi 1995, 2002). Affect makes us feel emotions, while feelings capture the phenomenon of affect and emotions and connote bodily, felt experience (Gould 2009).

As discussed in Orsini and Wiebe (2014) in the context of autistic activism, while social movement scholars have sought to highlight the role of "opportunity structures" in facilitating and constraining political and social change, this tells us little about the ways in which actors attach feelings and emotions to their actions (Gould 2009, 18). Disability activism, as a discursive and political field, is thus a rich case for exploring how actors perform "a kind of emotional j[i]u-jitsu" (Goodwin, Jasper, and Polletta 2004, 423). For example, Audre Lorde's quest for material revolution and recognition of

black women is intrinsically linked to emotion and art. For Lorde (2007, 39), emotion itself represents a form of resistance to the status quo: "For within living structures defined by profit, by linear power, by institutional dehumanization, our feelings were not meant to survive." In this collection, Drew Belsky details the role of grief in negotiating the ethics of representation and creating embodied art across identities, refusing to categorize loss, emotional responses, and relationships as subsidiary to the primary aims of critical scholarship. Catherine Frazee, Kathryn Church, and Melanie Panitch (this volume) also illustrate this emotional jiu-jitsu through their account of including the *Out from Under* exhibit in the Canadian Museum for Human Rights in Winnipeg. Frazee, Church, and Panitch demonstrate that emotionally-based haggling, tactics, and reactions were integral to achieving their aims and, further, that curatorial practices must be interrogated when considering the activist potential of disability art.

A focus on feeling rules is useful in thinking about disability politics in its temporal dimensions, especially as it pertains to exploring what it is appropriate to feel, and how this might shift over time. In an environment in which narratives of pity circulate around disability experience, disability activism can challenge the ableist assumptions embedded in these discourses.

In her original formulation, Hochschild distinguished framing rules from feeling rules, adding that feeling rules "do not apply to action but to what is often taken as a precursor to action" (Hochschild 1979, 566). Framing rules "refer to the rules according to which we ascribe definitions or meanings to situations." Feeling rules, on the other hand, "refer to guidelines for the assessment of fits and misfits between feeling and situation" (ibid.).

The ways in which feelings and emotions are ordered and expressed in relation to disability can enrich our understandings of disability activism. These new framing rules of disability activism also upset conventional ideas of what constitutes contentious politics or social movement action itself. As part of our efforts to challenge a conventional focus on disability activism's "successes" in the legal sphere and move beyond a focus on rational, strategic action, we are interested in how feelings and emotions as collectively generated sentiments can ground disability movements. An appreciation for the complex role of emotions and affects in disability politics asks us to reconsider how feeling rules might structure the environment in which activists and artists intervene. While not permanent or static, these rules can help us to uncover why certain emotions are privileged in activist settings during particular periods but discouraged in other contexts or periods.

These rules also help us to consider the relationships among art, agency, and intention. This is especially critical since an important critique in disability studies has centred on the need to move beyond pity or inspiration narratives. Positioning artistic, cultural, and radical interventions in the disability landscape means thinking about a template of emotions and affects that destabilizes ableist understandings of disability as always evoking sympathy, compassion, and pity. Anger, rage, and shame can be productive sites for imagining disability, as well.

Agency, Art, and Mobilization

Our choice of *Mobilizing Metaphor* as the title for this collection reflects an interest in a view of disability activism that is agency-based. As political, social, and cultural actors, we view disability activism as a mobilizing force – as an attempt to move beyond instrumental or strategic ways of thinking about disability itself solely as a metaphor. Disability activism, in all of its cultural, political, and artistic manifestations, implores us to challenge the idea that disability is a stand-in, a placeholder. At the same time, however, we reject the idea that artistic or cultural interventions that seek to reshape or rethink disability are somehow inferior to overtly political interventions. Both operate to challenge the terrain of disability activism and force us to confront the productive tensions that might emerge when we merge the artistic with the political.

The collection is organized into three key sections. The first section, "Assemblages of Disability Research, Art, and Social Transformation," explores critical places where disability scholarship and artistic practice or methods combine to enable social change. The chapter by Alexander McClelland and Jessica Whitbread, for example, deals with cultural production in the field of HIV, which can be traced to the trailblazing efforts of artists' collectives such as Gran Fury, better known for its slogan "Silence = Death." Their chapter on the PosterVirus campaign deals with the criminalization of people living with HIV and opens up a space for linking HIV activist worlds with disability arts production. Another example, Véro Leduc's chapter, "It Fell on Deaf Ears," is uniquely situated to reflect on her own experience as an artist-scholar who brings Deafhood into artistic focus through the creation of a graphic signed novel. Rather than view the graphic novel as a cultural product intended to communicate a message to her audience, Leduc is interested in the production of art itself as an intervention brimming with political and social meaning. She uses the term "artivism" to

capture this move from a focus on the consumption of cultural products to an emphasis on the process itself as the fundamental feature of artistic and social/political transformation. As Leduc makes clear, these processes do not exist outside of society; they are "enmeshed both within the transformation of my own practice and position, as well as within the communities to which I belong."

The second section, "Artistic Paths to Disability Activism," considers first-hand accounts of creating art or using art for disability justice. Art can represent different forms of knowledge that do not necessitate instrumental outcomes that are more typically found in human rights or legislative challenges linked to disability. Instead, art and even radical activism work on the level of meaning making and shared definitions. The challenge of art is to take seriously the visual, the enacted, the artistic, the seemingly disorganized as valid forms of knowledge production and social change. For example, Lindsay Eales shares her account of co-founding and performing with CRIPSie, an integrated dance group in Edmonton, Alberta, demonstrating that creating these alternative spaces represents an expression, and action, of social justice. In Chapter 9, which is adapted from a speech delivered at the University of Ottawa in November 2014, jes sachse explores the concept of the liminal, making connections to the tangible marginality of prison and asylum spaces and the conceptual liminality of disability art. sachse and the art they create delves into issues of curation and the production of bodies, raising difficult questions about voyeurism and the implications of "hyper-storytelling framed by whomever has the most hits," as sachse writes. Diane Driedger describes her experiences as an artist with disabilities who re-visions famous artwork by painting herself in. The artists in Driedger's chapter have some connection to disability, and her work exposes disability narratives that sometimes sit below the surface.

The final section, "Rethinking Agency in Canadian Disability Movements," includes chapters that consider new and renewed visions of agency and autonomy expressed through disability activist work. Pamela Moss's chapter on "broken embodiments," for example, forces us to confront the complex face of activism in terms of contested illnesses, drawing on the case of myalgic encephalomyelitis (ME). As Moss explains, people with ME "are more likely to experience their bodily sensations as broken embodiments rather than as simply feeling ill." Moss develops the notion of perching as a way of thinking through a complex series of interventions (social, political, and biomedical) that individuals living with ME mobilize to cope with, challenge, and resist attempts to articulate the meaning of ME.

As she explains, "Perching is a practice of positioning oneself within bio-medicine while maintaining a critical view of it." While hardly without its share of risks for the individual patient who must engage with biomedical ways of knowing ill or disabled bodies, perching can be strategically import-ant in nonetheless gaining legitimacy for the experience of living with ME, even if the interventions themselves do not dismantle hierarchies of scien-tific or biomedical authority.

It remains puzzling that social movement scholarship in Canada and more broadly has demonstrated only a limited understanding of the changing contours of disability activism and what this might hold for other accounts of social movement contestation, nationally but also in a compara-tive perspective. Certainly, initial interest and research on the Occupy movement paid close attention to the movement's use of symbols and slo-gans to culturally populate the movement. Moreover, the student move-ment that emerged in Quebec in the wake of protests against university tuition hikes garnered significant attention, even if the movement's progres-sive potential was challenged by its seeming inattention to accessibility for disabled students, both in terms of physical access to sites of protest as well as accessibility to higher education, as Gabriel Blouin Genest's chapter in this volume demonstrates.

Disability activism and art, the shape of which is difficult to predict, not only present unique opportunities to explore questions that have animated the field of social movement studies for decades, but also hold potential promise as sites for asking questions about the expanding affective worlds of activism, some of which escape the state-focused lens privileged by social movement scholars and, moreover, the role of emotions in generating so-cial change. In those cases where artistic or cultural forms of contention are addressed, they appear as supplements to more conventional modes of action, as tactics employed by actors to sensitize supporters or movement adherents. We hope this collection opens up spaces for thinking anew about the discursive and material boundaries that separate art, emotion, and disability activism. As this collection demonstrates, activists and scholars working in this field continue to disrupt taken-for-granted assumptions about what constitutes art, culture, and disability, not to mention activism. For us, this includes a reappraisal of artistic, radical, and affective practices as interventions in their own right, as well as a greater appreciation for how disabled bodies and minds figure in these interventions. This need not imply pitting activist practices against one another, or searching for bona fide ex-pressions of disability. Rather, it recognizes the productive potential of these

entanglements for how we rethink the shifting contours of disability activism in Canada and beyond.

NOTES

1 sachse uses lower-case letters and "they" and "their" to refer to themselves.
2 To represent ongoing debates in academic and community settings, we alternate between the phrases "person with a disability" and "disabled person."
3 Clifford was flown to Ottawa by the Ontario Coalition Against Poverty and is helping to relaunch the Ottawa Raise the Rates anti-poverty campaign.
4 For discussions of the difficult and tenuous role of professionals in the maintenance of oppressive regimes of power, see Kelly and Chapman (2015).
5 It is an accepted practice in Deaf studies to capitalize the "D" to denote those who identify deafness as a cultural minority and not as a medical difference or disability. Not all people with hearing impairments identify this way, however. For more discussion of Deaf/deafness, see Davis (1995), Corker (1998), Leduc (this collection), and Bath (this collection). We use "Deaf" in this chapter for ease of writing, but we have left the choice up to individual contributors rather than impose a uniform style throughout the volume.

WORKS CITED

Abbas, Jihan, Kathryn Church, Catherine Frazee, and Melanie Panitch. 2004. *Lights ... Camera ... Attitude! Introducing Disability Arts and Culture*. Toronto: Ryerson RBC Institute for Disability Studies Research and Education.

Ahmed, Sara. 2004. *The Cultural Politics of Emotion*. London: Routledge.

Barnartt, Sharon N. 2008. "Social Movement Diffusion? The Case of Disability Protests in the US and Canada." *Disability Studies Quarterly* 28 (1). http://dsq-sds.org/article/view/70/70.

Bondi, Liz, Joyce Davidson, and Mick Smith, eds. 2005. *Emotional Geographies*. Aldershot, UK: Ashgate Publishing.

Brophy, Sarah, and Janice Hladki. 2014. "Visual Autobiography in the Frame: Critical Embodiment and Cultural Pedagogy." In *Embodied Politics in Visual Autobiography*, edited by Sarah Brophy and Janice Hladki, 3–28. Toronto: University of Toronto Press.

Brown, Wendy. 1995. *States of Injury: Power and Freedom in Late Modernity*. Princeton: Princeton University Press.

Carroll, William, and R.S. Ratner. 2001. "Sustaining Oppositional Cultures in 'Post-Socialist' Times: A Comparative Study of Three Social Movement Organizations." *Sociology* 35 (3): 605–29.

Chivers, Sally. 2007. "Barrier by Barrier: The Canadian Disability Movement and the Fight for Equal Rights." In *Group Politics and Social Movements in Canada*, edited by Miriam Smith, 307–28. Peterborough, ON: Broadview Press.

Clifford, Ellen. 2014. "Fighting Back against Cuts to Disability Benefits: From UK to Ontario." Presentation at Disabled People Against Cuts Speaking Tour – Ottawa Event, hosted by the Raise the Rates campaign, Ottawa, May 7.

Corker, Mairian. 1998. *Deaf and Disabled, or Deafness Disabled?* Philadelphia: Open University Press.

Crawford Class Action Services. 2014. "Regional Centre Class Actions." http:// huroniaclassaction.com/.

Damasio, Antonio. 2005. *Descartes' Error: Emotion, Reason, and the Human Brain.* New York: Penguin Books.

Davis, Lennard J. 1995. *Enforcing Normalcy: Disability, Deafness, and the Body.* New York: Verso.

Dolmage, Jay Timothy. 2014. *Disability Rhetoric.* Syracuse, NY: Syracuse University Press.

Driedger, Diane. 1989. *The Last Civil Rights Movement: Disabled People's International.* New York: St. Martin's Press.

Erevelles, Nirmala. 2011. "The Color of Violence: Reflecting on Gender, Race and Disability in Wartime." In *Feminist Disability Studies*, edited by Kim Q. Hall, 117–35. Indianapolis: Indiana University Press.

Fisher, Lindsay. 2015. "Conversations with Strange Beauty: jes sachse." http:// tangledarts.org/conversations-with-strange-beauty-jes-sachse/.

Flam, Helena, and Debra King, eds. 2005. *Emotions and Social Movements.* New York: Routledge.

Garland-Thomson, Rosemarie. 2009. *Staring: How We Look.* New York: Oxford University Press.

Goodley, Dan, Rebecca Lawthom, and Katherine Runswick-Cole. 2014. "Dis/ability and Austerity: Beyond Work and Slow Death." *Disability & Society* 29 (6): 980–84. http://dx.doi.org/10.1080/09687599.2014.920125.

Goodwin, Jeff, James M. Jasper, and Francesca Polletta, eds. 2001. *Passionate Politics: Emotions and Social Movements.* Chicago: University of Chicago Press. http:// dx.doi.org/10.7208/chicago/9780226304007.001.0001.

–. 2004. "The Emotional Dimensions of Social Movements." In *The Blackwell Companion to Social Movements*, edited by David A. Snow, Sarah A. Soule, and Hanspeter Kriesi, 413–32. London: Blackwell Publishing.

Gorman, Rachel. 2013. "Mad Nation? Thinking through Race, Class and Mad Identity Politics." In *Mad Matters: A Critical Reader in Canadian Mad Studies*, edited by Brenda A. LeFrançois, Robert Menzies, and Geoffrey Reaume, 269–80. Toronto: Canadian Scholars' Press.

Gould, Deborah. 2009. *Moving Politics: Emotion and ACT UP's Fight against AIDS.* Chicago: University of Chicago Press. http://dx.doi.org/10.7208/chicago/9780 226305318.001.0001.

Greensmith, Cameron. 2012. "Pathologizing Indigeneity in the Caledonia 'Crisis.'" *Canadian Journal of Disability Studies* 1 (2): 19–42. http://dx.doi.org/10.15353/ cjds.v1i2.41.

Hochschild, Arlie. 1979. "Emotion Work, Feeling Rules, and Social Structure." *American Journal of Sociology* 85 (3): 551–75. http://dx.doi.org/10.1086/227049.

–. 1983. *The Managed Heart: Commercialization of Human Feeling.* Berkeley: University of California Press.

Hutchison, Peggy, Susan Arai, Alison Pedlar, John Lord, and Felice Yuen. 2007. "Role of Canadian User-Led Disability Organizations in the Non-Profit Sector." *Disability & Society* 22 (7): 701–16. http://dx.doi.org/10.1080/09687590701659550.

Jacobson, Rose, and Geoff McMurchy. 2010. *Focus on Disability and Deaf Arts in Canada.* Report to Canada Council for the Arts. http://canadacouncil.ca/~/media/files/research%20-%20en/focus%20on%20disability%20and%20deaf%20arts%20in%20canada/focusondisabilityanddeafartsincanada.pdf?mw=768.

Jasper, James M. 2006. "Emotions and the Microfoundations of Politics: Rethinking Ends and Means." In *Emotion, Politics and Society*, edited by Simon Clarke, Paul Hoggett, and Simon Thompson, 14–30. London: Palgrave Macmillan.

Kelly, Christine. 2013. "Towards Renewed Descriptions of Canadian Disability Movements: Disability Activism Outside of the Non-profit Sector." *Canadian Journal of Disability Studies* 2 (1): 1–27.

Kelly, Christine, and Chris Chapman. 2015. "Adversarial Allies: Care, Harm, and Resistance in the Helping Professions." *Journal of Progressive Human Services* 26 (1): 46–66. http://dx.doi.org/10.1080/10428232.2015.977377.

Kitchin, Rob, and Robert Wilton. 2003. "Disability Activism and the Politics of Scale." *Canadian Geographer* 47 (2): 97–115. http://dx.doi.org/10.1111/1541 -0064.00005.

Lakhani, Nina, and Jerome Taylor. 2012. "Hundreds Protest against Paralympic Sponsor Atos as Anger about Its Role in Slashing Benefits Bill Intensifies." *The Independent* (London, UK), August 29.

Lord, John. 2010. *Impact: Changing the Way We View Disability: The History, Perspective, and Vision of the Independent Living Movement in Canada.* Ottawa: Independent Living Canada.

Lord, John, and Peggy Hutchison. 2007. *Pathways to Inclusion: Building a New Story with People and Communities.* Concord, ON: Captus Press.

Lorde, Audre. 2007. *Sister Outsider: Essays and speeches by Audre Lorde.* Toronto: Crossing Press.

Massumi, Brian. 1995. "The Autonomy of Affect." *Cultural Critique* 31 (Autumn): 83–110. http://dx.doi.org/10.2307/1354446.

–. 2002. *Parables for the Virtual: Movement, Affect, Sensation.* Durham, NC: Duke University Press. http://dx.doi.org/10.1215/9780822383574.

McRuer, Robert. 2006. *Crip Theory: Cultural Signs of Queerness and Disability.* New York: NYU Press.

Million, Dian. 2013. *Therapeutic Nations: Healing in an Age of Indigenous Human Rights.* Tucson: University of Arizona Press.

Mingus, Mia. 2011. "Changing the Framework: Disability Justice." *Leaving Evidence* (blog), February 12. https://leavingevidence.wordpress.com/2011/02/12/changing -the-framework-disability-justice/.

Nanibush, Wanda. 2014. "An Interview with Rebecca Belmore." *Decolonization* 3 (1): 213–17.

Neufeldt, Aldred H. 2003. "Growth and Evolution of Disability Advocacy in Canada." In *Making Equality: History of Advocacy and Persons with Disabilities in*

Canada, edited by Deborah Stienstra and Aileen Wight-Felske, 11–32. Concord, ON: Captus Press.

Nussbaum, Martha C. 2001. *Upheavals of Thought: The Intelligence of Emotions.* Cambridge, NY: Cambridge University Press. http://dx.doi.org/10.1017/CBO 9780511840715.

–. 2004. *Hiding from Humanity: Disgust, Shame and the Law.* Princeton, NJ: Princeton University Press.

Orsini, Michael, and Sarah Wiebe. 2014. "Between Hope and Fear: Comparing the Emotional Landscapes of Autism Activism in Canada and the U.S." In *Comparing Canada: Methods and Perspectives on Canadian Politics*, edited by Luc Turgeon, Jennifer Wallner, Martin Papillon, and Stephen White, 147–67. Vancouver: UBC Press.

Ortiz, Isabel, and Matthew Cummins. 2013. *The Age of Austerity: A Review of Public Expenditures and Adjustment Measures in 181 Countries.* New York: Initiative for Policy Dialogue.

Peters, Yvonne. 2003. "From Charity to Equality: Canadians with Disabilities Take Their Rightful Place in Canada's Constitution." In *Making Equality: History of Advocacy and Persons with Disabilities in Canada*, edited by Deborah Stienstra and Aileen Wight-Felske, 119–36. Concord, ON: Captus Press.

Prince, Michael. 2012. "Canadian Disability Activism and Political Ideas: In and Between Neo-liberalism and Social Liberalism." *Canadian Journal of Disability Studies* 1 (1): 1–34. http://dx.doi.org/10.15353/cjds.v1i1.16.

Schalk, Sami. 2013. "Coming to Claim Crip: Disidentification with/in Disability Studies." *Disability Studies Quarterly* 33 (2). http://dsq-sds.org/article/view/ 3705.

Schweik, S.M. 2009. *The Ugly Laws: Disability in Public.* New York: NYU Press.

Stienstra, Deborah. 2003. "'Listen, Really Listen, to Us': Consultation, Disabled People and Governments in Canada." In *Making Equality: History of Advocacy and Persons with Disabilities in Canada*, edited by Deborah Stienstra and Aileen Wight-Felske, 33–47. Concord, ON: Captus Press.

Taylor, Sunaura, Marg Hall, Jessica Lehman, Rachel Liebert, Akemi Nishida, and Jean Stewart. 2016. "Krips, Cops and Occupy: Reflections from Oscar Grant Plaza." In *Occupying Disability: Critical Approaches to Community, Justice and Decolonizing Disability*, edited by Pamela Block, Devva Kasnitz, Akemi Nishida, and Nick Pollard, 15–30. New York: Springer.

Vanhala, Lisa. 2011. *Making Rights a Reality? Disability Rights Activists and Legal Mobilization.* New York: Cambridge University Press.

ASSEMBLAGES OF DISABILITY RESEARCH, ART, AND SOCIAL TRANSFORMATION

1

Fixing
The Claiming and Reclaiming
of Disability History

CATHERINE FRAZEE, KATHRYN CHURCH,
and MELANIE PANITCH

We are three activist scholars – a three-headed warrior – who together curated an exhibit of activist disability history.[1] Activism was not the subject of the exhibit, nor the object of study. Rather, our curatorial stance was activist, a conviction that disability history was not to be assembled and reported, but rather gleaned and claimed.

The exhibit was titled *Out from Under* (Ryerson University n.d.). Each contributor began with an object and an intuition. The intuition, that this particular object was significant in some way to the social history of disabled people, was the seed from which emerged a historical account.

Like the contributors, who came into this collaboration from a wide range of social locations and experience, the artifacts presented in *Out from Under* varied widely. Some were everyday objects: a shovel, a sweatshirt, a billboard. Others were highly charged: a death certificate, a eugenic poster, a Canadian flag. Altogether, the completed exhibit comprised thirteen installations.

In the beginning, our curatorial task was invitational and supportive. We guided collaborative reflection, helped to frame inquiry, worked through text and display elements to harmonize an accessible – and aesthetic – whole. As the exhibit took shape, we negotiated partnerships, orchestrated opportunities for public presentation, and, always, hustled for support.

All of this was as expected. What was unexpected, and what stretched our capacities as trustees and wayfinders for *Out from Under*, was the extent

to which we would feel ourselves called upon to champion an activist stance in our delicate negotiations with the cultural institutions that sought to showcase the exhibit. We have written separately about *Out from Under's* origins, its debut at the Abilities Arts Festival, and its coming of age, or "Arriving," at the Royal Ontario Museum (Church et al. 2010). In this chapter, we offer a single story that unfolded as we three worked toward the establishment of a permanent home for *Out from Under* at the iconic Canadian Museum for Human Rights (CMHR). Established in 2008 as a national museum at the urging of Canadian media magnate Izzy Asper, the CMHR was envisioned as a global beacon of human rights: a hub of educational activity dedicated to the evolution, celebration, and future of human rights and a magnificent tribute to the principles of justice and equality articulated in the 1948 Universal Declaration of Human Rights. Built at a cost of $351 million, the museum opened its doors in 2014 in Winnipeg, where it stands impressively at the Forks, a historic meeting place where the Red and Assiniboine Rivers meet on First Nations Treaty 1 land and the homeland of the Métis people.

Prologue

The installation that figures in this story is titled *FIXING*, created by then student and now alumnus of our undergraduate Disability Studies Program, Ryan Hutchins. Ryan entered the *Out from Under* collective with an artifact that she had purchased in 2006 on eBay – a souvenir program from a 1948 charity fundraising circus in Montreal. Struck by the seemingly maudlin and at times macabre contents of this program, Ryan explored two intersecting histories: the sometimes dehumanizing face of charity and the darker side of curative medicine. She did so, in our estimation, with delicacy and restraint, holding gently to the circus motif of her artifact and sensitive to the experience of children receiving treatment at the hospital supported by this charity.

We offer the story of *FIXING*, and its arrival at the CMHR, in real time. Our work together as activists and scholars proceeds through call and response, most often by email. For us, activist work is sparked and fuelled interactively and often understood only when the dust of skirmish settles.

This chapter recounts a journey that was unexpected and unscripted, and one for which the required activist interventions unfolded organically. We have since paused, replayed, transcribed, and polished to produce the very matter whose absence we started from: a script.[2]

Act One: "Unfortunate News"

> *March 5, 2014. It is 8:03 PM. Kathryn receives an email and*
> *forwards it immediately to Melanie and Catherine with the*
> *simple tag, "What to do?"*

The forwarded message is from MuseumGuy. We should explain here that MuseumGuy is a complex, composite character representing our interpretation of the curatorial, public relations, and administrative powers of our host Museum. He speaks in this narrative with a single voice, but it is the voice of an institution, a voice of many relations, spoken at different times by different individuals – sometimes our champion, sometimes our nemesis, always the Museum.

The subject is "Unfortunate News."

The message begins "I have some bad news to share with you."

From their separate virtual worlds, three curators drop their jaws simultaneously. It seems that the Museum had contacted Shriners International for approval to use images from our 1948 circus program as part of *Out from Under*'s *FIXING* installation. Shriners, in reply, had refused to grant permission. And that, evidently, was that. From a corporate vice president's office in Tampa, Florida, the Shriners Hospitals for Children (SHC) had spoken:

> SHC takes seriously its commitment to protect the dignity, rights, and confidentiality of the patients that have been entrusted to our care. While we applaud the Canadian Museum for Human Rights for its commitment to address issues related to disability rights, discrimination, and activism, SHC is not in a position to provide you with permission to use these images, nor to use or reference our organization's corporate name.

The gauntlet has been thrown. Will we stand corrected and concede that *FIXING* should be pulled from the collection that would be housed permanently at the CMHR? As disability activists, has our attention to the "dignity, rights, and confidentiality" of patients depicted in an artifact circus program been less acute than that of the organization "entrusted" to care for them?

On the other hand, is the contest for moral high ground ultimately moot? From our vantage point, Goliath has spoken with the force of law.

And the Museum, it is apparent, can proceed no further than the Shriners will permit.

As curators, we have consistently held the line that *Out from Under* is an all-or-nothing collection; exhibitors are never permitted to select out individual installations, for example, in accordance with their own allegiance to a particular historical narrative. Is the stark choice before us therefore whether to pull *FIXING* or to pull the entire exhibit? Or is there some space in this moment for pushing back?

As the ceiling fan churns overhead in the corner of her bedroom, Catherine, now four years retired, feels the sudden cascade of questions and implications like a swarm of bees. It is now 8:30 PM.

Email message.

From: Catherine Frazee

Dear God. This is incredible. And the fur on the back of my neck is standing straight up.

I am so keen to fight this one that I can hardly hold myself back.

Must go out to dinner now. Perhaps that will settle things down in my hypothalamus, but that's unlikely. I'll put a few thoughts into writing before bed.

Will there be an opportunity for the three of us to talk sometime tomorrow?

Raging Catherine

It is 8:42 PM.

Email message.

From: Kathryn Church, who really should be home by now

Happy to hear your raging voice!

I sent a short note back to MuseumGuy in which I said "Interesting when they started to care about these images being in the public eye" ... and asked if he had checked with their Legal.

It is 11:41 PM. And where is Melanie?

Email message.

From: Melanie Panitch

Unbelievable hypocrisy. Please start without me as I have
two meetings back to back in the A.M. No doubt we will need
more time and whatever we do we will have to move fast.

Sent from my iPhone

Next day, March 6, 2014, at 1:16 PM.

Email message.

From: Kathryn Church

MuseumGuy,

The co-curator initial response to your "unfortunate news" is that
we are unwilling to remove this artifact and this story from the
exhibit – it is a key part of a collection of 13 objects and major
issues that we are committed to bringing forward as a whole.

 I will write more further, and I've copied my colleagues here
for their response.

If she had felt any trepidation as she reached resolutely for the *FIXING*
gauntlet, Kathryn soon receives the validation of an important ally. At 3:29
PM, Ryerson's president, Sheldon Levy, who had been made aware in broad
strokes of a new challenge presenting itself in our negotiations with the
Museum, dispatches a one-sentence encouragement: "There is always con-
troversy over difficult issues but eliminating all controversy is putting *Out
from Under* back in the closet."

Thus fortified, the three curators await the Museum's response.

Act Two: "Proposing a Change"

Later that afternoon, 3:48 PM.

Email message.

From: Kathryn Church
Subject: Proposing a Change

Hello MuseumGuy,

I've discussed with Catherine Frazee a way of rewriting the text for *FIXING* that takes the Shriners organization out of mention. We are prepared to do that rewrite. It's relatively simple.

However, we feel that the program, being from 1948 and sold to the public at that time and again, more recently on eBay, is in the public domain and thus not under the copyright of the organization. Legal opinion should confirm that, beyond 50 years, this is the case.

We retain our commitment to including the actual circus program. We feel that the naming of the organization on the program is both subtle ... and highly contextualized in terms of time period. It's clear that the program is a historical document and not intended as a comment on the organization's current practice.

Would making the textual changes assist in finding a way forward?

Two hours later, MuseumGuy responds in legal voice. The term of copyright for published works is fifty years from the death of the author. In this case, since nothing is known about the author's life or death, the rule of thumb is to speculate he or she was forty years old when the work was created and died fifty years later. That would take us to 1998. Tack on the additional fifty years of standard copyright protection, and we are left with the fact that copyright on the contents of our circus program does not expire until 2048.

Catherine receives this news at 8:57 PM.

Email message.

From: Catherine Frazee

The Museum's legal opinion comes as very bad news. [Expletive deleted.]

There is probably a reasonable argument against it, but the back and forth jousting will take far more time than we have. The fact that there is an institutional opinion of this nature falls like an axe upon the but's and if's of our principled protest.

Worst case scenario, the museum decision stands. Then what?

I'm not prepared to let this one go, but any kind of advocacy in relation to the Shriners is going to take time. I wonder if any of our high-flying pals ... friendly donors or honorary doc recipients – are in a position to make an old boy phone call?

And as for MuseumGuy, if he pulls the Circus program, perhaps we have freed up a new space in the exhibit for a mysterious artifact that is embargoed until 2048. We could still call it *FIXING*, but with some new text that tells a story of how some histories remain hidden by decree.

Getting madder by the moment. And heading for Google to learn more about the Shriners ...

March 7, 2014. It's a new day. At 9:29 AM, the curator team switches into tactical gear. Kathryn begins to sketch out our options.

Email message.

From: Kathryn Church

A smatter of comments ...

I'm going to contact Ryerson Legal to ask about the School's place in all this given that we are already 7 years in ... Do you think I/we should go back to the president's office for further advice? ...

Do you think that a circus program has an "author" in the same way that books do? That might be a loophole.

I want the faculty/staff to discuss this issue, if only for information, support, and for future teaching (writing). Things might get bumpy.

I had suggested to Melanie that if we have to pull this one, we make a bid for an empty space in the exhibit and we write new text to signify all the objects that are not (yet) present, all the people affected, all the stories we are not allowed to tell, all the organizations who need to reflect on their practice ... you get my drift. I wonder, if the fur on your neck is still up (what a lovely thought), you might take a stab at that as a potential solution? Also, I wonder whether you might have time on the computer to probe the Shriners website for their current imaging practices? Are they still on about this way of selling their organization?

Happy International Women's Day (tomorrow).

She and Catherine caucus further by telephone, after which,
at 12:21 PM, she updates Melanie.

Email message.

From: Kathryn Church

Melanie,

To bring you up to date, after speaking with Catherine ...

If it's possible for MuseumGuy's Chairman to call Shriners and talk to them about the power of claiming this part of their history as [a] mark of their more progressive present practice, that would be our first preference. But time is short and they might not go for that.

Second preference is to create a "hole" in the exhibit for some text about embargoed images and redacted text, as well as signifying that the exhibit is not complete but could include other objects, people, stories etc. ... that would be a good dramatic substitute.

Third preference would be to re-write the text on imaging used by charitable organizations and how problematic that can be ... using an image yet to be discovered.

I'll present these by phone shortly and see how that goes.

Meanwhile, Melanie catches up on the action from
an airport cafeteria somewhere. It is 12:40 PM.

Email message.

From: Melanie Panitch

Very clever you thoughtful women.

But mostly I am saying 'Yikes!' every time I read the next message.

M

Sent from my iPhone

Shortly after, at 2:05 PM, what feels like a breakthrough.
Kathryn immediately takes to the keys.

Email message.

From: Kathryn Church

Colleagues!

Just off the phone with MuseumGuy. Pitched them the 3 options
that I wrote to you earlier. They took 2 and 3 (no phone call to "fix"
the Shriners).

So, we can keep *FIXING* if we write out the Shriners in the text
and find another image. And we can insert a "hole" to discuss
"what's missing" in terms of potential objects/stories/issues but
also the questions of things embargoed and/or censored due to
vested organizational interests.

I think that's not a bad deal but it has to happen quickly.

CF, I would then spur you on to the "missing" text ...

And would either of you know an image that we can substitute
that has no potential for legal action??

That's all for now, and I think I will go shopping!

Time: 3:30 PM.

Email message.

From: Catherine Frazee

Great. I'm all over it.

With relish,

Catherine

And so with gusto and optimism, the curators proceed. Catherine has a
lovely bee in her bonnet and a luxurious afternoon of activist writing ahead
of her. Melanie puts her iPhone on silent and settles her attentions to the
engagements actually scheduled for the afternoon. Kathryn reviews her
shopping list with Friday-afternoon confidence, then taps out a final mes-
sage to MuseumGuy at 3:31 PM.

Email message.

From: Kathryn Church

Hello MuseumGuy,

I've now spoken to Ryan who is the student, now alumnus, who brought the Shriners Program forward after purchasing it on eBay...
 Ryan asks whether it might not be enough to "black out" the identifiers in the imaging, both for the people and the organizational name ... through electronic means, I presume. We didn't think about that ... is that a viable possibility? She understands the complexities of the situation but is disappointed that her work isn't being retained in its original form and wants to find some way of keeping it whole.

Act Three: A Couple of Options

A few hours later, at 9:27 PM, Catherine is feeling the satisfactions of a good rant. It has been two days of fury, but from a cauldron of indignation and outrage, two short pieces of writing have emerged. If simple redactions to the original *FIXING* text do not satisfy the Shriners' concerns, perhaps one of these alternative framings will find its way into the Museum.

Email message.

From: Catherine Frazee
Subject: A Couple of Options

Hi there,

I've taken a couple of stabs at an alternative approach for FIXING ...
 I thought it best for us to have some alternatives up our sleeve.
 See what you think.

FIXING – Alternative Concept 1

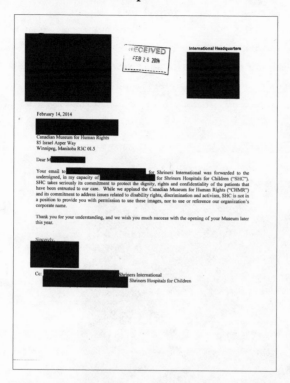

Redacted copy of letter from Shriners' legal representative, which the authors proposed to CMHR as a substitute artifact for the *FIXING* installation.

FIXING

History can be hard to own.

The impulse to defend our ancestors, our institutions and our tribal ways, sometimes gets the better of us.

"We meant well." "We didn't know better." "It was a very different time." It's all true, but so are the histories we'd rather not tell.

The story we won't be telling today was published in Canada in 1948.

It is the story of a boy whose "only means of locomotion were to drag himself along with the aid of his hands." Described as "a social outcast at the age of nine," the butt of bullying and "malicious

pranks," he was rescued by charity and medicine in a place where a "crippled child could be made a normal boy."

That story, and the photos that go along with it, are protected by copyright until 2048.

In the meantime, we are left with the awkward tension between a history of fixing and a fixing of history.

FIXING – Alternative Concept 2

Redacted circus program from 1948, which the authors proposed to CMHR as a modification to the artifact originally intended for the *FIXING* installation. Identifying elements have been redacted in order to address possible copyright issues.

FIXING

Sometimes the problem with history is locating it, sifting through haystacks of detail to find the nugget, the kernel of experience that connects lives across time.

But sometimes the problem with history is owning up to it, finding the courage to bear witness to our own dishonor.

Behind these redactions lies an object purchased on eBay in 2006. Published in 1948, it raises the question of how people with disabilities struggle to salvage pride of place from the rubble of pity and charity. Originally sold as a 25¢ souvenir, it offers a harsh reminder that in the rush to "fix" disability, dignity may suffer great harm.

Because of copyright protections in force until 2048, we cannot share the particular story that we discovered in this document.

Instead, we invite you to search out the nuggets of disability history in your own experience. For the sake of those whose lives remain hidden by the black ink of shame, we urge you to be fearless in your quest.

March 11, 2014. On Tuesday morning, the curators
make their next move. It is 8:47 AM.

Email message.

From: Kathryn Church

MuseumGuy,

I've just left phone messages for you on this matter. We have had several phone conversations about it here, three of us.

Bottom line: we have decided against substitute images. It's a lot of work for us to find them, limited time and personnel, and likely other organizational issues would emerge.

Where photos need to be removed, can we leave blank space? And Catherine has drafted new text to address the holes ...

We would like to retain the existing text but would edit to remove the name of the organization. Thus, retaining what we can, editing

and making "holes" where necessary, and the new text to address those revisions.

Melanie and Catherine, did I get this right?

Time: 2:10 PM.

Email message.

From: Catherine Frazee

MuseumGuy,

As Kathryn has indicated, the critical question for us is whether our text can be accompanied by any portion or facsimile of the original artifact. In other words, is there any way to redact segments of the circus program, especially its cover and the "unwanted child" article, for acceptable use? That is a legal question, we realize. Then I suppose the curatorial question is whether to proceed with a heavily redacted artifact or an artistically rendered blank space.

Alternatively, would the Museum permit us to use a properly redacted copy of the letter from Shriners' legal representative as the "artifact" for *FIXING?*

As Kathryn noted, we are all primed and at the ready for your decision and instructions!

March 12, 2014.

At 2:18 PM, a reply from MuseumGuy affirms the importance of retaining the "original message" of *FIXING.* The design team has rejected the suggestion of using an empty frame, and museum curators feel that focusing on what is hidden in disability history drifts too far from the "important point" to be made about stigma, charity, and curative ideologies.

Two possible avenues of pursuit are mentioned: to push back with regard to the Shriners, with independent legal advice about our rights in relation to the artifact; or to locate an alternative image/artifact that could be adapted to work with an accompanying text much closer to the original in intent and focus.

There have been no fewer than fifty-two emails to this point, one week into the *FIXING* situation.

But then, suddenly, things go quiet. We had pushed back and it now appears to us that the Museum may have relented. No pick-up on our alternative framings, but perhaps in some way, they have had the desired effect.

MuseumGuy has moved from "unfortunate news" to "we can explore." We have his commitment to preserve the original, "essential" message of *FIXING*. And for more than a month, no news is good news.

April 16, 2014.

At 5:17 PM, we hear again from MuseumGuy. He offers new text for *FIXING*, new accompanying images, and a new artifact – a mock circus program produced internally at the Museum. All direct quotes from the original artifact are gone. Instead, a broad reference is made to "travelling circuses and other charities," and archival images from US sources are used to illustrate before-and-after narratives of children casting off their crutches in the glow of medical cure.

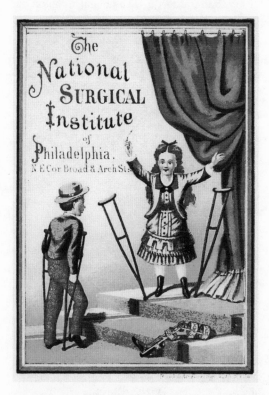

An archival advertisement from the National Surgical Institute of Philadelphia, proposed by CMHR to supplement their in-house fabrication of a generic circus program for the *FIXING* installation.

BEFORE AND AFTER

For decades in North America, travelling circuses and other charities raised money to help doctors transform "crippled" children through surgery. Charities used "Before" and "After" images to show how bodies had been "fixed."

A few messages were clear: Children with twisted legs and backs were a sorry sight. Clowns with painted faces and bizarre costumes were a happy sight. Doctors and nurses with grim expressions and stern intentions were a noble sight.

Medical heroes repaired children's bodies to render them "normal." When these surgeries succeeded, we were told that the children were deeply grateful.

Charities today may be less direct in their judgments about the "misfortune" of disability, but sentiments this brazen do not easily vanish. "Before" does not magically transform to "After."

April 18, 2014.

The ball is back in our court. At 3:12 PM, Melanie picks up the torch.

Email message.

From: Melanie Panitch

Hi both:

The more I look at ... this whole Shriners business the more troubled I am about us now including an American artifact and image in our activist Canadian disability history exhibit – in the Canadian Museum of Human Rights. I am more and more convinced we have to reject both of these. They clearly don't get it, still.

I know time is of the essence ... so what happened to them drafting a mock-up of a Shriners-type circus program? Or, back to a frame with blank page and the FIXING of history.

Really, neither Philadelphia nor Roosevelt's warm springs are acceptable.

Time: 2:02 AM.

Email message.

From: Catherine Frazee

You'll get no argument from me, Melanie.
The museum's proposal is completely unacceptable, and inexplicable.

April 21, 2014, 8:01 AM.

Email message.

From: Kathryn Church

MuseumGuy

... We are not happy with the substitute poster images that you are proposing. They have none of the zing of the image that we are being forced to remove ... and we are not happy going to "North America" (really, the United States) as opposed to Canada. It is the Canadian Museum of Human Rights ... for which neither Philadelphia nor Roosevelt's springs are acceptable.
 Which means that, while we can absorb the extractions of the organizational name in the revised text, we are not happy with the new paragraph that speaks to the proposed images.

The next day, in an email dispatched at 6:45 PM, MuseumGuy explains. Substitution of a mock circus program as the primary artifact for *FIXING* called for a supplementary process of research to locate one or two authentic images that would support the *FIXING* argument, "as opposed to a series of fake assets." Museum staff had undertaken considerable research to find suitable images that would speak to the before-and-after motif of *FIXING*, grounding the point of the installation with appropriate visual impact. Options were understandably limited, given the necessity to avoid questions of copyright and liability by steering clear of images tied to still-active charitable organizations. MuseumGuy offers reassurance that the Museum does not adhere to an exclusively Canadian curatorial stance and that its collection will include content "related to many parts of the world."

Two hours later, at 8:50 PM, Catherine weighs in with a message to Melanie and Kathryn.

Email message.

From: Catherine Frazee

Hello comrades,

Kathryn, thanks for writing the initial "reject" memo – sorry I wasn't more help but I could not find my way past fury to write anything constructive.

This is just getting messier and messier. I guess they've got a reasonable argument articulated here, but my skin crawls with the idea of using bogus images and artifacts, without any acknowledgment of the controversy. It all feels quite dishonest.

And now it feels as if we are being chastised for our failure to appreciate the "great deal of research" that staff have conducted in their pursuit of a happy compromise. Grrr ...

Sorry for venting, but I feel I am going to be of no help here. Perhaps because I have not been [directly] engaged with MuseumGuy, I have no collegial goodwill to draw from. You and Melanie have the benefit of some kind of relationship here, so I'll try to take my lead from you. And Ryan, of course, because she has the most at stake.

Intermission: And in the Centre Ring ...

FIXING is headed for stalemate. At the same time, if our stage were wide enough to accommodate all three rings of the circus, a spotlight would shine now on a gathering of dignitaries in an atrium of vaulted ceilings and glazed panels at the heart of Ryerson University's downtown campus. It is April 25, 2014. A media release announces that "Ryerson's ground-breaking disability rights exhibit moves to national stage": "The Canadian Museum for Human Rights (CMHR) signs an agreement with Ryerson University today that will see a groundbreaking exhibit on disability rights displayed in Canada's new national museum in Winnipeg when it opens September 20, 2014" (Ryerson University 2014).

On stage are three members of our cast, along with many new characters: Kathryn, Melanie, and one MuseumGuy persona, along with RyersonDean, MuseumDirector, and a diverse chorus of CommunityMembers, Exhibit-Contributors, Designers, and Producers. The mood is celebratory; the chatter is cordial. There is a prevailing sense of occasion. From the excited sound of blended conversation and speechmaking, snippets of script are heard:

KATHRYN CHURCH: The School of Disability Studies at Ryerson is proud and happy to play a part in making disability history public history ... just as this event today is a celebration, it is also an invitation to further acts of critical thought and activist creation.

And later, nodding to MuseumGuy:

KATHRYN CHURCH: MuseumGuy is rapidly on his way to an honorary degree in disability studies for his diplomatic negotiation of some tricky issues of translation as *Out from Under* takes its place in Canada's newest cultural institution ...

MUSEUMDIRECTOR: The concept of "breaking silence" on human rights violations is a strong and recurring theme in the CMHR, as well as stories of resiliency and survival.

Catherine isn't present, but gets her two cents in via a proxied text of closing remarks delivered by Christine Karcza, a long-standing *Out from Under* ally.

CATHERINE FRAZEE: History is personal ...

Real people live in, through, and in ever-expanding circles out from this exhibit. Real people seeking Freedom. Franchise. Dignity. Livelihood. Place.

Those of us who have conspired and collaborated to evoke their histories ... have felt our own lives quiver with the recognition of history's sacred trust.

Today we honour real people, people whose lives and struggles and everyday indignities are inextricably bound up in our own habits of heart and circumstance. Today we can be assured that these real lives and struggles and everyday indignities will be held in due regard ...

This afternoon ... we commit our very best to the project ahead – our diligence and respect, our passion and fearless conviction.

Because, for all of us, it's personal.

And Melanie takes it all in, offering her observations later in an email to Kathryn and Catherine.

April 27, 2014, 3:12 PM.

Email message.

From: Melanie Panitch

Capturing 'history as personal' struck a chord for MuseumGuy
who asked for a copy (which I had at hand) to take back to
Winnipeg for the team working on this exhibit. I also made sure he
met Ryan who he greeted as a bit of a celebrity ... MuseumDirector
spoke exquisitely and intelligently with passion ... and a bearing of
quiet strength. MuseumTeam stood near the front as 6 contributors
(Ryan, Kim, Christine, Ruth, Karen, and Cindy) spoke directly to
them about their object and, with appreciation, to the importance
of having their messages carried to and through the Museum.

...

I don't envy MuseumGuy's job but the timing of the event may
work for us; they loved it. Once again they got the message about
"fearless conviction." Now let's see.

Act Four: Up the Ladder

Melanie was right. MuseumGuy was in a tough spot. He knew, far better
than us, the forces and positions in play at the Museum. He also knew,
understood, and, by all indications, was sympathetic to the position that we
were taking in relation to *FIXING*. We had met together, in person and with
Catherine present via Skype, on the afternoon of April 24. Later that night,
at 10:48 PM, MuseumGuy had articulated our position in an email to col-
leagues at the Museum.

Message delivered. Gauntlet returned to the ground. And again, the email
chatter goes quiet. Into this breach, we decide to launch our most powerful
asset, no holds barred. Good Cop Melanie hops a flight to Winnipeg. Her
first report is guarded.

May 16, 2014, 10:42 AM.

Email message.

From: Melanie Panitch

Didn't [snag a ticket to see Germaine Greer's lecture at the Museum
last evening], but there were demonstrations by the trans folks.

And now the CMHR will sanction a place for demos. Kind of takes the sport out of it. More soon.

M

Sent from my iPhone

More calls, more meetings, more roller-coaster riding. Everyone doing their darndest. But *FIXING* has hit the wall. Kathryn dials up the bad cop pressure.

May 22, 2014, 2:06 PM.

Email message.

From: Kathryn Church

MuseumGuy,

I have had an update from Melanie on Out from Under as she and you worked through it in Winnipeg last week ... We are unhappy that the solution for the "FIXING" installation that we crafted ... was rejected elsewhere in the Museum. Whose decision was that? On the design side? Or with management?

... We will now have to brief the President about recent developments. I know already that his office is willing to work with us on a longer-term approach to the organization in question to see whether we can recover the original object and images.

We still hope for a better resolution to these difficulties.

Kathryn means business. She corners Ryerson's president, Sheldon Levy, at a university event and sketches out the two-minute version of the Shriners' saga. Levy is quickly on board.

May 22, 2014, 5:22 PM.

Email message.

From: Sheldon Levy, President of Ryerson University

We are here to help!
 The issue is important for many many reasons! It is too important an exhibit to have it compromised!

Sheldon

Things are heating up. The Museum will open to the public with great fanfare in just a few months. Our place in its inaugural collection, painstakingly negotiated over a period of four years, is hanging precariously in the balance. An emergency meeting is scheduled with the university provost and legal counsel.

Catherine, feeling her geographic distance, offers her best advice as her colleagues charge forward into battle.

May 29, 2014, 12:24 AM.

Email message.

From: Catherine Frazee

To paraphrase Maya Angelou, walk (and talk) like we have oil wells in our living room.[3]
I have my cell phone with me. Good luck.

Melanie, meanwhile, keeps up the friendly pressure.

May 30, 2014, 3:11 PM.

Email message.

From: Melanie Panitch

Hi MuseumGuys,

I wonder if you could send us along a copy of the flip book [containing all of the accompanying text and images for the exhibit]. We have a meeting scheduled with our Provost and University lawyer on Tuesday to take up the matter of approaching the Shriners through University channels. It would be very helpful if we could take that document to inform our conversations – and encourage their intervention on all our behalf.

Thanks,

Melanie

The requested flip book never comes. In fairness, MuseumGuy is juggling all manner of crises in "stakeholder relations" as community urgings for a museum that champions the claims of justice-seeking movements for recognition and place come up against the realities of curatorial decision making in a "museum of ideas" (Black 2014, A14; Busby 2014; Eberts 2012).

Media reports highlight passionate protests by and in solidarity with First Nations and Métis communities, LGBT activists, Ukrainian Canadians, and others. Beyond these reported controversies, an untold number of activists like ourselves are pressing the Museum to be ever-more unflinching in its account of human rights history.

MuseumGuy is firm but restrained in his response. The Museum's policy, he advises, is not to share draft text with any of the hundred-odd stakeholder groups and individuals "involved in various aspects of content development."

Meanwhile, our campaign to liberate *FIXING* is gaining momentum at Ryerson. As scheduled, Melanie and Kathryn meet with the university provost and legal counsel on June 4. Melanie's email to Catherine following the meeting tells the story.

June 4, 2014, 5:04 PM.

Email message.

From: Melanie Panitch

Good meeting where the lawyer assured us we own the artifact and have the right to display it, though not reproduce it. She would like a chronology of events and the name of the CMHR Lawyer and will write her/him.

The provost is supporting us in that they have to accept completed work.

He will also check ... whether they have any contacts with the Shriners.

We were in and out in 15 minutes.

More to come, you can be sure,

Melanie

May 30, 2014, 10:57 PM.

Email message.

From: Catherine Frazee

Melanie,

Wow! This is so much better than I dared to hope for ... Indeed there are oil wells pumping in our living room!

C

Sent from my iPhone

The tides of fortune on *FIXING* are turning, and we feel it. Ryerson's lawyer, upon instruction from the president, will draft a letter of opinion. We make haste to prepare the chronology she requested.

June 8, 2014, 5:23 PM.

Email message.

From: Kathryn Church

Melanie and Catherine,

I've assembled 20 pages of correspondence, as we mapped out over the phone ...
 Now that I see this all together, it's quite a record of saying "no"! It's also a record of being constructive in finding possible solutions.
 Catherine is working feverishly on a distilled chronology and addenda. Emails are focused, on task. But there are the inevitable moments of trepidation.

June 9, 2014, 12:05 PM.

Email message.

From: Catherine Frazee

I wonder where all of this is heading ... How seriously are we going to play hardball?? There's a lot at stake.

C

Kathryn is going to ride this train to the end of the line.

June 9, 2014, 4:35 PM.

Email message.

From: Kathryn Church

Hi MuseumGuy:

I appreciate the extra effort you made to send us the Museum's adjusted text for "FIXING." There is, however, a much bigger difficulty here which is increasingly troublesome. I'm referring to the

difference between Museum policy in relation to text/objects/
images (which we are only gradually discovering), and well estab-
lished practices of academic freedom and intellectual property
which guide our work.

We consider any alterations to Out from Under, without negoti-
ation and approval from the original curators, to be a violation of
the latter and thus, of great concern to us, and to Ryerson's senior
administration.

We have now sought advice from the university's lawyer. She has
confirmed that we have the right of ownership to display the object
in "FIXING" (the restrictions that exist are around reproduction
and distribution). A written opinion from her will be forthcoming.

With regret, we do not consider the matter to be settled.

Kathryn

The opinion, received by us at 1:37 PM on June 16 and dispatched a few
hours later to legal counsel at the CMHR, is a zinger. It reads in part:

June 16, 2014.

Attention: MuseumFolk

...

We understand that in light of [the February 14, 2014, letter
from Shriners Hospitals] you do not wish to include the [circus
program] ... at the Museum. It is our view that [the curators] are
entitled to include the artifact in the Project and exhibit the arti-
fact as it was legitimately purchased. Accordingly, the Museum
also has the right to exhibit the artifact.

Since the artifact was created prior to June 7, 1988, the copy-
right owner, Shriners Hospitals ... does not control the exhibition
right of the artifact, only the right of reproduction. The Copyright
Act, Section 3 (1)(g) states that the "copyright" in relation to a
work means the sole right ... to present at a public exhibition, for a
purpose other than sale or hire, an artistic work created after June
7, 1988, other than a map, chart, or plan. Accordingly, there are no
restrictions on the exhibition of the artifact.

Furthermore, copyright law permits [the curators] to comment on
the artifact and reference the Shriners Hospitals ... The Copyright

Act, Section 29.1 permits criticism or review if the source and name of author are mentioned. Accordingly, [the curators] are not required to make any changes to the text of their work in the Project ...

 We trust that the above is helpful and that the Museum will proceed to exhibit the artifact and commentary ... In the event that there is a claim against the Museum for any copyright infringement in relation to the exhibition of the artifact as part of the Project, we are willing to indemnify the Museum at our cost.

Relief, astonishment, and jubilation are just around the corner. *FIXING* is back on track!

An email from MuseumGuy at 6:07 PM on July 3 confirms that the museum will display the authentic 1948 Shrine Circus program, restore the original *FIXING* text, highlight an advertisement taken from the circus program, and include a quote excerpted from "The Unwanted Child" story about a boy named "Jean Paul" that features in the program. *FIXING* is fixed. It will feature the genuine item – an item that, for legal reasons, we dare not reproduce in this chapter but that readers are invited to view at the CMHR in Winnipeg, Manitoba.

The actual 1948 souvenir circus program is on display in the *Out from Under* exhibit at the CMHR. For the purposes of this publication, however, since we do not hold the right to reproduce the program, this figure shows only a blurred-out representation of this artifact.

FIXING

Before and After. In this souvenir program from the 1948 Shriners' circus in Montreal, a few messages are clear. Children with twisted legs and backs are a sorry sight.

Clowns with painted faces and bizarre costumes are a happy sight. Doctors and nurses with grim expressions and stern intentions are a noble sight. "Scouring the country for indigent, crippled kiddies," the heroes of this story repaired children's bodies to render them "normal." When these surgeries succeeded, we are told that the children's hearts were "full of gratitude."

Charities today may be less direct in their judgments about the "misfortune" of disability, but sentiments this brazen do not easily vanish. "Before" does not magically transform to "After."

This installation is dedicated to the man that we hope Jean Paul grew to be, and the men and women who these namelessly photographed children became. May they live with pride and solidarity.

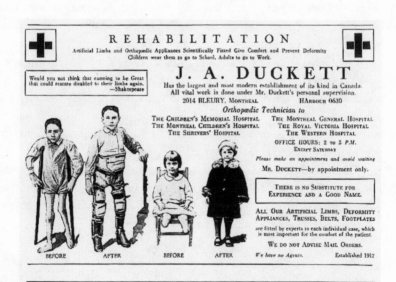

Advertisement for prosthetic devices and braces, 1948. Many children were compelled to undergo painful therapies involving these appliances so they would appear "normal."

Epilogue

Human rights, observes David Petrasek (2014) in an insightful blog post about controversies at the CMHR, are inevitably contested. "They are claims on power ... [and] as such, they necessarily generate disagreement." Petrasek warns that sterilizing the content of our human rights stories dulls our active sense of engagement in debates about power and justice. Debating historical wrongs, he argues, "better ensures we continue to draw lessons they may teach about the present."

It is in this spirit that we were compelled to tell the story of *FIXING*. It is a story that celebrates our collegial affinities and shared passion for the emancipatory power of cultural expression. It is an inquiry into dignity as commodity and gambit, a rumination on the audacity of paternalism and the reach of its influence.

It is a story of the marshalling of purpose required to maintain an activist stance already formed and "established" – a story in which we come to understand how activism is generative, how it requires new infusions of energy, how it reveals its own sudden vulnerabilities, how it is never at ease, even, surprisingly, in the most *friendly* places.

It is a story that ended well, all considered, and one that makes us keenly aware of the rare privilege of working within an organization that honours and nurtures activist impulse and that takes its lead from a simple posture of courageous conviction.

While we scratch our heads and shudder "who knew?" at the importance of section 3 (1)(g) and section 29.1 of the Copyright Act, we are nevertheless haunted by the knowledge that legal technicalities are rarely the fairy godmother of activist aspiration. In this instance, the law worked for us where our efforts at moral suasion seemed destined to fail. That troublesome truth is also part of the final reckoning in this story.

We conclude in humble recognition that "fixing" is a messy business, one for which the goal is not simply a stable and final resolution, but rather an illumination of process, a reckoning of forces, a continuing of the conversation about who we are and how we arrived here.

NOTES

1 After thirteen great years in the School of Disability Studies at Ryerson, Kathryn Church is currently director of the school and learning each day the possibilities and challenges of activist leadership. Melanie Panitch is the founding director of the School of Disability Studies (1999–2011) and author of *Disability, Mothers, and Organization: Accidental Activists*. Catherine Frazee is a professor emerita at

Ryerson's School of Disability Studies and is now pursuing all the pleasures of activist retirement; she blogs at http://fragileandwild.com when riled or beguiled.

2 Time stamps in this manuscript are accurate within two time zones. All dialogue is quoted directly from original sources, with minor edits for brevity.

3 Angelou, Maya. 1978. "And Still I Rise." https://www.youtube.com/watch?v=JqOqo 50LSZ0.

WORKS CITED

Black, Debra. 2014. "If You Build It, They Will Complain." *Toronto Star*, September 20. http://www.thestar.com/news/insight/2014/09/20/how_do_you_curate_a_museum_of_human_rights.html.

Busby, Karen. 2014. Interview with Carol Off. *As It Happens*, CBC Radio, September 16. http://www.cbc.ca/player/play/2520469615.

Church, Kathryn, Melanie Panitch, Catherine Frazee, and Phaedra Livingstone. 2010. "Out from Under: A Brief History of Everything." In *Re-Presenting Disability: Activism and Agency in the Museum*, edited by Richard Sandell, Jocelyn Dodd, and Rosemarie Garland-Thomson, 197–212. New York: Routledge.

Eberts, Mary. 2012. "Mary Eberts on Human Rights Museum." *CBC News*, December 3. http://www.cbc.ca/news/mary-eberts-on-human-rights-museum-1.450194.

Petrasek, David. 2014. "Inside and Out at the Human Rights Museum." *open GlobalRights* (blog), October 12. https://www.opendemocracy.net/openglobal rights-blog/david-petrasek/inside-and-out-at-human-rights-museum-0.

Ryerson University. 2014. "Ryerson's Groundbreaking Disability Rights Exhibit Moves to National Stage." Media release, April 25. http://www.ryerson.ca/news/media/General_Public/20140425_MR_OutFromUndMOU.html.

Ryerson University. n.d. "Out from Under: Disability, History and Things to Remember." Accessed December 4, 2014. http://www.ryerson.ca/ofu/.

2

Imagining Otherwise
The Ephemeral Spaces of Envisioning New Meanings

CARLA RICE, ELIZA CHANDLER,
and NADINE CHANGFOOT

Over the past thirty years in Canada, disability rights movements have made critically important interventions into the oppression of disabled people in diverse sectors of society by striving to guarantee that many people with disabilities have better access to human and equality rights. Although disability advocates working with and as judges, lawmakers, and other decision makers have broken down barriers preventing the fuller, more equitable participation of people with disabilities in Canadian society, many acknowledge that much work still needs to be done to bring disability experiences, and more complex accountings of those experiences, into decision-making processes across all spheres of communal life. In this chapter, we open creative and artistic avenues for discussing and desiring disability rights, and diversity in those rights, as our contribution to a conversation that so often tends toward imagining rights in strictly bureaucratic, standardizing, and normalizing terms.

The artistic and creative avenues we address centre on the participatory arts-based methods of digital storytelling and digital stories (three- to four-minute self-reflexive films) produced in the communal spaces of Envisioning New Meanings of Disability and Difference, a research project specifically designed to challenge misconceptions of disability and difference and expand understandings in open-ended, non-didactic ways. Recognizing how art is not independent of the context in which it is made, we then reflect upon the

generation of an "aesthetic community" (Rancière 2009, 51) in the digital storytelling workshops; how vulnerability and intercorporeality were inspired among storytellers; and how the artworks produced demonstrate some of the ways that the arts might open creative avenues for discussing and desiring disability rights and disability justice.

We draw the concepts of "aesthetic community" and "relational aesthetic" from Jacques Rancière (2009) and Nicolas Bourriaud (2002) respectively. Rancière theorizes imagined spaces of resistance against dominant power relations of capitalism and colonialism, while Bourriaud theorizes relational art as having democratic intent and purposive resistance that is conceived relationally among artists and audiences without overdetermining outcomes. Within Envisioning, digital storytelling spaces that were constituted with attention to disability, aesthetic community, and relational aesthetic became "cripped," meaning that those embodying disability and difference, particularly at the margins, were given voice, seen, and heard in ways they previously were not (Fritsch 2012). This practice of activism and what it creates allows us to fight for disability justice–oriented social change through understanding that to live a fulfilled life requires that we reimagine the rights that the Canadian Charter of Rights and Freedom seeks to protect and attend to justice-based concerns, which may not be definable, and therefore protectable, by such documents. This occurs not by identifying rights in the digital stories themselves, but in part through contributing to an expansive understanding, made available in the stories, that the lives of disabled persons require more than Charter rights as currently interpreted.

We write this chapter as three women who have shifting and multiple experiences living with disabilities and embodied differences. We write through our shifting and multiple relations with and within the arts-based research projects analyzed, as participant storytellers (where we each made our own digital stories), as facilitators and facilitators in training, as workshop organizers, as invested members of the research team, and as an audience of the digital stories. These multiple positions and perspectives cannot be untangled. We also write this chapter as colleagues and friends who have spent many hours thinking about this project together. We recognize (and enjoy) that the authorship becomes blurred and entangled throughout this chapter, which is representative of how these ideas were collaboratively generated. We follow a tradition in disability studies of blurry writing together (Hughes and Paterson 1997, 2004; Mitchell and Snyder 1997, 2000, 2003, 2011; Shildrick and Price 1996; Titchkosky and Michalko 2009).

Envisioning New Meanings of Disability and Difference

Envisioning New Meanings of Disability and Difference was an Ontario Trillium Foundation–funded research project that ran from 2006 to 2009 across three communities in Ontario (Toronto, Peterborough, and Sudbury) as a collaborative effort among various leaders in women's, disability, and health services sectors, including the YWCA of Peterborough, Victoria, and Haliburton; the YWCA of Sudbury; the Women with Disabilities and Deaf Women's Program at Springtide Resources in Toronto; Women's College Research Institute at Women's College Hospital in Toronto; and the Gender and Women's Studies Program at Trent University in Peterborough. Envisioning explored the efficacy and power of the arts in contributing to social inclusion by inviting women who identified as living with disability or difference to use digital storytelling and photovoice (a visual methodology that puts cameras into the hands of participants [Wang 1999]) as ways of exploring their embodied experiences. This project described "embodied difference" in a nondeterministic way, leaving the category open-ended for women to self-identify (a theme we will return to at the end of our chapter) (Rice, Renooy, and Odette 2008). Embodied difference could include, but was not limited to, women with mobility and sensory disabilities; chronic illness; mental, learning, and intellectual disabilities; and facial and physical differences (Rice, Zitzelsberger, Porch, and Ignagni 2009). Our project resists further bounding of the categories of disability and difference, agreeing with Margrit Shildrick (2007, 223) that this would "close down, and thus normalize, what must otherwise remain a shifting nexus of both physical and mental states that resists full and final definition." Envisioning was the predecessor to Project Re•Vision, a Canadian Institutes of Health Research–funded research project that used arts-based methods, specifically digital storytelling and theatre, to dismantle stereotypical understandings of disability and physical difference that can create barriers to healthcare, education, and inclusion in the broader community, on which the three of us are researchers.

The aim of Envisioning was to uncover and address the gaps in how women with disabilities and differences see themselves and are seen by others. In intensive workshops that taught the fundamentals of representation, storytelling, photography, and filmmaking (Lambert 2010, 2013), participants had opportunities to take photographs and make digital stories to speak back to dominant representations about their bodies and lives. Our approach resonated with that of other scholars and activists committed

to exploring the possibilities and limits of emergent arts-based methods such as digital storytelling for constructing knowledge and inciting change (Benmayor 2008; Brushwood Rose 2009; Cole et al. 2004; Vivienne 2011; Vivienne and Burgess 2013). It also followed a vibrant disability arts movement that has garnered attention in Canada and elsewhere in recent years as a new genre to give expression to disability experience and challenge imposed invisibility by reimagining bodily difference (Roman 2009a, 2009b). The disability arts and culture movement grew out of the disability rights movement in the late 1970s/early 1980s and marked a shift in disability activism away from securing legal rights for persons with disabilities and making public space accessible (in line with the social model) to focusing on aesthetic and cultural concerns (Gorman 2011). Although disability arts have been incubating in Canada for over three decades, "disability culture" has been conceived of only as a concept, and disability art has been officially recognized as a distinct form of art practice (through receiving federal and provincial funding) only since 2000 (Gorman 2011). Many credit these developments to Ryerson's School of Disability Studies' disability cultural event, An Evening of Disability and Deaf Culture, which began in 2000 as the first of its kind in Canada, and to Vancouver's Kickstart festival and Calgary's Balancing Acts, which launched soon after in 2001 and 2002 respectively (Abbas et al. 2004; Gorman 2011).

Envisioning and Project Re•Vision digital storytelling workshops were dedicated to creating spaces where disability was welcomed in, thus allowing artists to tell complex and nuanced stories about their embodied experiences. (Almost) all of our workshop organizers, facilitators, technical support people, and volunteers identify as disabled women, disabled trans/genderqueer individuals, and/or those who embody difference. Such disability leadership models part of what these projects were trying to achieve: advancement of new understandings of disabled people as agentive, creative, and effective leaders. Before the workshop, we asked participants to share with us their accessibility requirements and how we might make the workshop space and the artistic process more comfortable for them. We began each workshop with a conversation about how we could work collectively to ensure that the workshop was a safe(r) space and how we might welcome and further desire disability. We discussed how embodied differences might disrupt workshop processes in ways that we together could be open to and be changed by, rather than these differences simply being tolerated. This conversation established our space as one that would not tolerate

racist, sexist, ableist, sanist, and queer and transphobic language or behaviour, insisting that to achieve this we had to hold each other and ourselves accountable.

Working in groups designed and led by facilitators living with disabilities and differences gave participants and facilitators the opportunity to individually and collectively challenge outsider perceptions and explore alternative ideas of difference. To that end, facilitators led the group in a discussion about how a disability justice framework might approach questions of representation, suggesting that while workshop participants may share the common goal to "talk back" to dominant representations of disability or embodied differences, we were not all talking back to the same kinds of representations. Because disability is clarified by other aspects of identity, we discussed how, for example, a white, middle-class woman with a physical disability may be represented as pitiable while a radicalized psychiatric survivor who is living on the streets may be represented as dangerous and criminal. In these ways, we worked to achieve a sense of community and safety within our workshops, which allowed participants to tell complex and unique stories of disability and embodied difference.

The digital storytelling processes and outputs created through Envisioning workshops made space for new representations of disability and embodied difference to emerge. With its unique emphasis on image and narrative, the digital storytelling genre enabled storytellers to represent their sensory worlds in surprising new ways, conveying the volatility and instability of human embodied experience and opening possibilities for intimate encounters with difference (Rice 2014, forthcoming). We believe in the power and the efficacy of the arts and have witnessed how digital stories, in their multiplicity, disrupt a "single story" of disability (Adichie 2009). We have also experienced how these digital stories transform the way that we (all of us: healthcare providers, educators, administrators, cultural workers, artists, activists, and so on) understand experiences of disability – for it is hard to argue with a story, especially with one, we contend, from the margins. In what follows, we discuss and share links for two digital stories created as part of the Envisioning New Meanings project by Peterborough-based genderqueer disability artist jes sachse and Toronto-based disability artist Lindsay Fisher, and one from Re•Vision by Aboriginal disabled artist Vanessa Dion Fletcher (Potawatomi and Lenape). As our brief interpretation of these stories and the following more detailed analysis of the process of their making demonstrate, digital stories are pedagogical in ways that

disrupt bio-pedagogical ways of teaching – that is, normalizing and moralizing instructions for life – and instead work as body-becoming pedagogies that open up new, non-didactic possibilities for living in and with difference (Rice 2014, 2016). In other words, as sure as we are that these stories do teach, we cannot be sure *what* they teach. Central to the project of understanding these digital stories as arts-based interventions that work toward achieving disability justice, as we explicate throughout this chapter, is the idea that the artworks undoubtedly teach us about what it means to acquire justice and live a fulfilled life; they also allow us to approach the project of obtaining rights and freedoms in an open-ended, undetermined way, one that does not profess, prescribe, or standardize how justice is enacted.

We recognize that these stories could be subject to critique. At the same time, we note that the stories in digital story artistic form have been brought forth from the margins, from abjected parts of selves. When embodiments have been marginalized, abjected, or minimized through colonization, ableism, heteronormativity, and so on, the emergence of new representations need to be given time and space to breathe – to allow their justice-seeking effects to unfold, be heard, and take hold. This could be understood as an inverse contrapuntal reading, following Emma Larocque's (2010, 12) argument regarding the need to foreground Aboriginal self-representations rather than criticize them according to traditions of Western criticism that can be aggressive and ruthless. Larocque explains that both the creation of Aboriginal material and literary criticism of it represent new bodies of knowledge that distinguish themselves from Western literary traditions. Extending Larocque's insightful analysis to disability, we assert that art making and storytelling from the margins deserve time and space to breathe, in recognition of the works' struggles to come to representation. When thought of as newly emerging, representations from the margins deserve consideration from whence they came.

Our approach is indicative of our commitment to upholding and enacting disability justice. Embedded in our open-ended, undetermined approach to imagining what kinds of representations participants might be "talking back" to, as described previously, we also imagine the sorts of rights and justice that individuals require to feel safe, secure, and fulfilled to be multiplicitous. All disabled people are not protected equally under the Charter. Because such protection depends on citizenship and immigration status, differently located and embodied disabled people resist and talk back to the lack of rights or to injustices in different ways. Although our

workshops did not formally address the Charter per se, we engaged themes of what is needed for disabled people to live safe and fulfilled lives in the midst of a culture that, because of ableism, can feel inhospitable and even dangerous for those of us who embody difference. We anticipated that the people who came to our workshops shared in our belief that art is an effective tool to mobilize change and that creating new representations of diverse embodiments can provoke new understandings of disability and embodied difference, but we did not hold assumptions about what forces and circumstances might make one feel insecure and, therefore, what (artistic or other) avenues one must take to mobilize justice. Experiences of ableism and, thusly, tactics for resisting it are vast and not wholly knowable. It is this understanding that led us to set up the workshops in a way that prioritized listening deeply to stories. Traditionally, digital storytelling workshops highly value stories, particularly stories that are marginalized, and we worked hard to establish a safer space in which stories could be told and listened to – even stories that were disruptive to our closely held beliefs and disability politics. In our workshops, storytellers and story-listeners shared the responsibility of respecting stories, learning from stories, and being changed by stories (Dion 2009). This held true even when they exceeded our expectations for what a story about disability or embodied difference could be or should do.

One evocative illustration of the power of digital stories to bring audiences closer to disability experience is found in a digital story made by genderqueer disabled artist, Envisioning filmmaker, and now Re•Vision facilitator jes sachse. In their piece *Body Language,* sachse explores the complexities of looking at relations for people with disabilities within a representational history of disabled people that can largely be characterized as one of being put on display or hidden away (Chandler and Rice 2013; Garland-Thomson 1997, 2009; Metzl and Poirier 2004; Tregaskis 2002).[1] In this digital story, we see many different photographs of sachse, from childhood to adulthood, laughing with friends, creating in the art studio, and standing by train tracks. Toward the end of the video, we see photographs of sachse, nude, stretching their limbs and standing in front of sun-filled windows. By daring viewers to look at their body and imagine how it feels to look like them, sachse subverts the typically voyeuristic, dominating practices of looking that structure encounters with bodily difference and provokes us to consider how intense looking can remake audience perceptions (http://www.envisioningnewmeanings.ca/?page_id=40). sachse's incitement to us to look, coupled with an invitation to question our urge to

stare, challenges audiences to acknowledge our responses to their differences and, ultimately, our relationships with our own. Through this refraction, sachse refocuses our collective gaze onto societal views of difference and illuminates the myriad ways we may share the experience of what it is to be vulnerable, flawed, and in other ways embodying of "difference," especially in relation to the culturally idealized masculinist, non-disabled, and neoliberalized mode of embodiment – impregnable, independent, self-contained, and always under control (Shildrick 1997, 2002).

The second digital story we discuss was created by Lindsay Fisher, a visual artist, a graphic designer, an Envisioning storyteller, and a Re•Vision workshop facilitator. Fisher's film, *First Impressions*, does more than grant people permission to look intently at her. In her search to discover what onlookers see when fixing their eyes on her face, she asks audiences to see beyond first impressions to find value in difference (http://www.envisioning newmeanings.ca/?page_id=28). This digital story features hundreds of photographs, in which Fisher is making different facial expressions that accentuate her difference, flashing rapidly on the screen. Fisher describes beginning her storymaking process by recollecting moments in her life when she was most aware of being different; while she aimed to tell a counter-story that disrupted the typical disability tragedy narrative, she also wanted to discover something about her bodily difference that would surprise her when she saw it – something that she herself did not know was there. What emerged from her technique of taking and editing into a short film over three hundred photographs of herself "making faces" is a provocative exploration of embodiment from inside her skin – fluid, dynamic, continuously shifting – which she contrasts with the view from outside it, the ways that responses to difference are thought to be already socially and culturally made. Layering this insight, she offers a delightful meditation on the pleasures and sensualities of her embodied experiences. By subverting the usual ways that difference is either desexualized or fetishized in normative culture, she claims her facial difference as a site of sensuality charged with erotic possibility.

The final digital story we discuss illustrates another counter-representation of disability. Vanessa Dion Fletcher is an Aboriginal artist (Potawatomi and Lenape) living in Toronto. In her work entitled *Words*, Fletcher uses homophones to juxtapose her first-person experiences of a learning disability with the objectifying language of diagnostic tests. This digital story features a blank piece of white paper on which the viewer sees a hand write out words, homophones, and sentences from a psychologist's diagnostic report.

The soundtrack consists of Fletcher's playing with the different meanings of homophones – "whole" and "hole," for example. She asks us to consider the ways that the language of deficiency limits children and how the magic of words might open other possibilities for being and becoming (http://projectrevision.ca/videos; scroll down to Vanessa Dion Fletcher and enter the password, projectrevision). Fletcher also identifies as a person living with a learning disability who spells in non-normative ways due to a lack of short-term memory. Using words that sound alike but have different spellings and meanings, Fletcher provokes audiences to consider how her own unique ways of spelling, typically read as mistakes, can instead be understood as her means of injecting new meaning into written language. Her piece beautifully illustrates the unpredictable and non-proscriptive possibilities that open when we welcome disability in. The works of sachse, Fisher, and Fletcher offer important insights into how disabled artists themselves learn even as they teach others to see and, in multiple and diverse ways, to sense difference and disability differently. Put another way, the self-learning that the artists share is inextricably connected to the teaching they offer us as viewers.

The Fleeting Enactment of Aesthetic Community

Thus far, we have highlighted individual digital stories that have, in sachse's film, subverted looking/staring relations and intervened in normative perceptions; in Fisher's, claimed sensuality, erotic possibility, and delight in her embodied experience; and in Fletcher's, created new sites of meaning from words transformed from "errors" (so-considered by the outside) when she becomes the centre and empowered subject of her film. At the conclusion of every digital storytelling workshop – both Envisioning and Re•Vision – the films were screened together with their makers present. We have noted how this collective experience gave rise to the experience of aesthetic community, a community whose artful constitution is primarily sensory and unrepresentable in words and that beckons towards a future of possibilities.

Relational Aesthetics and Aesthetic Relations

During the screenings held at the close of Envisioning and Re•Vision workshops, we experienced how the digital stories conveyed the specificity of each person's experience through artistic renderings that poured forth complex and multiple meanings. The films flooded the senses with visual and aural representations and story narratives to hover over and fill the space in,

between, and among the filmmaker-viewers. In these screenings, there was no imperative to bring the multidimensional sensations we felt in the room under the control of language and analysis, nor did we feel that was possible. Instead, participant-viewers tacitly acknowledged a rich polyphony that disrupted language and analysis. We talked little after viewing the stories; together, they created an affective effect that acknowledged new subjective experiences that transmitted sensations of understanding irreducible to existing scholarly narratives of disability and defied language. A palpable prelinguistic moment of understanding lingered in the air, one that unsettled us in part because of the diverse and multiple manifestations of living with disability and difference ushered in. Facilitating the workshops and the film screenings unsettled stereotypes and uplifted us in that something new, but not yet known in language, was brought forth that had not been invited forth previously. It was also suspenseful in that participants tacitly acknowledged how the prelinguistic knowledge could gestate for future narratives and possibilities. Disability arts challenge dominant norms of disability, create cathartic recognition of the lived experience of disability outside those dominant norms, and generate a moving sense of possibility for the future (Abbas et al. 2004; Roman 2009a; Ware 2008). We seek to build on this knowledge by bringing into words an aesthetic dimension that is critical to evolving conceptions of disability justice: a cripped relational aesthetic (Changfoot 2016) and aesthetic community that preserve the polyphony and specificity of stories such as those of sachse, Fisher, and Fletcher. The relational aesthetic and aesthetic community support an expansive meaning of disability rights because the experiences brought to light exceed the understanding or imagining of a rights-bearing person living with disability and difference.

The creation and presentation of the stories constituted, using the work of Rancière (2009), a dissensual sensory knowledge whereby perception and emotion were brought to light from experiences not previously given much attention. What was invisible was brought into focus and became the centre of attention, even if only briefly. This constructive searching remains, for us, a constant reminder of how daily experience at the margins needs to be presenced to strategize how to make change for the better. Rancière (2009, 58) refers to two regimes of sense: "a regime of conjunction and a regime of disjunction." Interpreting Rancière, we understand conjunction as referring to the multiple, intersecting complexities of the current age or a specific locality and disjunction as referring to the contestation

and resistance arising within an aesthetic community in the current age and a specific locality. For Rancière, the two regimes coinciding at once create dissensus, the intermingling of minds and hearts of those involved, upon which community is built. To illustrate: in their film, sachse reveals a regime of conjunction comprising the dominant able-bodied gaze and bodily norms of self-control, invulnerability, and containment of one's flaws. In inviting the viewer to become vulnerable through sachse's film, they bring the community of filmmakers, now viewers, into their world, and in so doing, troubles and decentres the dominant able-bodied gaze and norms. This troubling and decentring does not manifest in words: it manifests in a chastened and productive silence having to do with the intersubjective encounter created with the viewer(s) and a questioning and shattering of the able-bodied gaze. By deftly making the able-bodied gaze visible in relation to what it makes "other," a dissensus emerges that troubles, decentres, and shatters ableist assumptions and ways of looking. The collective experience of making and screening digital stories created multiple moments of dissensus that together constituted a new sense of community, a new possibility or emergent understanding of disability and difference (which created space for sachse's body in ways not yet fixed or completed), and with this, a new awareness of the conspicuous absence of vocabulary for what was coming into existence. This new sensing of community that did not yet exist hovered above and within the present, creating a tension of yearning for the new amid the complex problematic of the present.

Importantly, the bonds created within this aesthetic community were formed through a relational aesthetic that developed during the making of the stories themselves, especially the sharing of the story narratives in the story circles prior to and as foundational for the creation of the films. Bourriaud (2002, 16) argues that "relational aesthetics" arise from art itself because art "creates free areas and time spans whose rhythm contrasts with those structuring everyday life." Art facilitates certain encounters between persons that would not occur otherwise because our communication with one another is so highly regulated. Among Envisioning filmmakers, facilitators, and researchers who attended the workshops and final screenings, new encounters occurred that generated a deeper understanding of the very wide range of experiences that living with disability and difference entails, both challenging and enlivening. Bourriaud likens encounters with art to a game of tennis: there is a serve and a return, implying continued exchange with a willing partner and a potential for transformation from competition to

communication along with an emergent understanding that the communication brings forth. In such encounters, Bourriaud anticipates the emergence of a horizon, "a desired future or world which the exchange will reveal in discussion" (23).

Forming a temporary community through intimate contact over three intense days (the length of the workshops), Envisioning filmmakers and facilitators carried the memory of the relational aesthetic, of artful relating and relating artfully, which continues to be a powerful memory and inspiration for further action. We engaged in no debate or dialogue over specific political, social, or economic change or how the group would be part of that change. At the same time, we experienced a palpable sense that better conditions of life were possible by virtue of the conditions and experience of the digital filmmaking and the resulting films themselves. Participants did not put these possibilities into words or a program of action per se. Rather, we witnessed how these came into existence as a *present absence* from the stories themselves. We felt the future in the negative spaces, in the interstices, created by the stories that showed implicitly what should not and need not have happened in terms of experiences of marginalization, indignities, violence, and exclusions that the storytellers had experienced and animated. Multiple and complex identities were held together, observed, and respected without the push or goal to constitute new authoritative narratives or to forge a forced sense of solidarity. Becoming knowledgeable in a sensory and aesthetic way prior to problematization, scholarly narrative, and activism was enough in this space, knowing that the rest would come in time.

We recognize that the aesthetic community created in the Envisioning and Re•Vision workshops was ephemeral; in these spaces, disability and difference were desired, but when the workshops ended, we were still confronted with the ableist logic that circulates in normative culture. The workshops created an important place of freedom that is not (yet), or only partially, experienced outside the space. We think Envisioning and Re•Vision offered this space of freedom in part through the temporary suspension of the everyday, where sensate experience of embodied difference is largely outlawed (Changfoot 2016; Hennessy 2002, 85), where it is rarely possible to express and explore personal reflections entwined with the social, economic, and political in a meaningful way. In this way, the spaces of alterity created through Envisioning and Re•Vision could be described as a "fleeting [enactment] of community" (Chandler 2012) that is "fragile and vulnerable" (Bauman 2001, 14).

Intercorporeality and Vulnerability as Conditions of Possibility for Aesthetic Community

We each experienced how a fleeting aesthetic community was generated in our digital storytelling workshops as the boundaries between us (researchers and workshop facilitators) and them (workshop participants and storytellers) were blurred. Thus, we experienced how our corporeal boundaries were necessarily similarly blurred. There remained, of course, the distinction between those whose bodily differences caused them to encounter ableist attitudes and disabling practices more frequently than others (we are not suggesting that we all became disabled within the workshops, even within our open-ended understanding of what disability is and could become). We repeatedly noticed, though, that in the workshops – filled with stories, emotions, technical instructions, creativity, and, undeniably, the requirement for physical and emotional stamina, no matter our attempts to make these workshops into accessible and flexible spaces – we experienced our corporealities in relation to the others in the room. This corporeal mixing inspired embodied self-reflexivity and provoked vulnerability, which, in turn, created the conditions of possibility for generating an aesthetic community among those present.

Self-reflexivity – the willingness to turn the gaze on one's self even when this may lead to discomforting and unsettling truths – requires that critical researchers make themselves vulnerable (Behar 1997). Since we were asking women involved in Envisioning to expose their vulnerabilities, disabled and non-disabled researchers on the project also felt ethically impelled to acknowledge their/our own vulnerability through creating digital stories that called attention to power relations based on appearance, ability, and bodily difference; that analyzed shared vulnerabilities across differing experiences of body privilege and abjection; and that blurred boundaries that exist in our culture – by this we mean Western anglo hegemonic culture – between categories of normal and abnormal, disability and other bodily difference, male and female, and the disabled and non-disabled worlds. Through consideration of their/our vulnerabilities and corporealities via the digital storytelling genre, disabled and non-disabled researchers entered into aesthetic relations with disabled facilitators and storytellers in the workshop space. Thus, the willingness to make oneself vulnerable and to make a story of the intercorporeal became the conditions of possibility for entering into the aesthetic community the workshops fleetingly created.

Beyond the omnipresence of ableist attitudes and disabling practices in normative culture, what in part contributed to making Envisioning's

enactment of aesthetic community so fleeting and ephemeral is that vulnerability is defined so negatively in our society; a conventional definition describes it as a susceptibility to being wounded or hurt and an openness to criticism or attack. Vulnerability is also associated with the feminine, the disabled, the aged, the marginalized, the weak – all groups seen as more prone or susceptible to harm due to their embodiment (illness, disability, pregnancy) or social disadvantage (poverty), especially in an ableist, masculinist world that privileges self-contained, autonomous, and independent selfhood (Shildrick 2000, 2002). While vulnerability can increase people's susceptibility to suffering and inequality (since groups marked as vulnerable are socially rendered violable), it is also the ground for human exchange, empowerment, and growth. It is necessary for human being and human understanding. It is fundamental to relationship and to social life. Legal scholar Martha Fineman (2008, 8) reclaims the term "vulnerability" from its negative associations to its potential as a "universal, inevitable, enduring aspect of the human condition" shared by every human being. She argues that the negative and positive possibilities of vulnerability are important, since they capture the inherent interdependence that underpins human existence. This challenges the myth of the invulnerable autonomous self that is the basis of Western legal systems and social policies and enjoins us to rethink these by taking the vulnerable self, our shared common human experience, as our starting point in building a more equitable society.

Because our culture uses vulnerability to justify cultural abjection and social exclusion, it is difficult for people to be vulnerable. Some groups, such as people with disabilities, are forcibly positioned as vulnerable (Breckenridge and Vogler 2001). And people learn that they may be violated if they show vulnerability. But when people decide to make themselves vulnerable, this can interrupt prevailing norms and provoke personal and collective transformation. This is especially true when individuals in privileged positions unmask their vulnerabilities in an effort to deepen understanding and expose the operations of power surrounding constructions of vulnerability. For example, in contrast to the typical ways we culturally "know" researchers as disembodied experts, those who write from their body histories reveal a shared vulnerability, animating Fineman's (2008) declamation of the term and blurring boundaries between bodies forcibly and intentionally positioned as vulnerable (halifax 2011). While there are different social and material consequences for those whose vulnerability is imposed rather than (ethically) impelled, non-disabled researchers' articulations of vulnerability in the context of the cultural imperative as, or at least appearing

to be, all-knowing challenges expectations of who and what a vulnerable self is or could be. Even more, the provocation to shared vulnerability created in Envisioning and Re•Vision workshops fostered ephemeral communities that opened participant-viewers to sensate experiences of embodied difference that enabled them to begin imagining otherwise. This imagining otherwise opens possibilities of who is and is not a rights-bearing citizen and exposes the limits of this dichotomy alongside inviting a fuller conception of disability justice.

Disability Justice Approaches to the Charter

We end our chapter by positing that arts-based interventions, such as Envisioning and Re•Vision, can move the disability movement beyond a rights-based framework. While we respect and are indebted to the important wins of the disability rights movement, we propose that we must work alongside the movement for social change beyond rights-based orientation and toward disability justice, toward what Eli Clare (1999, 168) refers to as "liberation." For our definition of disability justice, we refer to the Bay Area–based disability activist movement that emerged out of an acknowledgment that rights-based movements serve only subjects who are recognized as rights-bearing citizens, leaving behind people who are not recognized and therefore not protected under legislation such as the Charter. These are people such as stateless bodies who may not be recognized as citizens within the nation-state in which they live. Disability justice also opens up to and desires different ways of experiencing disability and acknowledges that social exclusion and oppression of disabled people may be caused by the ways that ableism interacts with racism, sexism, colonialism, and queerphobia (Mingus 2011). As disability justice activist Mia Mingus (2011) writes,

> Disability justice activists are engaged in building an understanding of disability that is more complex, whole and interconnected than what we have previously found. We are disabled people who are people of color; women, genderqueer and transgender; poor and working class; youth; immigrants; lesbian, gay, bisexual and queer; and more.

At the same time as disability justice acknowledges that disability rights may not recognize and therefore not protect all citizens, this framework, particularly when used to think about the political potential of arts-based interventions, does not determine or predict what obtaining justice would look or feel like. Rather, disability justice acknowledges that because systems

of oppressions – such as racism, colonialism, and ableism – work together to oppress people in ways that are pervasive and multiplicitous, we cannot predict what liberation from such oppression would look or feel like. We propose that arts-based interventions, such as the digital stories created in our workshops, can "crip" – that is, open with desire that which disability disrupts (Fritsch 2012) – what disability activism could be and what disability justice could become. In this section, we attend to three critical possibilities for crip activism in three prongs: *what we are fighting for, who we are fighting beside/with,* and *how we are fighting.*

First, arts-based interventions can crip *what we are fighting for* in that, through a disability justice framework, we can work for social change beyond the rights recognized and protected under the Charter. Among other things, sachse's, Fisher's, and Fletcher's digital stories are all calling for a radical recognition of crip(ped) subjectivity, demanding of their audience that we attend to what is produced through disability. Fisher's film, for example, is demanding recognition of her disabled body as sexually agentive and desirable. More than articulating her sexual subjectivity, she gives us a sense of the sexual pleasure generated by her difference in her description of how, when a boy kisses her "missing ear," she can feel it through her whole body. The right to be recognized as a sexual subject, one in charge of one's own sexuality and sexual health, is not a right that could accurately be defined and therefore protected by the Charter. Even if the right to be understood as sexually agentive did appear in the Charter, there would be no way to guarantee that this right would be protected. Art has the capacity to open up what we are fighting for – a shift in imagining what is required to live a fulfilled life – and art's ever-expanding essence has the capacity to hold a polyvocal understanding of what our justice-based concerns are and could become.

Second, arts-based interventions can crip *who we are fighting beside/ with,* in that a disability justice framework can expand our understanding of who disabled people are and which disabled people are recognized as citizens and, more than this, worth protecting under the law. Recognition of the gendered, racial, sexual, class, and geographic diversity within the category of disability requires an understanding that what provides rights and freedoms for one person does not guarantee the same for another. For example, legislation such as the Accessibility for Ontarians with Disabilities Act may allow some disabled people in Ontario to access public space with greater ease. A disability justice framework requires us, however, to attend to the imbricating ways that certain bodies are kept out of spaces through

systemic racism, sexism, queer and transphobia, and more, and goes beyond positioning disability as a logistical problem to be fixed. As an example, as important as it is to create barrier-free environments like washrooms, the dismantling of systemic transphobia to ensure that all barrier-free washrooms also be gender neutral/all-gender is also required to make sure that public space is accessible to all disabled people. Shifting our imagination of who "we" are, thinking carefully about how different aspects of our social location and identity can clarify how disability is interpreted and, thus, how we experience disability, helps us to know, unquestionably, what rights we should be fighting for.

Finally, arts-based interventions can crip *how we are fighting* by expanding what is counted as effective activism. In her chapter "Unhealthy Disabled," Susan Wendell (2013) uses a feminist disability studies analysis to interrogate traditional activist practices, suggesting that thinking about disabled materiality crips the ways we practise and recognize activism. Wendell (2013, 163) suggests that many of the ways that disability political action is structured are, indeed, exclusionary. Of the intimate ways that disability materiality, particularly chronic pain, touches normative activist practices, she writes,

> On a bad day of physical or mental [pain], we may be unable to attend a meeting or workshop, to write a letter, to answer the phone, or to respond to e-mail. We may need notice in advance of work to be done, in order to work only on good days or more slowly on days when we are very ill. We may need to work in teams, so that someone else can take over when we cannot work at all ... Commitment to a cause is usually equated to energy expended, even to pushing one's body and mind excessively, if not cruelly ... Yet in political activity, all-day meetings and evening events after a full day's work are assumed to be appropriate. Stamina is required for commitment to a cause. (167)

As we conclude this chapter, we wonder, with Wendell's provocation, how we might crip what counts as activism in a way that pushes beyond the traditional forms of activism that may require people to stay up late, be publicly present, write letters, and walk or roll long distances, and therefore be accessible only to certain bodies. Opening up understandings of activist practices to include forms such as arts-based interventions could be more inclusive to different kinds of people, such as people who get tired, who may not be able to leave the house, who cannot spell in normative ways,

and whose sexuality is fetishized or framed as deviant. Arts-based activist practices may also be more accessible to precariously placed people who cannot come into contact with police because of a different set of risks, such as disabled people with a criminal record; disabled people who are stateless; immigrants on caregiver visas who become disabled on the job and risk deportation should their disability be revealed; or mad people who cannot risk incarceration. What possibilities open up beyond traditional and exclusionary activist practices when we think about artistic interventions as activism?

sachse's, Fisher's, and Fletcher's stories, along with others in the Envisioning and Re•Vision archive, were made with the animating question of "what is your difference as a woman living with disability and difference?" Their own stories are part of an extensive polyphony that is unruly, defying control by existing concepts of disability and difference. We are in the wonderfull and challenging labour of making meaning from the stories and channelling their unruliness toward generative possibilities, including rethinking disability rights and moving toward disability justice. The opening up to multiple and richly diverse new narratives with accompanying sensations provided through the visual and aural in the films pushes us to open further and disrupt our imagined identity of the normative rights-bearing person living with disability. The films push and move us to a capaciousness to imagine the multiplicity of identities of persons living with disability, persons who should willingly and rightfully participate fully in all aspects of society as they choose. The films are themselves activism in their conveyance of multiple and richly diverse experiences of women living with disability and difference. sachse's, Fisher's, and Fletcher's films tell stories that not only disrupt ableist stereotypes concerning looking and beauty, sensuality, pleasure, and learning, but point in their own directions to possibilities for advocacy, meaningful support, and, perhaps more importantly, new practices of living well. Seeing these films as activist themselves, as part of and within an established activist disability arts movement, can productively support a rethinking in approach toward rights and justice.

More than changing the way we practise and recognize activism, might arts-based activism also allow us to think differently about what it is we are fighting for and, indeed, the kind of world we are fighting for? Could artistic interventions move the conversation about disability rights beyond bureaucratic, standardizing terms, beyond what is achieved in the recognition of disabled people under the Canadian Charter of Rights and Freedoms, and on to liberation and the multiplicity of rights- and justice-based worlds that

we are fighting for? Might the aesthetic community enacted in our workshops, and the ways of being (vulnerable) and becoming together that these spaces allowed, serve as a model for a kind of world we want to imagine and inhabit? We engage this discussion not to diminish the absolute necessity of having (some of) our rights protected by the Charter and similar legislation, nor to dismiss the labour and fierce activism of the formative disability rights movement. The framework underpinning Envisioning and Re•Vision, with its expansive, body-becoming understanding of what disability is and who disabled people can be (Rice 2014), opens the category of disabled people to people who may not be recognized as disabled under the law or protected under various charters, who are often the same people who have been marginalized with our movement – sick people, trans folks, mad-identified people, non-disabled people with visible and invisible physical differences, fat people, psychiatric survivors, people with workplace injuries, new immigrants, migrants, and stateless bodies. More than this, disability arts, as sachse's, Fisher's, and Fletcher's films demonstrate, "imagine otherwise," create new possibilities for living together and experiencing the world rather than attempting to fit our different bodies in a system that does not desire us, or desires us only and always as "problems," living reminders of what it means to be abnormal. Disability arts, such as these digital stories, allow us to imagine disability in new, self-determined ways and open up to ideas of disability justice and how we might imagine a world otherwise.

NOTE

1 The singular "they" is sachse's preferred pronoun.

WORKS CITED

Abbas, Jihan, Kathryn Church, Catherine Frazee, and Melanie Panitch. 2004. *Lights ... Camera ... Attitude! Introducing Disability Arts and Culture.* Toronto: Ryerson RBC Institute for Disability Studies Research and Education.

Adichie, Chimamanda. 2009. "The Danger of a Single Story." TEDGlobal video. http://www.ted.com/talks/chimamanda_adichie_the_danger_of_a_single_story.html.

Bauman, Zygmunt. 2001. *Community: Seeking Safety in an Insecure World.* Cambridge: Polity.

Behar, Ruth. 1997. *The Vulnerable Observer: Anthropology That Breaks Your Heart.* Boston: Beacon Press.

Benmayor, Rina. 2008. "Digital Storytelling as a Signature Pedagogy for the New Humanities." *Arts and Humanities in Higher Education* 7 (2): 188–204. http://dx.doi.org/10.1177/1474022208088648.

Bourriaud, Nicolas. 2002. *Relational Aesthetics*. Translated by Simon Pleasance, Fronza Woods, and Mathieu Copeland. Paris: Les presses du réel.

Breckenridge, Carol A., and Candace A. Vogler. 2001. "The Critical Limits of Embodiment: Disability's Criticism." *Public Culture* 13 (3): 349–57. http://dx.doi.org/10.1215/08992363-13-3-349.

Brushwood Rose, Chloe. 2009. "The (Im)Possibilities of Self Representation: Exploring the Limits of Storytelling in the Digital Stories of Women and Girls." *Changing English* 16 (2): 211–20. http://dx.doi.org/10.1080/13586840902863194.

Chandler, Eliza. 2012. "Cripping Community: New Meanings of Disability and Community." *No More Potlucks* 19. http://nomorepotlucks.org/site/cripping-community-new-meanings-of-disability-and-community/.

Chandler, Eliza, and Carla Rice. 2013. *Revisioning Disability and Difference*. Oshawa, ON: Faculty of Health Sciences, University of Ontario Institute of Technology.

Changfoot, Nadine. 2016. "Creating Meaning: Creating Emancipatory Moments through Storying Outlawed Experiences and Relational Aesthetic." *Socialist Studies/Études Socialistes* 11 (1): 62–84.

Clare, Eli. 1999. *Exile and Pride: Queerness and Liberation*. Cambridge, MA: South End Press.

Cole, Ardra, Lorri Neilsen, Gary Knowles, and Teresa Luciani, eds. 2004. *Provoked by Art: Theorizing Arts-Informed Research*. Toronto: Backalong Books.

Dion, Susan. 2009. *Braiding Histories: Learning from Aboriginal People's Experiences and Perspectives*. Vancouver: UBC Press.

Fineman, Martha. 2008. "The Vulnerable Subject and the Responsive State." *Yale Journal of Law and Feminism* 20 (1): 1–22.

Fritsch, Kelly. 2012. "Crip Theory." Paper presented at the Society for Disability Studies Conference. Denver, June 8.

Garland-Thomson, Rosemarie. 1997. *Extraordinary Bodies: Figuring Physical Disability in American Culture and Literature*. New York: Columbia University Press.

–. 2009. *Staring: How We Look*. Toronto: Oxford University Press.

Gorman, Rachel. 2011. "Whose Disability Culture?" *Fuse* 34 (3): 46–51. First published 2007.

halifax, nancy viva davis. 2011. "Scar Tissue." *Open Words* 5 (1): 73–81.

Hennessy, Rosemary. 2002. "Reclaiming Marxist Feminism for a Need-Based Sexual Politics." In *The Socialist Feminist Project: A Contemporary Reader in Theory and Politics*, edited by Nancy Holmstrom, 83–89. New York: Monthly Review Press.

Hughes, Bill, and Kevin Paterson. 1997. "The Social Model of Disability and the Disappearing Body: Towards a Sociology of Impairment." *Disability & Society* 12 (3): 325–40. http://dx.doi.org/10.1080/09687599727209.

–. 2004. "The Social Model of Disability and the Disappearing Body." In *The Body: Critical Concepts in Sociology*, edited by Andrew Blaikie, 325–40. London: Routledge.

Lambert, Joe. 2010. *The Digital Storytelling Cookbook*. San Francisco: Digital Diner Press.

–. 2013. *Digital Storytelling: Capturing Lives, Creating Community*. New York: Routledge.

Larocque, Emma. 2010. *When the Other Is Me: Native Resistance Discourse, 1850–1990*. Winnipeg: University of Manitoba Press.

Metzl, Jonathan M., and Suzanne Poirier. 2004. "Editors' Preface: Difference and Identity in Medicine." *Literature and Medicine* 23 (1): vi–xii. http://dx.doi.org/10.1353/lm.2004.0008.

Mingus, Mia. 2011. "Changing the Framework: Disability Justice." *Leaving Evidence* (blog), February 12. https://leavingevidence.wordpress.com/2011/02/12/changing-the-framework-disability-justice/.

Mitchell, David T., and Sharon L. Snyder. 1997. *The Body and Physical Difference: Discourses of Disability*. Ann Arbor: University of Michigan Press.

–. 2000. *Narrative Prosthesis: Disability and the Dependencies of Discourse*. Ann Arbor: University of Michigan Press.

–. 2003. "The Eugenic Atlantic: Race, Disability, and the Making of an International Eugenic Science, 1800–1945." *Disability & Society* 18 (7): 843–64. http://dx.doi.org/10.1080/0968759032000127281.

–. 2011. *Cultural Locations of Disability*. Chicago: University of Chicago Press.

Rancière, Jacques. 2009. *The Emancipated Spectator*. Translated by Gregory Elliott. London: Verso.

Rice, Carla. 2014. *Becoming Women: The Embodied Self in Image Culture*. Toronto: University of Toronto Press.

–. 2016. "Revisioning Fat: From Enforcing Norms to Exploring Possibilities Unique to Different Bodies." In *Obesity in Canada: Historical and Critical Perspectives*, edited by Wendy Mitchinson, Jenny Ellison, and Deborah McPhail, 419–40. Toronto: University of Toronto Press.

–. Forthcoming. "Volatile Bodies and Vulnerable Researchers: The Risks of Embodiment Research." In *Embodiment, Pedagogy and Decolonization: Critical and Materialist Considerations*, edited by Sheila Batacharya and Renita Wong. Edmonton, AB: Athabasca University Press.

Rice, Carla, Lorna Renooy, and Fran Odette. 2008. *Talking about Body Image, Identity, and Difference*. Toronto: York Institute for Health Research, York University.

Rice, Carla, Hilde Zitzelsberger, Wendy Porch, and Esther Ignagni. 2009. "Creating Community across Disability and Difference." In *Rethinking Normalcy: A Disability Studies Reader*, edited by Tanya Titchkosky and Rod Michalko, 318–29. Toronto: Canadian Scholars' Press.

Roman, Leslie G. 2009a. "Disability Arts and Culture as Public Pedagogy." *International Journal of Inclusive Education* 13 (7): 667–75. http://dx.doi.org/10.1080/13603110903041912.

–. 2009b. "Go Figure! Public Pedagogies, Invisible Impairments and the Performative Paradoxes of Visibility as Veracity." *International Journal of Inclusive Education* 13 (7): 677–98. http://dx.doi.org/10.1080/13603110903041920.

Shildrick, Margrit. 1997. *Leaky Bodies and Boundaries: Feminism, Postmodernism and (Bio)Ethics*. London: Routledge.

–. 2000. "Becoming Vulnerable: Contagious Encounters and the Ethics of Risk." *Journal of Medical Humanities* 21 (4): 215–27. http://dx.doi.org/10.1023/A:1009025125203.

–. 2002. *Embodying the Monster: Encounters with the Vulnerable Self.* London: Sage.

–. 2007. "Dangerous Discourses: Anxiety, Desire, and Disability." *Studies in Gender and Sexuality* 8 (3): 221–44. http://dx.doi.org/10.1080/15240650701226490.

Shildrick, Margrit, and Janet Price. 1996. "Breaking the Boundaries of the Broken Body." *Body & Society* 2 (4): 93–113. http://dx.doi.org/10.1177/1357034X9600 2004006.

Titchkosky, Tanya, and Rod Michalko. 2009. "Introduction." In *Rethinking Normalcy: A Disability Studies Reader*, edited by Tanya Titchkosky and Rod Michalko, 1–14. Toronto: Canadian Scholars' Press.

Tregaskis, Claire. 2002. "Social Model Theory: The Story So Far." *Disability & Society* 17 (4): 457–70. http://dx.doi.org/10.1080/09687590220140377.

Vivienne, Sonja. 2011. "Trans Digital Storytelling: Everyday Activism, Mutable Identity and the Problem of Visibility." *Gay & Lesbian Issues & Psychology Review* 7 (1): 43–54.

Vivienne, Sonja, and Jean Burgess. 2013. "The Remediation of the Personal Photograph and the Politics of Self-Representation in Digital Storytelling." *Journal of Material Culture* 18 (3): 279–98. http://dx.doi.org/10.1177/ 1359183513492080.

Wang, Carolyn C. 1999. "Photovoice: A Participatory Action Research Strategy Applied to Women's Health." *Journal of Women's Health* 8 (2): 185–92. http://dx.doi.org/10.1089/jwh.1999.8.185.

Ware, Linda. 2008. "Worlds Remade: Inclusion through Engagement with Disability Art." *Journal of Inclusive Education* 12 (5–6): 563–83. http://dx.doi.org/ 10.1080/13603110802377615.

Wendell, Susan. 2013. "Unhealthy Disabled: Treating Chronic Illnesses as Disability." In *The Disability Studies Reader*, 4th ed., edited by L. Davis, 161–76. New York: Routledge.

PosterVirus
Claiming Sexual Autonomy for People with HIV through Collective Action

ALEXANDER McCLELLAND and
JESSICA WHITBREAD

This chapter examines the theoretical approach, the practices, and a number of the outcomes of Toronto's AIDS ACTION NOW! activist art affinity group, PosterVirus. PosterVirus, we argue, has allowed for the assertion of new formations of autonomous sexual HIV-positive subjectivities, ones that resist and oppose the juridical, policing, and penal apparatus of state, medical, and civil society institutions that regulate the daily lives of people living with HIV in Canada.

We begin with a poem by Montreal author and artist Jordan Arseneault, which was written to accompany his *SILENCE = SEX* poster for the 2013 iteration of a PosterVirus affinity group project. The poster and poem describe the harsh realities of disclosure to sex partners from the perspective of a person with HIV within the current judicial context, where not disclosing one's HIV-positive status is a criminal offence. The text is as follows:

The New Equation

It's that awkward moment when ...
You're naked in bed with a boy you've just made out with on a rooftop.
Looking up at the little toy cross
On top of the big, dark mountain.

That awkward moment where you bring in the Greek chorus
Of Angels in America characters

And the dump truck of dead bodies and
News segments of ashes actions
And Diamanda Galas howling over Fire in My Belly.

That awkward moment when you decide to cough it up
To rip the band-aid off the unhealed wound
And tell him:

I just need to tell you something that's really not easy to say and
I'm legally required to tell you before we take this any further:

I have been shortlisted for a very special prize.
I am on the shortlist for those who didn't win the bet.
I am biopolitically pegged for a lifetime of awkward moments.

There's 50 parts per millilitre of me
That are Having It Very
difficult; that are too late for a vaccine,
That didn't do their due diligence
And that echo a Harsh Interior Voice
Saying "stay away,"
Even though any other combination of bodies in a moment like this
Would just be getting it on right now.

It's that awkward moment where you look up at the
SILENCE = DEATH poster
On his cluttered bedroom wall
And say the words
I AM HIV POSITIVE
Only to see him freeze, lose his boner, sigh,
And explain trippingly that he has an anxiety disorder
And "just can't take it right now."

It's that awkward moment when you want to rip a hypocritical poster
off someone's wall
Or at least half of it:
SILENCE = riiipppppppp crumple crumple
SILENCE =
SILENCE = SEX
All those posters say THAT to me now:
Silence equals sex.

If you just keep your mouth shut
And don't talk about cells and replication and undetectability
And minor cuts or abrasions
And rinsing with lemon juice
And tests every three months
And how you ever got it in the first place ...

"Oh," you ask "you were in a video PSA about serophobia too?"
"Yes, I'm sure you are very open-minded.
Thank you for showing me that," you say,
As you put your clothes back on.

SILENCE = SEX
Get used to the new equation,
Cause these bastards just don't know the math.

(Arseneault 2013)

To address the fears and sense of normlessness that so many people with HIV face in the current punitive context, Arseneault published the poster and accompanying poem online and read the poem publicly at the Poster-Virus launch at the Art Gallery of Ontario and in Montreal for World AIDS Day. The *SILENCE = SEX* poster directly copies the graphic design and font

Jordan Arseneault,
SILENCE = SEX
poster, 2013.

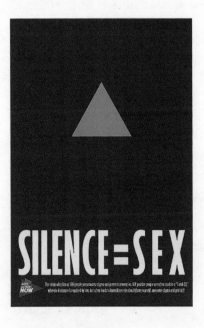

of the original and iconic American *SILENCE = DEATH* poster developed
by the collective Gran Fury. The modality of revisitation, repetition, and
remix calls us to recognize that not much has changed since the early days of
the HIV epidemic. At the bottom of the remixed poster is the following text:

> The criminalization of HIV+ people perpetrates stigma and prevents pre-
> vention. HIV+ people are often caught in a "Catch 22" wherein disclosure
> is required by law, but often leads to immediate rejection. Inform yourself:
> overcome stigma and get laid! (Arseneault 2013)

In this context of increasing legal governance and the associated fears and
stigma that emerge as we move through the third decade of the AIDS epi-
demic, PosterVirus was created as a direct-action arts project focused on in-
stigating new conversations to address these and other complex issues we
face as people living with HIV. The affinity group is one that emerged out of
fear, anger, and a passion to change the institutional constraints imposed
on us through dominant ways of understanding what is possible for people
living with HIV. Seeking to reconceptualize epistemologies of living with
HIV, we follow the lead of disability rights activists and scholars who have
been working to challenge the ways in which disabled people are institu-
tionally framed – ways that are often counter to the lived realities of people
with disabilities. HIV activists and scholars have in some cases had a tenu-
ous relationship identifying HIV with disability and at other times have em-
braced the label.

We explore some of these complexities, but at the same time we follow
Robert McRuer (2002, 2005), who calls for a broad, systematic critique and
coalition building for greater cross-fertilization between disability activists
and academics with AIDS and queer activists and academics. We take in-
spiration from this call and from the work of disability, race, and HIV scholar
Chris Bell, who understood AIDS as a form of disability and stated that "dis-
ability shares much in common with other maligned identities insofar as
departures from the norm are seen as threats to the mainstream body pol-
itic" (Bell 2011, 1) and, thus, that the work of critical approaches to studying
disability is to help deconstruct the systems that would keep those divergent
bodies in separate spheres. We see promise in engaging with the critical
work of disability movements that aim to challenge bodily norms and stake
claims on forms of autonomy. As the creators and curators of the affinity
group, we have worked with over twenty artists over three years to produce
a range of activist posters aimed at reframing social and political discourses

related to the ongoing HIV epidemic in Canada. As of 2011, 71,300 people were living with HIV in Canada, with approximately 4,000 new infections a year (Public Health Agency of Canada 2012). The number of infections has been on a consistent rise, with an 11.4 percent increase since 2008. Canada has what is known as a concentrated epidemic among populations of gay men, Aboriginal people, people who use drugs, newcomers, and people of colour.

The chapter opens with a discussion of contemporary theory and practice from disability movements before providing some historical and social context to situate the emergence and relevance of our project. We also discuss some of the complexities related to talking about HIV and disability in relation to one another. We then analyze a number of the artworks of the PosterVirus affinity group in relation to disability scholarship and activism frameworks. Toward this objective, we address some of the challenges of linking disability and HIV responses, as well as some potential sites of commonality, namely those that aim to reclaim an autonomous sexual subjectivity for people living with HIV and disabled people, one free from forms of institutional invention, regulation, and control. We end with some brief thoughts on how people living with disabilities and people living with HIV/ AIDS can counter forms of oppression by contesting institutional definitions.

Building a Bridge: Theory and Practice from Disability Movements

In working to challenge conceptual practices that inflict forms of violence against people living with HIV, our project addresses a number of principles of critical disability theory and radical disability activism, which we have summarized and adapted from the work of Helen Meekosha and Russell Shuttleworth (2009), Chris Bell (2011), and A.J. Withers (2012). These principles are not intended to define the field of critical disability theory and radical disability activism, but rather are components of these diverse areas of study that we have engaged with and employed in our work and that underpin our approach in PosterVirus. These principles include (1) understanding the impossibility of reducing the social lives of ill, unhealthy, and/or disabled people to objective facts (and challenging approaches that do); (2) diverging from medicalized models and addressing the social and political aspects of what makes people ill, unhealthy, and/or disabled instead of understanding the individual as solely responsible for their illness and/ or disability; (3) ensuring collaborative knowledge production to define, contextualize, and inform understandings of illness and/or disability by working across disciplines and cultures to involve a diversity of activists,

scholars, students, and especially people living with the defined illnesses or disabilities; (4) challenging the view that biomedicine and experts can cure, heal, or rehabilitate; and (5) linking theory to practice in the ongoing struggle for autonomy and a participatory society for people who are understood as ill, unhealthy, and/or disabled (Bell 2011; Meekosha and Shuttleworth 2009; Withers 2012). As noted by Bell (2011, 1),

> Disability scholars contend that cultural barriers preclude the full participation of disabled subjects in society similar to the ways that homophobia and heterosexism, racism, and sexism deter queer-identified, racial minority, and female subjects from operating at their fullest potential. The work of Disability Studies scholars has enlivened and richened discussions of corporeality and human diversity.

Along this trajectory of critical disability scholars and activists, and those who cross multiple worlds, our aim, as put by Véro Leduc in her research-creation work for deaf communities outlined in this volume, is to "deconstruct the minoritization" of people with disabilities. Throughout our discussion, we reflect on principles from critical disability theory and radical disability activism and outline how they underpin the development of the messages of these posters and our rationale for why these principles help to reframe dominant discussions in the response to AIDS. This analysis moves us away from the institutional regimes of medicine, science, and the law to then stake claims for a renewed sexual subjectivity grounded in the lived experiences of people living with HIV. As such, we hope this project crosses multiple boundaries to answer McRuer's (2002, 2005) call to action, mobilizing cultural production to bridge new terrain for activists and academics from the AIDS and disability milieus to speak with and engage each other and to build broader audiences collectively.

Your Nostalgia Is Killing Me!

We now historically situate our work and briefly describe how we have arrived at the contemporary moment in which our project is needed and has been made possible. To do so, we follow the lead of PosterVirus participants from 2013. In challenging our community to consider *how* and *why* AIDS history is mobilized, Ian Bradley-Perrin and Vincent Chevalier developed a poster with the slogan "Your Nostalgia Is Killing Me!" which is splashed across the computer-generated room of a teenager, with Googled images of "AIDS art" plastered on the wall. Because of HIV's temporal specificity –

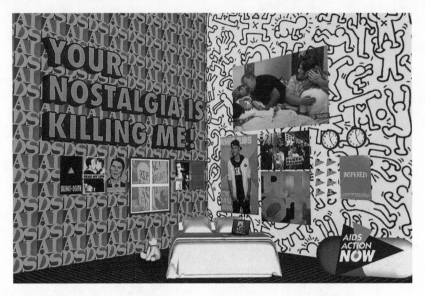

Vincent Chevalier and Ian Bradley-Perrin, *Your Nostalgia Is Killing Me!*
poster, 2013.

meaning that the epidemic is often defined in relation to points in time or
HIV of the past versus HIV of the present – this context remixes and dis-
rupts notions of progress. Here, "Your Nostalgia Is Killing Me!" is important
because it challenges notions of how the past is commodified and mobilized
in the service of capital production and how the past of AIDS activism can
be romanticized as a golden age of social activism. As noted by Chevalier
and Bradley-Perrin (2013),

> It is not the remembering and it is neither the history, nor the material cul-
> ture nor the valorization of the battles won and lost that impedes our move-
> ment forward, but rather the unpinning of our past from the circumstances
> from which the fights were born. It is this that makes light of the impetus to
> resist; the gentrification of our memories and our worshipping of idols
> whose miracles are forgotten.

Thus, we reflect on the past, not to reify or commodify, but rather to re-
member where we have come from so we can be confident in our ongoing
work. Similar to how we understand disability as a construction produced
through social relations, so too is history; we continue to acknowledge that
the process of telling history is subjective, relational, fluid, and dynamic.

Some Brief History
It was only in 1989 that a Canadian prime minister, Brian Mulroney, uttered the word "AIDS" for the first time in public. This was seven years after the first death in Canada due to AIDS (Silversides 2003). The case was reported in the *Canada Diseases Weekly Report*, which detailed the accounts of a Haitian man living in Windsor, Ontario, who had died of a rare pneumonia in February 1982 (Robertson 2005). "Silence thus marked the official responses to epidemic. Silence contributed to it," said Canadian AIDS activist Michael Lynch (quoted in Silversides 2003, 228) in memorializing the first ten years of the AIDS crisis. It is out of the context of institutionalized silence and the insurmountable death toll that an angry and impassioned activist force emerged. Lynch was one of the founders of Toronto's AIDS ACTION NOW!, a group that formed in 1987, the same year that well-known group ACT UP (AIDS Coalition to Unleash Power) asserted its presence south of the border in New York City, to counter state and institutional silence and inaction. Using multiple tactics of direct action, advocacy, civil disobedience, community mobilization, capacity building, and education, these groups formed a historic urban social movement focused on the rights of people most affected by the epidemic. By the end of that year there were fourteen reported cases of AIDS across Canada and four more suspected. Mulroney's statement came after there had been 820 deaths due to AIDS and approximately forty thousand recorded cases of HIV in the country (Public Health Agency of Canada 2008).

In response to the institutionalized silence, future members of the still-nascent ACT UP New York formed the artist collective the Silence = Death Project, members of which would help to form the larger activist art affinity group and ACT UP public relations arm known as Gran Fury. This group developed the iconic *SILENCE = DEATH* poster, now synonymous with the historic social activist milieu. Using the tactics of advertising and public relations, the posters asserted a voice of anger in public space across New York City. Avram Finkelstein (2010), a member of the collective who developed the iconic political work, stated in a video interview that their aim was to stake claims on "authoritative space" and to appropriate the use of the ever-present urban advertising vernacular. In this context, authoritative space can be understood as both the material space of the city and the political discursive space of policy making, institutional decision making, and media punditry.

Following in this historical activist art tradition, the PosterVirus affinity group is a platform for artists and activists – many of them located in

Canada – to work on a broad range of issues that affect their lives in relation to HIV, such as medication and treatment access, sexism, homophobia, sexual autonomy, mental health, trauma, misogyny, religion, incarceration, racism, harm reduction, history, loss, criminalization, medicalization, sex work, colonization, poverty, and public health surveillance. In some cases, the target audience of the poster messages, provocations, and resistant declarations has been the general public, and in other instances, the audience has been those who are part of the HIV response, including people living with HIV.

With every round of the project, a different group of artists is invited to design posters in partnership with a group of activists. The affinity group invites and works with emerging and well-known artists such as Kent Monkman, Allyson Mitchell, John Greyson, Micah Lexier, Mikiki, Cecilia Berkovic, Vincent Chevalier and Ian Bradley-Perrin, Daryl Vocat, Jessica MacCormack, Natalie Wood, Scott Treleaven, Chris Jones, and Ted Kerr to develop posters, which are then simultaneously launched in the streets of Toronto and through various online platforms, including Facebook and Tumblr for the annual Day Without Art on December 1. Day Without Art started in 1989 as a day of mourning for those lost in the arts community, and over the years it has become a way of remembering and celebrating art made by people living with HIV. The collaboratively developed posters enter the public sphere both materially and digitally, plastered across the streets of seven North American cities and dispersed online, where some have become Internet memes. There has also been a PosterVirus zine, and each poster published is often accompanied by a short text, artist statement, declaration, poem, or manifesto. To date, we have printed over 22,500 copies of the posters, all of which have been funded through a grassroots social practice initiative called No Pants No Problem, which was developed by Jessica Whitbread.

The PosterVirus project started in 2011, the official thirtieth anniversary of the discovery of AIDS. The third decade of AIDS is an era in which a majority of early Canadian and international grassroots AIDS activist movements have dissipated. Similar to many other social movements, Canada's HIV response was ignited out of the anger and necessity of activists, but has since been severely limited over time through funding constraints and a move toward the NGO-ization of HIV community-based organizations. The affinity group has aimed to reinvigorate activist imaginations, move back toward the grassroots, and challenge the hierarchical organization of the institutionalized AIDS response. By sidestepping the AIDS industry, which

has framed HIV discourses as solely within the bounds of biomedicine, and top-down, state-controlled public health institutions, PosterVirus challenges the dominant and often damaging ways in which AIDS is signified – a similar approach to critical disability studies activists and scholars (Bell 2011, 2012; McClelland and Whitbread 2012; McRuer 2002, 2005; Meekosha and Shuttleworth 2009; Withers 2012). Those who control the dominant representations and conceptualizations of disease and disability have the power to shape *how, why,* and under *what* contexts responses are developed and directed, and thus how the lives of people living with HIV and disabled people are organized, controlled, and regulated. As Paula Treichler (1987) wrote, AIDS is an "epidemic of signification," thus noting that there are multiple, competing, and contradictory ways in which the epidemic is represented and understood. By creating space for counter-discourses, PosterVirus has been staking claims on the material space where people living with HIV work and live, as well as intervening in discursive spaces within the HIV response to reframe complex, controversial, or taboo ideas related to what it means to live with HIV in the contemporary context.

Dividing Lines between the Sick and the Well, the Disabled and the Manageable

While our project follows in the footsteps of the historical trajectory of AIDS activist street art, today our current targets are often different. In the past context of mass death, ACT UP and AIDS ACTION NOW! were seeking access to medication, treatment, and political recognition. In the current context, PosterVirus is highly diverse and seeks similar aims, but in an era in which people living with HIV are living longer due to certain forms of access to treatment. Our project also aims to address the institutional and political constraints imposed on our bodies and how *living* with HIV is understood socially, culturally, and politically. Similar to disability activists and academics, we know that as people living with HIV, we do not often control the definition of what is able-bodied or healthy (Bell 2011; Withers 2012). And while no sole actor or institution defines health or illness, conceptions of health and illness are constructed through a heterogeneous arrangement of intersecting and contradictory forms of knowledge. Within this complex field of knowledge, people living with HIV have often been sidelined and marginalized from the "expert" ways of knowing (i.e., the human and social sciences). Bell (2012) notes that since the beginning of the responses to the AIDS epidemic, prevention efforts have been organized in expert and top-down paternalistic ways resulting in a "politics of

containment" (212) aimed at identifying and containing the "monstrous other" (224). This politics of containment, one on which the logic of public health is predicated, has resulted in understanding people living with HIV as less than human and in need of institutional regulation and control.

While many scholars and activists contend that AIDS is a form of disability, notions of disability have been contentious for people living with HIV, with some people actively embracing the label and/or identity and others vehemently rejecting such notions. Tim McCaskell (2009), a founding member of AIDS ACTION NOW!, noted that one of the legacies of the direct-action organization's early work in the 1980s and '90s was in creating a space for the identity of a person *living* with HIV, as opposed to dying with HIV. A focus on dying was how people had been socially and politically marked by government and medical institutions and various forms of media hype in the early days of the epidemic. This led to government funding directed primarily to support end-of-life care instead of treatments to support people to stay alive (Smith 1995).

In addition, McCaskell stated that creating the subjectivity of a person *living* with HIV helped to formulate an identity that was outside of the homosexual milieu to further amplify the collective voices of HIV-positive people. But this push for the acknowledgment of the *living* as well as the fighting that many were doing at the time, while vital to address stigma and to keep people alive, also had the effect of sometimes marginalizing those who may have been too sick to go to the demo. As with all social movements, recognized forms of activism can be exclusive for certain embodiments (Wendell 2001). As McRuer (2002, 225) also states, "An emphasis on living with AIDS has at times been less about resistance to HIV negative, AIDS-phobic ideas and more about identification of the supposedly more abject or ill – those, indeed, who are 'really' disabled." While we honour and deeply acknowledge the hard work of those who came before us in the movement of activists with HIV, a focus on a short-term politics of survival has resulted in long-term consequences, including the privileging of biomedical knowledge, "expertise," and exclusive notions of health that can marginalize certain people at the expense of others.

The classification of disability for people with HIV emerges primarily along class lines, with wealthy and middle-class activists and other people living with HIV who have access to a range of resources often identifying with a form of HIV that is a chronic, but manageable, condition similar to diabetes, and those in need of financial support embracing the label of disability so as to enable access to life-saving social supports – often called by

those connected to the program as "being on disability." In some cases, HIV has been understood as an invisible disability, while in others, the embodied visibility of living with HIV is highly present based on how manifestations of medication side effects can be externalized on the body, such as with fat redistribution around the body from lipodystrophy.

Thus, for HIV-positive people, "disability" is not often understood as a constant state of being, but rather a state relegated to the poor; those who can afford access to medications (or can afford to mitigate the impacts of side effects with expensive treatments and surgeries) can escape the visible markers of disability. This is similar to how disability activists and theorists understand disability – not as a static notion, but rather defined through a heterogeneous arrangement and formation of knowledges, including those of medical, administrative, bureaucratic, and public health institutions – as well as how individuals perceive themselves and claim forms of identity (Bell 2011). Our goal with this discussion of the complexities of assigning disability to HIV is to present the past and existing tensions, many of which are unresolvable and, for some, highly personal. This is to be understood not as an all-encompassing analysis, but rather as a gesture toward some past and present debates and to highlight the need for more critical work in this area to further complicate notions of disability among people living with HIV.

Disability has also become linked to one's level of infectiousness, and infectiousness in turn is now linked to notions of criminality. Within the HIV milieu, biomedical knowledge acts as a dividing line between the sick and the well, and what controls the metrics of "health" for people with HIV is the use of viral load – a techno-scientific identity marker. This biometric is an abstracted measurement of the virus that is actively replicating in the blood of HIV-positive people and can indicate how "infectious" someone is, as defined through the regimes of biomedical knowledge. This measurement has great implications for how we are treated institutionally, medically, legally, and socially, as it is now used to define the extent of care or social benefits to which we are entitled. Achieving an undetectable viral load indicates notions of health, results in HIV being understood as a chronic-manageable condition, and is the result of a responsibilized HIV-positive subject who complies with medical and treatment regimes (Race 2001). Achieving an undetectable viral load can be very liberating for people with the virus, as it can mean they have a dramatically reduced chance of transmitting the virus to sexual or drug-sharing partners. But it is not possible biologically for everyone to achieve a low viral load. The flip side of the

increased use of undetectability is an emerging viral underclass: those who cannot achieve undetectable status and are thus understood to be in need of increased medical and state surveillance and control. In these processes, the agency and autonomy of people living with HIV are undermined, understood as mere instruments in the HIV response to advance prevention aims.

Sexual Autonomy and the Carceral State

The focus of our discussion over the next few pages is on the PosterVirus posters *I Party, I Bareback, I'm Positive, I'm Responsible* and *Fuck Positive Women*. These posters were developed by people living with HIV and work to reframe what it means to live autonomously with HIV in the present. Claiming sexual autonomy and sexual rights for people living with HIV is of vital importance, as HIV exposure and transmission are increasingly becoming sites of criminal regulation. A fast-growing social phenomenon in Canada – one that is disproportionate in scope to other countries of similar economic development – is the legal governance of HIV. There have been more than 155 criminal law cases since 1989 related to exposure or non-disclosure of HIV, with 69 percent of these cases occurring between 2004 and 2010 (Mykhalovskiy and Betteridge 2012). In these cases, people's photographs are plastered across media outlets with sensationalized headlines condemning the person with HIV as a criminal, a vector of disease, and a dangerous, reckless, and irresponsible person. The landmark *Mabior* Supreme Court of Canada decision states that people are obliged to tell a partner they have HIV before they engage in sex that poses a "realistic possibility" of transmission. The legal test requires sex with a condom, and, as noted previously, the person with HIV must have a low viral load. Criminal charges can range from assault to attempted murder and do not require HIV transmission to occur, with the most common charge being aggravated sexual assault, one of the most egregious charges in the criminal code. Social scientists have documented that the law related to HIV non-disclosure and exposure has been applied asymmetrically along class, race, and gender lines, leading to a sense of uncertainty among people living with HIV (Mykhalovskiy 2011; Mykhalovskiy, Betteridge, and McLay 2010).

The ways in which the institutional logics of the criminal justice system conceptualize people living with HIV can be much the same as the ways in which this system conceptualizes people who are classified as having forms of mental illness: one is presumed guilty merely through one's existence (Price 2011).[1] People living with HIV, people classified as having forms of mental illness, and/or others who are understood as risks can be subjected

to intense forms of both medical and legal surveillance and scrutiny. An example of such medico-legal regulation and criminalization of people classified with mental illnesses in Ontario is the contested practice of Community Treatment Orders under the Ontario Mental Health Act, renamed Brian's Law in 1996, which allows for the mandated (i.e., required against their will) psychiatric treatment of people institutionally recorded as having a history of non-compliance and a potential for violence (Snow and Austin 2009). A similar law in Ontario, under section 22 of the Ontario Health Protection and Promotion Act, is directed toward people living with HIV and other classified communicable diseases. This law enables public health authorities to label certain recalcitrant people as "unwilling" or "unable" to protect the public and thus mandate them (i.e., require them against their will) to attend counselling, to have sex with condoms, to restrict penetrative sex, and to reveal the names of sex and drug-sharing partners. Those labelled as either "unwilling" or "unable" can be thus categorized because of developmental, social, psychological, environmental, social, cultural, or access-to-information factors. These sorts of laws create a hybrid space where medical knowledge acts to restrict autonomy and can expand the understanding of criminality beyond just the breaking of laws to a realm where being "criminal" is a component of "abnormal" character or biological traits. This expanded realm of criminality subjects certain "abnormal" and "risky" populations to heightened surveillance, scrutiny, regulation, and control – ideological practices that act to displace one's own local autonomy for the sake of a conceptual notion of public safety.

Sexual autonomy as a concept may hold a different subjective space in disability circles related to issues of addressing prostheses, mobility technologies, personal support workers, guardians, and/or caregivers. Sexual autonomy for people with HIV may mean freedom from institutional restraints and the material consequences of the apparatus of criminalization. Despite these potential differences, Russell Shuttleworth's (2014, 77) call for an "agentic [sexual] subjectivity, one that can work in productive tandem with a diversity of differently embodied disabled people together to transform the negative understanding of disability that permeates Western societies" is one that resonates with us as people living with HIV and could be a future site of collaboration and cross-fertilization for HIV and disability scholars and activists. In academic disability circles, authors such as Shuttleworth (2014) have been contending with issues of sexual autonomy, aiming to theoretically carve out a space for an autonomous sexual subjectivity for disabled people who had been constructed as asexual. Others have

documented how the heightened sexual regulation of young people labelled
with intellectual disabilities can result in a lack of autonomy and has led to
instances of increased sexual health risk taking (McClelland et al. 2012).

I Party, I Bareback, I'm Positive, I'm Responsible

In the first iteration of PosterVirus in 2011, artist and activist Mikiki, in col-
laboration with a gay men's outreach worker, Scott Donald, developed the
I Party, I Bareback, I'm Positive, I'm Responsible poster. The words appear
on a white background in capital letters and are text cut-outs revealing a
naked white man's torso that is reminiscent of vintage gay pornography. In
its essence, the poster is a declarative from the point of view of a gay man
living with HIV, a man who takes drugs and has condomless sex but who
still understands his behaviour as responsible. Both Mikiki and Donald are
living with HIV, and they met while doing peer outreach with other positive
gay men in bars and bathhouses in Toronto.

The message in this collaborative work emerges out of a context in which
the lives of people living with HIV are increasingly regulated and responsibil-
ized through biomedical and social norms. Achieving institutionalized
standards of health is seen as the responsibility of people with HIV. Those

Mikiki and Scott Donald,
*I Party, I Bareback, I'm Positive,
I'm Responsible* poster, 2011.

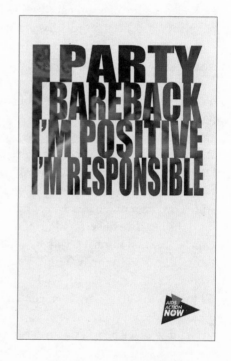

who take their medications, participate in community-empowerment in-
itiatives, practise "safer" sex, and abstain from substance use are understood
as responsible, while those who do not are irresponsible and thus in need of
heightened surveillance and control practices (Kinsman 1996). Under this
logic of risk, people living with HIV are constructed as a problem, a problem
to be managed and protected from the mythical general public, a notion pro-
moted by a range of public health, media, and government institutions and
the medical profession (Kinsman 2005, 100).

This social organization of people living with HIV as a risk to the general
public is ideological, where ideology refers to knowledge formations that
attend to "managing people's lives that are not grounded in actual experien-
ces and practices" (Kinsman 2005, 101). At the same time, those same
people living with HIV are resisting ideological practices and are taking
control of their lives and making informed decisions with the local and in-
stitutional knowledge that is available to them. Advances in anti-retroviral
medications, for those who can achieve a low viral load, result in the very
high potential that they are no longer infectious through sexual contact.
Prior to this biomedical advance, gay men developed the practice of sero-
sorting, where people of the same HIV status have sex with one another as
a way to reduce onward transmission of the virus. HIV-positive gay men
have been making informed choices about their sex lives, despite outdated
and paternalistic prevention interventions telling them the opposite. The
poster aims to disrupt the popular institutional narrative of health and
responsibility, while staking claims of sexual agency for positive people. In
an interview about the work, Mikiki stated:

> My poster was about identifying a new queer and poz [positive] cultural
> project that's being undertaken, one that challenges the historical or more
> common cultural understanding of PHAs [people with HIV and AIDS] as
> inherently irresponsible. The idea of "responsible" and "irresponsible" as
> this dichotomy or binary could really use some queering up. It is important
> to recognize when we get into the lives of other people [that] it's useful for
> most of us "rational people" to realize there is a grey area where people ac-
> tually live. (Mikiki and McClelland 2012)

When the poster was first introduced on the streets of Toronto and online,
it was met with both praise and condemnation. The project was criticized for
promoting condomless sex and drug use among people living with HIV,
which some saw as running counter to historically developed prevention

messages. In Montreal, the local English-language AIDS service organization hosted a community forum to talk about the implications of the poster's content for its work and the community it serves. Online, many contentious conversations took place, some pointedly attacking us as co-curators and others directed at Mikiki and Donald. These conversations surfaced a number of visceral fears from those who had lived through the late 1980s and early 1990s before the rollout of effective anti-retroviral combination medications.

For some who experienced the loss of friends and loved ones during those years, sexual subjectivities were formed in relation to the practice of "safe sex," which was understood as a communal responsibility of people in queer communities. *I Party, I Bareback, I'm Positive, I'm Responsible*, as a declaration, was thus seen not as a new assertion of sexual autonomy and subjective possibility, but as an attack against past HIV responses. In addition, forms of stigma and paternalism held by some people in the HIV response community about what is possible for people with HIV also emerged, including statements like "We can't tell gay men with HIV that they can have pleasurable, autonomous sex lives!" Gay men living with HIV being honest about practices in their lives and asserting them loudly has not commonly occurred in the response to HIV. Those of us with HIV are usually understood as vectors to be controlled through prevention initiatives, not as individuals with agency, desire, and sexual decision-making power.

Employing disability activism approaches and theory, we can understand the importance of decentring the biomedical dominance and normalization of health and able-bodiedness that act to construct a certain type of healthy, responsibilized subject with HIV (Withers 2012). Mikiki further elaborates:

> There is this idea of PHAs (people with HIV and AIDS) as something to be "controlled"; because we have a HIV-positive diagnosis there is this existing empirical evidence of our "misbehaviour." So you know, we are marked, like the mark of the beast, or potentially a scarlet letter. So Public Health now has its target market (which is us) they have the authority to surveil, monitor, and intervene in our lives. Then Public Health also has the self-granted right to be able to punish as well. (Mikiki and McClelland 2012)

Mikiki and Donald's poster aims to reframe the process of normalization and blur the dividing line between the sick and the well, the responsible and the irresponsible, and the able-bodied and the disabled. As McRuer (2002, 223) notes, "The AIDS epidemic, more than any other contemporary crises, demonstrates not only the fluid and contradictory nature of identity, but

also the ways in which the division of 'us' from 'them,' in all of its mani-
festations, is institutionalized." Gary Kinsman, a former member of AIDS
ACTION NOW!, has argued that HIV transmission has been constructed
as a site of individual responsibility and a critical regulatory site in the AIDS
epidemic. With this, the law, police, community-based organizations, and
public and mental health institutions come to regulate the "irresponsible,"
those who are risky and living with HIV.

Fuck Positive Women

In 2011, we launched another poster with a loud and sexual declarative, the
Fuck Positive Women poster, a collaboration between artist Allyson Mitchell,
Jessica Whitbread, and the International Community of Women Living
with HIV/AIDS (ICW). The poster is a photograph of an unfinished multi-
coloured cross-stitch with the words "Fuck Positive Women" in capital let-
ters. The juxtaposition of the historically feminized craft and rude sexual
declaration are what make the piece confrontational. The poster developed
out of discussions between Whitbread, who is living with HIV, and Mitchell,
a leading Canadian lesbian feminist artist and York University professor.
Upon developing the concept, the two then consulted ICW on the mes-
sage. To elaborate the varied messages in this poster, we turn to an edited
excerpt from the statement about the work that Mitchell read publicly at the
PosterVirus launch at the Art Gallery of Ontario in 2011:

> "Fuck Positive Women" was created to interrupt the gendered popular
> discourse around women and HIV as sexless, sex dangerous, and/or sex
> negative.
>
> When Jessica and I first met to think about this project we considered
> the kinds of representations of positive women that we are very familiar
> with ... positive women as mothers, as victims, as not from or living here in
> this place.
>
> We talked about the sentiment of sex negativity that is put upon positive
> women and decided that we wanted something different. We wanted our
> poster to ask:
>
> Why aren't women allowed to be subjects of their sexuality rather than
> objects?
>
> Why aren't positive women allowed to talk about sex as freely as gay
> men?
>
> Why can't we express an urgent, horny, powerful and open message
> about positive women and sexuality?

So the message of "Fuck Positive Women" is a directive – a confident and supportive message meant to relocate positive sexual energy around the bodies of positive women (and when I say women, I am of course including trans and gender queer women ALL self-identified women). "Fuck Positive Women" can also be read as a declarative for its double meaning about how positive women are fucked when it comes to awareness, visibility, options, policy, and support on the large part. Making this kind of a rude point hopefully contributes to some of the ways that positive women can get unfucked by healthcare, government policies, and awareness campaigns. (Mitchell 2011)

This poster was met with similar critical feedback as the *I Party, I Bareback, I'm Positive, I'm Responsible* piece. Women living with HIV asserting sexual agency and desire do not appear often in the response to HIV. Women with HIV are typically understood as a problem requiring intervention or as a population to be regulated by the state and public health. There are multiple interventions targeting women living with HIV so that they do not pass on HIV to their babies, but very rarely anything asserting that many women are more than just people who have babies. *Fuck Positive Women* asserts an individual sexual self for women living with HIV.

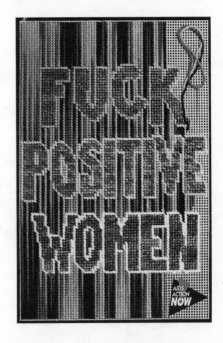

Allyson Mitchell, Jessica
Whitbread, and the International
Community of Women Living
with HIV/AIDS, *Fuck Positive
Women* poster, 2011.

Conclusion

Our collaborative project seeks to undermine othering ideologies that define how we should respond to HIV, and through this we aim to challenge dominant notions of how people with HIV ought to be, or behave, and/or have sex (or not have sex for that matter). For people living with HIV, criminal law is actively employed as a means to regulate our sexual lives. External actors and institutions often mediate the sexual lives of people with disabilities; either they are understood as asexual because of social stigma or as people who are overly sexual and in need of regulation through various means of control. People with disabilities, and/or those who are institutionally marked as unhealthy, are not conceived as part of ideological notions of the public. As Arseneault (2013) eloquently states, we are "biopolitically pegged" as the other for life. But this place of the other can also be liberating and powerful. Despite being fraught with normlessness, uncertainty can also allow for new creative formations to help imagine and define ourselves, and our communities, on our own terms. By challenging ideological notions of illness and the institutional drive toward increasing criminalization of HIV, we have learned from those in the disability activist milieu. We are working on presenting new forms of sexual subjectivity and a community of people living with HIV who are actively resisting a politics of containment and dominant prescribed understandings of what it means to be HIV-positive (Bell 2012). As Fink (2013) notes, the PosterVirus affinity group has proposed "a constellation of representational and resistant cultures for building disabled community and for changing how we understand what it currently means to be HIV positive." Mobilizing the lived experiences of people living with HIV and disabled people through creative means can pierce holes in the conceptual framings of institutions, institutions that are disconnected from the realities of living with HIV and being disabled and that do damage and violence to our lives on a daily basis.

NOTE

1 We use the plural of "logics" here as a term because we contest a unified and universalizing understanding of the "law," acknowledging rather that the law operates under multiple, arbitrary, competing, extra-local, ideological, and heterogeneous forms of knowledge. See Rose and Valverde (1998) and Valverde, Levi, and Moore (2005).

WORKS CITED

Arseneault, Jordan. 2013. "The New Equation." http://postervirus.tumblr.com/post/35974194219/silence-sex-the-new-equation-by-jordan.

Bell, Chris, ed. 2011. *Blackness and Disability: Critical Examinations and Cultural Interventions*. Forecaast, vol. 21. East Lansing: Michigan State University Press.

—. 2012. "I'm Not the Man I Used to Be: Sex, HIV and Cultural 'Responsibility.'" In *Sex and Disability*, edited by Eric McRuer and Anna Mallow, 208–28. Durham and London: Duke University Press. http://dx.doi.org/10.1215/9780822394877-011.

Chevalier, Vincent, and Ian Bradley-Perrin. 2013. "Your Nostalgia Is Killing Me." PosterVirus. Accessed April 12, 2016. http://postervirus.tumblr.com/post/6756 9099579/your-nostalgia-is-killing-me-vincent-chevalier.

Fink, Marty. 2013. "Two Ghost Stories: Disability Activism and HIV/AIDS." *Jump Cut: a Review of Contemporary Media*. http://www.ejumpcut.org/archive/jc55.2013/FinkDisabilityAids/text.html.

Finkelstein, Avram. 2010. "Avram Finkelstein: Silence = Death." YouTube video. https://www.youtube.com/watch?v=7tCN9YdMRiA.

Kinsman, Gary. 1996. "'Responsibility' as a Strategy of Governance: Regulating People Living with AIDS and Lesbians and Gay Men in Ontario." *Economy and Society* 25 (3): 393–409. http://dx.doi.org/10.1080/03085149600000021.

—. 2005. "Vectors of Hope and Possibility: Commentary on Reckless Vectors." *Sexuality Research & Social Policy* 2 (2): 99–105. http://dx.doi.org/10.1525/srsp.2005.2.2.99.

McCaskell, Tim. 2009. "25 Years of Advocacy." YouTube video. https://www.youtube.com/watch?v=L1qmBLvctxE&list=UUWcqG3oF4Srawf33gmuqEcQ.

McClelland, Alex, Sarah Flicker, Denise Nepveux, Stephanie Nixon, Tess Vo, Ciann Wilson, Zack Marshall, Robb Travers, and Devon Proudfoot. 2012. "Seeking Safer Sexual Spaces: Queer and Trans Young People Labelled with Intellectual Disabilities and the Paradoxical Risks of Restriction." *Journal of Homosexuality* 59 (6): 808–19. http://dx.doi.org/10.1080/00918369.2012.694760.

McClelland, Alex, and Jessica Whitbread. 2012. "Fuck the AIDS Industrial Complex." PosterVirus. Accessed April 12, 2016. http://postervirus.tumblr.com/post/35825204212/postervirus-2012-fuck-the-aids-industrial#_=_.

McRuer, Robert. 2002. "Critical Investments: AIDS, Christopher Reeve, and Queer/Disabilities Studies." *Journal of Medical Humanities* 23 (3): 221–37.

—. 2005. "Disability and the NAMES Project." *Public Historian* 27 (2): 53–61. http://dx.doi.org/10.1525/tph.2005.27.2.53.

Meekosha, Helen, and Russell Shuttleworth. 2009. "What's So 'Critical' about Critical Disability Studies?" *Australian Journal of Human Rights* 15 (1): 47–76.

Mikiki and McClelland, Alex. 2012. "Not All Redemption Songs." *PositiveLite.com*, March 18. http://www.positivelite.com/component/zoo/item/not-all-redemption-songs.

Mitchell, Allyson. 2011. "Statement on *FUCK POSITIVE WOMEN*." Reading at Art Gallery of Ontario, December 1.

Mykhalovskiy, Eric. 2011. "The Problem of 'Significant Risk': Exploring the Public Health Impact of Criminalizing HIV Non-Disclosure." *Social Science & Medicine* 73 (5): 668–75. http://dx.doi.org/10.1016/j.socscimed.2011.06.051.

Mykhalovskiy, Eric, and Glenn Betteridge. 2012. "Who? What? Where? When? And with What Consequences? An Analysis of Criminal Cases of HIV Non-Disclosure in Canada." *Canadian Journal of Law & Society* 27 (1): 31–53. http://dx.doi.org/10.3138/cjls.27.1.031.

Mykhalovskiy, Eric, Glenn Betteridge, and David McLay. 2010. *HIV Non-Disclosure and the Criminal Law: Establishing Policy Options for Ontario.* Toronto: Ontario HIV Treatment Network.

Price, Margaret. 2011. *Mad at School: Rhetorics of Mental Disability and Academic Life.* Ann Arbor: Michigan University Press.

Public Health Agency of Canada. 2008. *HIV and AIDS in Canada: Surveillance Report to December 31, 2008.* Ottawa: Public Health Agency of Canada.

–. 2012. *HIV and AIDS in Canada: Surveillance Report to December 31, 2012.* Ottawa: Public Health Agency of Canada.

Race, Kane. 2001. "The Undetectable Crisis: Changing Technologies of Risk." *Sexualities* 4 (2): 167–89. http://dx.doi.org/10.1177/136346001004002004.

Robertson, Mark L. 2005. "An Annotated Chronology of the History of AIDS in Toronto: The First Five Years, 1981–1986." *Canadian Bulletin of Medical History/ Bulletin canadien d'histoire de la médecine* 22 (2): 313–51.

Rose, Nikolas, and Mariana Valverde. 1998. "Governed by Law?" *Social & Legal Studies* 7 (4): 541–51. http://dx.doi.org/10.1177/096466399800700405.

Shuttleworth, Russell. 2014. "Conceptualising Disabled Sexual Subjectivity." In *The Politics of Recognition and Social Justice: Transforming Subjectivities and New Forms of Resistance,* edited by Maria Pallotta-Chiarolli and Bob Pease, 77–90. New York: Routledge.

Silversides, Ann. 2003. *AIDS Activist: Michael Lynch and the Politics of Community.* Toronto: Between the Lines.

Smith, George. 1995. "Accessing Treatments: Managing the AIDS Epidemic in Ontario." In *Knowledge, Experience, and Ruling Relations,* edited by M. Campbell and A. Manicom, 18–34. Toronto: University of Toronto Press.

Snow, N., and W.J. Austin. 2009. "Community Treatment Orders: The Ethical Balancing Act in Community Mental Health." *Journal of Psychiatric and Mental Health Nursing* 16 (2): 177–86. http://dx.doi.org/10.1111/j.1365-2850.2008.01363.x.

Treichler, Paula A. 1987. "AIDS, Homophobia, and Biomedical Discourse: An Epidemic of Signification." *October* 43: 31–70.

Valverde, Mariana, Ron Levi, and Dawn Moore. 2005. "Legal Knowledges of Risks." In *Law and Risk,* edited by the Law Commission of Canada, 86–120. Vancouver: UBC Press.

Wendell, Susan. 2001. "Unhealthy Disabled: Treating Chronic Illnesses as Disabilities." *Hypatia* 16 (4): 17–33. http://dx.doi.org/10.1111/j.1527-2001.2001.tb00751.x.

Withers, A.J. 2012. *Disability Politics and Theory.* Toronto: Fernwood Publishing.

Deaf and Disability Arts
Insiders, Outsiders, and the Potential of Progressive Studios

KRISTIN NELSON

The creative act is not performed by the artist alone.

– *Marcel Duchamp, 1957*

Canadian visual artists with disabilities are still largely underrepresented in arts institutions. These institutions – and the curators they employ – must play an active role in the acquisition, representation. and dissemination of Canadian art by artists with disabilities today. Deaf and disability arts – a self-defined political movement in Canada with the goal of creating a visible disability culture – cannot represent and promote the work of all artists with disabilities. Publicly funded Canadian visual arts institutions could exhibit the work of a broader range of artists with disabilities by incorporating outsider art as a genre, therefore making connections with outsider art communities and progressive studios at home and abroad. Today, the term "outsider" has seen a complete *détournement*, revealing, at least to a general degree, the outsider as having been embraced as a cultural construct akin to that of individuality. However, embracing outsider art presents both a problem and a potential within Deaf and disability arts discourse within Canada.

While Canadians with disabilities are still largely underrepresented in art institutions, outsider artists are gaining visibility and popularity within mainstream arts and culture outside of Canada. International arts institutions such as the American Visionary Art Museum in Baltimore, Maryland, and

the Tate Modern in London, England, collect outsider art, *art brut,* visionary art, and, occasionally, folk art; they do not, however, collect work that currently falls under the banner of Deaf and disability arts. In the same vein, Deaf and disability artists and curators in Canada tend to avoid association with outsider art because of its historical connection to art therapy and a medical model of disability. According to Per Koren Solvang (2012, 183), "Art therapy itself is not perceived as a problem, but for the artist struggling for recognition in the cultural field, being perceived as a patient seems like discrimination."

The most well-known artists and collectors of outsider art have historically been closely related to the institutions of psychiatry, but this relationship has changed in the last two decades with the emergence of independent collectors and gallery owners specializing in this art, which they describe as intuitive, visionary, and marginal (Solvang 2012). Outsider art has been gaining in popularity, mainly within the United States and Europe, and the work of artists from progressive studios is being hailed and exhibited in visual arts institutions under this terminology. Progressive studios, of which there are arguably several in Canada, facilitate the creation and dissemination of art by artists with developmental, mental, and physical disabilities. Yet Canadian art institutions and academic researchers are all hesitant to use the internationally accepted term "outsider art."

The intersection of outsider art and Deaf and disability arts lies in progressive studios. People creating art in progressive studios who are unable to verbalize their artistic and/or political intentions only complicate the role of Deaf and disability artists as defined by the movement. It is therefore difficult for progressive studios to become part of the political discussions within the Deaf and disability arts movement without making claims on behalf of some artists. This is perhaps why some progressive studios are more inclined to align themselves with outsider art.

Understandably, the Deaf and disability arts movement wants to maintain distance from outsider art's history of fetishizing and profiting from people who are excluded or marginalized from society. There is a power dynamic between the discoverer (the curator/critic who stands inside the reputable arts institutions) and the discovered (the artist with a disability who has historically been excluded from these arts institutions). Within this insider/outsider mentality, the insider has the power to determine under what circumstances the outsider is welcomed in as well as to appropriate outsider identities when wealth, recognition, and other benefits can be gained from doing so.

Even the Deaf and disability arts movement, though, which prides itself on allowing artists with disabilities to represent themselves, excludes some artists with disabilities. Self-representation is one of the main tenets of the Deaf and disability arts movement. In other words, you can be an artist with a disability, but you are not a Deaf and disability artist until or unless you communicate – either verbally or through your art – that your politics align with the Deaf and disability arts movement. This can exclude artists who either cannot or choose not to communicate their alignment with these politics. Deaf and disability arts, in its very definition, cannot address, promote, or professionalize the work made by *all* people with disabilities.

Discussions of outsider art in relation to Deaf and disability arts happen today, but generally from the perspectives of outsider art and its supporters. Canadian institutions may benefit from exhibiting and collecting outsider art to connect the work of some Canadian artists with disabilities to international outsider arts communities and to remain in dialogue with international arts institutions whose goals are to exhibit and collect this work. It can be argued that by not participating in outsider art, both the Deaf and disability arts movement and publicly funded Canadian visual arts institutions are negating the work of some artists with disabilities. Several important questions will be considered throughout this chapter. What potential does outsider art have as a possible category within Canadian art institutions? Do the problems of outsider art with respect to disability arts outweigh the benefits of the potential visibility that association with the outsider genre can afford some artists with disabilities? Who does Deaf and disability art exclude in its search for inclusion and professionalization of Deaf artists and artists with disabilities in the mainstream art world?

Terms and definitions of the Deaf and disability arts and culture movements have been taken directly from reports produced by the Canada Council for the Arts (2012) and by the Deaf and disability arts movement. Questions will be raised about who is left out of a Canadian Deaf and disability arts movement and about the potential of outsider art as a globally endorsed category to make known some of the work by artists with developmental, mental, and physical disabilities who are engaging in art studios worldwide.

The History of Outsider Art

Roger Cardinal (1972) was the first to introduce the term "outsider art" to English-language speakers, translating from Jean Dubuffet's (1901–85) term *art brut*, or raw art. Dubuffet was a collector of *art brut* and was inspired by

Dr. Hans Prinzhorn's 1922 collection *Artistry of the Mentally Ill*. Previously known as "asylum art," this art included work produced by Dr. Prinzhorn's patients from the Heidelberg Psychiatric Clinic in Germany as well as work collected from other German psychiatric hospitals. While Dubuffet made marginalized forms of early twentieth-century art more visible, some of the terms he used – such as *art primitif* and *art naif* – have since become highly contentious, contributing to the further marginalization of these art forms.

Cardinal distinguished outsider art from "cooked art" – art that is predetermined by a set of rules and aesthetic judgments developed by the elite and imposed by existing systems of education in art. Work that is not "cooked" was considered by Cardinal and Dubuffet to be more authentic. The idea of authenticity was important to Dubuffet; he argued that outsider art must come directly from an individual without filters of cultural meaning, influence, or tradition, all of which he believed stifle creativity (Cardinal 1972). Ironically, the rules used to define authentic outsider art have often been imposed by and discussed in elite circles of critics, curators, and collectors – the very elitism that Dubuffet was trying to circumvent in his search for an art that was anti-cultural.

The Evolution of Outsider Art

What may have seemed radical in the early twentieth century we can now understand as problematic, and perhaps for this reason, some Deaf and disability artists and academics still fear association with the term "outsider art." This fear is somewhat unfounded, however, since the production and critique of outsider art are continuously shifting and evolving. As Anne Bowler (1997, 23) explains, there is a "changing discourse surrounding the artistic products of the insane – from the category of artifact to art." Although Bowler's use of the word "insane" is jarring and problematic, this changing discourse is also noted by Sue Steward (2011, 24), who states that "old outsider art definitions around art and innocence no longer hold." In one of his more recent articles, Cardinal (2009, 1460) argues, "Outsider Art earns its name not because of an association with a lurid case history or a sensational biography, but because it offers its audience a thrilling visual experience."

Today, this "thrilling" visual experience is gaining visibility in a variety of ways. Curators such as Matthew Higgs (director of White Columns in New York) and James Brett (director of the Museum of Everything in London) have increased the visibility of outsider artists by discussing and exhibiting their work within publicly funded museums and visual arts institutions. The

American Folk Art Museum in New York, which opened in 1961 and exhibits self-taught and outsider artists, noted a 30 percent increase in visitorship in its 2015 fiscal year (American Folk Art Museum n.d.). And journalists such as Miranda Sawyer of BBC's *The Culture Show* and Alan Yentob of BBC's *imagine* ... have brought media attention to the genre through short documentaries. Interest in outsider art by the media, curators, and arts institutions creates new venues to discuss the ethics of categorizing and exhibiting outsider art. Outsider art continues to be bought and sold in private galleries such as Ricco Maresca Gallery in New York. But it is also being shown in museums and other spaces that make it accessible to wider audiences – from the successful *Exhibition #4*, held at Selfridges, a department store in London, to ongoing exhibitions at the American Folk Art Museum and the Collection de l'art brut in Lausanne, Switzerland.

Challenges for Outsider Art and Artists

Although outsider art is attracting attention and gaining popularity, some kinds of attention are harmful to artists because they set up an insider/outsider dichotomy. For example, *Parallel Visions*, an exhibition held at the Los Angeles County Museum of Art in 1992, featured the work of thirty-four outsider artists (including artwork from Dr. Prinzhorn's collection) alongside the work of forty artists who took inspiration from outsider art. A more recent exhibition – *La Collection selon ... Les Impatients*, held at Espace Création Loto-Québec in Montreal in 2012 – juxtaposed the work of "insider" and "outsider" artists. Curators, galleries, and outsider art fans must find ways to focus more on the aesthetics of the work itself and not rely on methods of comparison when displaying outsider art. Outsider art exhibited as inspiration for other artists can devalue the works' aesthetic contribution to the history of visual art and its cultural capital. Elizabeth Sweeney (2012) explores different ways in which curators may make better choices when it comes to displaying artwork by artists with disabilities. She says, "It will be helpful to question the ability for all involved to be conscious of the reliance on good intentions, examine and address the power relationships, and take into account the ways they themselves as curators identify or understand disability" (56).

Another challenge in the display of outsider art is the ongoing fetishization of the artists' biographies rather than celebration of the artists' works. An example of this can be found at Intuit: The Center for Intuitive and Outsider Art, in Chicago, which features the Henry Darger Room, a collection

of belongings and furnishings gathered from the apartment of the quintessential outsider artist Henry Darger (1892–1973). "Here, the curators devote less attention to representational accuracy in favor of creating a visceral statement on Darger's habitat," writes Emily Doucet (2010–11, 60), a Winnipeg writer, on visiting the Darger room. The European Outsider Art Association, established in 2009, attempts to address these issues surrounding the ethics of displaying the work of outsider artists in an attempt to promote their rights (European Outsider Art Association n.d.).

The labelling and categorization of outsider art is another constant point of contention, especially for artists who are no longer alive or who cannot communicate for themselves, as well as for those whose practice is isolated from progressive studios and other communal art spaces. The problem with the label "outsider art" is that it is not usually adopted by the artists themselves; most often, it is attributed by critics and curators to artists who either have a disability and/or who work in a progressive studio. A handful of artists have recently claimed outsider art status for themselves, such as Jarvis Cocker, who spoke at a panel on outsider art at the Institute of Contemporary Arts in London in 2010 called "Don't Call Me Crazy: How We Fell in Love with Outsider Art" (Institute of Contemporary Arts 2010).

In its original interpretation, in order for work to be considered outsider art, Dubuffet and others argued that it must be made by people who are not connected to arts institutions or schools, and some people today would argue that this includes progressive studios. Historically, outsider art must also be "authentic," meaning that it exists outside of culture and is not corrupted by the shifting fashions of high art. It is more difficult today, in a highly explored and connected world, for any one person or group of people to exist in such isolation.

The term "outsider art" makes space, within an art historical context, for the dissemination of particular work with a defined aesthetic. The outsider art aesthetic, as defined by Jean Dubuffet and the interpretation of *art brut* by Roger Cardinal, today is constantly redefined and questioned by its fans, critics, and curators and by a few artists. Since the early beginnings of outsider art in asylums or medical institutions, many avenues for its creation and exhibition have emerged. Magazines, festivals, art fairs, critics, and museums – primarily in Europe and the United States – remain dedicated to the dissemination, content, and policing of the boundaries of outsider art. Progressive studios, which will be explored later in the chapter, are enabling some of today's artists with disabilities to have their work exhibited, and

therefore valued, outside of a studio and within an artistic and cultural context.

Outsider art and its community, in its current context, would benefit from ongoing dialogue with Deaf and disability arts participants, scholars, and academics to help reduce the fear and stigma of associating outsider artists with artists with disabilities. The nuance of every individual artist's situation and the intentions of those involved in the process of art exhibition make it difficult to claim that outsider art is either a hindrance or a benefit to artists with disabilities. Rather, it is of greater importance to begin and to continue dialogue between outsider artists, fans, critics, and curators and those involved in the Deaf and disability arts movement.

Introduction to Deaf and Disability Arts

Deaf and disability arts encompass many different artistic practices, including music, poetry, performance art, dance, and the visual arts. In Canada, Ryerson University published a disability arts report in 2004, and from 2010 to 2012 the Canada Council for the Arts commissioned several reports on Deaf and disability arts and an executive summary to assist in the creation of a strategy for improving, supporting, and promoting Deaf and disability arts in Canada. The executive summary defines Deaf and disability arts as "diverse artistic practices, where artists explore the perspectives, embodiments, expressions, identities, languages, cultures, histories and/or lived experiences of deaf or disabled people" (Canada Council for the Arts 2012, 3). In this definition, Deaf and disability arts incorporate the distinct experiences and perspectives of people living with disabilities. In other words, disability artists not only are responsible for creating art, but must simultaneously consider the ways in which their art *represents* disability culture.

These reports help to define Deaf and disability arts and culture in a time of uncertainty, when "disability identity has begun to enter murkier grounds" (Davis 2013, 263). This is most apparent in the Ryerson University report and their choice of visual artists used to represent disability arts. Jane Cameron (1949–2000), an artist from Alberta with Down syndrome who worked in textiles, is used as an example of an artist working within the disability arts and culture movement. This definition, however, is problematic, since "Jane did not consider her work to have political implications" (Abbas et al. 2004, 30). In addition, while Cameron's art might have been seen as political by those around her, she herself did not claim to be a disability artist (Abbas et al. 2004). Without this key component of self-identification

with the disability arts movement, Cameron's work should not be used to represent it.

Two problems of Deaf and disability arts arise when visual artists like Jane Cameron, whose "approach seeks to distance disability" (Abbas et al. 2004, 31), are defined as disability artists. To be considered a disability artist, one must create work that *represents* one or more disability cultures or one must self-identify as an artist whose *intent* is to advance the professional status of disability artists. The problem with representation is that it limits the kind of art that can be made, dissuading Deaf and disability artists who want to explore art in more abstract ways without jeopardizing their inclusion within the Deaf and disability arts community. The problem with requiring artists' intent for inclusion in the Deaf and disability arts movement is that it inherently excludes artists who, either purposefully or by default of their disability, do not explicitly state their intent. Including the work of Jane Cameron under the category of visual artist within Ryerson University's report on the Deaf and disability arts movement (Abbas et al. 2004) is curious considering how her work contradicts the very definition of disability arts offered in the same report. Cameron's work was popular and, according to her website as well as the report, many people were fans of her work, making her worthy of note as an artist with a disability. The implications of these issues will be addressed in greater detail below.

The Role of Representation in Deaf and Disability Arts

In the contexts of visual arts and Deaf and disability arts, I use the term "representation" to refer to the inclusion of images of people with disabilities within visual culture. "There has long been a sense within the disability rights movement and amongst disability scholars that representation matters; that public portrayal of disabled people [has] effects and consequences" (Sandell and Dodd 2010, 3). Many depictions of disability in visual culture and the media have represented people with disabilities as being burdens, laughable, sinister, asexual, pitiable, victims, etc. (Jacobson and McMurchy 2010, 3). A role for disability arts is to combat these negative stereotypes by replacing them with images of, by, and for people with disabilities.

Examples of artwork aligned with the Deaf and disability arts movement in Canada include *Wingspan*, a dance piece performed by Shannon and Geoff McMurchy at the Vancouver International Dance Festival in 2001; the film *A Different Breed* by James J. Doyle, produced by Stage Left Productions in 2009; and David Roche's short film *Beauty School*, directed by Adam Grant Warren in 2012. Through dance and autobiographical and

fictional storytelling, these works communicate varying representations of disability, inviting new perceptions of seemingly non-conforming bodies and lived experiences.

In cases where representation is not easy to pinpoint, the artist's intent and the context of the work must define it as being related to disability. Balancing Acts, a Deaf and disability arts festival in Calgary, states that it "use[s] the performing arts to challenge dominant norms about disabled people" (Balancing Acts n.d.). Using the performing arts and placing bodies centre stage asks the viewer to encounter disability directly; this line of thinking, however, becomes trickier if the artist performing does not have a visible disability.

The Deaf and disability arts movement has since exploded, as evidenced by the "more than 50 disability/Deaf arts festivals and hundreds of organizations, producing companies and projects currently populat[ing] the international circuit" (Jacobson and McMurchy, 1). Other Deaf and disability arts festivals in Canada include Winnipeg's Art + Body Fair, Toronto's Tangled Art + Disability festival, and Vancouver's Kickstart Disability Arts and Culture festival. The political strategy of these festivals is to create positive representations that form a visible disability culture. Artists with disabilities who do not use their art to represent their experiences are left out of this strategy.

Balancing Acts (n.d.) takes a firm position on this matter, stating that "not all artists, writers, and performers who have a disability are helping to promote disability art and culture – or to represent the lived experience of disability in their work. Some of these creators do not deal with themes related to disability at all, and enjoy careers in the mainstream instead." Using a somewhat accusatory tone to describe certain artists with disabilities who are not helping to promote Deaf and disability arts and culture creates an unnecessary divide between artists who do not represent disability culture and those who do. The promoters of Balancing Acts also imply that some artists with disabilities are actually *impeding* the progress of what Deaf and disability arts is trying to accomplish as a political movement.

Placing artists at the forefront of a political movement to create images of Deaf and disability culture reduces art to a utilitarian role and downplays the role of aesthetics in art. Furthermore, artists whose work does not display visual cues or representations of disability must state their affiliation to the Deaf and disability arts movement through different means, such as statements of intent. Indeed, "artivism" – a recent term used to describe the

combination of art and activism – might equally be applied to Deaf and disability arts.

The Roles of Self-Determination and Intent in Deaf and Disability Arts

Self-determination and the identification as a participant in Deaf and disability arts can be confusing for visual artists whose work lacks representations and the expression of physical bodies. A determination of the artist's intent is needed to validate their contribution to this new Deaf and disability art activism; otherwise they are simply an artist with a disability. The label "artist with a disability" identifies those who do not participate in or are not seen as being part of the Deaf and disability arts movements. To participate in Deaf and disability arts, an artist must openly state their identity, their purpose in the creation of art, and their political contribution to a new visible disability culture. If an artist with a disability is opposed to art making for a self-determined political purpose, then they are on the outside of the Deaf and disability arts movement and may identify as an artist with a disability, or as an artist.

According to the Canada Council for the Arts (2012, 15), "Disability arts are created by disabled people," but "not all artists who have a disability produce disability arts ... In recent years, however, an increasing number of artists with disabilities have chosen to identify and take on the title of 'Disability Artist.'" Since some artists with disabilities are unable to communicate the intent of their artistic production, an inability to participate in and self-identify with Deaf and disability arts creates a divide in the movement between artists with physical disabilities and artists with developmental or mental disabilities, which conflicts with its philosophy of inclusion.

Despite the popular slogan "Nothing about us, without us" (United Nations n.d.), a motto used at the 2004 International Day of Disabled Persons and a key component of Deaf and disability arts, not all artists are included. According to Elizabeth Sweeney (2012, 53) in her critical analysis of curatorial strategies of Deaf and disability art in Canada, "Critical analysis of art, especially the representation of disability in art, must question who is in control of the message, who is taking credit, and who is directly profiting from it." Self-determination in the Deaf and disability arts movement means that artists with disabilities are the ones making, showing, and promoting their own artwork.

As such, a problem arises for some artists with disabilities who are working in progressive studios with little control over the way their artwork is

represented, exhibited, and promoted. For example, Judith Scott (1943–2005) – an artist who was deaf and had Down syndrome – worked at Creative Growth Art Center in Oakland, California, the best-known progressive studio in the United States. Since Scott's death, her large sculptural works have been exhibited widely. While her artistic intentions were never communicated, Scott's work is highly regarded both within the Deaf and disability arts community and by outsider art supporters. Since Scott cannot agree or disagree, her work has become fair game in its representation by academics, curators, and collectors.

In contrast, US-based and self-proclaimed Deaf sound artist Christine Sun Kim has gained worldwide attention within both the Deaf and disability arts movement and the conventional art world alike. Kim, unlike Scott, has actively participated in Deaf and disability arts events, including performances in the 2013 Art + Body Fair, held in conjunction with send + receive in Winnipeg (Christine Sun Kim n.d.). Whether Sun Kim's act of participation in a Deaf and disability arts–related event automatically associates her with the Deaf and disability arts movement or not, a division occurs between artists who make art with the intent of making it visible within artistic, educational, and institutional structures and those who make art outside of these same existing structures and artistic conventions. This points to the exclusion of artists who remain outside of a disability culture paradigm created by Deaf and disability arts. In its quest for social recognition within the cultural sector, the Deaf and disability arts movement overlooks the issue of intent in relation to disability.

Critiques of Intent: Disability Aesthetics as an Alternative to Disability Arts?

Just as outsider art cannot exist without collectors and supporters, Deaf and disability arts cannot successfully be maintained without the engagement of an outside audience to appreciate and make real its goals of eradicating stereotypes of disability. As Marcel Duchamp (1957) so aptly noted, "The creative act is not performed by the artist alone." Art does not exist in and of itself; it needs an audience to view the work, curators to show the work, buyers to collect the work, and critics to talk and write about the work within the context of existing artistic discourses. Artists' works and intentions are always subject to categorization through the identity politics of race, class, gender, and ability.

Tobin Siebers (2010) widens the scope of Deaf and disability arts beyond questions of intent and political position. He argues that "disability is not, therefore, one subject of art among others. It is not merely a theme. It is not

only a personal or autobiographical response embedded in an artwork. It is not solely a political act. It is all of these things, but it is more" (20). Siebers argues for disability aesthetics as a more meaningful place to explore the themes related to disability in art. Aesthetics, according to Siebers, is the "domain in which the sensation of otherness is felt at its most powerful" (25). This otherness can be felt in the presence of non-representational art without consideration of the artist's intent or the work's political contributions. An artist's work *is* a contribution to arts culture, regardless of its contribution to identity politics. Therefore, an artist with a disability may contribute to Deaf and disability culture even when the artist does not explicitly state this intention. Siebers relies on examples of the work of Judith Scott to widen the political themes related to disability in art. Her position is unique, however, as she is touted as an outsider artist – Scott completed her work at Creative Growth – and was used as an exemplary case by academics in the field of art and disability. Despite this overlap, the value of her example remains: by speaking of the merits of the work's aesthetic value, and not *for* or *about* the artist themselves, we may broaden what Deaf and disability arts can do.

Progressive Studios and Deaf and Disability Arts

Having previously examined the differences between Deaf and disability arts and artists with disabilities, we can now investigate where an overlap occurs with Deaf and disability art and outsider art. One of the similarities is that both negate their relationship to art as a form of therapy. In the Canada Council report written in 2004, we understand that "the therapeutic domain must therefore be problematized as it serves as yet another means by which disability is segregated and isolated from the broader social and cultural world" (Abbas et al. 2004, 9). Cardinal (1972, 39) states, "Art Brut does not seek approval. It has for instance nothing to do with art therapy." Progressive studios are places where it is possible to explore the topics of art and disability *and* outsider art due to the nature of their connection to both.

By adopting a shared terminology of "progressive studio," organizations supporting artists with disabilities might help increase the visibility of artists working within them, helping to connect Canadian discourse on Deaf and disability arts with international discourse on outsider art. For this reason, I use the term "progressive studio" when referring to studio spaces that enable marginalized populations – including people with developmental and mental disabilities – to make art.

Progressive studios that support artists with disabilities in the creation
and dissemination of their work in the visual arts have existed internation-
ally since the 1970s and in Canada since the 1980s. Most of these studios
are not-for-profit and are funded through a combination of partnerships
with governmental agencies, private funders, and corporations. In Canada
today, these studios include Gallery Gachet (Vancouver), Studio C (Calgary),
the Nina Haggerty Centre for the Arts (Edmonton), Artbeat Studio (Win-
nipeg), the Creative Spirit Art Centre (Toronto), Les Impatients (Montreal),
and Veith Street Studio Association (Halifax).

Each of these studios offers programs, workshops, studio spaces, gallery
spaces, and other supports needed for the creation, the exhibition, and to
some extent the sale of artists' work. Artists may or may not meet with staff
on a semi-regular basis to discuss their progress, interests, and integration
into different artistic communities. Similar to communal studios where art-
ists might share space, each artist may have their own easel, table, or work
area and may focus on one or more creative approaches, such as painting,
sculpture, photography, ceramics, or fibre arts. Moreover, artists' biograph-
ies and work may be featured on the studio's website, and if the artist can or
does agree, their work is made available for sale. Similar to any other work
environment, long-term relationships are created to assist in sustaining art-
istic practices and to develop community within progressive studios. While
these spaces share similar goals and programming, there seems to be little
communication between them and their international counterparts.

My use of the term "progressive studio" defined earlier, *includes* those
with some connection to a therapeutic or medical focus. Differentiating pro-
gressive studios from amateur workshops and art therapy–based studios in
this way is promoted only by a select group of people, mainly critics and
curators in the United States and Europe. Creating debate over what quali-
fies as a progressive studio while querying the conditions under which art is
created further separates artists with disabilities from an international com-
munity of art workshops and studios. In addition, funding for these studios
varies greatly from one to the next due to different financial structures both
nationally and internationally. Collaboration between progressive studios is
needed to gain a better understanding of the role that the artists with disabil-
ities working in them can play in the art world and in Deaf and disability arts.

Progressive Studios and Outsider Art

Creative Growth, founded in 1974 in Oakland, California, is perhaps the
most referenced progressive studio today. In addition to the late Judith

Scott, its artists include Dan Miller and William Scott, who contribute to today's current interest in outsider art (Smith 2007). There are "150 artists with disabilities at Creative Growth Art Center, [and we] ensur[e] each artist receives professional grade materials, exceptional artistic instruction, premium exhibition and promotion opportunities in [the] gallery and abroad, partnerships with renowned Visiting Artists, and a secure, creative home of peers" (Creative Growth n.d.).

In both Canada and abroad, some progressive studios offer art therapy as part of their programming. An example of this is Les Impatients in Montreal, an initiative of the Fondation pour l'art therapeutique et l'art brut du Québec. Éric Mattson, curator of an exhibition at Les Impatients featuring artist Antonio Mazza's work, said about this exhibit,

> And it merits attention. On the one hand, because he has built a very specific and singular lexicon of objects, animals, and people over all these years. And on the other, because there has been a consistency in his work since 1992. This, in my opinion, is what constitutes an oeuvre. What is an artist if not a person who looks at the world and retransmits it to others through their own lens of interpretation? His unique signature has enormous power. That said, he is not conscious of being an artist. This is why this is outsider art in its purest form. (original translation, quoted in Laurence 2009; translation by Trina LeBlanc and the author)

Since Mazza's association is with both art therapy and outsider art, he has not been recognized by the Deaf and disability arts movement because "Disability Art is fundamentally different from – and, in some cases, diametrically opposed to – the domain of art therapy" (Abbas et al. 2004, 9). By disregarding the curators working within the genre of outsider art and exhibitions of work by so-called "outsider" artists, the Deaf and disability arts movement is missing out on valuable opportunities to engage both progressive studios and arts and cultural workers in conversation about the history of the marginalization of artists with disabilities.

A recent exhibition by the Museum of Everything, titled *Exhibition #4*, surveyed the work of artists from progressive studios worldwide (Museum of Everything 2011). Of 250 artists and seventy-five studios featured in this exhibition, only one artist (Laurie Marshall) and one studio (Gallery Gachet) were Canadian. Some progressive studios claim their explicit relationship to the term "outsider art." For example, Gallery Gachet in Vancouver makes reference to outsider art on its website: "We strive to provide a focal point

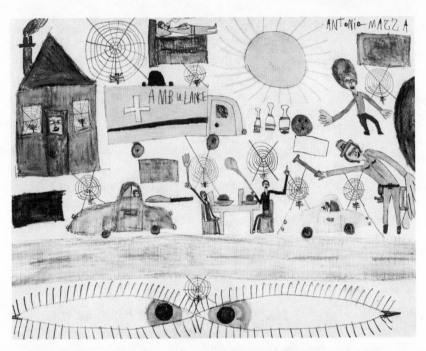

Antonio Mazza, *Traffic Service* (translated title), 1996, lead pencil and watercolour pencil on cardboard, 34.2 cm x 44.2 cm. Les Impatients Collection, 1996.51.

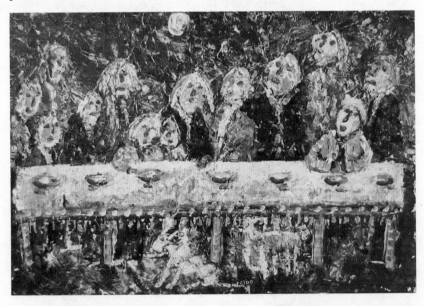

Laurie Marshall, *Family Gathering #1*, 2011, acrylic on wood, 40.64 cm x 60.96 cm, courtesy of the artist.

for dialogue amongst outsider/dissident artists" (Gallery Gachet n.d.). This publicly stated connection to outsider art on its website might be one of the reasons why one of the gallery's artists was included in the survey of art from progressive studios in *Exhibition #4*. A fear among other Canadian progressive studios of openly embracing the term "outsider art" might be part of the reason why the work of other artists was not recognized within this exhibition.

Some critics argue that because progressive studios run workshops taught by art students and professionally trained artists, outsider art cannot be created in these spaces. This argument is exemplified in an article by French art critic and theorist, Laurent Danchin, "The Problems of Definition in the Ever Broadening Field of Outsider Art," included in a 2011 issue of *Raw Vision* – a magazine dedicated to outsider, *brut*, folk, naïve, intuitive, and visionary art. Danchin states that "real outsider art fans – collectors, curators, critics, gallery owners, artists and so on – are individuals or small groups of people. Workshops are social institutions" (Danchin 2011, 57). His belief is that outsider artists are those who work outside of culture and who therefore possess "'raw' creativity which contrasts completely with the prosaic world of conceptual and institutional contemporary art" (*Raw Vision* n.d.). Even if workshops held at progressive studios are taught by professional artists, these provide only basic training and cannot be described as a substitute for the history and conventions of the art world. In an article on art and disability in the same issue of *Raw Vision*, Sue Steward (2011, 23–24) agrees that artists working in progressive studios are simply given the tools to explore and succeed as artists and that critics often misunderstand this work as collaborative, thereby excluding their work from the field of self-taught and outsider art. The belief that "real" outsider art cannot be made in a progressive studio derives from a fear of the evolving nature of how, where, and by whom this art is made and categorized.

Progressive studios enable artists with mental and developmental disabilities to encounter and participate in the world of outsider art. *Exhibition #4*, in its use of the term "progressive studio" within its exhibition catalogue and its connection to the world of outsider art, begins an interesting discussion about the labels given to the artists working within them. It is clear that artists working within these studios have been labelled as outsider artists by members of the art world (e.g., Judith Scott and Antonio Mazza) and furthermore that this work is being exhibited outside of progressive studios within existing institutional frameworks, allowing some artists with disabilities into the conventional world of visual arts and culture.

Conclusion

In comparison to Deaf and disability arts, where the artist with a disability is in control of the dissemination of their own artistic product, outsider art could seem like a step backward, as outsider artists are often not in control of the labelling of their artistic practice. According to Matthew Higgs (2011, xiv), outsider and self-taught art "makes everything much more complicated, which is perhaps why this work is so profoundly engaging." The Deaf and disability arts movement and outsider art have obvious grounds for conflict, since the intention of Deaf and disability arts is to *include* artists with disabilities into all aspects of the arts and culture sector, while outsider art values that which is anti-cultural. These categories, however, are not mutually exclusive, since work by *some* artists with disabilities has been labelled, placed, shown, and promoted as outsider art, and some Canadian studios serve Deaf and disability artists through outsider art. Moreover, both Deaf and disability arts and outsider art have promoted and categorized artists who did not necessarily identify with these labels.

One can understand the desire of Deaf and disability arts to distance itself from the medicalization and therapeutic treatment of individuals in its quest for self-determination and for the professionalization of artists with disabilities. Outsider art – despite its beginnings as an anti-cultural movement and its connections to the medical system – can and should be discussed within the context of Deaf and disability arts. As progressive studios participate in outsider art exhibitions and claim a connection to outsider art, they can offer a link between outsider art and disability art. Curators working within Canada's art institutions should be responsible for knowing about and visiting the various progressive studios to see what art is being made, enabling more art by artists with disabilities to be seen outside of a medical model and inside a museum.

Publicly funded Canadian art institutions – and the curators they employ – must play a role in the acquisition, representation, and dissemination of Canadian art by Deaf and disability artists today. One way of doing this would be to establish better relationships with existing progressive studios in Canada that support the work of artists with disabilities. It is feasible that the National Gallery of Canada could include, among its three hundred annual acquisitions, the work of artists such as Laurie Marshall (Gallery Gachet), the only artist in Canada to be included in a retrospective of seventy-five internationally recognized progressive studios, and Antonio Mazza (Les Impatients), who has sustained an artistic practice for over fifteen years. Mazza's long-standing drawing practice, exhibition history, and aesthetic

value are consistent with the ways in which curators determine factors of inclusion. Yet Mazza does not identify as an artist with a disability or with the Deaf and disability arts movement. Likewise, the Deaf and disability arts movement might not want to be associated with him, because the progressive studio with which he is associated is categorized under the banners of art therapy and outsider art.

The language and terms, or discourses, used to define the work of artists with disabilities are creating divisions and barriers that exclude some artists. Canadian art institutions, progressive studios, and academic researchers in the field of disability studies are all hesitant to use internationally accepted language such as "outsider art," "*art brut*," and "visionary art." "Sometimes we are so worried about saying the 'right thing' or using the wrong terminology and offending people that nobody says anything. We just have to start talking," Nancy Hansen suggests (quoted in Canada Council for the Arts 2012, 10). The reintegration of these terms in Canada may help connect Canadian artists with disabilities to international outsider arts communities, while also connecting Canadian arts institutions to international dialogues about outsider art.

Museums have become increasingly sensitized to the topic of disability over the last two decades, although in very selective ways (Sweeney 2012). Disabled people have been conceived almost entirely as potential audiences who must be accommodated through the implementation of accessibility strategies. Can we place value on outsider art in Canada while still engaging in ethical practices and discussions? Can we create spaces for exhibiting artwork by artists with disabilities, regardless of whether or not they identify with the Deaf and disability arts movement? Existing progressive studios across Canada are a good platform for new research into the spaces that exist between outsider art and Deaf and disability arts and the dissemination and preservation of the work of more artists with disabilities.

If outsider art is a current trend in the international scene – one that continues to inspire an international dialogue about its boundaries, inclusivity, and ethical practices – then Canadian institutions should be participating in this dialogue, acquiring and showing works by artists in progressive studios in countries where outsider art is embraced. By using existing terminologies – as problematic as they may be – Canadian art institutions and Canadian artists with disabilities will connect and contribute to larger global communities. To borrow from Graham and Jackson (this volume), "The factions within the overall movement are not weaknesses." Where delimitations of the Deaf and disability arts movement lie, also lie sites for change.

WORKS CITED

Abbas, Jihan, Kathryn Church, Catherine Frazee, and Melanie Panitch. 2004. *Lights ... Camera ... Attitude! Introducing Disability Arts and Culture.* Ryerson RBC Institute for Disability Studies Research and Education.

American Folk Art Museum. n.d. "About the Museum: Mission." Accessed June 2, 2016. http://folkartmuseum.org/about/mission/.

Balancing Acts. n.d. "Aesthetics." Accessed February 2013. http://www.balancing -acts.org/aesthetics.htm.

Bowler, Anne E. 1997. "Asylum Art." In *Outsider Art: Contesting Boundaries in Contemporary Culture,* edited by Vera L. Zoldberg and Joni Maya Cherbo, 11– 36. New York: Cambridge University Press.

Canada Council for the Arts. 2012. *Executive Summary: Expanding the Arts: Deaf and Disability Arts, Access and Equality Strategy.* Ottawa: Canada Council for the Arts.

Cardinal, Roger. 1972. *Outsider Art.* New York: Praeger Publishers.

–. 2009. "From Outsider Art and the Autistic Creator." *Philosophical Transactions of the Royal Society* 364 (1522): 1459–66. http://dx.doi.org/10.1098/rstb.2008.0325.

Creative Growth. n.d. "Get Involved." Accessed November 14, 2011. http://creative-growth.org/get-involved/.

Danchin, Laurent. 2011. "The Problems of Definition in the Ever-Broadening Field of Outsider Art." *Raw Vision* 73 (Fall): 57.

Davis, Lennard J. 2013. "The End of Identity Politics: On Disability as an Unstable Category." In *The Disability Studies Reader,* 4th ed., edited by Lennard J. Davis, 263–77. New York: Routledge.

Doucet, Emily G. 2010–11. "Inhabiting the Spaces of Henry Darger's Monsters." *Paperwait* 13: 59–62.

Duchamp, Marcel. 1957. "The Creative Act." Transcript and sound recording accessed June 2, 2016. *Brainpickings* (blog). https://www.brainpickings.org/index. php/2012/08/23/the-creative-act-marcel-duchamp-1957/.

European Outsider Art Association. n.d. "Mission." Accessed May 16, 2014. http:// www.outsiderartassociation.eu/index.php?option=com_content&view= article&id=10&line=bg_rod.png&Itemid=7.

Gallery Gachet. n.d. "About." Accessed July 2, 2013. http://gachet.org/about/.

Higgs, Matthew, interview by James Brett. 2011. "The Appendix of Everything." In *Everything #4.* London/New York: The Museum of Everything.

Institute of Contemporary Arts. 2010. "Don't Call Me Crazy: How We Fell in Love with Outsider Art." Accessed August 5, 2013. http://www.ica.org.uk/whats-on/ don't-call-me-crazy-how-we-fell-love-outsider-art.

Jacobson, Rose, and Geoff McMurchy. 2010. *Focus on Disability and Deaf Arts in Canada.* Ottawa: Canada Council for the Arts.

Laurence, Jean-Christophe. 2009. "Antonio Mazza ou l'art inconscient." *La Presse,* October 17. http://www.lapresse.ca/arts/arts-visuels/200910/17/01-912357 -antonio-mazza-ou-lart-inconscient.php.

Museum of Everything. 2011. The Museum of Everything, Exhibition #4. London/ New York: Museum of Everything.

Raw Vision. n.d. "About." Accessed June 13, 2013. http://rawvision.com/about.

Sandell, Richard, and Jocelyn Dodd. 2010. "Activist Practice." In *Re-Presenting Disability: Activism and Agency in the Museum,* edited by Richard Sandell, Jocelyn Dodd, and Rosemarie Garland-Thomson, 3–22. London: Routledge.

Siebers, Tobin. 2010. *Disability Aesthetics.* Ann Arbor: University of Michigan Press.

Smith, Roberta. 2007. "Creative Growth." *New York Times,* Art in Review, July 20.

Solvang, Per Koren. 2012. "From Identity Politics to Dismodernism? Changes in the Social Meaning of Disability Art." *ALTER: European Journal of Disability Research* 6 (3): 178–87.

Steward, Sue. 2011. "Art & Disability." *Raw Vision* 73 (Fall): 20–27.

Sun Kim, Christine. n.d. "CV." http://christinesunkim.com/details/cv/.

Sweeney, Elizabeth M. 2012. "(Dis)played: American Able and the Display of Contemporary Disability Art." Master's thesis, York University, Toronto.

United Nations. n.d. "International Day of Disabled Persons, 2004 – Nothing about Us, Without Us." Accessed August 27, 2014. http://www.un.org/disabilities/default.asp?id=114.

5

"It Fell on Deaf Ears"
Deafhood through the Graphic Signed Novel as a Form of Artivism

VÉRO LEDUC

To be deaf is not to not hear ... but a social relation.

– Douglas Baynton, 1996

What does it mean to live as a Deaf person? As with all social identities, it involves both specificities and singularities. In addition to being specifically designated, identified, or self-identified as Deaf, what can be said about the singular ways of living as a Deaf person? In general, dominant medical, cultural, and social perspectives consider deafness a lack, a void, or an emptiness. Indeed, hearing people "imagin[e] themselves without hearing – which is ... not to be Deaf" (Lane 2010, 88). More than just a level of hearing ability, being Deaf is a way of being in the world. First conceived by Deaf scholar Paddy Ladd (2003), the concept of Deafhood offers a different way of interpreting the experience of deafness: "Deafhood means a process, a journey for all Deaf people. ... Deafness is a term often determined by the medical field [whereas] Deafhood is a process, not a state, which focuses on people's existential stances" (Gertz 2006, translated from ASL,[1] in Luczak 2007, 3).

As part of my doctoral studies, I completed a research-creation project based on the production of a graphic signed novel,[2] *It Fell on Deaf Ears (C'est tombé dans l'oreille d'une Sourde)*, in which Deafhood is mobilized as a central concept. This chapter explores my research-creation process and its place within an artivist approach, discusses the graphic signed novel as

Véro Leduc, *C'est tombé dans l'oreille d'une Sourde (It Fell on Deaf Ears)*, 2016.
Detail from the cover of the graphic signed novel, www.bdlsq.net.

research-creation, and then turns to questions raised by and resulting from
its production, such as aspects of the historicity of Deafhood, notions of
Deaf belonging, and the issue of Deaf "voices." I conclude with a reflection
on artivism as a means of fighting oppression.

My experience of oppression prompted me to look more closely at Deaf-
hood. According to feminist philosopher Iris Marion Young (1990, 41),
"Oppression designates the disadvantage and injustice some people suffer
not because a tyrannical power coerces them, but because of the everyday
practices of a well-intentioned liberal society."

For the last number of years, my academic, activist, and artistic work has
been guided by the desire to deconstruct the minoritization of certain social
groups (women, queer people, sex workers, and people living with HIV,
among others). In time, this work has led me to understand that processes
of social change and transformation are rife with paradoxes and nuances
that shape daily practices. It was therefore with the intention of embracing
these paradoxes and nuances as instigators of transformation that I began to
explore Deafhood as a complex and constitutive experience – as suggested
by Teresa de Lauretis (1984, 159), for whom experience is a "process by
which, for all social beings, subjectivity is constructed."

By situating the singular experience of Deafhood as a complex process
of becoming, I seek to understand how this process and its affects and ef-
fects are conceived, actualized, and communicated. I do so from a particular

perspective; that is, in the context of the production of a bilingual graphic signed novel in Langue des signes québécoise (LSQ; Quebec Sign Language) and French that serves as a site of exploration of various philosophical, theoretical, epistemological, ethical, artistic, and political issues.

By focusing on the affects and effects of living as Deaf, I seek not to discover some sort of Deaf essence, but to question what Deaf epistemological perspectives might look like. As Owen Wrigley states, "Deafness is less about audiology than it is about epistemology" (quoted in Brueggemann 1999, 151). Through this process, I aim to document and reflect on Deafhood by examining the multiplicity of ways of living in and considering the world as a Deaf person.

One hundred copies of the first version of my graphic novel – in French only – were distributed as a zine in Deaf, hearing, academic, and activist communities, in addition to being available online (Leduc 2012). The other iteration I did for my PhD is a bilingual videographic novel, in web format in LSQ and French that combined illustration and video. I describe the first edition of *It Fell on Deaf Ears* as a form of autoethnography, "an approach to research and writing that seeks to describe and systematically analyze (graphy) personal experience (auto) in order to understand cultural experience (ethno)" (Ellis, Adams, and Bochner 2011, n.p.). The creative process for the second version has led me to situate my work as a form of artivist practice; I approach particular socio-political issues of Deafhood and oppression through artistic creation with the aim of raising awareness and conceptualizing the possibilities of socio-political transformation, including in my own practice and work. Available online in video format, *It Fell on Deaf Ears* features black and white drawings, pictures edited with graphics software, texts in French, and animated video of protagonists signing LSQ. These videos consist of excerpts of encounters with five Deaf people conducted in the context of my doctoral thesis.[3]

I am interested in the complexity of Deafhood, particularly as seen through the concepts of becoming, assemblage, and interstice (Deleuze and Guattari 1980). The idea of becoming allows me to apprehend transformational movements, actions, and ongoing processes while avoiding the search for an ontology of Deaf being or culture. The notion of assemblage is a way to explore the configuration and shifting articulation of several dimensions of Deafhood. The conception of interstice allows for an understanding of Deafhood through dimensions that seem incommunicable or at least difficult to communicate. An interstice is "the space between things or parts, especially a space between things closely set: a crack, a crevice, an interval"

(Rochielle 2008, 102). It is also a space of emerging thought, reflection, and creation.

To question the effects and affects of living as Deaf and related epistemological perspectives, the graphic signed novel addresses themes such as oppression, agency, everyday practices, audism, and the historicity of Deafhood as discussed during my encounters with Deaf people. In other words, I seek opportunities to explore different times and spaces of Deafhood while remaining conscious of the limits of this concept.[4]

The Graphic Signed Novel as Artivism

Combining art and activism, artivism brings together multiple definitions of art, activism, and community, as well as the interactions between them (Barndt 2006; Lemoine and Ouardi 2010; Willard 2008). Given the impressive variety of approaches that embrace art and politics in one way or the other, how can the process of creating a graphic signed novel constitute a form of artivism?

Because I consider that activism encompasses a diversity of actions undertaken with the intention of creating socio-political change, the process of producing *It Fell on Deaf Ears* provided me with the opportunity to pursue this goal through artistic creation. While acknowledging the importance of systemic change, I do not consider socio-political transformation as something to be imposed on society from outside, but as truly enmeshed both within the transformation of my own practice and position, as well as within the communities to which I belong.

More broadly, my experience of creating a graphic signed novel is much inspired by the principles of community art:

The community arts movement is inspired by social justice activism and is grounded in the principle of cultural democracy. Community art is often used as a tool for stimulating dialogue, for documenting community-rooted narratives and for encouraging self-empowerment. (Feinberg and Davis 2009)

Community arts practices generally involve an active collaborative process between artists and community members in the form of collective projects (Chagnon, Neumark, and Lachapelle 2011). Because my work is inspired by encounters with Deaf people, I attach great importance to ethical questions throughout the process. I met each participant for an initial confidential encounter that was professionally recorded at Cinéall, a Deaf

production company equipped with a green screen to be replaced with a background image in postproduction. I then selected inspiring segments and engaged in a second dialogue with each collaborator. Next, each participant had the opportunity to watch their segments, engage in meaningful dialogue to ensure consent, and give final consent for public distribution of the graphic signed novel in which they are featured. I then proceeded to edit and translate the material to create a graphic signed novel in which each encounter constitutes a video chapter.

Although I acknowledge that the participation and collaboration of many Deaf people are at the core of the production of *It Fell on Deaf Ears*, the context of my doctoral studies requires that I be the sole copyright owner (it is "my" thesis). Thus, even though the values and perspectives informing my graphic signed novel are similar to those identified by Pohanna Pyne Feinberg and Heather Davis (2009), I accept, as an ethical responsibility, that questions of power and privilege cannot be avoided. Although the process aims to be as collaborative and ethical as possible and is inscribed in an artivist approach, the fact remains that I was granted a PhD for this research-creation project, whereas other Deaf collaborators will be considered only as contributors. I recognize that the process of my creation differs from a collective approach in which all contributors are meant to reap the same benefits. I remain convinced, however, that it qualifies as an artivist approach due to its intention of raising awareness and contributing to socio-political transformation, and due to its dedication to ethical concerns.

As stated by the founders of ATSA (Socially Acceptable Terrorist Action), art has the potential to "stimulate debate and become part of society ..., to serve as a trigger for collective reflection" (quoted in Lamoureux 2009, 96; LeBlanc's translation). This collective act of reflection is expressed through different artivist opportunities for reflection and exchange and is inscribed in them. Thus, the production process of *It Fell on Deaf Ears* is deeply situated within my activist undertakings with people from the Deaf community and the different challenges and questions that came to inhabit me.

Although "art can offer a chance for society to collectively reflect on the imaginary figures it depends upon for its very consistency, its self-understanding" (Holmes quoted in Mouffe 2007), I believe it is not only a product from which reflection or political change can emerge, but also a process imbricated in everyday politics and reflexivity. This is why I consider this graphic signed novel as more than just an artifact; the creative process as artivism allows for reflexivity and creativity as well as epistemological and political reflection.

The Graphic Signed Novel as Research-Creation

Creation is meant to be a sensitive and engaging way to construct and share ideas, representations of the world, learning, and knowledge by creating a dialogue between the experiential and the conceptual (Gosselin and Le Coguiec 2006). When combined with research, the very concepts of theory, creativity, and knowledge are challenged and subject to redefinition (Chapman and Sawchuk 2012). Comic books, including graphic novels, have the ability not only to evoke the effects and affects of cultural and socio-political realities larger than the stories they tell, but also to *transform* ways of perceiving and experiencing these realities. I have devoured hundreds of comics and have come to appreciate them as an innovative means to communicate experience – especially of those who are minoritized – and an amazing site of philosophical possibilities.

Since the nineteenth century, comics have taken on many forms, including documentaries and graphic novels. Because these types of comics stand apart from superhero classicism, they are known as alternative, underground, or independent. Appearing first in Japan with the autobiographical work of Yoshiharu Tsuge, independent comics arrived in the United States during the 1970s with authors like Robert Crumb, who combined childhood memories with reflections on social issues, and Art Spiegelman, whose work offers a stunning documentary approach to the Holocaust (Delporte 2011). These trends remained marginal until the 1990s, when the form took off and independent comic book publishers were established (Menu 2011). At the same time, queer and riot grrrl movements contributed to an explosion of zines, small independent publications that gave "voice" to a variety of traditionally marginalized groups, including women and queer people (Falardeau 2008; Jeppesen 2010; Schilt 2003).

Feminist and anti-racist movements have long asserted that the personal is political. By giving "access to the intimate" (Menu 2011, 83), or everyday practices, comics can treat subjective experience from a perspective open to broader social realities. Thus, they allow the critical exploration of a variety of taboos and/or little-known cultural and socio-political realities in a form that has the potential to touch audiences in particular ways, especially through artistic and political humour and reappropriation (Bochner and Ellis 2003; Boukala 2010).

Although I was born with moderate/severe deafness, I have been labelled hard of hearing and grew up reading lips – except those of cartoons. I became involved in the Deaf community and fluent in sign language only in my early thirties, somewhat late and in many ways naïve about Deafhood.

As a result, historicizing Deafhood was the first step in the creation of *It Fell on Deaf Ears* and one of its main concerns, given that one cannot understand the oppression faced by Deaf people without a certain awareness of its genealogy.

Historicizing Deafhood: A Brief Deaf History

Deaf people were associated with madness, idiocy, and other forms of deviance until the eighteenth century, after which the advent of scientism opened the door to ideals of normalization and eugenics (Bauman 2004; Davis 2008). Alexander Graham Bell, son and husband of deaf women and famous for inventing the telephone, feared the creation of a deaf race. In his *Memoir upon the Formation of a Deaf Variety of the Human Race* (1884), Bell insisted on the importance of deaf people marrying hearing individuals in order to eventually eliminate deaf people. Eugenics peaked in the Nazi era, when thousands of Deaf people were executed, or sterilized against their will (Davis 2008; Lane 2008).

In 1880 in Milan, the Second International Congress on Education of the Deaf banned the use of sign language in schools, identifying speech as that which distinguishes human beings from animals and something that needed to be enforced:

> The impact of the ban was felt throughout the West. Deaf and signing teachers were dismissed and corrective measures taken to prevent students from signing: tying students' hands behind their backs and preventing older students from socializing with younger ones in order to stop them from transmitting the language are but two examples. It is a traumatic date. (Witcher et al. 2014; LeBlanc's translation)

This was the beginning of the supremacy of oralism: "an all-encompassing set of policies and discourses aimed at preventing [Deaf people] from learning or using sign language to communicate" (Ladd 2003, 7). The method, which consists of teaching Deaf people to oralize through various speech therapies, caused them to spend the better part of their education learning to oralize, to the detriment of their overall education (Jankowski 1997).

Although Deaf people have been consciously forming communities since the nineteenth century, the concept of Deaf pride – along with other minority pride movements reappropriating stigmatized identities in order to deconstruct stigmatization – appeared in the 1980s, a historic period of Deaf awakening (Jankowski 1997; Lachance 2007). Until then, Deaf people had

always been defined by others, specifically by "hearing people who do not know themselves [as such], but are featured in Deaf mythologies as a form of ontological alterity" (Gaucher 2010, 45; LeBlanc's translation). The emerging Deaf social movement advanced the positive claim that Deaf people perceive and consider the world differently than hearing people (Padden and Humphries 1988). Within Deaf studies, authors encourage setting aside the idea of hearing loss in favour of Deaf gain (Bauman and Murray 2009, 2014). This reversal shifts the site of differentiation from deafness (a medical perspective associated with deficiency) to sign language (a cultural perspective associated with Deaf empowerment). One aspect of Deaf empowerment is Deaf people's desire to assert themselves while deconstructing historical subjugation under the yoke of medical and eugenicist paradigms. Inspired by Black Power and other social movements, members of the Deaf movement fought for the rights to define themselves (Jankowski 1997).

When considered in terms of identity and identity politics, however, self-definition can also lead to divergent perspectives. While the mobilization of Deaf people has the potential to unite individuals thus "called," to use Giorgio Agamben's expression (1990), things get more complicated when forced to define what is meant by the term "Deaf person." In 1972, James Woodward proposed distinct spellings to differentiate between the medically diagnosed state of physical deafness ("deaf") and belonging to Deaf culture ("Deaf"), which have since become convention (Napier 2002). Given the difficulty in distinguishing how and when one passes from one category to the other, though, the paradox of this distinction is that the terms are often combined (d/Deaf), like doppelgängers (Brueggemann 2009, 14). While it is precisely for its potential to move beyond the dead end of the "d/D" binary that the concept of Deafhood is particularly promising, it is worthwhile to outline some of the principal approaches to situating Deaf specificity.

Are You Deaf or What?

While some categorize Deaf people as disabled, others consider them a cultural or linguistic minority (Burch and Kafer 2010; Davis 1995; Kymlicka 1998; Lane 2010; Padden and Humphries 1988). In one of the first articles published in LSQ, it is clear that these different schools of thought have a long history: "Aristotle considered Deaf people other than human, for he believed that humanity was confirmed by the utterance of speech, [while] Plato, for his part, recognized a true language in the gestures of the Deaf" (Witcher et al. 2014; LeBlanc's translation).

The idea of considering Deaf people a linguistic or cultural minority emerged in the 1970s along with a variety of other social and minority movements (Baynton 2008; Davis 2008). Many Deaf perspectives inspired by linguistic or cultural models refuse classification in the register of disability, arguing that a Spanish speaker who does not speak English or a black person who does not have the privileges accorded to white people do not consider this a disability; the inability to speak/understand a spoken language should not be the exception (Baynton 2008; Davis 1995; Lane 2008). Rather than ask, "Do Deaf People *Have* a Disability?" (Lane 2008, emphasis added), I postulate that, for most people, Deaf people are *considered* disabled (Brueggemann 2008, 179).

The linguistic model posits that when a Deaf person meets a non-signer, she "does not think 'I cannot hear and therefore cannot communicate with this person', but rather, 'Our languages are different and therefore we cannot communicate with each other'" (Mae Lentz quoted in Baynton 2008, 308). In my view, this argument is not sufficient to distinguish deafness from disability. In fact, rather than saying "I cannot walk and therefore cannot accompany you to the show in this building with stairs," a person using a wheelchair could say to a person who can walk, "Our bodies are different, and because society is organized almost exclusively for able bodies, we cannot equitably coexist." Some critical models of disability propose conceptions of bodily difference in terms not of individual lack, but of social oppression. This makes it possible to situate Deaf people, for example, as experiencing particular ways of being in the world currently unrecognized as equal to hearing people's ways of being.

It would appear that when Deaf people refuse to be identified as disabled, it is in response to the same medical model that critical disability activists and researchers also reject. And when Deaf people do embrace this label, it is not because they believe they have a lack or (hearing) loss, but because of the rich alliances they see with activist movements fighting for the rights of people with disabilities and to remove barriers to their social recognition and participation. Debates between disability studies/communities and their Deaf counterparts are complicated, making it impossible to explore them in depth here.[5] But given these debates and the subject of this book, I could not omit a brief discussion of issues surrounding how Deaf people consider themselves and are socially considered by others.

I argue that bodily difference is not the core point of distinction between living as Deaf and living as hearing. Rather, it is a question of language. Because sign and spoken languages are different and society is organized

almost exclusively for language speakers, not signers, equitable coexistence is currently difficult. When the site of discrimination is displaced from bodily to language difference, similarities between Deaf and disabled realities become less obvious. For instance, why are more connections not made between Deaf and First Nations in the struggle to have their languages officially recognized in this country? Indeed, this is an excellent example of the difference between specificity – identifying or being identified as Deaf – and singularities – the many ways of living this specificity (Agamben 1990; Probyn 1996).

In the first version of my graphic signed novel, I included a reflection on the words that forge our relationship to the world:

All of a sudden I don't want to be "hard" of hearing anymore;
Am I Deaf if sign language isn't my first language?
Am I hearing if I hear anyway, but not like hearing people?
Where are we going when we leave behind the words
(and the worldviews they carry) we don't want anymore?
Reeling in the "in-between" says Brenda Brueggemann
You say to me: I am "Deafian"
It sounds like "Martian," but I like it.
(Leduc 2012, 2; LeBlanc's translation)

Deaf Belonging

One of the strengths of the concept of Deafhood is the distance it allows from the question of whether or not one is deaf or Deaf. By calling for an end to the habitual reiteration of "d/D," Brueggemann invites an understanding of Deaf people as belonging to "a kaleidoscope of identities" (2008, 181) through what she calls in-betweenness: "What if we don't 'draw the line' on, around, through, or under where someone is (and isn't) 'culturally deaf' or not? What if we stop footnoting and explaining and educating *them* – meaning largely hearing people – again and again and again?" (Brueggemann 2009, 15).

Because identity is always in a state of transition and transformation (Garland-Thomson 2011), Elizabeth Probyn's (1996) discussion of becoming uses the concept of belonging in order to incorporate more of the movement inherent in the course of a life by distancing it from the notion of identity, which tends to favour ontological, if not essentialist, views of socially identified bodies. Although belonging is "a process that is fuelled by yearning rather than the positing of identity as a stable state" (Probyn 1996,

19), it is not voluntary – we do not choose to belong the way we choose a pair of shoes – rather, it is intrinsically linked to "the deep historicity of why, how, where, and with whom we may feel that we *belong*" (35). For example, to follow Agamben (1990), "being called" one thing or another – being socially designated as a woman, queer, or Deaf – shapes our relationship to the world. Because relationality shapes its ontology, belonging is never "already-constituted"; it is a becoming (Massumi 2002, 76).

Through the production of *It Fell on Deaf Ears*, I situate Deafhood within the genealogy I have attempted to outline here. Approaching the challenges of transformation from an artivist perspective requires recognizing the complexity of Deafhood. As suggested by the epigraph, to be Deaf forges our way of experiencing and considering both the world and our lives. I consider this complexity an ongoing discovery and expansion of its limits, including the political and epistemological challenges of Deaf voice and the three-dimensionality of sign languages.

Deaf Voices

The term "voice" is politically significant, especially when discussing the voices of minoritized people within activist circles and social movements. Much of my activism was anchored in the wish to give voice to the communities to which I belong. Voice has less to do with sound emitted during speech than "a distinctive perspective on the world that needs to be acknowledged" (Couldry 2010, 1). The challenges raised by Deaf voices are problematic not only because the word "voice" may not be appropriate for sign languages or evokes a history of Deaf oppression through oralism, but also because voicing claims for social change assumes that they need to be heard. Phrases such as "make our voices heard" may give political power to activists, but when these voices are not heard by the appropriate authorities, audist discourses sometimes take over. Think, for example, of the statements "stop turning a deaf ear to our claims" or "government is in a deaf dialogue," to turn a French phrase. Audism – an oppressive practice like racism or sexism (Bauman 2004; Gertz 2008) – often spreads through language in ways that perpetuate dominant hearing norms and privilege, including oppressive idiomatic expressions.

Critical to the act of speaking up is being heard or listened to. It seems that these communicative dimensions must be present for social consideration, itself required for a certain level of social recognition. While many subaltern voices have emerged since the rise of social movements and been

transformed through various theoretical waves and renewals, Deafhood poses the following question: how can one be heard without speaking? How can one be heard while signing if sign language is socially and politically not fully recognized and supported?

Historically, in North America at least, the majority of social movements (feminist, anti-racist, anti-ableist) have had the advantage of speaking the dominant language, a clear asset in the fight for the recognition of their human rights. As Jankowski (1997, 163) points out, "In the case of the Deaf social movement, communication is not merely the means, but the issue itself." Because "Deaf ... are excluded from communicating their demands in that dominant mode of speech" (Jankowski 1997, 10), they lack an important tool most other social movements are able to use. How can Deaf voices be understood? How can Deaf claims be lent an ear?

The challenge goes beyond finding synonyms for "voice" or "hearing" better suited to sign language; many idiomatic expressions refer in one way or another to the notion of voice, speech, or the ability to hear – three components inappropriate, if not prejudicial, to a Deaf epistemology. Twenty-five years ago, Gayatri Chakravorty Spivak (1988) asked, "Can the subaltern speak?" Today, questions emerging from the varied fields of queer, crip, and Deaf studies allow us to move beyond acknowledging the oppression of certain kinds of knowledge and perspectives (Foucault [1977] 2001; Haraway 1988) to ask the following questions: What do subalterns say, both with their voices and their signs? Who is paying attention to them, especially when they do not speak, but sign?

If it is true that, "for deaf life truly to be heard [on the public stage] (for a subaltern voice truly 'to speak' and no longer to be subaltern), the very terms of discourse on that stage – its very 'alphabet' – would need to be transformed" (Bechter 2008, 60), then these epistemological and political questions become ethical and methodological ones as well. For example, not only are many languages, metaphors, and expressions audist, but they are also filled with *ableist* metaphors – "take a step forward," "taking it step by step" – and *visionist* ones – "make us visible," "envisioning the future," "shed light on the subject," "see what I mean."[6] I came to realize how the languages of political claims and social recognition are filled with problematic idiomatic expressions. How can we preserve their power without resorting to oppressive expressions? It is from this perspective that I reappropriated the expression "It fell on deaf ears" as the title of my graphic signed novel, capitalizing the D in a polysemous invitation to political reflection.

Furthermore, the three-dimensional modality of sign language requires strategies to assert the value of a Deaf epistemology, as was evident in the challenges I faced while producing a graphic signed novel. Sign language upsets the very notion of writing of spoken languages by exposing its inability to express *movement*, an essential component of sign language. Beginning with the fifteenth-century Cervera manuscript, the oldest known example of written movement, there have been over one hundred movement notation systems. There are approximately 121 sign languages in the world (Padden 2010), but only very few forms of sign writings, including Stokoe notation, invented by hearing linguist William Stokoe (1960); SignWriting, invented by hearing dancer Valerie Sutton (1974); and, more recently, si5s, invented by Deaf artist Robert Arnold (2003). However, because very few people know or use these forms and because these systems are not used to write LSQ, I believe that video remains the most powerful and accessible medium to express and read sign languages.

Thus, the production of a bilingual work in LSQ and French confronted me with the problem of redefining the very acts of writing and signing. For the first version of the graphic novel, a notebook was my principal tool for collecting memories, thoughts, and drawings later used to create. But how could I embrace a creative process that situates sign language at the forefront and not just in subsequent translation? How could my creation avoid being a transposition of my memories and raw material from French to sign language? It took me some time to deconstruct this relationship to writing/creating, until the day I used my cellular phone to record sporadic signed reflections and the following alert appeared on the screen: "No more space – delete some files to save this video."

An important insight was that writing in French allows me to play on absence/presence, something I find more difficult in sign language. Writing in French does not show my face, but signing LSQ requires it, because facial expressions are an essential component of sign language. How could I recreate the distance I feel when reading books in French and accessing the authors' thoughts or voices without seeing their faces? In 1913, Veditz signed, "As long as we have our films, we can preserve signs" (NADvlogs 2010). A century later, I wonder how technological development could inform not only the preservation of signs, but also the expression of their possibilities through creation.

Artivism embraces art as a means for socio-political transformation, and its forms are incredibly diverse. The creative process led me to a very

pragmatic investigation of the politics of language and writing, shattering many of my assumptions about research and creation. Artivism is both an approach and a process through which oppression can be recognized and transformed by focusing on seemingly small details and, as such, has changed my practice. It is my hope that my work successfully addresses and communicates issues of oppression.

Fighting Oppression through Artivism

If oppression is indeed experienced through everyday practices (Young 1990), it is because these practices are based on specific forms of ignorance and naïveté themselves directly linked to their social, political, historical, and cultural conditions of possibility. Discussing Deafhood and audism in a graphic signed novel is one way to recognize, question, and perhaps transform them.

By situating Deafhood as a site of knowledge/power (Foucault 1980), I explore the experience of oppression as subjectively constitutive and capable of contributing to Deaf epistemological perspectives. I attempt to grasp the complexity of oppression by conceptualizing its affective dimensions, specifically through the concept of dissonance. This allows me to qualify exactly what is experienced during often well-intentioned everyday oppressive interactions (Young 1990). Dissonance can be understood as affects emerging from dissensions momentarily inexpressible because they are unintelligible within the communicational possibilities of everyday interactions and oppressions. In other words, I use the concept of dissonance to apprehend what is experienced when forms of micro-violence become commonplace, although this does not mean that they can be made explicit in everyday communicational moments, so to speak/sign.

Dissonance can also be a site of agency. For example, the reiteration of everyday violence – cultural, epistemological, symbolic, etc. – shapes the conditions of agency. Therefore, dissonance must be recognized as a site of power as conceived by Foucault:

> Power is not intrinsically, nor is it only, negative: it is not just the power to deny, to suppress, to constrain ... Power is also positive and productive. It produces possibilities of action, of choice – and ultimately, it produces the conditions for the exercise of freedom ... Power is therefore not opposed to freedom. And freedom, correspondingly, is not freedom *from* power – it is not a privileged zone outside power, unconstrained by power – but a potentiality internal to power, even an effect of power. (Halperin 1999, 17)

This is the lens through which I perceive dissonance as a site of agency and creativity. By helping me to understand my own and other Deaf people's experiences, the graphic signed novel allows me to consider the political, emotional, and everyday dimensions of Deafhood, particularly through the interstitial nuances that bring experiences of suffering and agency to the surface (Ahmed 2001; Massumi 2002; Probyn 1996). Put differently, it allows me to reflect upon and communicate multiple aspects that sometimes seem incommunicable.

Because dissonance is one of the materials out of which my graphic signed novel is created, it is important for me to situate it politically. Ahmed (2001, 10) asks, "What role do emotions play in the constitution of the relationship between subjects and communities?" and observes that emotions play a crucial role in the "surfacing" of individual and collective bodies:

> Such an argument clearly challenges any assumption that emotions are a private matter, that they simply belong to individuals and that they come from within and then move outwards towards others. It suggests that emotions are not simply "within" or "without," but that they define the contours of the multiple worlds that are inhabited by different subjects. (Ahmed 2001, 10)

Reflecting on why I perceive *It Fell on Deaf Ears* as a form of artivism, I argue that the humour and naïveté of the comic or graphic novel form facilitates open-mindedness toward delicate topics, both for me and the audience, and has the potential to name stigma, raise awareness about Deaf issues, demystify prejudices, and promote socio-political transformations. However, saying that artivism can change people, and eventually the world, is perhaps a truism.

Of greater concern for me are questions of relational ethics, especially within activist, community, and academic circles. Creating a graphic signed novel is an opportunity to foster links with Deaf people, activists, artists, and allies. Artivism is often considered a way to create change in oppressive situations that might be perceived as external. For me, however, it is also a reflexive practice that aims to build solidarity and belonging while stimulating reflection on how making changes in our everyday lives and practices is more complex than it may first appear.

More often than not, sharing a personal story means sharing information about relationships and other people, including those closest to us (Ellis,

Adams, and Bochner 2011). It is important for me to consider relational ethics and the potential harm that telling a particular story could cause to others. This ethical concern means taking measures such as "[showing our] work to others implicated in or by [our] texts, allowing these others to respond, and/or acknowledging how these others feel about what is being written about them and allowing them to talk back to how they have been represented in the text" (Ellis, Adams, and Bochner 2011, 11). This approach is inspirational, but challenging. For example, it is difficult to document the everyday practices of audism within my closest relationships; i.e., among family, friends, collaborators, and others. Telling a relative that some of her or his words, gestures, or attitudes are oppressive is no easy task. What risks am I willing to take? Tony Adams and Stacy Holman Jones (2011, 109) ask, "And what of the stories we are not ready or willing to tell? What of the stories that blink and waver on the threshold of thought, speech, and intelligibility?"

Activism asks for change, and changes are rarely comfortable. For me, engaging in an artivist approach is a personal and political commitment to challenging my comfort zone in different ways, especially through creation and the issues addressed. My initial intention was to address oppression and the possibilities of transformation through my work, but I would never have imagined that my perspectives would be so deeply disrupted, especially regarding language and writing and the resulting political and epistemological challenges. It is my hope that *It Fell on Deaf Ears* will be an invitation to risk deconstructing one's comfort zones to push the limits of what we are ready to challenge and to open new possibilities of transformation.

To conclude, I would like to say – since I cannot sign here – that my graphic signed novel aims to offer an engaging way to raise awareness and stimulate reflection not only to increase the social recognition of Deaf people and related human rights issues, but also to deepen awareness and commitment to social change within our activist, academic, and artistic communities and everyday practices.

ACKNOWLEDGMENT
This chapter has been translated from the French by Catriona LeBlanc. I am grateful to Michael Orsini for funding the translation and to Line Grenier and Pamela Witcher, whose feedback allowed me to improve the text.

NOTES

1 Original ASL quote: http://www.joeybaer.com/video/ggdeafhood.mov (0:51–1:50).
2 "Graphic signed novel" is the English term selected for this chapter. In French,
 the French expression *bande dessignée* is a combination of *bande dessinée* (a cat-
 egory that includes both comic strips and graphic novels) and "sign" (as in sign
 languages).
3 The graphic signed novel also features excerpts of encounters with members of my
 family conducted for my PhD, but space limitations prevent me from discussing this
 further.
4 I use the concept of Deafhood because it provides a critical distance from deafness,
 but I would prefer a more appropriate concept that would allow for critical and epis-
 temological perspectives while avoiding the essentialist tendencies inherent in the
 term "Deafhood." The issue is similar to how the concept of gender or feminist per-
 spectives embraces much more than womanhood.
5 See Lane (2008) for an argument supporting a necessary dissociation between Deaf
 studies/movements and disability studies/movements (by rejecting the medical
 model) and Baynton (2008) for arguments defending the similarities between them
 and a call to conceptualize Deaf people as both disabled (following the social model
 paradigm) and a cultural minority. For a discussion of collaborations between stud-
 ies and movements defending Deaf and disabled rights, see Jankowski (1997) and
 Davis (2008).
6 I would like to thank Rod Michalko and Tanya Titchkosky for encouraging me to
 coin the word "visionist" in my search for a term equivalent to "audist" for people
 who are blind (ocularcentrism would be the equivalent of phonocentrism).

WORKS CITED

Adams, Tony E., and Stacy Holman Jones. 2011. "Telling Stories: Reflexivity, Queer
 Theory, and Autoethnography." *Cultural Studies ↔ Critical Methodologies* 11
 (2): 108–16. http://dx.doi.org/10.1177/1532708611401329.
Agamben, Giorgio. 1990. *La communauté qui vient. Théorie de la singularité
 quelconque.* Paris: Seuil.
Ahmed, Sara. 2001. "Communities That Feel: Intensity, Difference and Attachment"
 In *Conference Proceedings, Affective Encounters. Rethinking Embodiment in Fem-
 inist Media Studies*, edited by Anu Koivunen and Susanna Paasonen, 10–24.
 Turku: University of Turku, Media Studies. https://susannapaasonen.files.
 wordpress.com/2014/11/proceedings.pdf.
Barndt, Deborah. 2006. *Wild Fire: Art as Activism.* Toronto: Sumach Press.
Bauman, H-Dirksen L. 2004. "Audism: Exploring the Metaphysics of Oppression."
 Journal of Deaf Studies and Deaf Education 9 (2): 239–46. http://dx.doi.org/
 10.1093/deafed/enh025.
Bauman, H-Dirksen L., and Joseph M. Murray. 2009. "Reframing: From Hearing
 Loss to Deaf Gain." Translated from ASL by Fallon Brizendine and Emily
 Schenker. *Deaf Studies Digital Journal* 1. ASL version: http://dsdj.gallaudet.edu/
 index.php?issue=1§ion_id=2&entry_id=19. English version: http://dsdj.
 gallaudet.edu/assets/section/section2/entry19/DSDJ_entry19.pdf.

–., eds. 2014. *Deaf Gain: Raising the Stakes for Human Diversity.* Minneapolis: University of Minnesota Press.

Baynton, Douglas C. 1996. *Forbidden Signs: American Culture and the Campaign against Sign Language.* Chicago: University of Chicago Press.

–. 2008. "Beyond Culture: Deaf Studies and the Deaf Body." In *Open Your Eyes: Deaf Studies Talking,* edited by H-Dirksen L. Bauman, 293–313. Minneapolis: University of Minnesota Press.

Bechter, Franck. 2008. "The Deaf Convert Culture and Its Lessons for Deaf Theory." In *Open Your Eyes: Deaf Studies Talking,* edited by H-Dirksen L. Bauman, 60–79. Minneapolis: University of Minnesota Press.

Bell, Alexander Graham. 1884. *Memoir upon the Formation of a Deaf Variety of the Human Race.* http://babel.hathitrust.org/cgi/pt?id=mdp.39015031059887;view =1up;seq=1.

Bochner, Arthur P., and Carolyn Ellis. 2003. "An Introduction to the Arts and Narrative Research: Art as Inquiry." *Qualitative Inquiry* 9 (4): 506–14. http:// dx.doi.org/10.1177/1077800403254394.

Boukala, Mouloud. 2010. "Autoreprésentation et hétérostigmatisation en bandes dessinées." *Ethnologies, Folklore Studies Association of Canada* 31 (2): 219–39.

Brueggemann, Brenda Jo. 1999. *Lend Me Your Ear: Rhetorical Constructions of Deafness.* Washington, DC: Gallaudet University Press.

–. 2008. "Think-Between: A Deaf Studies Commonplace Book." In *Open Your Eyes: Deaf Studies Talking,* edited by H-Dirksen L. Bauman, 177–88. Minneapolis: University of Minnesota Press.

–. 2009. *Deaf Subjects: Between Identities and Places.* New York: NYU Press.

Burch, Susan, and Alison Kafer. 2010. *Deaf and Disability Studies.* Washington, DC: Gallaudet University Press.

Chagnon, Johanne, Devora Neumark, and Louise Lachapelle. 2011. *Célébrer la collaboration. Art communautaire et art activiste humaniste au Québec et ailleurs.* Montreal and Calgary: Engrenage Noir/LEVIER, Lux Éditeur and Detselig Enterprises.

Chapman, Owen, and Kim Sawchuk. 2012. "Research-Creation: Intervention, Analysis and 'Family Resemblances.'" *Canadian Journal of Communication* 37 (1): 5–26.

Couldry, Nick. 2010. *Why Voice Matters: Culture and Politics after Neoliberalism.* Los Angeles: Sage.

Davis, Lennard J. 1995. *Enforcing Normalcy: Disability, Deafness, and the Body.* London and New York: Verso.

–. 2008. "Postdeafness." In *Open Your Eyes: Deaf Studies Talking,* edited by H-Dirksen L. Bauman, 315–25. Minneapolis: University of Minnesota Press.

De Lauretis, Teresa. 1984. *Alice Doesn't: Feminism, Semiotics, Cinema.* Bloomington: Indiana University Press.

Deleuze, Gilles, and Félix Guattari. 1980. *Mille Plateaux: Capitalisme et schizophrénie 2.* Paris: Minuit.

Delporte, Julie. 2011. *La bande dessinée autobiographique à l'heure des technologies numériques.* Montreal: Colosse.

Ellis, Carolyn, Tony E. Adams, and Arthur P. Bochner. 2011. "Autoethnography: An Overview." *Forum Qualitative Sozial Forschung* 12 (1). http://www.qualitative -research.net/index.php/fqs/article/view/1589.

Falardeau, Mira. 2008. *Histoire de la bande dessinée au Québec*. Montreal: VLB.

Feinberg, Pohanna Pyne, and Heather Davis. 2009. "Community Art?" *Inspire Art*. http://inspireart.org/fr/resources/communityart/.

Foucault, Michel. (1977) 2001. "Cours du 7 janvier 1976." In *Dits et Écrits*, edited by Daniel Defert and François Ewald, with Jacques Lagrange, 160–74. Paris: Quarto Gallimard.

–. 1980. *Power/Knowledge: Selected Interviews and Other Writings*. New York: Pantheon.

Garland-Thomson, Rosemarie. 2011. "Integrating Disability, Transforming Feminist Theory." In *Feminist Disability Studies*, edited by Kim Q. Hall, 14–47. Bloomington: Indiana University Press.

Gaucher, Charles. 2010. "Les fondements de l'identité sourde." In *Les Sourds: Aux origines d'une identité plurielle*, edited by Charles Gaucher and Stéphane Vibert, 45–66. Brussels: P.I.E. Peter Lang.

Gertz, Genie. 2006. "A Journey to Deafhood." VLOG. http://www.joeybaer.com/journey/index.htm.

–. 2008. "Dysconscious Audism: A Theoretical Proposition." In *Open Your Eyes: Deaf Studies Talking*, edited by H-Dirksen L. Bauman, 219–34. Minneapolis: University of Minnesota Press.

Gosselin, Pierre, and Éric Le Coguiec, eds. 2006. *La recherche création: Pour une compréhension de la recherche en pratique artistique*. Montreal: Presses de l'Université du Québec.

Halperin, David. 1999. *Saint = Foucault, Towards a Gay Hagiography*. New York: Oxford University Press.

Haraway, Donna. 1988. "Situated Knowledges: The Science Question in Feminism and the Privilege of Partial Perspective." *Feminist Studies* 14 (3): 575–99.

Jankowski, Katherine. 1997. *Deaf Empowerment: Emergence, Struggle and Rhetoric*. Washington, DC: Gallaudet University Press.

Jeppesen, Sandra. 2010. "Queer Anarchist Autonomous Zones and Publics: Direct Action Vomiting against Homonormative Consumerism." *Sexualities* 13 (4): 463–78. http://dx.doi.org/10.1177/1363460710370652.

Kymlicka, Will. 1998. *Finding Our Way: Rethinking Ethnocultural Relations in Canada*. Don Mills, ON: Oxford University Press.

Lachance, Nathalie. 2007. *Territoire, transmission et culture sourde. Perspectives historiques et réalités contemporaines*. Quebec City: Presses de l'Université Laval.

Ladd, Paddy. 2003. *Understanding Deaf Culture: In Search of Deafhood*. Clevedon, UK: Multilingual Matters.

Lamoureux, Ève. 2009. *Art et politique. Nouvelles formes d'engagement artistique au Québec*. Montreal: Écosociété.

Lane, Harlan. 2008. "Do Deaf People Have a Disability?" In *Open Your Eyes: Deaf Studies Talking*, edited by H-Dirksen L. Bauman, 277–92. Minneapolis: University of Minnesota Press.

–. 2010. "Construction of Deafness." In *The Disability Studies Reader*, 3rd ed., edited by Lennard J. Davis, 79–91. New York: Routledge.

Leduc, Véro. 2012. "C'est tombé dans l'oreille d'une Sourde." http://media.wix.com/ugd/1e875f_1afdecebad86438980291bd97b001d9f.pdf.

Lemoine, Stéphanie, and Samira Ouardi. 2010. *Artivisme: Art, action politique et résistance culturelle.* Paris: Alternatives.

Luczak, Raymond. 2007. *Eyes of Desire 2: A Deaf GLBT Reader.* Minneapolis: Handtype Press.

Massumi, Brian. 2002. *Parables for the Virtual: Movement, Affect, Sensation.* Durham: Duke University Press. http://dx.doi.org/10.1215/9780822383574.

Menu, Jean-Christophe. 2011. *La bande dessinée et son double.* Paris: L'Association.

Mouffe, Chantal. 2007. "Artistic Activism and Agonistic Spaces." *Art & Research: A Journal of Ideas, Contexts and Methods* 1 (2). www.artandresearch.org.uk/v1n2/mouffe.html.

NADvlogs. 2010. "The Preservation of Sign Language by George W. Veditz." YouTube video. https://www.youtube.com/watch?v=XITbj3NTLUQ.

Napier, Jemina. 2002. "The D/deaf-H/hearing Debate." *Sign Language Studies* 2 (2): 141–49. http://dx.doi.org/10.1353/sls.2002.0006.

Padden, Carol. 2010. "Sign Language Geography." In *Deaf around the World: The Impact of Language*, edited by Mathur Gaurav and Donna Jo Napoli, 19–37. Oxford: Oxford University Press. http://dx.doi.org/10.1093/acprof:oso/9780199732548.003.0001.

Padden, Carol, and Tom Humphries. 1988. *Deaf in America: Voices from a Culture.* Cambridge, MA: Harvard University Press.

Probyn, Elizabeth. 1996. *Outside Belongings.* New York: Routledge.

Rochielle, Jules. 2008. "Spaces and Places. Mapping Story in Community Engagement." In *Access All Areas: Conversations on Engaged Arts*, edited by Tania Willard, 102–6. Vancouver: Visible Arts Society.

Schilt, Kristen. 2003. "'A Little Too Ironic': The Appropriation and Packaging of Riot Grrrl Politics by Mainstream Female Musicians." *Popular Music and Society* 26 (1): 5–16. http://dx.doi.org/10.1080/0300776032000076351.

Spivak, Gayatri Chakravorty. 1988. "Can the Subaltern Speak?" In *Marxism and the Interpretation of Culture*, edited by C. Nelson and L. Grossberg, 271–313. Chicago: University of Illinois Press.

Willard, Tania, ed. 2008. *Access All Areas: Conversations on Engaged Arts.* Vancouver: Visible Arts Society.

Witcher, Pamela, Geneviève Deguire, Julie Chateauvert, and Dominique Lemay. 2014. "La communauté sourde québécoise. Une minorité linguistique en lutte!" [French and LSQ]. *À Bâbord!* 53. https://www.ababord.org/spip.php?article1754=.

Young, Iris Marion. 1990. *Justice and the Politics of Difference.* Princeton: Princeton Paperbacks.

ARTISTIC PATHS TO DISABILITY ACTIVISM

(Dis)quiet in the Peanut Gallery
Performing Social Justice through Integrated Dance

LINDSAY EALES

In the majority of dance communities, there is little or no space for people who experience disability (Benjamin 2002).[1] In response to this exclusion, alternative disability dance spaces, or "integrated dance communities," have emerged over the last few decades. Integrated dance is a physical art form in which people of a wide range of embodiments explore, create, rehearse, and perform dance together (Benjamin 2002). Integrated dance has the potential to promote social justice by creating opportunities for, and shifting attitudes toward, people who experience disability (Herman and Chatfield 2010; Irving and Giles 2011; Smith 2005; Whatley 2007). This chapter engages theoretically with the final integrated dance performance of my arts-based thesis: a performance ethnography exploring how members of Edmonton's CRIPSiE integrated dance community, including me, perform social justice through art creation. This research emerged out of ongoing conversations and questions within our community about dancers' experiences of social injustice relating to disability and other forms of marginalization. It also emerged out of our explicit desires to create more socially just spaces and more politically explicit performances.

The performance that resulted from this research project is entitled *(Dis)quiet in the Peanut Gallery* (video available at http://www.cripsie.ca/disquiet.html). In this chapter, I use focus group transcripts, movement descriptions, and critical disability theory to explicate and analyze this co-created performance on social justice and integrated dance. Each section

of this chapter begins with a block quotation taken from a collaboratively composed speech that plays during the performance. I follow each quotation by detailing the movement of the subsequent vignette that was collectively choreographed to act against the content of the speech. I then provide an analysis of each vignette that is informed by focus group discussions, choreographic choices, and critical theory.

Performance ethnography is a qualitative arts-based research methodology that uses creative, embodied enactments – such as dance – to generate and share knowledge (Denzin 2003; Hamera 2011). This methodology accounts for how not all knowledge can (or should) be put into words, and it is employed with the intention of creating both emotional and intellectual responses to research. In this way, performance ethnography is reflective of how integrated dancers already generate and express their knowledges through their artistic practices. Judith Hamera (2011, 322) suggests that "there are no prescriptions for operationalizing performance ethnography. The complexities of each site, each location in place and history demands its own unique negotiations." This research project, therefore, is informed largely by the existing practices of the eleven dancer-collaborators involved from the CRIPSiE integrated dance community (formerly iDANCE).

Our research project included eleven two-hour rehearsals and five one-hour focus groups. Rehearsals and focus groups consisted of a non-linear, cyclical, and dialogical process of discussion, collaborative selection of themes to explore through movement, dance improvisation, setting choreographed movement, and rehearsal (for more details, see Eales 2013). The project culminated in two live performances in Edmonton, Alberta. Upon completion of the performances, the dancers were provided the opportunity to member-check my written master's thesis and edit content. All but two dancers chose to use their real names in the dissemination of the research results; the other two are represented by pseudonyms.

As a co-founder and committed dancer of CRIPSiE, as well as a researcher and person diagnosed with bipolar disorder, I was also an active participant in the construction and performance of this performance ethnography (Denzin 2003; Hamera 2011). There are benefits and limitations to the multi-layered position that I held within this inquiry (see Mayan 2009). One potential limitation was that dancers could be reluctant to share with the group for fear of potential implications to their ongoing dance participation (even though they were assured it would not limit their capacity to dance with CRIPSiE). Alternatively, having already established rapport and an understanding of the integrated dance culture, I was in a unique position

to report on the experience with depth and complexity. Undoubtedly, my perception of disability, as informed by my personal experiences and my academic research, has altered the ways that the group discusses and represents disability in practice and performances. To remain reflexive about my involvement, ongoing reflection and dialogue with the dancers were central to my engagement as a collaborator.

In the written text below, I weave together choreographic descriptions, dancers' insights from focus groups, and critical theories (many of which were discussed by the group throughout the research process). I do so to demonstrate how this performance ethnography (re)presents collaboratively developed expressions of the various social injustices that the dancers face. I also suggest that this performance ethnography offers collectively imagined possibilities of more socially just engagements.

Please Stand?

> *Hello ladies and gentlemen. Please stand and*
> *welcome the esteemed ... [record scratch].*

Twelve empty chairs fill the far right corner of the stage: an area the dancers call the "polite audience." Music begins and the dancers (with the exception of me) slowly move from the theatre's audience into the polite audience onstage. Iris, using her power chair, pulls up near the back of the inaccessible seating arrangement. Alison wheels up to the front row. Ian greets her and, in an initial act of rebellion, moves a chair so that she can position herself in the middle of the row. Once seated, dancers face upstage left and await a speaker. A sickly sweet voice calls the dancers to attention. The speaker demands that the dancers "please stand and welcome ..." Most follow these instructions until they notice that Iris and Alison remain seated in their wheelchairs. The rest of the dancers awkwardly sit down. Everyone waits politely – straining, as Kaylee puts it, to "put on a happy face" – wringing their hands, suppressing grimaces, committing ever-greater efforts to present a publicly acceptable image.

The Veiling of Subtle, and Not-So-Subtle, Violences
When a room full of wheelchair users is asked to "stand and welcome" an "esteemed" speaker, which bodies and ways of being are ignored, devalued, and effaced? Should those of us who are not using wheelchairs stand, as is socially expected? Or should we remain seated in solidarity with those who

do not stand? Throughout our early focus groups and rehearsals, we wrestled with the idea of performing "socially appropriate" behaviour in spaces where many of us felt erased.

In the first focus group of this research process, we discussed a recent performance experience at a twenty-fifth anniversary celebration of Rick Hansen's Man in Motion worldwide wheelchair tour. At this event, we huddled together waiting to perform, squished in the back corner of a crowded gym, with our dancers who use wheelchairs pressed against the inaccessible bleachers that seated the majority of the audience. As a marching band paraded past, signalling the arrival of Rick Hansen, one of our dancers was trapped on the outside end of the bleachers. She shrieked in panic, surmising, "I bet you anything, because I am sitting here and I'm in a wheelchair, and sure enough he turns around and I'm like 'oh!'" She shared in a focus group that she felt she was being exploited for a photo opportunity when Rick Hansen took her hand and offered a syrupy and slightly patronizing "Thank you for coming out." We sat through numerous speeches by politicians and organizers until the master of ceremonies announced to the audience that our group was there "to waste time" by performing until Rick Hansen returned from media interviews. This dancer commented:

> I'm so used to being used ... you're "oh cute and you're here for us because you're disabled," and I'm so used to it, but when they said "to waste your time" I was just thinking how much work went into it, and we all had stopped our lives entirely to be there ... and we get there and they made us move off to the side because we were in the way, in a place where the disabled are supposed to be okay. And I don't know that I've ever felt so uncomfortable ... this was very in your face. And it's ...

"Condescending," Iris said, finishing her fellow dancer's sentence. These dancers' frustration at being discarded as a waste of time and an obstruction left many of us questioning for whom this event was intended. A.J. Withers (2012, 79) suggests that the charity model "constructs an idea of disability that is designed to benefit those wanting to feel better about themselves." Sharon Snyder and David Mitchell (2006, 59) similarly argue, "Debasement [is] an in-built feature of the charitable relationship in which the recipient degrades himself and the benefactor grows increasingly exalted." At an event that was promoted as an invitation to inspire social change surrounding disability, many of us felt debased instead, while an entourage made up largely

of normatively ambulating and speaking white male speakers, organizers, and politicians were exalted.

This debasement extends beyond charity events into our daily lives. Many of our dancers consistently navigate difficult, and sometimes violating, situations in which we feel coerced to behave in a polite, grateful manner. Within a focus group, Roxanne explained how, during a significant health crisis, she was forced to put on a hospital gown:

> I'm like, "Well, no, I don't, I've worn the right clothing"; they can see everything ... [she giggles]. You know, uh uh, no way. [The nurse says,] "The doctor will not see you, he makes people with sinus infections change into a gown." And so right then I just break right down.

The requirement of changing into a hospital gown is a process that can threaten dignity for most people (Baillie 2009) and can be physically challenging, energy consuming, and often painful for Roxanne. An authoritarian doctor's demand, which did not consider her body or her needs, was a debasement that she was forced to endure if she wished to access healthcare in an emergency. Baillie (2009) argues that authoritarian staff in acute care settings can be a significant threat to patient dignity. Roxanne used to get livid in these situations and storm out; now she just cries, feeling "sadness that people have to do this to each other." This experience echoes Sullivan's (2005, 42) exploration of how patients learn that, within medical and rehabilitative settings, "to survive, [they] must continually be aware of keeping their bodies docile." As a result of a lifetime of experience with medical professionals, Roxanne knows what she needs to do to survive: she needs to choose crying and putting on the gown over expressing anger at the violation of her dignity.

At the same time, Sullivan (2005) argues that individuals often find ways to resist violating medical situations where they are offered very little control. By sharing personal stories in the integrated dance context, both Roxanne and a number of other dancers came to recognize that our healthcare (and other) experiences were not individual misfortune, but shared social injustice. In a focus group, Ian suggested one way that our dance performance engages social justice is by honouring and politicizing each other's experiences of healthcare-based injustice (see Brown and Zavestoski 2004; McGibbon 2012) and creating space to share those stories through movement. The politicization of these experiences motivates the onstage journey

from the audience we sometimes are (polite and docile) to the audience we would like to be (loud, riotous, actively supportive, challenging, and dissenting). Arguably, targeting health-based social injustice through integrated dance is a health social movement practice because it "employ[s] creative media tactics to highlight the need for structural social change" (Brown and Zavestoski 2004, 691).

Building Accessible Infrastructure?

> *One of the greatest catastrophes experienced by a human being ...*
> *But even after tragic loss ...*
> *and the courage to overcome ...*
> *We've come so far in building accessible infrastructure ...*
> *[record scratch].*

A bright yellow helium balloon with a smiley face floats eerily behind the podium as a speech is broadcast overhead. The dancers react to this speech with subtle but increasing surprise and disillusionment. A record scratch breaks up the polite audience for the first time. Red light washes over the stage. Kaylee, Kelsie, and Anna, who might be read as non-disabled, slink off of their chairs and into the middle of the stage. Their bodies stack next to each other to form a set of stairs. Alison sits at the bottom of these stairs and stretches from her wheelchair toward the top, but she cannot traverse them.

Iris wheels around the back of the stage to approach the stairs from another angle. She then drives directly into the bodies that make up the stairs, and they collapse, rolling along with her momentum. Alison joins Iris, and they pull Kaylee, Kelsie, and Anna out of their way. Iris and Alison interlock their bodies and chairs and spin around each other in the newly accessible space. They refuse to rejoin the polite audience, wheeling along the back of the stage instead. From this position, they build the beginnings of the (dis)quieted audience.

(In)Accessibility

The stairs that Iris and Alison collapsed in this vignette, taken most literally, were a representation of the physical inaccessibility some of our dancers experience. The dancers also understood these stairs as a symbol of social and political inaccessibility. We constructed this second vignette with the assumption that the audience would perceive our performers as disabled

based on visible bodily differences, informed by the dominance of medical models of disability. Critical disability scholars use the term "medical models" to refer to the way that medical professionals and others frame certain kinds of bodily difference as pathological and in need of remediation by medical experts (Linton 1998; Withers 2012). During our rehearsal process, medical models of disability were certainly one of the many ways in which dancers understood disability, our bodies, and our relationships to society (e.g., dancers sometimes identified with our diagnoses, pathologized some of our non-normative bodily functions, and articulated our needs for medical care). At the same time, many dancers expressed a desire to complicate and challenge the dominance of the medical model throughout our performance. In consciously negotiating the choice to have dancers using wheelchairs as the focus of the second vignette, we discussed the concern that we might perpetuate medical notions of disability. We decided, however, to forefront Roxanne's, Iris's, and Alison's experiences of physical inaccessibility as both a lived reality that can be visually represented and a symbol of the widespread and complex issues of other forms of (in)accessibility.

For many dancers in our group, the most basic supports and opportunities remain physically, socially, and/or economically inaccessible. Critical disability scholars over the last forty years have developed theories that engage with the phenomena of disability in a more nuanced way than medical models tended to do (Peers, Spencer-Cavaliere, and Eales 2014; Withers 2012), accounting for embodied, social, cultural, and political aspects of disability. One of the earliest politicized approaches to disability is the UK-based social model (Oliver 1996; Shakespeare 2006; Union of the Physically Impaired Against Segregation 1976), which articulates the problem of disability not as a medical problem of individual bodies, but as a problem of social injustice – the result of social structures that marginalize and thus actively disable people. Social justice action therefore includes changes to architecture, policy, and attitudes. A number of our dancers understand our experiences of disability as not only medical but also significantly affected by disabling social structures. The stairs in this vignette are reflective of these more socially informed disability understandings.

Accessibility is a vital issue that structures the social, health, and political possibilities for many Canadians in their daily lives (Prince 2009; Titchkosky 2008). As I will discuss throughout this section, the group's understanding of accessibility started by focusing on the removal of physical barriers for wheelchair users and then expanded to recognize and mitigate other significant barriers to full participation, including financial inaccessibility,

assumptions about intellectual and physical capacity, legal guardianship, and normalizing time constraints. Roxanne began the discussion of accessibility by describing her attempt to develop a community coffee shop that employed people experiencing disability:

> I made the deal, there was no ramp ... [the] second day I was there, there was a ramp ... but, that's as far as it went. And the owner of the building ... is saying, "So, are your people coming?" And I'm like, "There's no washroom!" ... And the owner is like "Really? Really? They'd be that picky?" We're talking about basic access! ... What they don't understand is you need accessibility first. Before anything else ... But they think that somehow we're supposed to get around that, and eventually when we prove our worth, they'll put it in. Well, we need it in order to prove our worth!

Roxanne's story describes the expectations and attitudes that underlie and perpetuate widespread physical inaccessibility. Other dancers quickly added their own experiences of other forms of inaccessibility, most notably the rampant and multi-faceted inaccessibility of post-secondary education (Titchkosky 2011). Kasia, Ian, Roxanne, Alison, and I have all experienced varying degrees of educational inaccessibility. Kasia could not access education because of prohibitively high costs for international students. Even applying for university programs requires Ian to negotiate the consent of his legal guardians. Alison had to fight for extra time to write her exams. I had to appeal a denial by my program for the accommodation of part-time professional placements. Accessibility, in post-secondary institutions and beyond, requires far more than the installation of ramps (Titchkosky 2011; Withers 2012).

People who experience disability often have to deal with non-disabled people's expectations that we should simply overcome barriers (even to the extreme of overcoming the need to use a washroom) in order to include ourselves (Clare 1999; Titchkosky 2008). These expectations perpetuate the inaccessible structures that drastically decrease the opportunities for some people to engage in their communities. These attitudes are further elucidated by a later exchange recounted by Roxanne: "Basically [he] told me that the ramp he built ... was a favour he did for me!" The idea that accessibility is a favour continues to place the responsibility of access upon individuals experiencing disability, disavowing non-disabled people from responsibility to make structural change (Linton 2006). It was important,

therefore, in this vignette, that seemingly non-disabled dancers formed the inaccessible stairs with their bodies. This choice reflects the understanding that people actively (though sometimes unknowingly) participate in creating and perpetuating inaccessibility.

Within our performance, rather than simply building a ramp, the dancers chose to obliterate the stairs that were composed by their bodies: a symbol of radical access for the dancers that includes, but moves beyond, physical accessibility. Withers (2012, 118) writes,

> Radical access means acknowledging systemic barriers that exclude people, particularly certain kinds of people with certain kinds of minds and/or bodies, and working to ensure not only the presence of those who have been left out, but also their comfort, participation, and leadership. Spaces that need to incorporate radical access principles are organizational, they are educational and institutional, but they are also the spaces closest to us: our cafes, our offices, our homes, and our hearts.

Dance is one way that radical access can be negotiated and reimagined. As Iris stated, "I wish I could throw all those stairs out ... if it has to be through dance, then so be it!" While not actually being able to remove all stairs from her world, dance can potentially affect larger social attitudes about inaccessibility and thus contribute to radical access. Through dance, Iris gains a stage from which to challenge disabling spaces, attitudes, and experiences.

Many of our dancers suggested we do social justice work through dance by recognizing and attempting to shift inaccessible structures, in both rehearsals and everyday life; by impacting disabling attitudes through performance; and by collectively imagining (and shaping) our world otherwise. As a dance collective, we work to create radical access in "the spaces closest to us": our rehearsal spaces, our performances, our community, and our hearts (Withers 2012, 118).

You Could Live a Normal Life Too?

For all persons with disabilities ...
you have to find strength in adversity ...
with our healthy and active programming ...
you could live a normal life too ... [record scratch].

Three dancers shake violently in reaction to the last sentence of this speech and move out to centre stage. Anna, slender and graceful, walks on her toes, hips swaying. She moves toward Kelsie and Kaylee and, abruptly manipulating their limbs and torsos, moulds them into sexualized poses. She finishes by forcing Ian to flex his arms to show off his muscles. Anna then strikes a pose on the opposite side of the stage with her hand on her hip and her breasts and buttocks sticking out.

Kelsie and Kaylee stumble on tiptoe and one of Ian's arms spasms, un-raveling his hypermasculinized body positioning. Kelsie, Kaylee, and Ian fall into each other and, shaking against each other's bodies, move into inter-dependent weight-sharing lifts and poses. As she had done to the others, Anna begins moulding herself under the audience's gaze. Kaylee reaches out to Anna and invites her away from her self-manipulation. The four dancers then swing and roll around each other to sit along the back of the stage. A (dis)quieted counter-audience, extending away from the polite audience, begins to grow in numbers.

Disability, Able-bodiedness, and Bodies of Difference

This vignette stems from discussions on rehabilitation and gender and body-shape expectations. We desired to interrogate and destabilize dominant masculinities and dominant femininities and to challenge able-bodiedness and gender as stable, apolitical, natural embodiments (McRuer 2006). We explored normalization as an oppressive force that all of our dancers are subjected to in varying degrees (Davis 2002; Withers 2012).

Having been "rehabilitated" as a child, Ian shared his experience of being trained to walk normatively, something he regards as a pointless venture. He shared how being (in)voluntarily encouraged to approximate able-bodiedness shaped his understanding of (and disdain for) normaliza-tion. This sentiment resonated with various dancers within the group. Kelsie and Kaylee, for example, discussed their experiences of normalizing expect-ations around body size and body image in dance and beyond:

KELSIE: I guess I notice in the body, coming back to [CRIPSiE] ... that I've spent my entire dance career being the biggest woman in the room.
ROXANNE: Really?!!? ...
KAYLEE: And you know, I do, I have this thing in my head when I go places, I'll be like, "Am I the biggest one here?
ROXANNE: Huh! Really??! Oh! My god. I wouldn't have thought that of either of you.

KAYLEE: ... Everywhere I go it's like, "Am I the biggest? Oh! I am." And
then other times it's like "Oh! No, I'm not!" and I was like, why
do I do this?
KELSIE: Yeah.

Kaylee's comment reflects how some women are marked by their experiences of weight-related bullying in (and beyond) physical activity settings (Rice 2010), yet she challenged herself with regards to why she polices her own body size. Kelsie echoed Kaylee's sentiment when she shared:

I was thinking about coming here and suddenly I'm another dancing body, and I don't feel that apartness of ... [being told that] because I have D-cups that my body is inherently sexual. And everything I do I read sexual, no matter what I do about it. Sorry, and that was actually kind of deeply upsetting to me, obviously.

Kelsie repeatedly articulated during focus groups that the emotional weight of weighing more is lighter in our dance community and the shame of hypersexualization is less searing. Roxanne was dismayed by Kelsie and Kaylee's experiences. Their bodies seem to fit a beauty ideal against which bodies like hers are often measured. It was disheartening to her that these bodies, and these women, would be subject to such intense normalization and policing by both themselves and others. This sharing by Kelsie and Kaylee seemed to reframe discussions about normalization, extending our destabilization of bodies beyond those that are read as disabled. Informed by these discussions, the dancers poke fun at gender performance, dancing exaggerated stereotypes of femininity and masculinity imperfectly and with mocking. Ann Cooper Albright (1997) suggests that dance can reinforce gender norms when normatively read bodies perform gender normatively. She argues, however, that "there can be a disjunction between the dancer's physicality and what that movement represents" (33). In other words, Ian's "disabled" body or Kaylee and Kelsie's "non-typical" female-dancer bodies performing normative gendered movement can create a disjunction that points to gender norms and opens space for critique. At the same time, it was important for Anna's rather gender-typical body to be included in this vignette because it points to a crucial understanding of gender norms; the intention was not to say that specific bodies do not fit the norm, but that all bodies are subject to normalizing forces.

These dancers complicate gender and body size expectations and push against normalizing forces by expanding from hypergendered, individualistic movement and shifting into more collective, yet arguably somewhat hyperathletic, movement. Kelsie flips herself upside down on a kneeling Kaylee; Ian braces her landing; Kelsie carries Ian; Kaylee swings Anna to the ground, where Anna takes Kaylee's weight and springs her into the air. Cooper Albright (1997, 54) argues that while favouring muscular hyperathleticism in contemporary dance may provide an important alternative physicality to hypergendered femininity, it may also serve to "embody cultural anxiety about the inevitable fragility of human bodies." This anxiety of which Cooper Albright speaks is reminiscent of the anxiety about disability and disabled bodies in general and has been articulated as a root cause for ableism (Shildrick 2005). What is interesting about Cooper Albright's (1997) critique, then, is how gendered expectations and ableist expectations mutually inform each other (McRuer 2006). Further, it points to the difficulties of challenging gendered movements and embodiments without reinforcing ableist ideals (and, perhaps, vice versa; see Clare 1999).

The complexity of the bodies on the stage during this vignette – bodies read as disabled, non-disabled, woman, man, fat, and thin – may offer unique opportunities for simultaneous critique of gendered, sized, and (dis)ableist confines of movement and embodiment. The group negotiates this complexity, and grapples with the sometimes contradictory critiques, in part by creating collaborative rather than individual responses to them – by highlighting collective action and interdependence. The dancers also actively challenge the understanding of social justice as a practice enacted by one group of privileged "helpers" upon another less fortunate group. Instead, the group strives to enact an always-ongoing (and imperfect) practice of mutual sharing and support among diverse people who experience some similar struggles and some widely different ones. Through reaching out to each other across difference, we collectively demonstrate strength and consideration in our interconnected interactions: not without gendered movement or the occasional revelling in displays of hyperathleticism, but with a mind to challenging gender norms, assumed abilities, and normativity.

This Land of Opportunity?

Our welcoming and multicultural nation ...
and in this land of opportunity ...
follow your passions, and you will succeed ... [record scratch].

As the words "follow your passions, and you will succeed" boom over-head, Kasia unleashes her bottled frustration and kicks the chair out from in front of her. A cutting red beam from a laser pointer then trains on Kasia's guts. She notices and clutches her belly nervously and does her best to blend in. A figure, Lindsay, moves with eerie vacancy from the theatre audience and begins to walk toward her with the laser pointer. Lindsay stalks Kasia with disinterest: a banal task for Lindsay; a matter of life and death for Kasia. Laurel and Alex frantically move to shield Kasia from the beam. Kasia breaks from the polite audience and runs desperately in circles, the whole time being seared by the laser. She finds the (dis)quieted audience spread across the back of the stage and weaves between and behind them to avoid the beam. As she is shielded, hidden, and collectively supported, each person on stage becomes a target in her wake. Everyone is implicated.

Lindsay stands centre stage vacantly following Kasia with the laser pointer. Alex approaches her from behind, takes her hand, and turns it to direct the beam upon her own chest. She falls back into a chair that Laurel slides in behind her. Ian approaches and stands behind Lindsay, shaking the laser pointer from her hand. In much the same way that Anna moulded him, Ian puppeteers Lindsay to sit up straight and polite and to "put on a happy face." Kasia reaches up, unfolding with the support of the disquieted audience.

Immigration, Citizenship, and Other Forms of Structural Oppression
In an audience question period after our first performance, Kasia reflected with some of the other dancers on the motivation for the fourth vignette:

> KASIA: I would say that the laser definitely represents insecurity that I carry around with me every single day. 'Cause I don't know what's going to happen to me, like, I have my life here and my passion and dreams, but it seems like it's not enough ... Especially how I feel like I don't have any rights, ... 'cause I don't have my papers, so I can't speak up for myself ... And it's been a challenge. Like, for example, living without Alberta healthcare for a year, with my family, or just the fear of being deported at all times ... So when everything is going good, it's amazing, and you have money, you have this, but what if you get sick or something is going to go wrong? Who's gonna care for you? [silence]
> LINDSAY: Yeah [Kasia and Lindsay hug].
> LAUREL: I'll protect you [she puts the scarf out in front of Kasia like she does in the dance].

Kasia spoke with heart-wrenching honesty about the threat she experiences as a result of her tenuous immigration status as well as the lack of control over her life and her lack of access to basic services.

Dancing alongside Kasia as she navigates the immigration system has pushed many of us to question what we have been taught about our nation. We are taught we are a welcoming multicultural land, rich with diversity and opportunity (Thobani 2007). But for whom? Our dancers mostly identify as white, lower- and middle-class Canadians. Learning more about the daily impacts of racism, ethnocentrism, and immigration from Kasia has challenged us to consider our nation and our own privilege more critically. Although it is vital that we combat ableism and disableism, Withers (2012, 107) argues that "one cannot choose to fight only disabl[e]ism ... poverty, sexism, heterosexism/homophobia, transphobia, racism and ageism must be fought in tandem." Informed by Kasia, the dancers echoed Withers's (2012) sentiment that while we may actively engage in social justice practices around disability, it is also crucial to challenge other forms of oppression. Kasia's experiences push me to reflect on who is not represented within our group; what attitudes and structures, within our group and in society at large, systemically exclude dancers from racialized, colonized, and queer communities? I feel implicated in the oppression of others; I feel the laser pointer in my hand. Sparked by this moment of insight, our community began actively seeking out anti-oppressive training and more consciously connecting with communities engaging with racialization, colonization, and queerness.

The structural inequality Kasia encounters, right here at home, deeply affects the collective understanding we have about the intersectionalities of social (in)justice. For example, without healthcare, Kasia experiences a different, but just as significant, threat to her health as our Canadian dancers with significant illness do. She runs around frantically, on stage as in life, trying to meet the demands of an immigration system that threatens to endanger her way of life. The frantic full-time job of protecting and assuring one's very (way of) life is a common, culturally produced experience among immigrants and other oppressed communities (Cruikshank 1999; Thobani 2007). According to Dean Spade (2011, 26), our culture's "shifting understandings of gender, ability, and migration – and the meanings attached to different populations through those shifts – determine who lives, for how long, and under what conditions." In other words, being recognized and administratively categorized by one's supposed disability, citizenship, race, or gender can have real and dangerous consequences (Cruikshank 1999).

Many of our dancers are denied basic access to education, healthcare, and meaningful citizenship (see Prince 2009) for a plethora of intersecting administrative reasons. The dancers echoed Spade's (2011) assertion that the very systems that are purportedly structured to support groups categorized as vulnerable often reproduce the unequal distribution of poverty, violence, and early death (see also Peers 2009, 2015).

Within our group, there are a wide variety of understandings of what social justice is and how it can be achieved. These varied approaches to social justice are demonstrated by how each dancer moves to protect Kasia in similar yet unique ways. Social justice action, as understood by this group, can include strategies of increasing awareness and knowledge, action on a local level, universal design alongside access to accommodation, and self-reflection about how one oppresses at the same time as being oppressed. A pivotal philosophy that permeates the group is the importance of acting with, not for, those most affected by social injustices. A diversity of socially just engagements broadens the range of ways that we can support each other through injustice and the ways we can activate for change. We cannot do everything, but we can do something.

The Care We Need

> *The Care We Need*
> *Our most vulnerable populations ...*
> *ensure your loved ones receive the care they need ...*
> *donate today ... [record scratch].*

The (dis)quieted audience is scattered across the back of the stage, bubbling with dissent and staring back into the observing audience. Lindsay remains nervously seated, directly facing the lecturing happy-face balloon. The rest of the dancers clutch their stomachs and heads in exasperation as the balloon squawks out promises of charitable salvation. Their hands come to fists in front of their mouths. They bite hard on their fists in defiance, biting the proverbial (charitable) hand that purports to feed them, biting the metaphoric gag of prescribed indebtedness that silences them. The dancers creep forward into the space on hands and wheels and hips and elbows. They grasp and swing chairs violently, deconstructing the inaccessible orderly rows, dismantling the onstage audience. Gradually, out of purposeful chaos, chairs are laid against and upon Lindsay in the centre of the stage, creating a cage of metal that encloses her. As she reaches up out of the cage,

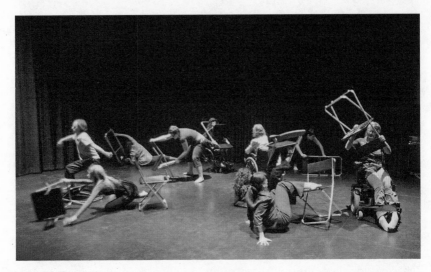

CRIPSiE, still from *(Dis)quiet in the Peanut Gallery*, 2013. Photo by Tracy Kolenchuk.

a last chair is placed in her outstretched hand. She trembles and strains under the weight. She collapses. The cage tumbles down with her. Alison slowly weaves her way through the mess of chairs strewn around Lindsay. She reaches down with care. Gently, Alison picks Lindsay off the ground, drawing her into the group for a final rebellion.

Deconstruction, Loss of Composure, and Utopia

Throughout the performance, the dancers each left the domesticated space of passive compliance, rejecting the polite audience to create small bursts of deconstruction. These vignettes, almost daydreams, allowed for the possibility of imagining our bodies, our worlds, and our lives otherwise. With the call to "donate today," as charities frequently implore, we began our outright rebellion in this fifth vignette. Referring to both her de(con)struction of the human stairs in the vignette on accessibility and the group's confrontation of Lindsay when she was hunting down Kasia with the laser, Iris reflected:

> The vignettes, and the lashing out at the man, as they say, [were] really free-ing for me. It's like, I finally get to say it, I finally get to say "I can't do those stairs!" ... I wish I could throw all stairs out and throw them away! And, create the world that they say, that these "wonderful" speakers say, we have that we don't have!

The dancers, importantly, did not return to the polite audience after we danced our vignettes: they each chose to join the (dis)quieted audience. With every dancer that joined the (dis)quieted audience, the group increasingly seethed with tension and disillusionment until we erupted, as though pulled by Alex's call from an earlier focus group: "Come on, people: do something!" In this final vignette, deconstruction was not simply a space to visit, a dream world. Rather, the group collectively, and literally, deconstructed the inaccessible staging of our polite and passive listening space.

On stage, we can dance out against the hardest things that we face. When we are offstage some of our greatest challenges and most painful or uncontrollable circumstances are not so easy to confront. One such reoccurring conversation in our group is about death and dying. Over the course of our research project, as many as four of the dancers had to intimately face our own mortality due to periods of serious illness or suicidal contemplations. Some things are too big to know what to do with. Ian articulated what choices remain when there is seemingly nothing we can do:

> Well, and then there's also ... the power of just being there, as opposed to being there for a purpose ... It's not something that we need to have a purpose for, it's just something where you just need to be. And then things that happen as a result of that, that you can endure that together.

Ian touched on an important aspect of relational ethics that are enacted within this group (see Austin, Bergum, and Dossetor 2003). Being there for each other is sometimes the only, albeit important, way we can support each other through the most difficult experiences of our lives.

So, while we can be together, what do we do now? The polite audience has been deconstructed. The pile of chairs has fallen. The stage is disordered, messy. How might we (re)compose our deconstructed bodies and worlds? Must we compose ourselves? McRuer (2006, 166) argues no: "I argue for the desirability of a loss of composure, since it is only in such a state that heteronormativity might be questioned or resisted and that new (queer/disabled) identities and communities might be imagined."

Our loss of composure in our final vignette creates an opportunity for breaking: breaking out of our daily experiences of oppression; breaking expectations of disability, normativity and community; breaking down, together. We can be elated and devastated, deeply hoping, and intensely lost, all at once. Maybe this loss of composure creates just enough space for

a creative spark, a connection, a small wedge into the large structures that surround and enfold us?

What we are feeling, and what we are making of it – community and art – Cvetkovich (2007) tells us, can be utopic. We create "a utopia that exists in the here and now ... a utopia that includes hardship and violence and that offers strategies for survival ... the point would be to offer a vision of hope and possibility that doesn't foreclose despair and exhaustion" (Cvetkovich 2007, 467). Onstage we craft an imaginary, seemingly utopic, world in which we confront and defeat the daily violences we encounter. Throughout our creative process, we enact our own complex utopia: sharing in the "hardship and violence" and creating dance performances as collective "strategies for survival."

More Needs to Happen!

> *More needs to happen, so that one day we can achieve*
> *"a fully inclusive world ... where the wheelchair is obsolete."*[2]
> *Now please stand for the national anthem.*

The dancers are reluctantly called to attention for the last time by the floating yellow happy-face balloon. Our disdain for the talking head turns to hope for an instant with the words "more needs to happen, so that one day we can achieve a fully inclusive world." The group nods vigorously in agreement. This hope is soon crushed by the conclusion: "where the wheelchair is obsolete." A guttural and desperate "no!!" erupts from each dancer. We all grasp Iris or Alison and their chairs. A world without wheelchairs is a world in which Iris, Alison, and Roxanne are isolated, immobilized, normalized, excised from our collective. This is deeply troubling. "Now please stand for the national anthem" is salt in the wound. Defiantly, each of us refuses to stand and exclude the others. Laurel, Kelsie, and Kaylee lift Alison in her wheelchair, and the four dancers parade forth to confront the speaker. Alex swoops in and grabs the balloon, drawing it into Alison's hands. She raises a pin in her fist. Slash. The balloon pops and then wilts. The dancers turn to face the observing audience. We bite our fists. The performance comes to an end, but the (dis)quieted peanut gallery does not.

NOTES

1 I use the term "disability" and the phrase "person experiencing disability" (Peers 2009, 657) in reference to the wide variety of perspectives, experiences, identities, bodily impacts, and social structures that constitute our dancers' varied understandings of the term.
2 This is a direct quote from the Rick Hansen Foundation's (2015, 2) Fundraising Handbook for Community Events.

WORKS CITED

Austin, Wendy, Vangie Bergum, and John Dossetor. 2003. "Relational Ethics: An Action Ethic as a Foundation for Health Care." In *Approaches to Ethics: Nursing beyond Boundaries*, edited by Verena Tschudin, 45–52. Edinburgh: Butterworth-Heinemann-Elsevier Science.

Baillie, Lesley. 2009. "Patient Dignity in an Acute Hospital Setting: A Case Study." *International Journal of Nursing Studies* 46 (1): 23–37. http://dx.doi.org/10.1016/j.ijnurstu.2008.08.003.

Benjamin, Adam. 2002. *Making an Entrance: Theory and Practice for Disabled and Non-Disabled Dancers*. London: Routledge.

Brown, Phil, and Stephen Zavestoski. 2004. "Social Movements in Health: An Introduction." *Sociology of Health and Illness* 26 (6): 679–94. http://dx.doi.org/10.1111/j.0141-9889.2004.00413.x.

Clare, Eli. 1999. *Exile & Pride: Disability, Queerness, and Liberation*, 2nd ed. Cambridge: South End Press.

Cooper Albright, Anne. 1997. *Choreographing Difference: The Body and Identity in Contemporary Dance*. Middletown, CT: Wesleyan University Press.

Cruikshank, Barbara. 1999. *The Will to Empower: Democratic Citizens and Other Subjects*. Ithaca: Cornell University Press.

Cvetkovich, Ann. 2007. "Public Feelings." *South Atlantic Quarterly* 106 (3): 459–68. http://dx.doi.org/10.1215/00382876-2007-004.

Davis, Lennard J. 2002. *Bending Over Backwards: Disability, Dismodernism, and Other Difficult Positions*. New York: NYU Press.

Denzin, Norman K. 2003. *Performance Ethnography: Critical Pedagogy and the Politics of Culture*. Thousand Oaks, CA: Sage Publications.

Eales, Lindsay. 2013. "(Dis)quiet in the Peanut Gallery: A Transformative Performance Ethnography on Integrated Dance." Master's thesis, University of Alberta. https://era.library.ualberta.ca/public/view/item/uuid:5d9b3356-b31b-4b95-a86f-9ea37d568bc6.

Hamera, Judith. 2011. "Performance Ethnography." In *The Sage Handbook of Qualitative Research*, 4th ed., edited by Norman K. Denzin and Yvonna S. Lincoln, 317–30. Thousand Oaks, CA: Sage Publications.

Herman, Amanda, and Steven Chatfield. 2010. "A Detailed Analysis of DanceAbility's Contribution to Mixed-Ability Dance." *Journal of Dance Education* 10 (2): 41–55. http://dx.doi.org/10.1080/15290824.2010.10387159.

Irving, Hannah R., and Audrey R. Giles. 2011. "A Dance Revolution? Responding to Dominant Discourses in Contemporary Integrated Dance." *Leisure/Loisir: Journal of the Canadian Association for Leisure Studies* 35 (4): 371–89.

Linton, Simi. 1998. *Claiming Disability: Knowledge and Identity.* New York: NYU Press.

–. 2006. "Reassigning Meaning." In *The Disability Studies Reader*, 2nd ed., edited by Lennard J. Davis, 161–72. New York: Routledge.

Mayan, Maria J. 2009. *Essentials of Qualitative Inquiry.* Walnut Creek, CA: Left Coast Press.

McGibbon, Elizabeth A., ed. 2012. *Oppression: A Social Determinant of Health.* Winnipeg: Fernwood Publishing.

McRuer, Robert. 2006. *Crip Theory: Cultural Signs of Queerness and Disability.* New York: NYU Press.

Oliver, Michael. 1996. *Understanding Disability: From Theory to Practice.* New York: St. Martin's Press. http://dx.doi.org/10.1007/978-1-349-24269-6.

Peers, Danielle. 2009. "(Dis)empowering Paralympic Histories: Absent Athletes and Disabling Discourses." *Disability and Society* 24 (5): 653–65. http://dx.doi.org/10.1080/09687590903011113.

–. 2015. "From Inhalation to Inspiration: A Genealogical Auto-Ethnography of a Supercrip." In *Foucault and the Government of Disability*, 2nd ed., edited by Shelley Tremain, 331-49. Ann Arbor: University of Michigan Press.

Peers, Danielle, Nancy Spencer-Cavaliere, and Lindsay Eales. 2014. "Say What You Mean: Rethinking Disability Language in Adapted Physical Activity Quarterly." *Adapted Physical Activity Quarterly* 31 (3): 265–82. http://dx.doi.org/10.1123/apaq.2013-0091.

Prince, Michael J. 2009. *Absent Citizens: Disability Politics and Policy in Canada.* Toronto: University of Toronto Press.

Rice, Carla. 2010. "Becoming 'the Fat Girl': Acquisition of an Unfit Identity." In *Inequality in Canada: A Reader on the Intersections of Gender, Race, and Class*, 2nd ed., edited by Valerie Zawilski, 211–30. Don Mills, ON: Oxford University Press.

Rick Hansen Foundation. 2015. "Fundraising Handbook for Community Events." Accessed March 9, 2015. https://www.rickhansen.com/Portals/0/HowToHelp/Fundraise/RHF%20Fundraising%20Handbook%20FINAL.pdf.

Shakespeare, Tom. 2006. *Disability Rights and Wrongs.* London: Routledge.

Shildrick, Margrit. 2005. "The Disabled Body, Genealogy and Undecidability." *Cultural Studies* 19 (6): 755–70. http://dx.doi.org/10.1080/09502380500365754.

Smith, Owen. 2005. "Shifting Apollo's Frame: Challenging the Body Aesthetic in Theatre Dance." In *Bodies in Commotion: Disability and Performance*, edited by Carrie Sandahl and Philip Auslander, 73–85. Ann Arbor: University of Michigan Press.

Snyder, Sharon L., and David T. Mitchell. 2006. *Cultural Locations of Disability.* Chicago: University of Chicago Press. http://dx.doi.org/10.7208/chicago/9780226767307.001.0001.

Spade, Dean. 2011. *Normal Life: Administrative Violence, Critical Trans Politics, and the Limits of the Law.* Brooklyn: South End Press.

Sullivan, Martin. 2005. "Subjected Bodies: Paraplegia, Rehabilitation, and the Politics of Movement." In *Foucault and the Government of Disability*, edited by Shelley Tremain, 27–44. Ann Arbor: University of Michigan Press.

Thobani, Sunera. 2007. *Exalted Subjects: Studies in the Making of Race and Nation in Canada*. Toronto: University of Toronto Press.

Titchkosky, Tanya. 2008. "'To Pee or Not to Pee?' Ordinary Talk about Extraordinary Exclusions in a University Environment." *E-Journal of Canadian Journal of Sociology* 33 (1): 37–60.

–. 2011. *The Question of Access: Disability, Space, Meaning*. Toronto: University of Toronto Press.

Union of the Physically Impaired Against Segregation. 1976. "Fundamental Principles of Disability." http://disability-studies.leeds.ac.uk/files/library/UPIAS-fundamental-principles.pdf.

Whatley, Sarah. 2007. "Dance and Disability: The Dancer, the Viewer and the Presumption of Difference." *Research in Dance Education* 8 (1): 5–25. http://dx.doi.org/10.1080/14647890701272639.

Withers, A.J. 2012. *Disability Politics and Theory*. Winnipeg: Fernwood Publishing.

7

Battle Lines Drawn
Creative Resistance to Ableism through Online Media

JEFFREY PRESTON

I have always been obsessed with mass media, movies and television being my favourites. My earliest hopes and dreams were formed by what I saw on the screen, whether it be my childhood obsessions with catching ghosts like in *Ghostbusters* (1984) or becoming a fighter pilot like Maverick in *Top Gun* (1986). Despite being drawn to popular culture, I rarely engaged with mediated texts about disability, largely because I recognized early on that there were no characters to whom I could relate in the mainstream media – these myths of disability seemed completely foreign to my experience. Instead of the media reflecting back and validating my existence as a child born with a disability, life with a disability in the media appeared as through a refracting mirror, with any sliver of reality being warped and bent into something unrecognizable.

At the heart of ableism are the stories we tell ourselves about disability. From *Daredevil* to *Glee*, representations of disability rarely speak to the lived experience of disabled people or their allies. Instead, they depict the skewed perspective of content creators who, when designing disabled characters, typically do not identify as disabled and draw heavily on myths inculcated with pity and paternalism. For this reason, the struggle for disability equality must be fought not just in the streets, but also through the use of cultural and creative media. Created in 2010 by Clara Madrenas and me, *Cripz: A Webcomic* is an online comic strip that tells the story of two high school boys who use wheelchairs. Although fictional, *Cripz* is a referential

Jeffrey Preston and Clara Madrenas, image from *Cripz: A Webcomic*, 2010.

comic, largely based on personal experience and media depictions of disability, that attempts to capture and thereby deconstruct common imaginations of disability. In some ways, *Cripz* is an attempt to converse with the stories that reinforce a specific disabled subjectivity and provide an alternative narrative. Capturing these moments, recreating them in comic form to be shared with and contemplated by others, serves a dual purpose – we can educate people about life with a disability while at the same time revelling in the absurdity of our bizarre imaginations of disabled life. Ultimately, *Cripz* attempts to make space for and validate the existence of those who live outside the subjective myths of disability, and it was from this fertile ground that real-world activism began to take root, like stairbombing, the act of shutting down stairways with caution tape to simulate inaccessibility for the non-disabled.

This chapter is divided into three sections that roughly follow the chronological inception of *Cripz*. The first section aims to challenge three common myths often used to encapsulate disabled characters, namely the myth of the hero, the villain, and the burden/child. The second section deals with the inception and motivation of *Cripz* and the desire to use webcomics and other independent media forms to disrupt the dominant myths of disability perpetuated by mainstream mass media. The final section of this chapter

looks at the evolution of *Cripz* and the transition from disruptive stories to physical acts of resistance. Rather than simply identify the problems of disability in popular culture, this chapter aims to provide a possible form of resistance, a crip *détournement*, which can subvert and satirize these representations through creative resistance. This chapter considers how *Cripz* attempts to capitalize on new forms of cultural warfare, using tools like online publishing and publicity stunts to change societal perspectives on disability.

Throughout this chapter I deploy the terms "disabled" and "non-disabled" to refer to certain segments of the population. While these terms are often used to talk about specific groups of people, my usage here is far more fluid and aims to move away from perspectives that designate those with normal or proper bodies and those without (see Garland-Thomson 1997; McRuer 2006; Schalk 2013). For this reason, I use the term "disabled" to refer to both those with functional and cognitive impairments or limitations, medically or self-diagnosed, and the collection of individuals who experience disability within and outside themselves, including friends, family, professionals, and allies who encounter disability in critical and profound ways. Conversely, I use the term "non-disabled" or "able-bodied" to refer to what Rosemarie Garland-Thomson (1997) dubs the "normate" – those who identify themselves as not only normal but *not* disabled. Normates are wholly removed from the realm of disability, untouched by its appendages and ignorant, intentionally or otherwise, of its forms and functions. While I acknowledge that this sets up a binary, which can be problematic, my usage of "disabled" refers to those within the disabled communit(ies), however they find themselves involved, and of "nondisabled" as those who intentionally or unintentionally delineate themselves from the world of disability.

The Myth of Disability

Disability has long lived within the collective unconscious of the non-disabled public, a subject position whose borders are drawn and redrawn not just to mark aberrant bodies and behaviours but to demarcate the very limits of normality (Garland-Thomson 1997).

The media present a clear picture of *who* and *what* the disabled are, actively maintaining and constructing the public perception of disability. The result is a symbolic realm of misery and triumph, with three distinct mythical characters emerging. Drawing on the work of literary critic Roland Barthes, I argue that popular culture enforces myths of disability based on

three common myths: the hero, the villain, and the burden/child. The hero, sometimes called the "super-crip," involves stories of disabled people over-coming tragedy to attain some level of normalcy and independence. The second myth is an inversion of the heroic myth, the villain, which focuses on the ways in which one can be twisted by disability into a monstrous fig-ure. The most common is the third myth, that of the burden or child, in which the disabled are cast as naïve and pitiful, dependent on the non-disabled around them to survive. Of course, these three frames used to rep-resent disability are not static; disabled characters sometimes occupy all three myths within one text. To understand this clearly, though, I will first briefly explore Barthes's concept of mythology.

Barthes postulates that culture is dominated by mythologies, deep levels of signification that perpetuate the ideas of the dominant class, defining myth as "a system of communication, that it is a message. This allows one to perceive that myth cannot possibly be an object, a concept, or an idea; it is a mode of signification, a form" (Barthes 1972, 109). Barthes argues that any-thing can become myth once it is conveyed in discourse, but this discourse is not limited to speech – for example, pictorial communication is also a form of mythology (Barthes 1972, 111). Most important is that mythology is always political: "it is both of semiology inasmuch as it is a formal science, and of ideology inasmuch as it is an historical science; it studies ideas-in-form" (Barthes 1972, 112). Mythology actively works to present and maintain the ideology of the dominant class, the bourgeois, through several strategies Barthes explores in detail in *Mythologies* (150–54). Barthes's work is significant because just as the dominant class has deployed powerful myths to endorse and maintain capitalism, the dominant ableist class also generates and deploys vast mythologies about ability that actively contain and control the limits of who can claim to be disabled.

Perhaps the most endearing and complicated frame used to depict life with a disability is that of the hero. The news media are particularly fond of triumphant stories in which disabled individuals rise above their limitations to accomplish incredible – or sometimes mundane but unexpected – feats. This representation is dependent on a dual interpretation of disability. As Jenny Morris (1997, 27) writes, "It is horrible beyond imagination to be dis-abled, but disabled people with guts can, if they only try hard enough, make themselves almost 'normal.'" In this way, disabled characters are left to face a simple decision: rise above your disability to become a hero or succumb to your limitations and become pitiful. Morris goes on to explain that these

representations leave us with an "overcoming all odds" model of disability, in which the disabled person is often presented in terms of a "brilliant mind in a crippled body," a phrase applied to celebrated theoretical physicist Stephen Hawking, who has a motor neuron disease. The non-disabled world finds disability, or injury, difficult to confront or to understand. Other people's pain is always frightening, primarily because people want to deny that it could happen to them. Lack of control over one's body is also very frightening, particularly as it can mean dependence on others (Morris 1997, 27).

Hawking is perhaps the best example of the complexity of this myth, as journalists often marvel at how someone so "profoundly disabled" – Hawking speaks with the aid of a speech-generating device – could possess such an incredible mind (cf. Donaldson 2014). In Hawking's story, there is a hope that nature will always compensate, that despite living within a "broken body," an individual will be given other superhuman gifts to atone for loss. Here it is most apparent that representations of disability are not reflections of reality but a reflection of the non-disabled's inherent fear of becoming disabled themselves. In this way, the representation of the hero is used to comfort the non-disabled subject, allaying their fears with promises of natural compensation and the ability to overcome limitation. This hope for natural compensation is replicated in comics, most notably through the blind character Matt Murdock, who is better known as *Daredevil*. Blinded at a young age, Murdock is given superpowers of echolocation and touch sensitivity that compensate for his inability to see, powers he will later use to become a superhero (Miller and Janson 2007). Despite his superhuman abilities, Murdock is still perpetually defined and limited by his disability, pulling "blind man bluffs" (Waid and Rivera 2012, 9), playing "blind" (Waid and Rivera 2012, 18), and being weakened by his blindness (Waid and Rivera 2012, 74). Much like Hawking, the reader is encouraged to feel awe at Murdock's ability *in spite of* his disability.

While some will claim that the hero myth fundamentally benefits disabled people, as it promotes a celebration and normalization of the disabled body, it is inherently flawed. One of the problems with these representations is that the belief of natural compensation reduces the urgency for accommodation, as the general public are led to believe that the disabled are provided with other skills to help them overcome these naturally occurring barriers. Further, these representations place enormous pressure on the disabled individual to perform the role of the overcomer, marking those who are struggling to navigate the world with their disabilities as somehow

deficient. Most distressing, though, is the reality that the heroic myth is largely rooted in pity and paternalism and, in this way, is not a celebration of legitimate or genuine accomplishment. It is this type of sympathetic praise that leads to headline news stories of disabled people accomplishing that which would otherwise be considered mundane or expected tasks of the non-disabled. A prime example of this is the early 2000s fad of students electing disabled peers as prom king/queen and the subsequent media craze that followed. For example, a front-page article in the *London Free Press* in Ontario celebrated a young disabled man's chance to be treated as "royalty" for a day, an achievement that was not deemed newsworthy for any of the non-disabled prom kings or queens in London that year (Anderson 2013).

Closely linked to the myth of the hero is that of the villain. Disabled people who are unable to rise above their challenges, to struggle their way into the ranks of normalcy, are left to succumb to their limitations and become villainous. For Paul Longmore, this representation most commonly breaks down into two closely linked stereotypes: the criminal and the monster. As Longmore (2003, 133) explains, "Disability has often been used as a melodramatic device not only in popular entertainment, but in literature as well. Among the most persistent is the association of disability with malevolence. Deformity of body symbolizes deformity of soul. Physical handicaps are made the emblems of evil." Longmore believes that the use of disability as a visual cue for villainy leads to a reinforcement of common prejudices that "disability is a punishment for evil; disabled people are embittered by their 'fate'; disabled people resent the nondisabled and would, if they could, destroy them" (Longmore 2003, 134). In this way, disability becomes closely linked to monstrosity, in which monstrous physical features, particularly deformities of the face, are linked to a twisting of the soul – the fractured external body is symbolic of a corrupt self (Longmore 2003, 135). A prime example of this representation comes in the form of Captain Hook, as represented in the Hollywood film *Hook* (2001). Losing his hand to a crocodile, an injury for which he blames Peter Pan, Hook goes on to declare war on childhood, attempting to kill the Lost Boys and exact revenge on Pan. Hook's entire identity is formed around his amputation, both in name and motivation. Longmore (2003, 135) concludes that all representations of the villainous disabled validate non-disabled fears of aberrant bodies and must conclude with an excising of the abnormality, leading to purification through execution of the monstrosity. In *Hook*, the movie cannot end before Hook is vanquished.

The final myth commonly used to encapsulate the disabled experience in popular culture is that of the child, or burden, perhaps most commonly associated with charity telethons. Along with charting the villainous disabled, Longmore has also written about the idea of disability as burden, connecting this myth back to the iconic Dickens character, Tiny Tim:

> The Tiny Tim image was made into a constant and powerful cultural symbol, especially on telethons. Its main purveyors were the disability charities. Within both the charity tradition and the operation of the medical model, that persona helped to shape the identities of millions of people with disabilities. (Longmore 2013, 34)

Charities seeking to raise money deploy the image of the poor, sickly Tiny Tim in an effort to garner more funds. In this way, "the hosts and the givers were the Cratchits gathered around the sweet pathetic children. Viewers at risk of becoming Scrooges peered through their TV screens ... By looking after the 'most weak,' they could buy a place at the telethon hearth" (Longmore 2013, 34). This call to action relies on the idea that the disabled are hopelessly dependent and incapable of surviving without the paternal charity of the non-disabled. Beth Haller (2010, 142) draws a similar connection to the relationship between charities and their Tiny Tims through her analysis of the ways in which Jerry Lewis subjects the disabled poster children, dubbed "Jerry's Kids," to his paternal authority.

It is this same line of thinking that informs an entire industry of heartwarming movies focused on the dependence of intellectually limited individuals on their reluctantly supportive non-disabled relatives, such as *Rain Man* (1998) and *I Am Sam* (2002). Ultimately, these representations present disability as a world of anxiety, where the disabled become a threat to the independence of the non-disabled through their dependency on family members to become principal caregivers. Further, these representations cast life with a disability as being inherently difficult and requiring the protection and supervision of a non-disabled matriarch – depictions of the child often tether the disabled to a caring and supportive mother figure, biological or otherwise, such as the relationship depicted between Artie and his mother in *Glee* (2013). These representations call on the audience to construct defences against the disabled, implying that disabled people must be contained through parental and medical power while at the same time demanding segregation of the disabled from the non-disabled. While texts that deploy the myth of the child are ambiguous as to whether or not this segregation is

morally just, they generally agree that segregation is necessary. While these three myths dominate the popular discourse of disability, they rarely speak to the actual lived experience of disability, not to mention contributing to the isolation and erasure of race, gender, sexuality, etc.

Digital Intervention: *Cripz* and Advocacy

In 2009, Clara Madrenas and I began talking about producing a webcomic to disrupt the dominant myths of disability by telling our own stories about disability. In retrospect, I am not sure why I never considered producing disability narratives until this point. Perhaps I was more comfortable as critic than producer, but the idea was equal parts shocking and exciting. As a long-time advocate, this was an opportunity for me to embody the root of the word "advocacy," to literally add our *voice* to the mediated discussion of disability subjectivity. Conceptually, we sought to develop a webcomic that spoke in the language of the mainstream media to play on and disrupt these myths through satire. Telling my own story seemed like a chance to disrupt the regularly scheduled program, to deconstruct mythical representations of disability using the language and conventions of mass media but with subversive intent. In a word, it felt like an opportunity for *détournement*.

The tactic of *détournement* was developed by the Situationists International (SI) in the 1960s to resist the malaise caused by mass media and consumerism. In her book *The Most Radical Gesture*, Sadie Plant (1992, 1) explains that the SI was a radical collection of thinkers and artists who "characterized modern capitalist society as an organization of spectacles: a frozen moment of history in which it is impossible to experience real life or actively participate in the construction of the lived world." One of the main strategies to resist this malaise, *détournement*, was originally proposed by Marcel Mariën as "a sort of embezzlement of convention" (Plant 1992, 86). Plant decodes the term *détournement* to lie somewhere between diversion and subversion, a turning around and reclamation of lost meaning: a way of putting the stasis of the spectacle in motion. It is plagiaristic, because its materials are those that already appear within the spectacle, and subversive, since its tactics are those of the "reversal of perspective," a challenge to meaning aimed at the context in which it arises (Plant 1992, 86). *Détournement* aims to be subversive to the spectacle from within the very spectacle it is attempting to derail.

The ultimate objective of *détournement* then is to demystify the spectacle and "reveal a totality of possible social and discursive relations which exceeds the spectacle's constraints" (Plant 1992, 86). The only way to do this,

though, is through the language *of* the spectacle. As Plant (1992, 88) states, "The situationists argued that the critical theory which struggles against alienation must itself 'be communicated in its own language – the language of contradiction, dialectical in form as well as in content.'"

While some may reduce this strategy to mere stunts or practical jokes, *détournement* can be an effective means of ideological warfare because it works to reveal popular culture for the spectacle it truly is – a collection of images that is a *reflection* of reality but not reality itself. It is this same logic that would inform modern counterculture movements, such as culture jamming, in which Kalle Lasn (2000, 124) claims we need to fight an information war by building meme factories that "put out a better product and beat the corporations at their own game."

Taking our cue from the SI and the culture jamming movement, Madrenas and I decided to launch our own artistic intervention, a webcomic, drawing lines of battle encoded with a disability narrative to counter the dominant myths of disability. Rather than producing a "realistic" representation of life with a disability, we wanted something that would follow other successful interventions and develop engaging and humorous stories that were bite-sized and palpable for the transient Internet audience. At the same time, we wanted to produce something that was both educational and interesting for a non-disabled audience, while also having insider humour geared toward disabled readers.

Pulling together these foundational requirements, we determined that the best setting for our story would be a high school, with the main characters being students, as it provided us with room to tell engaging and satirical stories about our own community, London, Ontario, during a formative and important time in all of our lives – puberty. Stories about teenagers are intriguing as a site for resistance, because it is a time when we become intensely focused on our bodies, the anxieties around transformation, and the desire to simply be normal. In this way, puberty is a moment of disablement for all of us, and perhaps it is the anxieties confronted in this period that, in part, inform our negativity writ large toward aberrant embodiments. As such, it seemed this would be the perfect place for an intervention and, thus, *Cripz: A Webcomic* was born.

Although we intended to release a new episode of *Cripz* weekly, we were cognizant of the fact that the Internet is a place where attention spans are limited. As such, our early focus in the webcomic was on developing strong characters to carry the story when a unified narrative would be otherwise absent. Starting in 2011, we self-published close to one hundred comics,

posted to our WordPress blog almost every Wednesday. We designed our webcomic with painted backgrounds and paper cutout characters, an ode to a popular SI *détournement* of cutout collages. As a whole, *Cripz* actively ran from its start in 2011 until we stopped producing the comics in 2013.

While an ensemble cast was introduced over the course of the series, *Cripz* was primarily focused on the lives of three unique teenagers who were drawn together, in part, by the ways in which they were so completely opposite. The first character is Rhett Breton, a well-read thirteen-year-old radical disability rights activist who recently moved to London, Ontario, from the United States. Rhett's extremism was developed to serve as an important foil to the other main character, Griffin Moonlove, a fellow physically disabled teenager who could not be more different from Rhett. Throughout the story, Griff is cast as a chauvinistic but lovable dolt who cares more about having a good time than participating in the disability rights movement. The third and final character is Kate Komichi, a quiet artsy woman who befriends Rhett and Griff several episodes into the first year. Kate is a character that we did not get enough time to fully develop and, as a result, she comes off as more of a secondary character. One obvious flaw in our designs was that despite our best intentions, the webcomic is sexually, racially, and disability normative, focusing primarily on two middle-class heterosexual white males in wheelchairs. Although not fully realized, our intent was for every character to have some form of disability, whether identified explicitly or not, in an attempt to explode the divisions between the disabled and the non-disabled. We were inspired by Julia Kristeva's work that suggests the ways in which disability is already always lurking within all of us, "not necessarily because 'it could happen to anyone,' but because *it* is already in me/us: in our dreams, our anxieties, our romantic and existential crises, in this *lack of being* that invades us when our resistances crumble and our 'interior castle' cracks" (Kristeva 2010, 44).

As mentioned earlier, our aim with the webcomic was to release strips that could be read individually or as a whole, with story arcs usually containing four or five episodes released individually on a weekly basis. Although the locations of the story would vary, a bulk of the episodes happen within the wheelchair-accessible bus that takes Rhett and Griff to school every morning, focusing on the conversations that would occur during these rides. We actively tried to depict much of Rhett's and Griff's lives as being spent on the bus to satirize accessible transit in Ontario and how much of a disabled person's life is spent booking and riding these dysfunctional systems. At the same time, this was an attempt to relocate the disabled character outside of

the walls of the home or the hospital, contrary to the myths of disability perpetuated in the mass media discussed earlier. While Rhett and Griff's conversations may span several episodes, each strip followed a typical narrative structure of set-up, extrapolation, and concluding joke so that while an episode may be intended to set up a broader storyline, it is still entertaining individually should it be the first and only episode a visitor reads.

Integral to the success of the comic was the marketing campaign, which relied heavily on social networking sites like Twitter and Facebook to push out content. By far, our biggest support came from people who knew Madrenas or me and wanted to spread the word. The majority of those who shared the comic that we did not know personally, however, appear to be youth with disabilities who had stumbled upon the comic, enjoyed it, and decided to pass it on to their friends, primarily over Facebook. The comic was also occasionally submitted to link aggregators such as Reddit, which would drive major traffic to the website when a particular episode would make it to the front page of the /r/webcomic subreddit.

In keeping with the tradition of *détournement*, *Cripz* provided us with the opportunity to promote a radical vision of disability and disability activism both within and outside the webcomic. First, I will discuss the ways in which the webcomic complicated, with varying degrees of success, the common myth of disability. Next, I will discuss the ways in which the webcomic also gave us an opportunity to work in the offline world, namely within the press itself, and how the strip also inspired and popularized two simple real-world crip *détournement* techniques: stairbombing and chairmobbing. Lastly, I will discuss how the webcomic provided an opportunity to inspire others with disabilities to take to the web and begin telling their own stories, to resist ableism creatively, and to counter the mass media's skewed production of disability.

One of the main objectives of the webcomic was to trouble myths of disability by producing characters who lived outside the typical boundaries of physical disability. When we began planning the characters for our webcomic, we developed several key rules that guided the creative process: (1) disclosure of diagnosed disability or disability origin stories would be kept to a minimum; (2) although connected to the disabled community, characters would not be formed by or obsessed with *being* disabled and would live in the real world, not just the mythical disabled world; and (3) no character, under any circumstance, would be redeeming or inspiring. Primarily this was achieved by creating two main characters who lived outside the normative world of disability. For Rhett, this meant opposing the docile and dependent

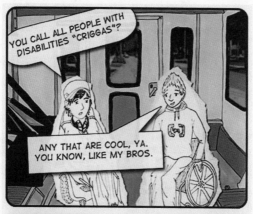

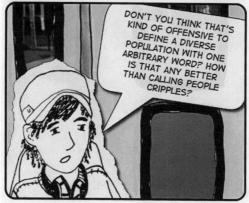

Jeffrey Preston and Clara Madrenas, "Criggas," from
Cripz: A Webcomic, 2010.

mythology of disability by espousing radical militant responses to ableism that, while bordering on the stereotype of the villain, firmly mark Rhett in the tradition of radicals such as Malcolm X or Che Guevara. Conversely, Griff stood as an obvious turn from the naïve and childlike myth of disability by being an active and playful character concerned primarily with accumulating wealth and women over quietly sitting on the sidelines. At the same time, Griff does not represent an overcoming super-crip, as his lascivious nature cast him as more sleazy and conniving than role-model material. As intended, neither of the main characters is particularly inspiring, and neither character is defined by or wholly focused on *why* they are in a wheelchair. We attempted to create characters who stood on their own, so to speak, without relying on disability to flesh out their identity.

Another core objective of the webcomic was to trouble the complicated world of language wrapped up around disability, both in medical and politicized terms. Primarily this was done through the invention of the term "crigga," which is a provocative alternative to the reclamation project of the word "cripple" and aims to form a bridge between the disabled community and the civil rights movement (Preston and Madrenas 2010c). We selected this term hoping that readers might be provoked into discussion about the problems with this term, but we had no formal response, and all informal comments seemed to indicate that people thought it was "cool" and that it did not generate the backlash we had intended. At the same time, this episode also intended to draw attention to the practice of lumping together the entire disabled population under the banner of "political correctness," which largely relies on a disenfranchising inside/outside modality and neglects the current disjointed and disconnected disabled community in Canada.

We also intentionally crafted storylines throughout the comic that would draw attention to the lived realities of disability that are rarely discussed in mainstream representations. One example of this ignorance is the ways in which the fashion industry, and standardized sizing in general, relegates some with physical disabilities to wearing children's clothing, as adult sizing does not accommodate the sizes or shapes of their bodies. Although certainly not intentional, the deployment of children's clothing on adult disabled bodies supports the myth of the child, a myth we looked to subvert by having Rhett refuse to wear clothing that was not age appropriate. We also saw this as an opportunity to draw attention to the still-recent and ongoing practice of warehousing the disabled in asylums and medical care facilities, something that comes up several times through Rhett's boycott of the fashion industry. Rather than wearing clothing not intended for him, Rhett resists by exclusively wearing hospital scrubs in an attempt to reclaim the uniform forced on inmates of the medical establishment (Preston and Madrenas 2010e). Ultimately, we hoped that Rhett's reclaiming of the medical garb would provoke readers to consider the ways in which the aforementioned myth of the child marks disabled characters as being woefully dependent, doomed to a life in an institution, by signifying the clothing of oppression to become a symbol of resistance.

Finally, our webcomic commented on trends in pop culture, particularly those that brushed up against disability. For this purpose, we actively brought popular mass media artifacts, primarily network television shows and big-budget movies, and injected crip criticism to reveal and disenfranchise the myths of disability present within the texts. A primary target of

Cripz was FOX's *Glee* and the brutally constructed character Artie Abrams and his obsession with walking (*Glee* 2011). Taking direct aim at the myth of the hero and the myth of the child, Rhett and Griff openly confront *Glee's* assurances that Artie's primary wish would be to walk again, stating instead that perhaps he was more interested in deriving sexual pleasure. This was a dual attack, first deconstructing the myth of the hero's obsession with over-coming, and at the same time injecting hypersexuality that aims to combat the myth of childlike desexualization (Preston and Madrenas 2010b). We also engaged with Hollywood more actively, attempting to insert disability into popular culture in a series dubbed "*Cripz* Goes to the Movies," which imagined what popular films would look like if the main characters had been disabled, such as *Harry Potter* (2001) and *Captain America* (2011). The goal of these strips was to, as *détournement* invites, use the messages of the spectacle against itself, finding humour in presenting disabled charac-ters outside the myths most often used to depict disability, unmasking the narrative of the texts while also asking questions about the lack of inclusion of diverse disabled characters in popular film. For the world of *Harry Potter*, this meant inquiring whether or not the wizarding world was wheelchair-accessible, commenting on the very real problem of inclusive schooling in Ontario while, at the same time, noting the apparent lack of physical differ-ence in a world *based* on kids who are different (Preston and Madrenas 2010a). Similarly, the *Captain America* spoof played with the myth of the

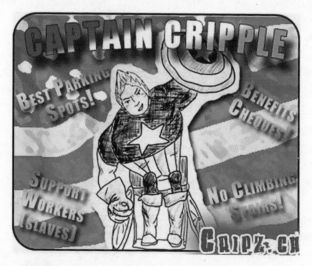

Jeffrey Preston and Clara Madrenas, image from "*Cripz* Goes to the Movies" series in *Cripz: A Webcomic*, 2010.

hero, sardonically explicating that, rather than the promise of natural compensation or the crushing guilt of dependency, disability promised certain privileges, namely parking spots, benefit cheques, support workers (dubbed "slaves"), and the chance to seduce women while other men are dying in World War II (Preston and Madrenas 2011).

Again, this comic attempted to satirize the three common myths of disability by presenting a polar-opposite imagination of the demands and desires of disabled characters.

Taking It to the Streets: *Cripz* and Activism

While the primary objective of the webcomic was to trouble ideas about disability within the text, we also were afforded several activist opportunities offline as the comic grew. For example, while we had no intention of pursuing a traditional media marketing campaign for the webcomic, especially the type that would cost money, *Cripz* did manage to garner some attention from members of the local press, who were interested in telling our story. We used these interviews as an opportunity to speak directly with mainstream media producers and work to control the way that we, as authors, would be portrayed in our own story. Rather than being oppositional, the webcomic acted as a common ground from which to discuss the language used and the ways in which the news media attempt to force certain narratives in stories involving people with disabilities and encourage equitable portrayals. This turned the moment of interview into an impromptu educational juncture, giving us an opportunity to speak back and actively show how the news media routinely let down the disabled public.

Perhaps the most entertaining forms of activism that evolved out of *Cripz* are the practices of stairbombing and chairmobbing. Because Rhett was cast as a renegade, we felt it necessary to develop some radical forms of resistance that he would begin to advocate within the world of the webcomic. The first idea, chairmobbing, is the simple practice of attempting to overload a commercial space with more wheelchairs than the area is intended to hold – for example, having twenty wheelchairs arrive at a theatre that has only four wheelchair spots. Based on the flash mobbing fad, which has its roots in *détournement*, chairmobbing is about actively showing business owners the cost of inaccessibility by providing tangible evidence that disabled consumers exist and want to spend their money.

Stairbombing is more complex and in keeping with the tradition of *détournement*. The foundational assumption of stairbombing is that, along the lines of social model thinking, the world is an inherently inaccessible

place designed along ableist assumptions of human physical and intellectual ability (Titchkosky 2011). Put simply, it is not the wheelchair that "disables" us but the fact that the average Canadian city is not designed to be accessible for wheelchairs. In a sense, then, our world is filled with designations of places we can and cannot visit: where there are ramps, we are welcome; where there are stairs, we are not. Stairbombing attempts to turn this logic on its head by empowering people with disabilities to begin telling the non-disabled where *they* can and cannot go through the use of yellow construction tape. As we have all been conditioned to never cross yellow caution tape, tape that can be procured easily and cheaply at a variety of stores, stairbombing is the act of blocking off stairways with caution tape, rendering them inaccessible for everyone. The idea of stairbombing was first brought forward in what was called a *"Cripz* Intervention."

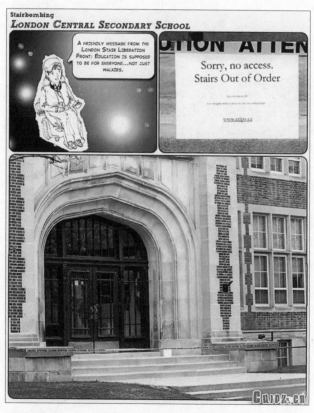

Jeffrey Preston and Clara Madrenas, image from *"Cripz* Interventions" series in *Cripz: A Webcomic,* 2010.

The idea behind the "*Cripz* Interventions" series was to have the character Rhett begin to physically affect the real-world London community while discussing said actions within the world of the webcomic. In the first stair-bombing, Madrenas and I taped off a local high school that, despite having a special education classroom, is extremely inaccessible. We then produced a webcomic with Rhett explaining that "education is supposed to be for everyone ... not just walkies" and two pictures of the school stairs being blocked off by caution tape and a sign reading "Sorry, no access. Stairs Out of Order" (Preston and Madrenas 2010d). From there, we encouraged readers, both offline and online, to buy rolls of caution tape and begin actively shutting down inaccessible spaces. Although the act of stairbombing has not gone viral, so to speak, we have had several successful stairbombing parties, in which groups of individuals, disabled and allies, gather and block off stairways together.

The result of this intervention is a confused non-disabled user who, upon encountering the tape, is met with the same type of frustration the disabled feel when arriving at a location only to discover it is inaccessible – how do we get in if there is no accessible door? In this way, stairbombing actively critiques the built environment, drawing attention to its flaws, while at the same time not being the type of civil disobedience that necessitates a high volume of protesters and risky hostile encounters with law enforcement, such as a physical blockade.

One of the last ways in which *Cripz* spawned greater activism was through educating and empowering others to begin telling their own stories online just as we had done. Since launching the webcomic, Madrenas and I have participated in numerous events and run countless workshops to give people the tools necessary to begin producing their own comics or stories online. By sharing the knowledge about how to create their own content, we hope to see a plethora of stories about disability emerge online that will reflect the reality that disability is a diverse and multi-faceted experience that is lived differently by everyone it touches.

Concluding Thoughts

For years, disability studies scholars have critiqued the abysmal representations of disability in popular culture. The stories we tell about disability are often simplistic, pitying, and paternalistic and serve only to elucidate the ways in which the non-disabled perceive disability. These representations often rely on three dominant mythologies of disability that cast disabled characters as heroes who triumph over nature's cruel design, villains who

succumb to their limitation, or burdensome children who naïvely bumble their way through this world with the help of their non-disabled overseers. Disabled people become entangled in these myths, subjected to their contours and expectations. In *Cripz: A Webcomic*, Clara Madrenas and I tried to live outside those expectations, playfully pulling at the threaded edges of the myth(s) of disability to reveal the absurdity of how we imagine and confront disability in popular culture.

While we are one voice, we are certainly not alone in re-envisioning the world of disability. With the explosion of social blogging sites such as WordPress (wordpress.com) and Tumblr (tumblr.com), it has never been technically easier and financially cheaper to post content online that is accessible, figuratively and literally. Anyone with a general understanding of word processing and computer operation is now capable of actively publishing online without knowing a single line of computer code. Integrated sharing and searchable tags allow the disabled community to grow online, connecting through creative resistance in ways only rivalled by the group-home uprisings in Britain that led to the forming of the Union of the Physically Impaired against Segregation and the subsequent birth of the social model of disability. Through the Internet, people with disabilities have the opportunity to begin telling their own stories, a *détournement* that actively derails the dominant non-disabled perceptions of disability that circulate in popular culture. Creating a flood of unique perspectives is the most powerful way to counter the simplistic hegemony of disability presented in the mainstream media, and I hope that *Cripz* has played at least a small part in building a diverse and nuanced tapestry of disability online.

WORKS CITED

Anderson, Melanie. 2013. "Jackson Smith Is Not Your Average Mr. Popular." *London Free Press*, June 4. http://www.lfpress.com/2013/06/04/jackson-smith-is-not-your-average-mr-popular.

Barthes, Roland. 1972. *Mythologies*. Translated by Annette Lavers. New York: Hill and Wang.

Captain America: The First Avenger. 2011. Directed by Joe Johnston. Marvel Studios.

Donaldson, Sarah. 2014. "A Brief History of Hawking." *The Telegraph*, April 6. http://www.telegraph.co.uk/culture/tvandradio/3614968/A-brief-history-of-Hawking.html.

Garland-Thomson, Rosemarie. 1997. *Extraordinary Bodies: Figuring Physical Disability in American Culture and Literature*. New York: Columbia University Press.

Glee. 2011. "Dream On" episode. Directed by Joss Whedon. DVD. Twentieth Century Fox Home Entertainment.

–. 2013. "Wonder-Ful" episode. Directed by Wendey Stanzler. DVD. Twentieth Century Fox Home Entertainment.

Haller, Beth A. 2010. *Representing Disability in an Ableist World: Essays on Mass Media.* Louisville, KY: Avocado Press.

Harry Potter and the Philosopher's Stone. 2001. Directed by Chris Columbus. DVD. Warner Home Video.

Hook. 2001. Directed by Steven Spielberg. DVD. Sony Pictures Home Entertainment.

I Am Sam. 2002. Directed by Jessie Nelson. DVD. Alliance Films.

Kristeva, Julia. 2010. *Hatred and Forgiveness.* New York: Columbia University Press.

Lasn, Kalle. 2000. *Culture Jam: How to Reverse America's Suicidal Consumer Binge, and Why We Must.* New York: HarperCollins.

Longmore, Paul K. 2003. *Why I Burned My Book and Other Essays on Disability.* Philadelphia: Temple University Press.

–. 2013. "'Heaven's Special Child': The Making of Poster Children." In *The Disability Studies Reader*, 4th ed., edited by Lennard J. Davis, 34–41. New York: Routledge.

McRuer, Robert. 2006. *Crip Theory: Cultural Signs of Queerness and Disability.* New York: NYU Press. Kindle edition.

Miller, Frank, and Klaus Janson. 2007. *Daredevil by Frank Miller & Klaus Janson Omnibus.* New York: Marvel.

Morris, Jenny. 1997. "A Feminist Perspective." In *Framed: Interrogating Disability in the Media*, edited by Ann Pointon and Chris Davis, 21–31. London: British Film Institute.

Plant, Sadie. 1992. *The Most Radical Gesture: The Situationist International in a Postmodern Age.* London: Routledge.

Preston, Jeffrey, and Clara Madrenas. 2010a. "*Cripz* Goes to the Movies: *Harry Potter.*" *Cripz: A Webcomic*, December 1. http://cripz.jeffpreston.ca/2010/12/01/cripz-goes-to-the-movies-harry-potter/.

–. 2010b. "Hulk SMASH!!" *Cripz: A Webcomic*, May 26. http://cripz.jeffpreston.ca/2010/05/26/hulk-smash/.

–. 2010c. "My Criggas Are Some Criggas That You Don't Wanna Try." *Cripz: A Webcomic*, May 8. http://cripz.jeffpreston.ca/2010/05/08/my-criggas-are-some-criggas-that-you-dont-wanna-try/.

–. 2010d. "Stairbombing – Central Secondary School." *Cripz: A Webcomic*, August 31. http://cripz.jeffpreston.ca/2010/08/31/stairbombing-central-secondary-school/.

–. 2010e. "The SHUN in Fashion." *Cripz: A Webcomic*, May 19. http://cripz.jeffpreston.ca/2010/05/19/the-shun-in-fashion/.

–. 2011. "*Cripz* Goes to the Movies: *Captain America.*" *Cripz: A Webcomic*, July 26. http://cripz.jeffpreston.ca/2011/07/26/captain-america/.

Rain Man. 1988. Directed by Barry Levinson. DVD, 2005. MGM Canada.

Schalk, Sami. 2013. "Coming to Claim Crip: Disidentification With/in Disability Studies." *Disability Studies Quarterly* 33 (2). http://dsq-sds.org/article/view/3705.

Titchkosky, Tanya. 2011. *The Question of Access: Disability, Space, Meaning.* Toronto: University of Toronto Press.

Waid, Mark, and Paolo Rivera. 2012. *Daredevil*, vol. 1. New York: Marvel.

Deconstructing Phonocentrism
A New Genre in Deaf Arts

PAULA BATH

On May 4, 2014, eleven Canadian Deaf artists came together in Gatineau, Quebec, for a forum sponsored by SPiLL, a Canadian non-profit Deaf arts organization established in 2009.[1] The artists' goal was to spend a week reflecting on how their artistic knowledge and practices have been affected by logocentrism (the presumed stability of meanings), phonocentrism (the superiority of spoken language), and the historical subordination of sign language. Over the course of the forum, participants discovered new ways to conceptualize their artistic practices as well as their personal identities and everyday lives.

On May 9, 2014, with the forum complete, the participants made a presentation to a group of invited guests. Written from the voice of an invited guest and allied artist, this chapter will describe SPiLL's Canadian Deaf Arts Forum. The chapter will attempt to locate this event in space, place, and time by recording personal observations and by capturing interview-based accounts from Deaf artist-participants and forum facilitators both leading up to and during the presentation. This chapter will also outline the theoretical framework underpinning the creation of the manifesto generated during the forum and present the radical paradigm shift it offers to Deaf arts and the Canadian arts landscape in general. It will situate the development of the manifesto within the readily established context of De'VIA, a widely known American Deaf arts manifesto that has also been adopted in Canada, and will critically examine the different points of departure between De'VIA

and the new manifesto generated at the SPiLL forum. In doing so, the chapter pays particular attention to the unique contributions each manifesto makes to the growing, eclectic North American Deaf arts landscape.

The incentive for SPiLL to plan the forum came from numerous comments made by Canadian culturally Deaf artists. We define "culturally Deaf" as deaf people who identify as being a part of a linguistic and cultural minority group that is defined by the beliefs and practices of Deaf culture and in which sign language plays a central role (Padden and Humphries 2005). SPiLL distinguishes this cultural group from other people, persons with disabilities, and even other deaf people for whom sign languages do not play a central role in their everyday life. The artists' messages were clear: we need to come together to deconstruct majority language and culture-centric artistic theories and practices – in other words, to discuss the ways in which the arts, in both theory and practice, are constructed from a spoken- and written-language-centric viewpoint. Other comments described the need to build a unifying foundation between Deaf artists and to create new discourses that develop our understanding of the Deaf arts genre. The creators of SPiLL believed that the forum had the potential to further develop the Deaf arts in Canada and to ignite social change. After more than a year of planning, SPiLL's Canadian Deaf Arts Forum moved beyond an idea to a reality.

Professional Deaf artists from across Canada from both the American Sign Language (ASL) and Langue des signes québécoise (LSQ; Quebec Sign Language) communities were invited to submit their portfolios and apply to attend. Participation in the forum was restricted to Deaf professional artists, which meant that no hearing artists or Deaf non-artists could attend. This decision was criticized by some Deaf advocates (non-artists) and some hearing artists who felt it was divisive and exclusionary. The goal, as explained by organizers, was to place artistic interests above social or political concerns and create a rare and empowering space for kindred Deaf artists to meet and share their values, perspectives, and experiences. Deaf artists regularly find themselves in institutions, communities, and spaces composed of, and often run by, members of the majority language and culture (i.e., hearing people, spoken language). In addition, it was thought that a narrow focus of arts professionals would more readily bring to light the specific values and interests of Canadian Deaf artists.

Despite the wet and grey weather, the artists began to arrive. At a venue tucked away among tall green trees that only gravel roads could reach, eleven artists from British Columbia, Alberta, Ontario, and Quebec gathered in a

rural town in Quebec just twenty minutes from Ottawa. Even with the narrowed participant focus, it was readily apparent that the group was far from homogeneous. The bilingual, bicultural nature of Canada became even more apparent when bringing together members of the francophone and anglophone Deaf communities. The artists from central and western Canada conversed in ASL, while those from Quebec used LSQ. Written texts, such as signs and PowerPoint slides, were available in English and French. In addition to the use of four different languages, language modalities (i.e., visual, tactile, auditory) diverged as well. Some of the artists who were present had grown up predominantly using spoken language and had only recently begun learning a signed language, which made it a challenge to host an event in an all-signing environment. In the face of language diversity and in line with the Deaf cultural value of language equality, the organizers chose International Sign (IS) as the shared "language" to be used for all formal instructional elements of the week. Although not a language, IS is a signed communication system familiar to Deaf people and is often used at international sporting and conference events. IS transcends nationality and is used to facilitate communication between people from different countries who use different sign languages. The use of IS at the forum was, in itself, a practice of accessibility intended to relieve any one language group from shouldering the burden of communication, as would be the case if either ASL or LSQ had been chosen as the primary language of the event. It was an attempt to make information and communication accessible to people of diverse language backgrounds.

Jolanta Lapiak, the forum's presenter, led the week-long exploration in IS and provided theoretical presentations, encouraged art exchanges, and left time each day for individual art production. Each activity sought to highlight the embedded phonocentric roots anchoring the knowledge structures and practices of each artist. Lapiak, a self-titled Ameslan literary and media artist, is deaf and was born to a Deaf family.[2] Lapiak has dedicated both her academic and artistic life to exploring deconstruction and phonocentrism theory in relation to sign language. Lapiak began her exploration during her Bachelor of Fine Arts degree (2001–05), which led to further research in the same area during her Master of Fine Arts program at NSCAD University in Halifax (2005–07). Lapiak developed her master's thesis through developing deconstructed works and producing art pieces. Lapiak is inspired by Jacques Derrida's (1997) work on deconstruction theory and phonocentrism. While Derrida examines the superiority of spoken language in relation to written language, Lapiak explores the superiority of spoken

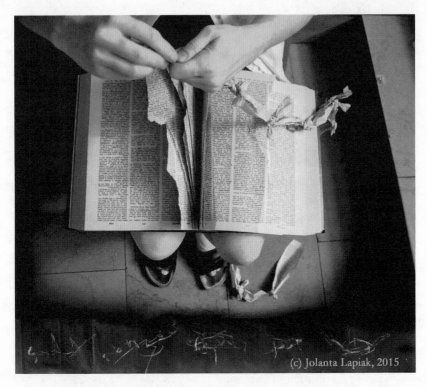

Jolanta Lapiak, still from *Unleashed from Phonocentrism*, 2007.

and written language in relation to signed language. Lapiak's work provokes deep theoretical inquiry. At a 2007 performance in Poland, *Unleashed from Phonocentrism*, Lapiak sat on a chair with a dictionary on her lap, tearing out the pages and then tying the ripped pieces together.

Deconstruction theory and phonocentrism were central ideas that animated the forum and discussions between Tiphaine Girault, Deaf artist and executive director of SPiLL, and a small circle of SPiLL colleagues. They began questioning the etiology of artistic knowledge and practice, and they wanted to deconstruct established theories and re-centre knowledge constructs from a Deaf and sign-language-centric perspective. As Girault explains:

> I am a comic artist. "Talk bubbles" extending from the mouth are used to show when characters are talking. I was taught and expected to use this technique, at university, but I have began to question – from a pure sign language-centric perspective – would talk bubbles exist naturally? Or would another technique be developed? I was eager to have these kinds of

discussions with other Deaf artists from different art genres. (Tiphaine Girault, personal communication, May 9, 2014)

Lapiak had been waiting for an opportunity to bring her body of work to a group of people. She felt confident that the pairing of deconstruction theory and the arts could give way to a manifesto and a movement.

Before I delve further into the discussions and insights resulting from the forum week, it is important that I situate this event in the context of North American Deaf arts history. A group of Deaf artists in the United States, decades ago, began to develop new vocabulary, discourses, and understanding of Deaf arts. Their work has shaped the contemporary conceptualization and understanding of Deaf arts in Canada. The movement, and subsequent manifesto, that marked this historical beginning is known as De'VIA.

De'VIA's Contributions to Deaf Arts

De'VIA (also written as Deaf View/Image Art) is not only a manifesto, but also a movement that has been growing steadily since its inception in 1989. During that year, in Washington, DC, at the Deaf Way I: International Conference on Deaf Culture, nine American Deaf artists met for four days. They discussed their art practices, their Deaf experiences, and the interaction between the two. The group, made up of painters, sculptors, fibre artists, video artists, and an arts historian, combined their experiences and ideas and developed a manifesto, which they named De'VIA (Durr 2006). The De'VIA movement seeks to foster minority cultural development, resists colonial pressures, and increases linguistic and cultural visibility.

Words such as "De'VIA" and "Deaf View/Image Art" are written representations of a concept that originated in American Sign Language. In ASL, the name has been recorded as (represented here in ASL gloss) DEAF-MINDBLOWUP-ART and DEAF-SEE-PICTURE-ART. This action was described by Patti Durr (1999, 51) as a cultural act of resistance: "The abbreviation itself [De'VIA] is an act of resistance by trying to create a totally new term that would reflect the meaning in the spirit of ASL rather than in English, the language of the dominant culture."

The De'VIA manifesto seeks to unravel the Deaf subject from the medical, political, and social constructs of deafness created by members of the majority language and cultural groups – hearing people. It seeks to capture experience from the perspective of a Deaf subject and to build a cultural foundation through shared experience. The De'VIA manifesto reads as follows:

De'VIA represents Deaf artists and perceptions based on their Deaf experiences. It uses formal art elements with the intention of expressing innate cultural or physical Deaf experience. These experiences may include Deaf metaphors, Deaf perspectives and Deaf insight in relationship with the environment (both the natural world and Deaf cultural environment), spiritual and everyday life. (RIT 1989; Deafart n.d.)

In doing so, the De'VIA movement also resists hegemonic discourses and oppression. By accounting for Deaf experiences, De'VIA responds, through art, to experiences of social and cultural marginalization. It engages in practices of resistance to the oppressive forces often generated in a non-Deaf-(hearing-)centric world that can impose itself onto culturally deaf people and the Deaf cultural way of life. De'VIA gives Deaf experience visibility, space, and place.

This brings us to another one of De'VIA's contributions, and the last one discussed in this chapter: increasing cultural visibility. In her article titled "De'VIA: Investigating Deaf Visual Art," Durr (2006, 168) writes that, like other marginalized groups, Deaf people have a strong desire to use art as a medium to record their history and preserve their culture, share and represent their collective experiences, and make social and political statements to bring about social change. She goes on to explain that following the De'VIA manifesto, a collective consciousness began to take shape, which was explored by examining the common themes found in two art categories: resistance and affirmation (169). While resistance art explores experiences of audism, oralism, identity confusion, and eugenics, affirmation art examines sign language, group affiliation, acculturation, and Deafhood.[3]

De'VIA is not limited to the American Deaf arts movement. It is an art genre present in the work of Canadian Deaf artists as well. The work of Canadian Deaf printmaker Tiphaine Girault was recently displayed at the *Viva De'VIA* exhibit (2014) at the Dyer Arts Center in New York. Her work, *Fragilité*, is a black and white image depicting a woman with her face covered, surrounded by symbols of feathers and hand-feathers, and holding an eye in the palm of her hand. Her piece depicts a sense of value for the visual and for sign language and calls for its protection and preservation.

De'VIA was pivotal in the Deaf arts genre, generating new vocabularies and stimulating new discourses that began to define concepts that were previously unknown. Along with neologism, it spurred cultural development in the Deaf community and contributed to linguistic and cultural visibility.

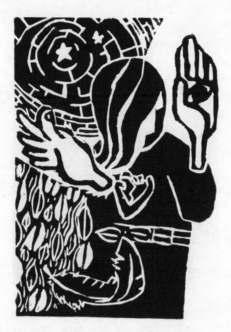

Tiphaine Girault, *Fragilité (Fragility)*, 2014.

Along with its contributions to early Deaf art history, De'VIA faced struggles and limitations. De'VIA was mistaken as a single, unifying definition of Deaf arts, when it can be argued that no one category can contain and reflect every perspective, idea, and piece of knowledge. Experiences will be left unexpressed and needs will traverse the category's prescribed boundaries. These shifts occurring in Deaf arts, however, do not pose a threat to the ties that bind De'VIA, but represent an opportunity for inquiry, for discussion, and for a more complex understanding of experience. These shifts give way to new discourse, new knowledge, and, in this case, art activism.

Traversing the De'VIA Boundary

Over the years, De'VIA has struggled with a number of issues. It has been criticized for lacking a formal connection to theory (Miller et al. 2006), and it establishes identity dichotomies by ignoring identity intersectionality (Jolanta Lapiak, personal communication, September 1, 2014). In 2002 at the Deaf Way II conference, some of the original signatories of the De'VIA manifesto presented *Deaf View Image Art: A Manifesto Revisited*. An audience member argued that De'VIA's lack of connection to mainstream art

history and theory calls into question whether this is "real art" or "true art" (Miller et al. 2006).

At the same event, De'VIA was defined to recognize only Deaf artists whose art was informed by their Deaf experience. Established with the goal of creating a space of cultural distinctiveness and pride, it invariably constructs identity dichotomies and barriers by excluding members from its own cultural group. During the presentation, the work of a Deaf artist, David Bloch, was discussed. His work, produced in the 1960s and 1970s, captured the experiences of deaf survivors of the Holocaust. When the De'VIA presenters were asked if Bloch's work would be classified as De'VIA art, the response was that this would depend on which cultural construct – Jewish or Deaf – was considered prominent during the production of the pieces (Miller et al. 2006). One can argue that, given this example, it would be difficult to dissect the "deaf experience" from a deaf person's lived experience – just as it would for a woman to remove her female experience or a father to remove his parental experience, and so on. There is still some ambiguity regarding whether hearing artists can produce De'VIA artwork. The text from the original 1989 De'VIA manifesto states that it includes "Deaf experience" *only* and excludes hearing artists' experience of Deaf-related themes. In 2002, De'VIA resolved to re-examine the exclusion of hearing artists, and Durr (2006) writes that De'VIA may be created by deaf, deafened, and hearing artists. That being said, more recently the Deaf Culture Centre defined De'VIA as art that stems from shared and common experiences between Deaf people by saying that De'VIA is art that "communicates our Deaf experience" (Deaf Culture Centre n.d).

In addition to the ambiguity regarding the inclusion or exclusion of hearing or non-Deaf artists, the definition of De'VIA can be seen to exclude deaf people if their artwork does not reflect a perceived "Deaf experience." De'VIA's emphasis on reflecting Deaf experience creates a cultural cohesion; on the other hand, any artist's work created without the intention of displaying their Deaf experience would fall well outside De'VIA's boundaries. The work, however, would exist in no Deaf arts category at all, since De'VIA is the only identified category used in North America to date. Although the definition of "Deaf experience" may still seem ambiguous, De'VIA nonetheless plays an important role in providing visibility through artistic accounts of the diverse experiences of Deaf people. In one way, the shifting body of knowledge and boundaries of De'VIA point to the need to continue investigating and defining Deaf arts theories and practices.

A New Point of Departure: Introducing a Deconstructivist Theoretical Framework

To understand how the new Deaf arts manifesto (developed at SPiLL's Canadian Deaf Arts Forum in 2015) builds on the pioneering work of the De'VIA movement, one should first consider Derrida's work on deconstruction and phonocentrism (Blackburn 2014; Jolanta Lapiak, personal communication, September 1, 2014). Derrida (1997) writes that there is a historical subordination of written language in relation to spoken language. Throughout time, this subordination has made its impact on societal knowledge constructs and on the presence of language in society. Derrida is known as the leader of the deconstructionist movement and made great strides in his work to dismantle spoken language superiority, also known as phonocentrism. Derrida's work did not, however, refer to spoken language superiority and signed language. Lapiak advanced Derrida's phonocentrism ideas by applying his theories to the subordination of sign language, and she uses the term "~~phonocentrism~~," in this manner with the strikethrough, to signify the deconstruction of phonocentrism in relation to sign language.

At the core of Derrida's (1997) theory is a critique of logocentrism, the starting point of logic, truth, and reason. Lapiak, the forum's facilitator, purposefully refers to herself as an "Ameslan artist" (and not Deaf). By doing so, Lapiak believes she resists the "deaf-hearing" binary by-product of logocentrism (Lapiak 2009). In Derrida's work in deconstruction theory, he deconstructs logocentrism and the presumed stability of meanings. The notion of deconstruction was first presented in the introduction to his 1962 translation of Edmund Husserl's *Origin of Geometry* (Derrida 1962). Derrida urges the importance of acknowledging the conflicting elements of an author's message, where the message itself can be undermined by its presentation (Blackburn 2014). Derrida goes on to say that the tendency to fix knowledge centres, in turn, generates oppositional lines of thinking, which need to be undone. He argues that instead of fixing centres of meaning (i.e., deaf and hearing), it is more beneficial to apply the practice of interpretation and reinterpretation, which is at the core of deconstruction theory and analysis.

Derrida's (1997) phonocentrism theoretical framework provides fruitful ground to examine the superiority of spoken language in relation to signed language. In addition to its connection with Lapiak's work, Derrida's phonocentrism theory has been linked to Deaf studies as demonstrated by the work of H-Dirksen L. Bauman (2008), who argues that "Derrida's critique [of phonocentrism] introduces the metaphysical backdrop, the ontological

orientation that sets up the conditions for institutions to enforce speech as the human norm. The notion of phonocentrism is beginning to enter the critical consciousness of Deaf Studies." The cumulative impact of phonocentrism on Deaf people over centuries is evident in various settings, such as social, education, and media settings. It can account for the subordination of sign language in society and the prevalence of long-standing myths about sign language. One such myth is that sign language is a universal language incapable of expressing abstract concepts. Phonocentrism has affected educational policy by the oppression of sign language use (Bauman 2008). It has also affected discourse constructions found in mainstream media with sign language being represented predominantly as a manual coded system of communication representing access to spoken language (Bath 2012).

Phonocentrism, Sign Language, and Deaf Art

In the weeks leading up to SPiLL's Deaf Arts Forum, the anticipation among the participants began to build. One participant, published comic artist Jean-François Isabelle, posted a four-panel image titled *Phonocentrism to Visuocentrism*. The black-and-white comic is a self-portrait of Isabelle, who starts off thinking in words, reflects on the concept of phonocentrism, then thinks in sign language and replaces the term "phonocentrism" with "visiocentrism." This comic displays his initial reflections on the concept of phonocentrism, yet to be explored. Isabelle's work asks, if we could replace *phono*centric knowledge structures with Deaf knowledge structures, what would exist in their place? (Isabelle, personal communication, May 9, 2014).

Isabelle's initial thinking, pre-forum, appears along the lines of De'VIA. Commonly discussed in Deaf studies is the notion of *visual*-centric knowledge structures. Ben Bahan (2008), a Deaf ASL literary artist and author, writes, "d/Deaf people are often referred to as visual-centric in the way in which they perceive the world around them." This line of thinking, replacing *phono*centrism with *visual*centrism, however, can be seen as a dichotomized approach to thinking. Arguably, De'VIA attempts to replace the focus of a "hearing" experience with a "Deaf" experience. Like De'VIA, phonocentrism theory is an act of resistance; its point of departure, however, is different. It seeks to deconstruct phonocentrism by placing sign language on par with spoken language.

Jolanta Lapiak, although inspired by Derrida's work in deconstruction and phonocentrism theory, struggled with representing the term in written

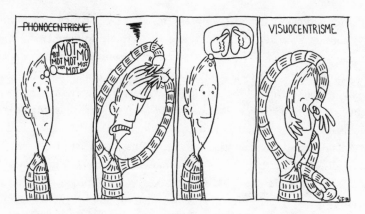

Jean-François Isabelle, *Phonocentrism to Visiocentrism* (translated title), 2014.

and signed language: "When I write or sign the word 'phonocentrism' I feel like I have reconstructed it, visually," explains Lapiak (personal communication, September 1, 2014). "I decided to then write and sign "~~phonocentrism~~" with a strikethrough, like it is under erasure. It is word play at a lexical level and, when applied to sign language, I feel it paves the way to develop new knowledge, theoretical concepts, and the opportunities for learning."

Written with a strikethrough, ~~phonocentrism~~ (signed in ASL gloss as 25-CIRCLE-TEMPLE-CROSSOUT) visually deconstructs the concept of phonocentrism. These concepts are artistically explored further during Lapiak's public art performances. In each piece she links ~~phonocentrism~~ to the concept of language and transformation. She takes pages of the English dictionary and burns, rips, crumbles, and shreds the pages. Page after page, word after word become extinguished. Dictionaries lie empty. The paper pages are tied together and then burned. The ripped pages are crumpled and then symbolically eaten. The violence felt during the performance is the artist's reflection of the spiritual violence that signed languages have suffered through the decades.

A key distinction between De'VIA and ~~phonocentrism~~ is that De'VIA is a Deaf experience movement and ~~phonocentrism~~ is a deconstructivist movement. Where De'VIA would represent, in resistance art, the possible oppressive experience of cochlear implants on Deaf identity, ~~phonocentrism~~ art would question the issue of phonocentrism, which prioritizes speech over signing (Jolanta Lapiak, personal communication, September 1, 2014).

While both movements resist oppression, De'VIA is concerned foremost with bringing visibility to Deaf experience, while ~~phonocentrism~~ is concerned about the current knowledge structures underpinning particular views or beliefs and critically analyzing those beliefs in relation to language. Moreover, unlike De'VIA, which looks at Deaf arts only, the theory and practice of ~~phonocentrism~~ can be applied to any domain: language, community, institutions, social practices, or education. In the case of SPiLL's Deaf Arts Forum, Lapiak applied the theory and practice to Deaf arts. Véro Leduc (this collection) describes her experience with the "question of language." She writes, "How could I embrace a creative process that situates sign language at the forefront and not just in subsequent translation?" Arguably, Leduc's inquiry can be seen as rooted in ~~phonocentrism~~ theory. Leduc's stance in deconstructivism was the catalyst to redefining the language practices in comic arts, by placing sign language as the dominant language. With deconstructivism, the implications reach far beyond art. In Leduc's case, her sign-language-centric comic art not only redefines an arts practice, but also has implications for language practices and the "writing" of a PhD thesis in general.

SPiLL's ~~Phonocentrism~~ Deconstruction and Deaf Arts Forum

On May 9, 2014, the final day of the forum, a now somewhat dishevelled retreat centre displayed tangible memories of the week's journey for the eleven artists: wet paint brushes lay in the large utility sink, pieces of charcoal were piled in plastic containers, and scrap paper with pencilled sketches was left scattered on tables. The halls were buzzing with the artists, and the week's organizers were preparing the large common room for the arrival of a small invited public. Those invited comprised the Deaf community, event funders, national and local arts funders, university and private researchers, and writers. The guests were invited to learn about the discussions and insights generated during the forum, witness the unveiling of the *Phonocentrism Deconstruction* manifesto, pose questions, and interact with forum participants. The eleven artists and forum participants were Chantal Deguire (filmmaker, Ontario), Christopher Welsh (puppeteer, Ontario), David Sullivan (visual artist, BC), Elizabeth Morris (actor, Ontario), Jean-François Isabelle (JiF; comic strip artist, Quebec), Pamela Witcher (visual artist, Quebec), Peter Owusu Ansah (visual artist, Ontario), Shannon Rusnak (web developer and media specialist, Alberta), Sylvain Gélinas (filmmaker, Quebec), Tiphaine Girault (comic strip artist and printmaker,

Quebec), and Véro Leduc (comic strip artist and painter, Quebec). As the invited guests began to gather in the large common room, the manifesto, hanging against a solid stone fireplace, quickly became a discussion piece. What did it mean? Why was it created? Written on two white poster boards, the piece articulated the collective ideas that had germinated during the week and was written in both French and English with recorded ASL and LSQ video versions. The *Phonocentrism Deconstruction* manifesto as presented on May 9, 2014, reads as follows:

> A ~~Phonocentrism~~ deconstructionist is a creative person who produces a work that questions, challenges and redefines phonocentric construction, seeks to recreate new formation through practice and process, and to induce social change.
>
> 1) Reframing from ~~phonocentric~~ to holistic diversity
> 2) Deconstructing logo-phonocentric implications in literature, language, image, symbol, behaviour, belief, and/or attitude
> 3) Works created by linguistic-cultural people of signed language
> 4) Use of any forms of text, such as momentary action, word, painting, drawing, video, digital media, poetry, sculpture, performance, design, installation, calligraphy, film, photography, graphic novel, drama, music, dance, and/or any other forms
> 5) Reframing from the thought lineage from Plato and Aristotle to thought lineage from the Derrida era
> 6) Sculpting language as a malleable material (thought and perception)
> 7) Advocacy and promotion for language rights of signed languages in both signed and written forms

One of the most striking initial observations about the manifesto is its omission of the word "Deaf." For a group of Deaf people to produce a text that does not include the term "Deaf" or the concept of "Deafness" in some way is essentially unheard of – arguably with good reason, since for centuries Deaf people have experienced repeated systemic oppression and, as a result, work to increase the visibility and an informed awareness about Deaf culture, Deaf people, and signed languages. One way to do this was through linguistic representation. Writing the term "Deaf," capitalized, is one such example. Rooted in self-representation efforts, the term moves beyond the medicalized meaning of "deaf" and encapsulates the meaning of people who

are deaf and who are members of a linguistic and cultural minority group. The conscious omission of the term "Deaf" could be seen, by some, as contradicting these efforts. From a deconstructivist viewpoint, however, this is not the case. The intention is to deconstruct existing logocentric and binary constructions (i.e., hearing and deaf) represented in language and to create a new space – a phonocentric space. This space emphasizes sign language and embraces complex identity constructs of gender, race, ability, and culture. It does not establish identity constructs in relation to audiology (i.e., deaf, hearing, hard of hearing). Everyone in the space is fluent in and/or committed to the equal presence of sign language. This is a fundamental distinction between phonocentrism and De'VIA. This theoretical discovery provided grounds for reflection for SPiLL's executives, future Deaf arts forums, and the arts and society in general. The original intent of this forum was to be for Deaf artists only. Now, in the face of phonocentrism theory, the membership criteria naturally shift. The criteria transcend the traditional audiological boundaries to create a space that invites all artists who sign.

Back in the forum centre, as one gazed around the room, the otherwise bare beige walls were lined with artwork – some pre-forum projects and several experimental pieces produced during the forum. Just to the left of the manifesto, Jean-François Isabelle's work hung. It included two large poster boards and a series of white sheets of paper with various dark pencil and coloured pastel sketches. They were just the beginning of his reflections from the forum. When asked if his four-panel comic, *Chroniques sourdiennes – Phonocentrism to Visuocentrism*, created pre-forum, still reflected his thoughts and ideas, Isabelle replied in LSQ:

No [shaking his head and smiling]. I will have to spend some more time on it. I am the kind of person that needs to take things away and integrate what I have learned – but for sure my art has changed. I look back at my earlier work and see that my art was very dark, angry. Phonocentrism has opened me up to a beauty that I did not have access to before. This beauty stems from being grounded in a phonocentric space where signed languages are placed on equal footing with spoken languages. I do not have to fight to put it there. (personal communication, May 9, 2014)

A few months after the forum, Isabelle disseminated a revised four-panel comic piece revisiting his reflections on phonocentrism. This version of the

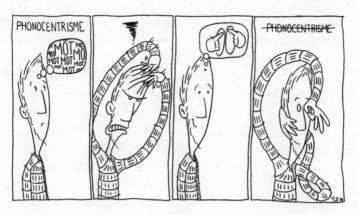

Jean-François Isabelle, *Phonocentrism to ~~Phonocentrism~~* (translated
title), 2014.

Chroniques sourdiennes strip is titled *Phonocentrism to ~~Phonocentrism~~*. It
speaks to the deconstruction of phonocentrism and is distinct from the ori-
ginal piece (shown on page 191). It depicts the exact same sequence of im-
ages as the original, but begins with phonocentrism as the basis of inquiry
and replaces it with ~~phonocentrism~~. The message is that ~~phonocentrism~~
does not readily replace one paradigm for another. It marks a new point of
departure as opposed to an answer. When one is in the space of inquiry and
deconstructs phonocentrism, new ways of seeing and doing result. These
new ways centre the concept of language and challenge the problematic
constructions of spoken languages as superior to signed languages.

Conclusion

In discourse, when something is absent – a concept, a meaning, a word, a
sign – there is no hole. There is no gaping black void easily identified, de-
fined, avoided, or filled. It is not like peering down a volcanic geyser, up an
entrance to a rocky cave, or into a dark rabbit hole. There exists no space at
all. What exists is just what has already existed – various ideologies, mean-
ings, words, and signs. As Jen Rinaldi and nancy viva davis halifax (this col-
lection) write, "Absence functions as a prerequisite for presence to hold."
The prerequisites, in this case, are the socially constructed discourses re-
inforcing a majority-positioned perspective in the arts.

The De'VIA and ~~phonocentrism~~ movements are parallel movements, yet
distinct in ideological standpoints. Both movements have begun the vital
process of mapping a diverse group's shared experiences. This process is

powerful and gives new language to new concepts stemming from unique perspectives and experiences. Prior to the De'VIA manifesto, the concept, sign, word (spoken and written) did not exist in North America, and over the years it has evolved as communities have evolved. At the time of this volume's publication, the public release of the *Phonocentrism Deconstruction* manifesto was too recent to analyze its impacts, its criticisms and limitations. Possible areas of future research could be to look at (1) how *Phonocentrism Deconstruction* has or has not had any destabilizing influences on artistic theory and practice; (2) what struggles it encounters as it challenges existing language, theory, knowledge structures, and practices; and (3) what criticism from the Deaf, Deaf arts, and mainstream arts communities it has received.

The signatories and presenters of the De'VIA manifesto stated that De'VIA developed out of a need to present Deaf experience in art. Arguably, De'VIA also presents Deaf experience beyond art, but in the world. De'VIA proponents encouraged other Deaf communities around the world to meet, to discuss, and to adopt the De'VIA manifesto and/or to generate their own reflection of their community's values and ideas. De'VIA was never intended to be an ending, but a beginning. In the face of another noticeable absence, the creators of the *Phonocentrism Deconstruction* manifesto also created new space – a new beginning. This new space did not exist before the forum, but together the Deaf artists created it by creating a new vocabulary and language from the perspective of deconstructivist theory. The *Phonocentrism Deconstruction* manifesto marks a new theoretical point of departure and the beginning of another Deaf arts genre.

NOTES

1 The word "Deaf" is capitalized to signify people who are deaf and engage in a Deaf cultural way of life by participating in the socio-cultural and linguistic practices of the Deaf community.

2 "Ameslan," meaning American Sign language, is an obsolete term from the 1960s that Lapiak revitalizes.

3 Audism, as coined by Tom Humphries in 1977, is a form of discrimination based on the notion that one is superior because of one's ability to hear.

WORKS CITED

Bahan, Ben. 2008. "Upon the Formation of a Visual Variety of the Human Race," In *Open Your Eyes: Deaf Studies Talking*, edited by H-Dirksen L. Bauman, 83–99. Minneapolis: University of Minnesota Press.

Bath, Paula M.C. 2012. "Perspectives from the Deaf Community: Representations of Deaf Identity in the *Toronto Star* Newspaper (2005–2010)." Master's thesis, University of Ottawa.

Bauman, H-Dirksen L. 2008. "Listening to Phonocentrisms with Deaf Eyes: Derrida's Mute Philosophy of (Sign) Language." *Essays in Philosophy* 9 (1). http://commons. pacificu.edu/cgi/viewcontent.cgi?article=1288&context=eip.

Blackburn, Simon. 2014. *The Oxford Dictionary of Philosophy*. New York: Oxford University Press.

Deafart. n.d. Home page. Accessed April 25, 2014. http://www.deafart.org.

Deaf Culture Centre. n.d. "De'VIA." Accessed March 30, 2016. http://www.deaf culturecentre.ca/public/visualarts/DeVia.aspx.

Derrida, Jacques. 1962. *Edmund Husserl's Origin of Geometry: An Introduction*. Lincoln, NB/London, UK: University of Nebraska Press.

–. 1997. *Of Grammatology*. Translated by Gayatri Chakravorty Spivak. Baltimore: Johns Hopkins University Press.

Durr, Patti. 1999. "Deconstructing the Forced Assimilation of Deaf People VIA De'VIA Resistance and Affirmation Art." *Visual Anthropology Review* 15 (2): 47–68.

–. 2006. "De'VIA: Investigating Deaf Visual Art." *Deaf Studies Today* 2: 167.

Humphries, Tom. 1977. "Communicating across Cultures (Deaf/Hearing) and Language Learning." PhD diss., Union Graduate School, Cincinnati.

Lapiak, Jolanta. 2009. "in the eye of phonocentrism: video documentation."

Miller, B., D. Sonnenstrahl, A. Whilhite, and P. Johnston. 2006. "Deaf View Image Art: A Manifesto Revisited." In *The Deaf Way II Reader: Perspectives from the Second International Conference on Deaf Culture*, edited by H. Goodstein, 251–64. Washington, DC: Gallaudet University Press.

Padden, C., and T. Humphries, T. 2005. *Inside Deaf Culture*. Cambridge, MA: Harvard University Press.

RIT (Rochester Institute of Technology). 1989. "Deaf View/Image Art: De'VIA." http://www.rit.edu/~w-dada/paddhd/publicDA/main/expressionsofculture/ DeVIA/index.htm.

Crip the Light Fantastic
Art as Liminal Emancipatory Practice in the Twenty-First Century

jes sachse

Come, and trip it as you go,
on the light fantastic toe.

— *John Milton, "L'Allegro"*

As John Milton's pastoral poem evokes, to get from point A to point B involves negotiation with space. To trip the light fantastic is to dance nimbly and lightly. It conjures up intentional lightness and air.

I have been undertaking the project of curating disability since 2008, and since that time, the digital landscape of our multimodal cultural production has changed considerably. As both artist and curator, I have quested to explore ways of depicting disabled embodiment outside of the photograph of the disabled body, creating new, radical simulacra and iconography that could mirror advances in disability justice, and acknowledge virtual networks, while dispelling the ableist myth of the individual.

In discussing the satiric body as a weapon – that is, the ways metaphor is used against marginalized bodies – we cannot ignore activisms that have used art and have strategically placed a vulnerable body as subject. These examples take on the project of speaking back to legacies of structural violence wreaked on "real" bodies. While vulnerable bodies are often metaphors used in a variety of ways in activism and art writ large, there are also

actual vulnerable bodies who intentionally create art to disrupt the harms of normativity.

While I often discuss the *abject*, reflecting Julia Kristeva's (1982) conceptualization as it pertains to the grotesque body, that body is not a homogeneous entity. To be more different than different, as it is defined by normal, is to fall off the map entirely. The project of decolonization centres within it a colliding and overlapping of disability, race, citizenship status, class, sexuality, and modes of communication. When we think about disability, we must also begin to think about place, about access to healthcare, about a presumed safety in that identity, about the situation in the global North or South, about conditions inside an asylum, and about assumptions of independent living.

Walt Whitman once said, "To have great poets, there must be great audiences."[1] I do not think he was merely being humble. He was pointing out the supercilious human tendency to leave context uncredited. We call the lack of empathy people possess for experiences outside their own "ignorance," and suggest instead that people be "tolerant" of difference. But rarely do we engage willingly with the magnificence of this unique terrain – that is, with difference and abjection.

In Canada, there is an invisibilizing politic of "inclusion" when it comes to speaking about disability. Somewhere along the way, Canadians have convinced themselves that if we just do not say the words, then the bad things did not happen. The language of disability, for example, is an ever-shape-shifting dance of "I see a person, not a disability," which simultaneously denies experience and legitimacy of voice. Without the power of self-advocacy, which is allegedly enshrined in this ever–politically auto-correcting language, the so-censored discourse creates repetitively flaccid dialogues, out of which provocative and momentous thinking and art cannot grow.

As an emerging artist, being given small platforms in and just outside the overlapping bubbles of academia and radical queer networks has afforded me opportunities to reflect on what it means to be an artist in Canada. National identity is something that this country strives to protect and perpetually manicure.

There is a very good chance that if you were to look at a picture of me, you would recognize me, at least at this moment in time. You might not know how, but you would be unmistakably sure you had seen my face before. That is not simply because I have a visible facial difference, an earmarker of my genetic condition. It is because, in 2010, I went viral.

Meme a Little Meme of Me

My interest in collaboratively participating in the public exhibition of *American Able* in 2010, a photograph series critiquing Dov Charney's notorious American Apparel fashion ads, lay squarely in the arena of political satire. The narratives told by *American Able* bump up against the politics governing how we are allowed to view disability. Mimicry of a ubiquitous and controversial fashion advertisement invites viewers to gaze at disability, at visible difference, and thereby become aware of themselves. An obvious disabled sexuality is met with confusion and resistance. The work challenges through art the history that we have memorized and boldly rewrites it as a history that we have ignored.

Years later, this series still causes ripples, despite no longer being current. Because disability art is still in the process of emancipating its creativity from the systemic forces that disable its corporealities, its content remains relevant and is arguably renewed with each surge of "shares" and "likes." Through the rapid digitization of our practices, cultural curation has become increasingly transient – despite early notions of this being an evolutionary step in archival development. No longer are works thought of as necessarily responsible to a linearity of progress; instead, they are now seen as a mutating network of relevance.

The Internet has illuminated the idea of networks versus locations. This notion of networks dispels the false human idea of the autonomous self. It reveals that we are an interdependence of factors, all living together as one thing and many things. If I lose a limb, I still exist. If I gain a prosthetic, I have not multiplied, whether that prosthetic be in the form of a care worker, an artificial limb, or a smartphone in my hand.

Platforms of social media have sculpted a hyperdemocracy of sharing and "liking" over the last decade, an exercise in Deleuzian foretold assemblages that have thrust various communities of marginalized voices into the mainstream of societal pulp. Invocations of voyeurism within a framework of the subject's choosing, whether sexual, satirical, political, or all of the above, involves the enactment of a new, multidirectional relationship between subject and audience, wherein both parties are, in fact, weaponized – made to destroy, disrupt, and assert power.

How, then, in the ubiquitous excitement of this burgeoning digital tool of liminal emancipation through art, do we warehouse violence? How can we examine harm and systemic harms in an environment that is giddy with liking, sharing, and "access for all?" Through my own praxis of philosophical intrigue as curator, political reactions as consumer, and personal response

as artist, I feel there is a need to cache untameable spectres of vitriol. In archiving, reframing, and reflecting on this vitriol in a digital age, we might begin to ask, what evolving curatorial responses have been generated by the assemblage of this awakened cyborg reality? What are some examples of a curatorial relationship that effectively keeps pace with the ways in which information sharing involves much more than just text and image, but rather a new language out of which a fragmented layer of links and traces are perpetually being moved through?

Dan Gilroy's debut crime thriller, *Nightcrawler* (2014), stars Jake Gyllenhaal as lead character Lou Bloom. Set in Los Angeles, the movie has Gyllenhaal playing a character who is supposedly a symbol of the late-twenty-something generation's utter jobless scramble against the harsh backdrop of a bleak economy and who is ultimately drawn to the rogue world of breaking news coverage. What fascinates me most about the film is how accurately it depicts the cultural age we are living in now – the Age of the Internet, depicted also as the Age of Curation or Curation en Masse.

It is not enough for Bloom to catch gripping footage by chance – he must sculpt and present every element of his work to play into the ways it contributes to stereotypes, stigmatizations, and fears that will ultimately reward him profitably. He is creating a brand and, simultaneously, laws and lives bend around that pursuit.

This should give us an indication of what art as emancipation is up against – an evolution of hyperstorytelling framed by whomever has the most hits, and those hits awarded to the fear or image or idea most affecting.

My experience as a disabled artist also working within themes of disability very much informs my curatorial approach to disability arts, along with the four years I spent working in journalism at the weekly Trent University news publication *Arthur*, of which I eventually became co-editor-in-chief (2010–11); often, it is how someone else tells your story that becomes louder than your own truth.

With a groundswell of radical artists in Canada pushing back against and attempting to decolonize disability through art, without disabled curators, arts sector employees, policy makers, and city cultural planners, we see the effect of "three limps forward, two limps back."

During every interview I gave when *American Able* first appeared, everyone seemed to refer to it as "a campaign," like I was selling body soap or something. Few took it seriously as a radical artistic framework or idea. Of course, this is not my only artistic work, but it was and still is the first (and perhaps only) work of mine to truly pervade the mainstream consciousness.

Because art is no longer required to be in active exhibition, its context may change as innumerably as it is searched, shared, tweeted, reblogged, and hyperlinked. This answers a desire for proliferation. But what exactly is being created? What are the frameworks of understanding through which we attempt to view and manage disability through art?

Prison and Asylums: How We Produce Disability

Disability art in Canada still remains entrenched in a white-centred charity model, one that largely fails to acknowledge the way that disability is simultaneously produced by global economic capitalism's effect on the South, by the prison industrial complex (PIC), and by the genocide inflicted on Indigenous people in Canada since contact. As Syrus Ware, Joan Ruzsa, and Giselle Dias (2014, 163) explain,

> The PIC is based on a set of interests created and maintained to support capitalism, patriarchy, imperialism, colonialism, racism, ableism, and white supremacy. When we begin to see the magnitude of the tentacles of the PIC and how it works to maintain power and control, we begin to understand that it is not a mistake that poor disabled indigenous and racialized bodies fill these spaces.

In 2010, Canada's Office of the Correctional Investigator released a report about the growing needs of prison populations. In a press release about the report, Correctional Investigator Howard Sapers states:

> Canadian penitentiaries are becoming the largest psychiatric facilities in the country. The Correctional Service of Canada assumes a legal duty of care to provide required mental health services, including clinical treatment and intervention ... In failing to meet this legal obligation, too many mentally ill offenders are simply being warehoused in federal penitentiaries. This is not effective or safe corrections.

This legacy of "warehousing" is applicable not just to prison spaces, but also to residential workforce schools for children and adults with disabilities. The most infamous of these was Huronia Regional Centre, a residential facility that closed in 2009 and was followed by the largest class-action lawsuit of its kind, which garnered a settlement of $35 million and a public apology from the Crown, delivered by Ontario Premier Kathleen Wynne. This historic achievement must include the rigorous work of ensuring that

justice is carried out for people who endured, in some cases, lifetimes of incarceration and abuse simply for being disabled. I am a member of a Toronto-based group working to support Huronia survivors, and I learned that doctors in the Ontario healthcare system would inform parents of children with disabilities that there was no other place for them to live a fulfilling life and urge their deportation to the facility and no further or ongoing contact. Social injustice, however, is further affected by state-sanctioned ableist violence, as care workers and group homes have been discovered to be withholding information to potential claimants because they fear that the topic of Huronia would "open old wounds" and they would have to "de-escalate" their client.

I have listened to these and many other harrowing accounts as a member of this group, which also involved attending the government's invitation-only "Open House" tours. Survivors were able to take tours of the space, as well as attempt to procure and store remaining items and fragments of the architecture with the hope of one day curating an exhibit that centres on survivors' stories and art. Additionally, we curated a show that took place on the International Day of Persons with Disabilities (December 3, 2014, Urbanspace Gallery, Toronto), almost exactly one year after the premier's apology to survivors. In the words of lead plaintiff Pat Seth, "We need to think about what art can do that a settlement or apology can't do."

Both prisons and massive residential institutions are warehouses of violence and abuse that have had a huge impact on disabled history in Canada and the production of disability itself, through abuse and neglect, racism and colonialism. As far as art is concerned, these spaces are invisible publics, not interacted with in the same manner as other communities where cultural production is nurtured and grows (see Warner 2002). Many "art shows" have and continue to occur using the work and artistic property of incarcerated inmates or asylum dwellers, not only not to their benefit (financially, or in a sense of professional development), but also, shockingly frequently, without crediting individual artists at all (holding gallery shows with unsigned, uncredited artworks, but naming the institutions from which they came, thereby creating a sort of lore). We should not only be telling these stories but also changing the framing and formats in ways that could reflect some of the revolutionary nuances of twenty-first-century cultural production.

Elizabeth Grosz illuminates the importance of framing (or arguably curating) artistic works, while also pointing out that art itself shifts our frames of reference. She writes:

Like architecture, art is not only the movement of territorialization, the movement of joining the body to the chaos of the universe itself according to the body's needs and interest; it is also the converse movement, that of deterritorialization, of cutting through territories, breaking up systems of enclosure and performance, traversing territory in order to retouch chaos, enabling something mad, asystematic, something of the chaotic outside to reassert and restore itself in and through the body, through works and events that impact the body. If framing creates the very condition for the plane of composition and thus of any particular works of art, art itself is equally a project that disjars, distends, and transforms frames, that focuses on the intervals and conjunctions between frames. (Grosz 2013, 18)

I hope one example of transforming the terriorities that frame disability is my work, *Freedom Tube*. The drinking straw, or more affectionately "freedom tube" for folks with various disabilities, represents a tether, a connection, an ability to access something. During a two-week stay at Artscape Gibraltar Point on the Toronto Islands, I was able to spend a great deal of time thinking about this small synthetic and innocuous object, present in front of me in the thousands. Alone, it is a symbol of freedom; woven together, it is home.

Another prominent symbol is the ramp. I had the opportunity to contemplate this object while constructing a piece I called *wish you were here:* an outdoor sculpture that was the culmination of a month-long disability-focused residency, accumulated in over eighteen metres of angle iron. Placing the artwork in a public domain outside the gallery setting subsequently subjects it to the elements, to rust and weathering – a metal object alive in its subjectivity and, thusly and necessarily, on a trajectory toward death. The skeletal assemblage presents a ramp structure standing over 120 centimetres high and wide and 200 centimetres long, with an incline of 30 degrees and unattached to any building or entrance. Without this physical presence of functionality, we are invited, through the sculpture's translucent material intentionality, to consider the object as a network of ethereal subjects.

The 16-gauge aluminum "field" that occupies the ramp's slope reflects the process of finding wheelchair cartography. With contributed tire marks from fellow artist-in-residence Kazumi Tsuruoka as guides, a heavy metal etching interprets and forges this treading as desire lines found where path making occurs. Often less seen, these paths occur away from roads and institutional promptings, found and memorized by those who tread there.

Disability art allows normate bodies to approach the disabled experience that brings us to the threshold. Embedded in the title of this essay is the term "liminality." I do not believe art's objective is ever one of product, of spectacle, or of display, but rather one of *movement through*. The feminist dream of utopia or "the rev" – the revolution – is always already realized as conceptual actions disrupt the colonially embedded frameworks. Naturally, that includes the larger canon of Canadian art.

ACKNOWLEDGMENT

This chapter was revised from a lecture delivered by jes sachse at the University of Ottawa on November 5, 2014, hosted by the Institute of Feminist and Gender Studies.

NOTE

1 http://www.bartleby.com/229/3003.html.

WORKS CITED

Grosz, Elizabeth. 2013. *Chaos, Territory, Art: Deleuze and the Framing of the Earth.* New York: Columbia University Press.

Kristeva, Julia. 1982. *Powers of Horror: An Essay on Abjection.* New York: Columbia University Press.

Nightcrawler. 2014. Directed by Dan Gilroy. Bold Films.

Office of the Correctional Investigator. 2010. "Report Finds Serious Gaps in the Planning and Delivery of Mental Health Services for Federally Sentenced Offenders." September 23. http://www.oci-bec.gc.ca/cnt/comm/press/press 20100923-eng.aspx.

Ware, Syrus, Joan Ruzsa, and Giselle Dias. 2014. "It Can't Be Fixed Because It's Not Broken: Racism and Disability in the Prison Industrial Complex." In *Disability Incarcerated: Imprisonment and Disability in the United States and Canada,* edited by Liat Ben-Moshe, Chris Chapman, and Allison C. Carey, 163–84. New York: Palgrave Macmillan. http://dx.doi.org/10.1057/9781137388476.0015.

Warner, Michael. 2002. "Publics and Counter Publics." *Public Culture* 14 (1): 49–90. http://dx.doi.org/10.1215/08992363-14-1-49.

10

Claiming "the Masters" for Disability Rights
An Artist's Journey

DIANE DRIEDGER

"Here's another sad story," the art museum guide pronounces with a shake of her head. "Renoir had arthritis for the last twenty years of his life and he could not open his hands. He had to have assistants put his paintbrush in his fist so that he could paint. This painting here is done that way; see the broad strokes."

I listened to the guide at the Winnipeg Art Gallery's 2013 *100 Masters* exhibit and thought to myself, "Yes, a life lived in broad strokes." Painting strokes can be affected by disability, but is this "such a sad story?" Many accomplished and famous visual artists, whom I will refer to as "the Masters," had physical or mental disabilities. Art critics do not often discuss their disabilities, or if they do, they discuss it in a negative manner. Were their lives a tragedy? Did they paint in spite of disability or because of it? Was their vision a unique disabled vision? When I looked at their paintings about ten years ago, I realized that I had a place in those pieces of art, not only because I am a person who has a disability, but because I share many common perspectives with them. The way they lived and worked with disability affected their art and affected the message that the Masters were telling the world. To examine this, I decided to paint myself into the Masters' paintings, to see how I fit in. I would discover my relationship to them through my own painting process and thus discover more about myself as an artist with a disability.

Along the way, I encountered four artists who fascinated me either because of their subject matter and painting style or because of their process of painting with disabilities: Frida Kahlo, Vincent Van Gogh, Claude Monet, and Maud Lewis. Kahlo, who had many physical disabilities and chronic illnesses, often painted self-portraits from her bed. Van Gogh is perhaps the most famous for being disabled as he cut off his ear in a mental health crisis and is rumoured to have eaten his lead paints. Monet, an impressionist artist, developed cataracts, and his sight was affected for the last part of his life. Maud Lewis was a Canadian painter who was self-taught and is considered a premier folk artist. Lewis had a physical disability.

Frida Kahlo: Painting Myself into the Picture

Frida Kahlo (1907–54), the Mexican painter who had disabilities due to polio and a bus accident, had many surgeries to alleviate pain and spent much of her time lying in bed. She rigged up a mirror on the underside of the canopy of her bed in order to see herself, and she used an easel set up on her bed. From this position she painted many self-portraits. Kahlo lived an active artistic, political, and emotional life and has documented this well in her diary, letters, and paintings. I read her diary and realized that many of her experiences of chronic pain reminded me of my own. I have fibromyalgia, which causes stiffness, pain, and fatigue and can be overwhelming at times. I looked further into her work and realized that she was a sister in disability. She had painted herself as a means of dealing with living life with disability. I wondered if I started to paint myself into my pictures whether I would make discoveries about living with my disability. Until that point, I had been painting watercolour landscapes of Trinidad and Tobago and from around Winnipeg. I loved the brilliant colours and soothing landscapes and blue and green tones. It was a getaway from my pain and from thinking about pain.

Perhaps I could also paint myself into her paintings to show solidarity with her. I began by painting myself into Kahlo's *The Two Fridas*. In my painting, *Me and Frida Kahlo*, I painted myself as one of the Fridas to show how she offered me a framework, a support system through the blood veins shared in the painting. After I completed the painting, I found out I had breast cancer, and this painting foreshadowed it in a way: my PICC line to deliver chemo was connected to my heart through my arm, just like in my painting (Driedger 2006).

I learned that Frida Kahlo might have had fibromyalgia, too. Doctors looking at her case after her death thought that her chronic pain could have been fibromyalgia (Martinez-Lavin et al., 2000). Yes, she had polio and one

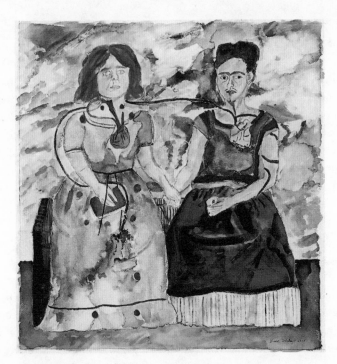

Diane Driedger, *Me and Frida Kahlo*, 2005.

leg was weakened, and she had a broken pelvis and various other broken bones from her accident, but over time and with many surgeries, she probably developed fibromyalgia. Now she really was a sister! And the doctors pointed to a drawing in her diary that shows arrows pointing at pain points on her body, exactly where they would have been if she had had that chronic illness (Kahlo 1995).

Kahlo's painting *The Broken Column* began to mean something different to me than to the art critics I was reading. They discussed her chronic physical pain and that the nails riddling her naked torso in the painting depict the pain, that her back is a disintegrating column and that her psychological pain is reflected in her tears and in the bleak landscape surrounding her (Bauer 2007; Kettenmann 2000; Martin-Gropius-Bau and Bank Austria Kunstforum 2010). There is, however, little discussion of her gaze. It is a steady and unflinching challenge to the viewer: here is pain and weakness whether you want to see them or not.

I decided to paint my face into her painting and name it *Crucifixion*. My back is not a crumbling column; rather, my experience is one of suffering

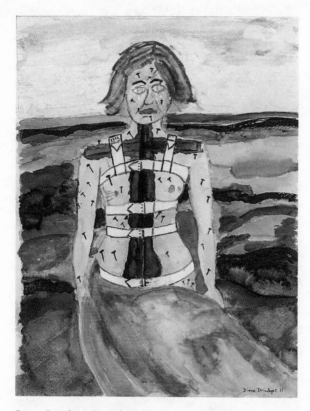

Diane Driedger, *Crucifixion*, 2011.

on a cross, the body pulled this way and that due to nails of pain and fatigue weighing me down. Frida's loincloth hearkens to Christ's clothes on the cross, how he is portrayed with only a drape in Western art (Herrera 2002). My painting challenges the viewer to see the breast that is off-kilter, not like the other, due to breast cancer surgery. "It exists," says my unflinching, sad stare. This painting is a claiming of space for Frida and for me – we have a right to have chronic pain and look different, and we take up this space on the canvas. No hiding here. No invisible tears under brave fronts. Now that you know, accept me as I am.

Her stare is counteracting the tendency in our society to disbelieve that pain can really be "that bad," as it is not visible to all. In a letter to her boyfriend, Alejandro, Frida talked about the invisibility of her pain and how others did not believe it existed. "I am still unwell and without hope. As always, no one believes it" (Kahlo 2006, 91). I see this as a proclamation of disability rights: "We are here, we take up space, deal with it." For so many

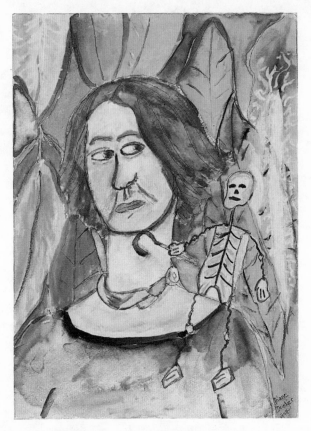

Diane Driedger, *Self-Portrait with Skeleton, after Frida
Kahlo's Self-Portrait with Parrot,* 2011.

years, people with disabilities have felt the need to fit in, to hide their differ-
ences, to apologize for different bodies and minds.

From Kahlo's proclamation of life with disability, I moved on to look at
her acquaintance with death in her paintings. Skeletons appear often in her
works. In *The Dream (The Bed),* the skeleton atop Frida's bed canopy is
the Judas figure that is exploded at Easter by Mexicans – exploding death.
She sleeps peacefully in the bed below. For me, due to my experience with
cancer in 2006, I have been on the brink looking over with that skeleton. In
fact, it is on my shoulder, a little devil voice whispering, "I'm still here."

Kahlo painted many self-portraits with her parrots and monkeys to
show her relationship to life. I have substituted a skeleton, instead of a bird
or animal, in my painting *Self-Portrait with Skeleton, after Frida Kahlo's
Self-Portrait with Parrot.* In Frida's original painting, she still stares at the

viewer full on. In my painting, I am facing forward, but my eyes are slanting to the side, as if preparing and tentatively watching with death's sickle under my chin. Indeed, life abounds in the tropical foliage in the background while my mortal coil is played out in the foreground.

Historically, disability has reminded people of death and the fragility of human life. People do not want to deal with disability in case it is contagious. Fraternizing with death is not something we do every day in the Western world. In fact, we try to cancel it out with a fury of busyness and perfection. If only we look a certain way, we will live forever.

Vincent Van Gogh: Baring It All

Dutch painter Vincent Van Gogh (1853–90) has a lot to say to me about my breast cancer experience. A master of the self-portrait, he could not afford to pay many models, and he painted himself at different times in his life and sent the portraits to his brother Theo as evidence of how he was faring (Denvir 1994, 12). His painting *Self-Portrait with Bandaged Ear* has intrigued me ever since I was a child. He had a crisis and then cut off his ear, gave it to a prostitute, and painted himself in the aftermath? This is audacious to say the least. Mental health disabilities were and are not viewed favourably by society. In fact, after the ear-cutting incident, the citizens of the town where he lived circulated a petition asking him to leave because he was unstable and no one wanted him around; they thought his family should care for him or send him to an asylum (Gayford 2006).

Considering the shaming of the community and the fact that Paul Gauguin, his roommate, left right after this incident without saying goodbye, it is interesting that Van Gogh logged this experience through a painting. He then sent it to his brother Theo as evidence that he was doing quite well. The bandage is still there as a testimony to the "disability," "the chronic illness" and its ups and downs. Van Gogh spoke about the variability of his symptoms and his not knowing when they would flare up. In his letters to his brother and his mother, he wrote that he had epilepsy according to doctors and that he was not "mad," but he was not sure about that himself (Van Gogh 1991). Whatever his disability, he was waving its flag with that bandaged ear.

I decided to paint myself into this painting in *Self-Portrait with Bandaged Breast, after Vincent Van Gogh's Self-Portrait with Bandaged Ear*. Vincent's painting shows his gaze connecting directly with the viewer. It is a matter-of-fact gaze of, "Here I am, I survived, and this is what I look like." The audacity of proclaiming this so publicly caused me to paint myself with

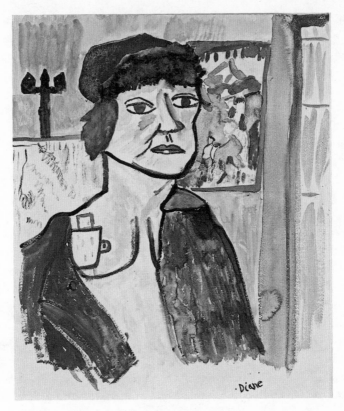

Diane Driedger, *Self-Portrait with Bandaged Breast, after Vincent Van Gogh's Self-Portrait with Bandaged Ear*, 2010.

a bared and bandaged breast. I wanted to take on that matter-of-fact attitude.

Again, this represents a slap in the face of society's yearning for perfection. I was especially struck with this when I saw my painting on the cover of *Canadian Woman Studies'* "Women and Cancer" issue (2010) on the newsstand in Ottawa. I found my sensibilities challenged. Was that the right thing to do? To unmask perfection? Will people recognize me? This could have all remained hidden, but I chose to reveal myself, just as Vincent had chosen to reveal himself.

Claude Monet: Seeing His Own Vision

Claude Monet (1840–1926) was a French impressionist whose artistic career spanned sixty years. In mid-career, he started noticing that his eyes

were changing – he saw things differently. He learned that he had a cataract in one of his eyes and that he could have an operation. He refused, stating that he thought the operation would change how he saw things and he did not want to take that chance (Tucker 1998). He was in the middle of painting the *Water Lilies* series in his garden at Giverny. Monet trusted his vision, a vision that his eye doctor deemed in need of fixing. Monet continued to paint with declining eyesight for another ten years. At that time, he found he had very little sight left and decided to have cataract operations on both eyes. After the operations, he found that indeed his sense of colour had changed. He could not see the blues and greens the way he had before. Monet relied on reading the names on his paint tubes, as he could not see those tones (Metropolitan Museum of Art 1978).

Monet's work with light and colour was renowned, and much of it was done with altered eyesight – that is, altered from what is considered "normal." Great art was born out of a unique vision. It begs the question of whose view is normal. It tells me that as people with disabilities, we need to trust our senses, even if they are not normal.

I painted *Cancerlilies* as a riff on Monet's *Water Lilies* paintings, which I have always loved. Monet saw greens and blues and later yellows and reds. As I was undergoing chemotherapy for breast cancer, the image of the cancer cells lived in my mind. I chose to reflect the terror in the beauty of water lilies. These cancerlilies are beautiful and terrifying – red the colour of the blood, effort, and rage that these cancer cells, the lilies, bring on. Water lilies, so calm and serene, beautiful and delicate, become raging red corpuscles running amok in my painting. The viewer and I cannot turn away. They exist. This is human experience. Cancer, terrible and lovely, was a part of me for a while and may still be lurking in the red shadows of my body, waiting.

The redness of the cells, the off-kilter nature of what was going on in my bloodstream, was part of this vision. For me, it was a blurred vision – I could not look at the cancer too closely or else I would be stuck there with it, it would solidify in my psyche. Monet-like blurry watercolour strokes were what my body could manage at the time, after a year of cancer treatment.

I painted this work in a flurry of motion before the energy seeped away from my hands. It is a whole-body painting, as it was a large painting that required leaning into it with whatever physical strength I had. I have heard from other artists that it takes a lot of strength to paint large paintings; I agree that it does. I do not do it very often due to energy constraints and pain from my fibromyalgia, and the nerve damage from my cancer treatment.

Diane Driedger, *Cancerlilies,* 2008.

Maud Lewis: Happy Practicality

Maud Lewis (1903–70) was a Nova Scotia folk art painter. She had rheumatoid arthritis and other disabilities that caused her face and hands, in particular, to appear abnormal by society's standards. She was self-conscious about this according to the video *The Illuminated Life of Maud Lewis* (d'Entremont 1998). Photos of her after the onset of her facial differences showed her always covering her chin with her hand, and she walked with her chin deep in her coat.

There is no evidence from Lewis herself as to what she thought about her disabilities. Her life unwound mainly on the canvas, not in words. She married a long-time bachelor, Everett Lewis, and they lived in a small house next to the highway near Marshalltown, Nova Scotia (Woolaver and Brooks 1996). Her childhood was reportedly a happy one filled with sleigh rides and car rides in the countryside. She painted these idyllic scenes from her past. Art critics assumed that she painted happy images to escape from her life of poverty and disability (Woolaver and Brooks 1996). Given that society tends to see disability as a tragedy, it was unsurprising that art critics believed that Lewis must have been sad and wanted to escape her existence. Why could those images not just be her state of mind as she painted? Maybe the images

Diane Driedger, *Crutches*, 2010. Photo by Christine Blais.

were her current reality, as she enjoyed painting so much. Maybe the scenes of bright colours, sunshine, birds, boats, and houses were her reality and she painted that happy reality.

Maud painted every day, and she sold her paintings for a few dollars to the tourists who happened by on the highway. Many of the scenes are repeated over and over. She also liked cats and flowers and painted them on canvas and on everyday objects in her surroundings. She decorated the stove and the dustpan with bright flowers. She painted all the walls in the house with cheery images. Her everyday life was filled with art and with the images in her head – her vision.

Lewis's vision informed a pair of wooden crutches that I painted for my friend Nancy, who wanted to have crutches that made a fashion statement. I added that maybe she should also make a statement about herself through her crutches. I painted her favourite disability rights sayings on her crutches in red and black, such as "Vegetables of the World Unite!," "Human Rights," and "Access is a State of Mind." These crutches became a moving art installation that was read by airport security people as she passed through sensors and that was referenced by a keynote speaker at a human rights conference in Britain (Hansen and Driedger 2010). The crutches were no longer just utilitarian; they had become a statement about Nancy's own life. They transformed Nancy's image of herself:

Nancy's crutches looked sharp and fashionable. For the first time in her life, culture, function and fashion intersected – a literal manifestation of

her pride as a disabled person. If Nancy had a difficult meeting, she would take the black and red crutches. She felt greater confidence as they constituted an integral part of her power suit. (Hansen and Driedger 2010, 300)

In addition, they engaged people who Nancy met while she was using the crutches. They advanced disability rights, as they helped "rewrite society's existing cultural narrative of disability" (Hansen and Driedger 2010, 303).

Maud Lewis's vision caught hold in my painting, as well. She painted many bluebirds, and I decided that I would paint myself into one of her works as the bluebird of happiness, taking flight on Lewis's bright and optimistic vision of life. Indeed, I am flying in *Self-Portrait as the Bluebird of Happiness in a Maud Lewis Painting*. After all my disability and cancer treatment, I am a happy bird still surveying the world and as mobile in my mind as ever. Am I denying my disability? No. I am going on. Disability is not tragedy; it is just another journey. There is irony in this painting, as well.

Diane Driedger, *Self-Portrait as the Bluebird of Happiness in a Maud Lewis Painting*, 2011.

Sometimes I do not feel like the bluebird of happiness. There are days when energy is sparse and pain is overwhelming and I am not a bluebird. The vision is there, however, the same as Lewis's vision painted on every surface in her house. We paint ourselves into our lives.

Conclusion: Art as Disability Rights

Art is a process, as is social change. The disability rights movement in Canada believed in political processes for change when it began more than forty years ago. Its leaders saw legislation and the Charter of Rights and Freedoms as the answer to protecting the rights of disabled people. This was important; however, as time went on, attitudes of society did not change substantially. In fact, the majority of Canadians do not think that disability is a human rights issue. According to a national survey on attitudes toward disability by Environics in 2004, it is most often seen as a personal, medical, or family issue (Prince 2009).

How do attitudes change? Here is a role for art. I have painted my reality of living with disability. I show my works and have them published in books, hoping that these images can portray my reality and provoke discussion about living with disability. Art is another way to get at the stubborn attitude problem. Art validates the experience of individual disabled artists. It also validates these experiences when others view it in public spheres. Images of disabled people are few and far between in the media and everyday life. Sure, there are more people with disabilities – both visible and invisible – out and about. But just being there does not change attitudes. Having legislation does not change attitudes on its own. Art? Another vehicle for change.

WORKS CITED

Bauer, Claudia. 2007. *Frida Kahlo*. Munich: Prestel-Verlag.
Canadian Woman Studies. 2010. "Women and Cancer" issue, 28 (2/3).
d'Entremont, Peter. 1998. *The Illuminated Life of Maud Lewis*. DVD. Director and producer. National Film Board of Canada.
Denvir, Bernard. 1994. *Vincent: A Complete Portrait*. Philadelphia: Running Press.
Driedger, Diane. 2006. "When the Body Protests: New Versions of Activism." *Canadian Woman Studies* 25 (3/4): 188–90.
Gayford, Martin. 2006. *The Yellow House: Van Gogh, Gauguin, and Nine Turbulent Weeks in Arles*. New York: Little, Brown and Company.
Hansen, Nancy, and Diane Driedger. 2010. "Art, Sticks and Politics." In *Living the Edges: A Disabled Women's Reader*, edited by Diane Driedger, 295–303. Toronto: Innana Publications and Education.

Herrera, Hayden. 2002. *Frida: A Biography of Frida Kahlo*. New York: HarperCollins.

Kahlo, Frida. 1995. *The Diary of Frida Kahlo: An Intimate Self-Portrait*. New York: Harry N. Abrams.

—. 2006. *Frida by Frida: Selection of Letters and Texts*. Mexico: Editorial RM.

Kettenmann, Andrea. 2000. *Kahlo*. Koln: Taschen.

Martin-Gropius-Bau and Bank Austria Kunstforum, eds. 2010. *Frida Kahlo Retrospective*. Munich: Prestel.

Martinez-Lavin, Manuel, Mary-Carmen Amigo, Javier Coindreau, and Juan Canoso. 2000. "Fibromyalgia in Frida Kahlo's Life and Art." *Arthritis and Rheumatism* 43 (3): 708–9.

Metropolitan Museum of Art. 1978. *Monet's Years at Giverny: Beyond Impressionism*. New York: Metropolitan Museum of Art.

Prince, Michael J. 2009. *Absent Citizens: Disability Politics and Policy in Canada*. Toronto: University of Toronto Press.

Tucker, Paul. 1998. *Monet in the 20th Century*. New Haven: Yale University Press.

Van Gogh, Vincent. 1991. *The Complete Letters of Vincent Van Gogh*, vol. 3. Boston: Little, Brown and Co.

Woolaver, Lance, and Bob Brooks. 1996. *The Illuminated Life of Maud Lewis*. Halifax: Nimbus Publishing and Art Gallery of Nova Scotia.

RETHINKING AGENCY IN CANADIAN DISABILITY MOVEMENTS

11

Perching as a Strategy for Seeking Legitimacy for Broken Embodiments
Embracing Biomedical Claims for ME

PAMELA MOSS

Biomedicine is the primary authority in defining illness and maintaining health in North America. The passkey into the world of biomedicine is diagnosis, a category backed by knowledge steeped in medical research and clinical practice upon which specific protocols are used to treat ill bodies. A diagnosis is shorthand for saying what is going awry in a body. Being able to name what is happening, especially when something is amiss, standardizes bodies in a way that makes illness and disease more manageable. Because a name already carries with it research insights from science and some practical considerations in treating the ill body, physicians can talk with each other without conferring directly.

Diagnoses, however, do not just assist physicians. Diagnoses, laden with the specifics of biomedical knowledge and developed with the purpose of making sense of bodily disease, get taken up by and transplanted into other types of systems, institutions, and processes. The authority of biomedicine extends beyond the boundaries of research and practice into realms where health and illness can be made to matter – workplaces, schools, families, friendships, courts, and spaces devoted to healing. Those who are ill also use diagnoses; they use them as entry tickets into the maze of biomedicine.

But what about those who have no diagnosis, yet are in chronic psychological, bodily, or emotional distress? Where does the body ill with migratory pain, extreme fatigue, and troublesome cognition fit into a diagnostic

category based on biomedical knowledge? What happens when there are attempts to capture what is going on in the body with a name that does not hold the same authority as other names? What happens when one's embodied sense of self is dislodged by the rupture of acute onset of illness? Where does it go? How do they make sense of their emotional collapse, their disordered connections, or their unsettled presence – in other words, how do they make sense of their broken embodiment?

I am most interested in the types of broken embodiments that have found no legitimacy, or only partial legitimacy, within biomedicine. Collectively, these broken embodiments have been variously known as medically unexplained symptoms (Zavestoski et al. 2004), unexplained illness (Pall 2007), and contested illness (Brown et al. 2012; Moss and Teghtsoonian 2008a). I focus my attention on what is known as myalgic encephalomyelitis (ME). ME has a long history of controversy in biomedicine as to its genesis, diagnosis, and treatment. People with an array of symptoms associated with ME are more likely to experience their bodily sensations as broken embodiments rather than as simply feeling ill (see Wendell 1996). Conditions identified as forerunners to ME were designated as psychosomatic, with psychiatry coming to be the authoritative treating discipline. With bodily disruptions manifested primarily as pain, fatigue, and cognitive impairment, ME is generally recognized as a complex disease process involving disturbances in multiple body systems, including the neurological, circulatory, endocrine, and lymphatic systems. That this patterned broken embodiment can be named ME makes it at least partially legitimate in biomedicine.

For people with broken embodiments commensurate with ME, innumerable political strategies exist for engaging with and moving through biomedicine. Strategies can involve activities such as lobbying for biomedical research money, acquiring and distributing biomedical knowledge, and conducting awareness campaigns (e.g., solvecfs.org, www.actionforme.org. uk, www.may12.org). Underlying the activities of these types of advocacy and activism organized around ME is the notion that becoming more embedded within biomedicine will confer more legitimacy. As a political strategy, *seeking legitimacy* can position both the category of ME as a disease as well as those diagnosed with ME more advantageously through respite from, and perhaps (partial) alleviation of, disabling aspects of symptoms. Once brought into the core of diagnosis, ME can be normalized much like other disabling diseases that have a wide range of severity (e.g., cystic fibrosis, multiple sclerosis, HIV). If physicians as gatekeepers legitimate ME and incorporate its possible diagnosis as a routine part of their practice, they

would be better equipped to provide more effective care through, for example, written support letters so that those diagnosed with ME could gain access to healthcare resources and disability supports through programs for guaranteed income, workplace accommodation, and accessible housing.

In the rest of this chapter, I explore in more depth the strategy of seeking legitimacy by introducing the notion of "perching" as a way to chart a path through biomedicine for the people with broken embodiments commensurate with ME. Perching is a practice of positioning oneself within biomedicine while maintaining a critical view of it. I first offer a framework for understanding biomedicine as an embodied apparatus, fashioned after Michel Foucault's *dispositif*. I argue that biomedicine is inclusive of and populated by a host of embodied interpersonal relationships, power relations, and discourses that have come to provide texture to what we understand as biomedicine. I then work through examples – some short, some long – of strategies that people use to find legitimacy in biomedicine for their broken embodiments. I close with some observations about perching as a political strategy that addresses the ebb and flow of power within biomedicine for people with ME.

Biomedical Authority, Power, and *Dispositif*

Biomedical authority has been explained in sociological terms as part of the interplay between social structures and individual manifestations of illness (e.g., Brown, Lyson, and Jenkins 2011; Greener 2008), as part of a wider process of medicalization from both above (physicians, researchers) and below (patients, social groups) (e.g., Conrad 2005; Conrad and Barker 2010) and as part of the cultural value of biomedicine in wider society (e.g., Horwitz 2002; McGann 2011; Pescosolido 2006). A general concern about these models, especially among disability scholars, is that power relations are not always accounted for adequately (but see Barker 2005; Jutel 2014). Several disability scholars have taken on the task of working through how power and biomedical authority are integrally related to the way in which disabled bodies and persons with disability are entangled within wider structures, processes, and institutions (e.g., Goodley, Hughes, and Davis 2012; Hall 2011; Hansen and Philo 2009; Moss and Dyck 2002; Moss and Teghtsoonian 2008b; Prince 2009; Tremain 2005, 2015), some of whom draw on Michel Foucault's ideas about power and the organization of power/knowledge. The uneven pathways of how power works can explain why some disability activists call for a halt to the medicalization of disability (e.g., Clare 1999; Stone 2008), while ME activists are more willing to actively seek out medicalization. Accounting

for broken embodiments commensurate with a diagnosis of ME means keeping the political strategy of seeking legitimacy alive while still being part of a wider disability politics.

Over the course of many years of writing, Foucault (1979, 1980a, 2003) offered a complex reading of power. In addition to what he termed "sovereign power," he argued that a different type of power was operating outside the formal channels of what one would usually understand as the authority of the state. He called this a "microphysics of power," a type of power that focuses on individuals and groups of individuals as well as their behaviours and conduct (Foucault 1979, 26–27). The microphysics of power is not about scale (the micro of the individual versus the macro of the sovereign), nor about location (places like homes or workplaces instead of national economies). Rather, the microphysics of power draws attention to power as a "point of view" (Foucault 2008, 186); that is, power is exercised through specific sets of relations, not possessed. In this sense, power is a strategy used to negotiate the ever-present tension among sets of relations and not just wielded through positions of privilege (Foucault 2008, 26). These relations that are in tension with each other include the relationships among people and groups of people; that is, power is exercised from multiple points within the depths of society. Thus, when someone seeks a physician's advice, the visit is not a situation where the physician wields power over a patient, nor is it an equivalent exchange of information about a set of bodily sensations and what to do about them. Rather, the relationship between the physician and the patient is already infused with a set of expectations that the physician knows what illness looks like and what to do about it, expectations that have been informed by the idea that biomedicine is *the* authority for treating illness. Both the physician and the patient have these expectations, and their own senses of self frame their interactions. This micro-instance of the exercise of power – set up between a physician and a patient in the form of a physician's office visit – is a site within which to work through how biomedical knowledge expresses itself.

This particular conception of power led Foucault to abandon the notion that there was any type of knowledge outside these sets of relations. In the case of biomedical knowledge, biomedicine does not exist outside the sets of relations that generate it, relations that include the distribution of public and private funding, research processes and facilities, the organization of medical practice in clinics and hospitals, the provision and delivery of healthcare services, the consumption of healthcare services, and the patient–doctor interaction in the physician's office. He argues that knowledge

production is entwined in this dense network of social relations that operate and are fuelled by a microphysics of power. He refers to this dense network as a particular formation of power/knowledge.

For Foucault, power/knowledge does not function smoothly or always in agreed-upon ways. In effect, power/knowledge comprises a specific historical configuration that holds within it the processes through which controversies and tensions have already been and continue to be mediated through the multiple and various exercises of power (those micro-instances of the exercise of power). Thus, biomedicine as a knowledge base and as a practice of that knowledge is not as coherent or powerful as society might see it to be. And, because knowledge is significantly tied to conceptions of truth, conflict over what constitutes truth plays a key role in the way in which power/knowledge comes into being. Foucault discussed the relationship between power and knowledge in terms of truth regimes. He argued that societies have a "'general politics' of truth," where societies mobilize discourses that are accepted and made to function as true (Foucault 1980c, 131). Mobilizing discourses involves augmenting and sustaining the dominance of specific claims, much like biomedicine is bolstered and reinforced through everyday interactions with family members urging someone to go to the physician about pain or fatigue and advertisements appealing to people experiencing listlessness and lack of concentration to mention the possibility of a specific drug at the next visit to the physician. These are just examples of how claims that biomedicine is the appropriate path to wellness work. Truth regimes assess claims of truth and falsity when coupled with the interactions among sets of relations within power/knowledge configurations, such as when formalized healthcare coverage is limited to biomedical practices only. Together, formations of power/knowledge and truth regimes put into action what Foucault referred to as a *dispositif*, or apparatus, which is a "system of relations that can be said to exist" within "a thoroughly heterogeneous ensemble consisting of discourses, institutions, architectural forms, regulatory decisions, laws, administrative measures, scientific statements, philosophical, moral and philanthropic propositions – in short, the said as much as the unsaid" (Foucault 1980b, 194).

Biomedicine as an Embodied Apparatus

If the practice of a microphysics of power within an apparatus has been shown to be embodied in some way, it may make sense to talk about an embodied apparatus. Feminist researchers interested in illness have shown how one might use apparatus conceptually to talk about how biomedicine

works, particularly in relationship to embodiment, as, for example, in the bodied experience of disease (Klawiter 2008), with bodily aspects of identity and selfhood post-illness (Gilbert, Ussher, and Perz 2012), through becoming a subject amid transforming one's own material and discursive body (Longhurst 2012), and conceiving bodies themselves as sites mediating idealized notions of bodies with the fleshy reality of what bodies actually are (Morgan 2011).

Attending to the bodily aspects of power can disclose *how* a microphysics of power might actually work within an apparatus. An apparatus can be said to be embodied when there is a recognition of a lived fusion among the discursive and material elements of any one apparatus (Moss and Prince 2014, 67). For example, when a woman collapses from fatigue and pain and goes to the emergency room at a hospital, she experiences biomedicine as an ensemble of things at the same time. Ideas of what it means to be sick, injured, disabled, and healthy, as well as what it means to be supported emotionally, physically, and institutionally, frame each encounter. She tells an intake clerk why she is there. After a (sometimes long) wait, she gets ushered through a door and into a treatment space. There is probably an adjustable hospital bed she crawls into, cuddling her arm that was weakened by a hemorrhagic stroke twenty years ago, separated from other patients with a bland-coloured privacy curtain. She is handed a paper cup holding a set of prescribed medications, which she takes compliantly while a nurse, or maybe a hematology technician, inserts a needle into a vein on the top of her hand. She lies waiting for a physician to look at her.

As we know, hospitals are not the only component of biomedicine where people live the fusion of ideas and the materiality of illness. The bodies that populate and act within one apparatus, say that of biomedicine, simultaneously populate and act in other ones. As a heterogeneous ensemble of both discursive and material elements, an apparatus contains a vast array of things that to varying degrees overlap with other apparatuses. This is to say that biomedicine – with its own distinct patterns of connections, truth regimes, and power/knowledge formations – can overlap with related systems that have their own constellations of discourses, sets of relations, and material objects, such as the state, science, fitness, psychiatry, and even fatness. Apparatuses can "plug into" one another (Foucault 2003, 222) and thus enhance a particular set of things or organization of elements reinforcing their solidity and authority as distinct apparatuses. The intake clerk could get alarmed if the woman gives no fixed address and presses for more information about insurance. The blood tests ordered would be different for a

woman in her early twenties than for a woman in her late forties. The nurse could focus on post-stroke effects and read the fatigue and pain through the woman's disabled body rather than charting the bodily sensation within a more recent time frame. The emotions of the woman lying down, waiting for the physician, might encompass fear of the unknown, dread of telling her story, or anxiety from being too ill to put words to her physical sensations. Broken embodiments commensurate with ME have left similar wakes in their paths as they made their way through biomedicine, when at the height of their (physical and emotional) vulnerability, they were expected to engage with biomedicine as *the* authority on health, leaving little, if any, room to resist, challenge, or refuse its dominance.

Using the notion of an *embodied* apparatus in thinking about biomedicine highlights three specific points about bodies, power, and authority that can be useful in developing strategies to activate a disability politics for those with broken embodiments. First, bodies are active mechanisms through which to exercise power rather than mere vessels through which to find truth or demonstrate knowledge (Moss and Prince 2014, 30). In short, bodies do things; they enact biomedicine (see Mol 2002). This insight, in tandem with the nomadic critique of the impaired subject (Roets and Braidotti 2012, 161), implies that subjects produced through the discursive and material elements of biomedicine do not have to reproduce the existing set of relations. They can challenge biomedicine in a variety of ways. Second, expanding on an embodied understanding of a microphysics of power unravels the solidity of texts governing the practice of biomedicine as well as the biomedical practices themselves. Understanding that power is not a one-way street permits a pinpointing of specific places where there is the potential to refuse the authority of biomedicine as the way to treat an ill body rather than solely expressing its authority. Working with sites (people, texts, practices, policy) that resonate with embodied understandings of power allows individuals to open up possibilities other than the one biomedicine has on offer. Third, appreciating the fusion of discourse and materiality in the everyday experience of illness vis-à-vis biomedicine permits a way to understand the specifics of what an individual experiences as well as a way to identify wider processes informing those experiences. Maintaining an awareness of the constitutive link between the discursive aspects of the material elements of biomedicine with the materializations of specific discourses facilitates the identification of specific strategies to challenge the authority of biomedicine.

Thus, activating a disability politics that grants agency to specific bodies, that resists influential apparatuses through micro-instances of the exercise

of power, and that recognizes that empowered individuals are embedded within wider systems of power can be effective in challenging the oppression of those with disabling illness. Armed with this kind of politics, exploring how people with bodily sensations commensurate with ME seek legitimacy can show how the microphysics of power can break, dissolving some of the seemingly tightly organized boundaries of biomedicine.

Perching as Part of Seeking Legitimacy

The type of politics arising out of the concept of biomedicine as an embodied apparatus – including notions of biomedicine being an embodied apparatus, micro-instances of the exercise of power connecting elements of biomedicine, and individuals being discursively and materially embedded in systemic processes – positions "breaks" in the microphysics of power as sites to challenge the authority of biomedicine. Disability activists are familiar with how some of the breaks in power relations can be used to organize politically; for example, by resisting the medicalization of disability, empowering practices of self-determination, and even choosing not to engage with biomedicine at all. Activists interested in bodies with medically unexplained symptoms, unexplained illness, or contested illness engage strategies that are not commonly understood to be political strategies within disability politics because they call for placing disabling illness squarely in the same set of relations – biomedicine – that is responsible for marginalizing broken embodiments and effectively making them inert.

Mapping these breaks is a useful way to find nooks and crannies that can be inhabited, at least for a while, so that individuals with symptoms commensurate with ME and ME activists can figure out how to navigate the truth regimes and organization of power/knowledge comprising biomedicine. Amelioration of pain and fatigue, surfacing from acute onset of debilitating symptoms, and revitalization of living an anguished life for a person with a broken embodiment are located in the things, items, and artifacts that biomedicine offers: diagnoses, prescriptions, and treatments. To access these things, people with bodily sensations commensurate with ME must find nooks to step into, rest a bit, and take stock of what is going on. They need to find a cranny to "perch" for a while, figure out the lay of the land, look for exposed crags to pick at in order to find something useful. As an outsider looking in, few visible entry points exist other than those well-trodden connections that are formally used to plot a course through biomedicine, as in requesting specialist referrals, medical tests, and medication.

This strategy of finding a place to inhabit inside biomedicine for a period of time to survey the terrain of the embodied apparatus is what I call "perching." For those individuals with ME, perching involves positioning oneself within biomedicine both as a source of information for a broken embodiment and as an embodied apparatus wherein one can act to challenge one's own oppression, marginalization, and powerlessness through micro-instances of the exercise of power. Politically, perching for a spell, observing the goings-on, and taking stock of the terrain make sense for those needing something from biomedicine. What is interesting about perching is that, like the microphysics of power, it is not a one-way street; perching not only entails scrutiny of the patterns of connections, the regulations operating within truth regimes, and the mapping of power/knowledge formations within biomedicine, but also necessitates near-constant examination of one's body so that the person with ME maintains up-to-date knowledge to convert into a "thing" that might help them, such as a diagnosis, prescription, or cure.

Of the places within biomedicine eventually laid bare through perching in various and multiple nooks and crannies by people with bodily sensations commensurate with ME, three are particularly important in seeking legitimacy. The first two, social networks of people already diagnosed with ME and the physician's office, are discussed in self-help books. The third, participation in defining ME, is the result of a longer-term collaborative project. All three mobilize non-biomedical knowledges to challenge the authority of biomedicine and demonstrate the porosity of the seemingly rigid boundaries of biomedical knowledge in determining what counts as illness and disability.

Social Networks of People Already Diagnosed with ME

Social networks of people diagnosed with ME, built through the practice of perching, are incredible resources for those beginning to experience the disabling effects of excessive fatigue, pain, and cognitive impairment. If there is no prior knowledge about ME, people usually will at some point start thinking that ME may be what is going on in their bodies. Through Internet searches and casual conversations, people will stumble across contact information for a local support group. Support groups are organized on a continuum from formal to informal. That they exist provides some legitimacy to ME as an illness, in that most are connected to national and international umbrella groups. During meetings, members gather not only to talk about their experience of illness, but to exchange information about

sympathetic local physicians, potential medical treatments, and the latest ME research.

Finding a sympathetic physician who knows about how ME works and who is not going to treat it as a psychiatric illness is vital in seeking out legitimacy. Support groups and their members are embedded in and able to share their maps of the local expressions of biomedicine. In nearly every self-help book, a key recommendation is to contact a local ME support group for a list of physicians in the area who are accepting patients. People with chronic illness are seen to take up more resources than non-chronically ill patients, and for this reason, some physicians are reluctant to take on yet another patient with ME (see Evans and Michael Smith Foundation for Health Research 2010). Physicians also regularly charge extra for filling out insurance applications and workplace or school notes. Most members of support groups have already traversed this landscape and can provide valuable input into choosing whom to see, thereby strategically controlling where to engage biomedicine.

Accessing treatment is high on the list of those living with ME. While many treatment regimens incorporate non-medical remedies – such as pacing, a healthy diet, Epsom salts baths, heating pads, lavender oil on a pillow, and over-the-counter drugs (Advil, Aspirin, NyQuil) – others require a physician's prescription. Physicians must prescribe, for example, low-level antibiotics for treating infections as part of a long-term therapy, synthetic thyroxine for thyroid replacement therapy, tricyclic antidepressants for inducing a higher quality of sleep, and extended-release opiates for chronic pain. Because of the fluctuating nature of ME (as with some of the other chronic, contested illnesses, such as fibromyalgia, food sensitivity, and environmental illness), people take up a treatment for a little while, let it go, and then look for something else. Exchanging information of what works for someone and what has not worked helps one sort through one's own approach to treating illness and making space to re-embody the broken body.

Those with ME are some of the most knowledgeable patients of their own condition – even before they see a physician. Support groups are a repository of knowledge about ME. Members have a command of available online resources for access to specialized biomedical knowledge that was once restricted to the medical profession. Recent scientific research articles are circulated alongside lay interpretations in newsletters. But make no mistake: these lay interpretations are highly technical pieces of writing. Descriptions are not simple reports about a link between fatigue and the HPA (hypothalamic-pituitary-adrenal) axis or fatigue and the presence of

the Epstein-Barr virus. Rather, the description would go into detail about *how* a disruption in the former would cause a string of symptoms relating to various sensory sensitivities, sleep cycles, and low cortisol levels in the blood and *how* the presence of the latter would impair the immune system by entering B cells and generating lymphoblastoids that are taken to sites of infection by lymphocytes. In other words, the social networks built up for those with ME are not just limited to one's immediate circle of co-sufferers, as stereotypes of support groups might tell us. These social networks provide places for those with ME or those who think that they might have ME to position themselves to gain more effective access to a trove of information. As a point of contact with this vast apparatus, being informed by knowledge acquired through perching – as these social networks have shown – may make a difference (see Barker 2005; Brown et al. 2012). They challenge individual physicians in ways that those with other types of illnesses cannot. Readied with such biomedical knowledge, people with ME gain credence in confirming their broken embodiments, reading their ill bodies, accessing other elements within biomedicine, and challenging biomedical authority in their search for treatment of what ails them.

Encounters with Biomedical Physicians

Seeking legitimacy is partly a reaction to being dismissed and not taken seriously by those who are supposed to be in the know. Perching is the political response. A general practitioner is usually the first person someone encounters when seeking help for a broken embodiment. Yet people presenting with symptoms associated with ME, including pain that does not go away and a fatigue that cannot be adequately and coherently described by someone who finds it difficult to string two sentences together, may understand themselves to be taken as suspect patients, who must persuade the physician that they are not hypochondriacs (Segal 2005, 75).

This idea of persuasion sets up encounters between those with ME (who may not have been diagnosed yet) and the physician as a parlour game wherein patients attempt to persuade the physicians they are sick and the physicians try to convince the patients to adhere to a biomedical account of illness and treatment regimens. Perching is the way in which patients garner enough knowledge to approach a physician with the purpose of persuading a physician that they are ill. Persuasion, then, is part of a game of truth, where claims about the ill body are negotiated between a patient and a physician. This clash of truths – between experiential knowledge and biomedical knowledge – constitute truth regimes within which patients and

physicians play key roles. The process of designating truth and falsity acti-
vate and fuel biomedicine as an apparatus wherein physicians have the up-
per hand because their extensive training processes steeped in biomedical
knowledge grant them the authority to order tests and ascribe diagnoses
and because of the vulnerable positioning of the patient as broken and in
need of help. In the best-case scenario, the patient persuades the physician
that there is something wrong with the body and the physician provides
information that would facilitate access to treatment and healing. If this is
not the case, and the physician is not persuaded that an ill body actually
exists and claims that the illness is psychosomatic, or if the physician is con-
vinced that the patient is sick, but in a different way, the patient goes away
deflated. And sometimes what ends up happening with those with ME is
that bodies are cut up, drugged, and made sicker because the physicians do
not know what is wrong with them (see Moss 2003).

Because of the importance of the patient-physician dyad in cases where
the patient may be suspect (and truth claims clash), finding a supportive
general practitioner is high on the list of the person with ME in gaining
legitimacy. Being up on the most recent research and treatments available
to those with ME is useful in dealing with general practitioners who may not
know much about the complexity of the disease. Yet the perching approach
of becoming conversant with biomedical knowledge is a double-edged
sword – patients must spend time and energy learning (leading to exhaus-
tion and exacerbation of disabling bodily sensations), and physicians must
give up knowledge (authority). Sometimes this has adverse effects on pa-
tients: the doctor may refuse to write letters, take them on as patients, or
listen to their concerns. Sometimes, however, being conversant biomed-
ically enhances the interaction of knowledges between a physician and a
patient.

One mechanism that puts this latter notion into practice in an attempt
to facilitate the translation of experiential knowledge into biomedical know-
ledge is online personalized learning systems. These systems draw on mul-
tiple knowledges (clinical practice, scientific research, patient experience) to
create an environment where health is a collaboration among individuals
interested in health. These systems, often designed for chronic illness,
are ways for individuals to become more informed and more responsible
for their bodies. These systems seem to blend the purposes of healthcare
service and social networks – provision of care with peer support. These
systems provide perching spaces within biomedicine for people to negotiate
their own health needs (physically, emotionally, and psychologically), often

on their own schedule. The online venue permits people to engage with biomedical knowledge in non-traditional ways, which may have an impact on how biomedical knowledge addresses broken embodiments. As a disruption to biomedical knowledge, the standard knowledge for biomedicine as an apparatus, there is the potential for these online systems to transform the patient-physician relationship. The systems as designed fall short, however. The premise of the interaction among the participants in these systems is that authority still resides with biomedical knowledge in that the patient has to commit to learning, interacting, and networking, whereas the physicians continue more of the same work and the researchers gather more data.

Diagnostic and Treatment Protocols

If holding a particular diagnosis provides someone with access to the various parts of the apparatus of biomedicine, a key question is who gets to say what constitutes a diagnosis of ME? Politically, its corollary would be from which nook could someone perch to contribute to the discussion of determining the parameters of what ME is from the view of a person with a broken embodiment? Diagnoses are basically classifications of disease and illness encompassing both the body and the psyche. The *International Statistical Classification of Diseases and Related Health Problems;* the *International Classification of Functioning, Disability, and Health;* and the *Diagnostic and Statistical Manual of Mental Disorders* are the most prominent sets of guidelines in determining illness and disability across the globe (American Psychiatric Association 2013; World Health Organization 2001, 2011).

Inclusion of viewpoints other than those that frame and are already embedded in biomedicine, however, is tricky. When people enduring bodily distress clamour to be heard in a biomedical setting, they want the categories – the diagnoses – to reflect their experiences of illness. Throughout the 1990s in Canada and the United States, for example, those experiencing bodily sensations commensurate with ME fought against being diagnosed with clinical depression and fibromyalgia syndrome; in Ireland and the United Kingdom, they rebuffed depression, anxiety, and other serious psychiatric disorders. Resistance to a diagnosis that a person does not think fits (like depression) or refusal to accept the existence of a set of symptoms the doctor has identified (like depression as a symptom) can actually fall into diagnostic categories and be counted as an authentic disease. Colloquially, hypochondriacs are those who worry about each and every flutter in their body and rush off to see the physician. Biomedically, a host of categories capture such behaviour. Prior to 2013, a person might be diagnosed with

hypochondriasis, somatoform disorder, general anxiety disorder, pain disorder, or somatic symptom disorder. Since 2013, the very same person would be diagnosed with somatic symptom disorder along with a descriptor of the prominent issue, such as pain, medically unexplained symptoms, and illness anxiety (American Psychiatric Association 2013). All of these categories – or diagnoses –indicate the "it's all in your head" approach to understanding bodily distress.

In addition to excruciating headaches, flu-like sensations, extreme fatigue, and migratory pain that can burn, ache, and sting (sometimes at the same time), people with ME have what would be considered strange bodily sensations – electric skin, the brain scraping against the inside of the skull, adrenal rushes when asleep, and disproportionate anxiety responses to a fight-or-flight situation. These kinds of symptoms do not readily translate into biomedical parlance that would describe any disease as a distinct entity. Yet some diagnostic protocols are more embodied than others; that is, there is more resonance with the description of the disease and the experience of the illness. Elsewhere I have argued that the Canadian guidelines for the diagnosis of ME (Carruthers et al. 2003) were more embodied than other criteria used to distinguish ME from other diseases (Moss 2008). In that work, I show that these guidelines reoriented the debate about ME away from etiology toward the experience of the illness. With this shift, the description of the symptoms became more flexible such that the criteria were more inclusive of the experience of people actually ill with ME.

These criteria were revised into what is known as the International Consensus Criteria (Carruthers et al. 2011). The revision process arose in part because of criticism over the precision of the description of symptoms and the non-differentiation between ME and chronic fatigue syndrome (see Carruthers 2012; Jason et al. 2010). What is significant about these guidelines in light of looking at biomedicine as an embodied apparatus is that both sets – the original and the revision – included an activist as a voice for those with ME. Marjorie I. van de Sande, from the National ME/FM Action Network, sat on the panel that developed and revised these guidelines. She now holds a position at the Network as the *Consensus* coordinator – *Consensus* referring to the diagnostic and treatment protocol document itself. The National ME/FM Action Network, founded in 1993 by Lydia Neilson, coordinates national and international efforts to change the structures that regulate and govern people with ME. This group was able to insinuate itself into the process of producing the very parameters of defining

a disease, aspiring to legitimate the experiences of individuals with ME. This particular intervention as an example of perching shows that the relationships that hold the apparatus together and make it operate as an entity can also be engaged to gain legitimacy and make sense of broken embodiments.

On Perching as a Strategy for Legitimation

Without an entrance to the apparatus of biomedicine, people with broken embodiments commensurate with ME can only become interlopers with a singular goal of figuring out what is wrong with them so that what is broken can be fixed. In a ping-pong fashion, people are bopped, cajoled, and dispatched through the maze of elements in the apparatus as part of a truth game between bodily (experiential) and biomedical knowledge. Figuring out how to make one's way through biomedicine, steeped in a knowledge that on the surface seems comprehensible, but when scratched reveals the greyness of the claims and intricacies of their applications, is far more difficult for those without diagnoses or with questionable ones than those with legitimate ones. For those who experience a break in their psychological, bodily, and emotional well-being, the experience of such a disruption unsettles the coherence of life up to that point and initiates a process whereby people must reconnect themselves to the world around them (see Moss and Prince 2014; Shildrick and Price 1996). Yet if primed with the understanding that bodies can act, that there are breaks in the exercise of power, and that bodies are embedded in wider systems, people with ME, or those who think they might have ME, can find places to perch, look around, and chart a course of action.

Perching is somewhat like the military activity of reconnoitring, making a survey of the land in order to map out a strategy for engagement. Although not usually recognized by disability activists as a full-fledged political strategy, perching is much more than research or support; perching is an active negotiation of power that provides insights into the exercise of the microphysics of power and sites for further action. What people with ME, and those who think they might have ME, have shown is that there is benefit in sitting back and observing. Disability politics, too, can benefit from pausing, alighting in an informed positioning, and making plans from the information gathered.

Through a need to be recognized as ill, people with broken embodiments have politicized their engagement with biomedicine. The intensity of the

bodily sensations, the strange feeling of being engulfed in the unknown, and the overwhelming sense that something is wrong form an urgency in which they deem their bodies, not their minds, as in need of fixing. Their bodies are more than just their forgetfulness, their adrenaline rushes, their awkward balance, their short-temperedness, and their exhaustion. Their bodies exist as a site where these newly experienced sensations are put into dialogue with multiple knowledges that inform understandings of their own bodies. As truth regimes collide, these bodily disruptions are less like the concord of recovering from a short-term interruption with a firm expectation of returning to the ordinary and more like the commotion of a surprise disintegration with the suspense of an unfamiliar and uncertain resolution. In response, it makes sense that finding places to perch while plotting strategies for engagement with biomedicine emerged as an effective way to deal with their broken embodiments. Thus, they have sought (and continue to seek) legitimacy among those who have power to make decisions about their health, their livelihoods, their bodies, and their minds, because it matters – physically, psychologically, emotionally, and politically.

The effects of disabling illness extend far beyond the limits of the body. How knowledges interact and come to dominate particular realms of life – that is, the way they can plug into each other – configures the terrain of biomedicine as an embodied apparatus. Access to and distribution of health benefits, disability claims, and even life insurance depends on the ascription of specific disease categories. The specific sites where people find places to perch in their search for legitimacy are all points where there is a break in the microphysics of power. Residing in those breaks, just for a while, permits the absorption of information needed to figure out what to do next. Engaging these micro-instances of the exercise of power with the knowledge gained from reconnaissance gently shifts the organization of biomedicine as an embodied apparatus. For those with ME, having experienced the devastating effects of a broken embodiment, wheedling one's way into biomedicine is a feat indeed. So being able to claim legitimacy biomedically opens up spaces where those with bodily sensations commensurate with ME were once barred. Gaining access to those things that matter – diagnosis, prescriptions, and treatments – means being able to traverse more easily the intricacies of the predominant mode of healthcare delivery and service provision. It also comes with the peace of mind knowing that you were right – there was something wrong in the first place.

ACKNOWLEDGMENT

I thank Christine and Michael for their invitation to be part of this book project. I appreciate their work in bringing together such an accomplished group of disability scholars and activists. I also appreciate their comments on earlier drafts of this chapter as well as the comments from two anonymous reviewers. Their insights have made it stronger. I am aware of many of its shortcomings, particularly as they relate to those with ME. As an activist, I have been able only to provide some concepts to help think through biomedical knowledge in a way that makes it less formidable. I hope that, in some way, these concepts make life easier for those living with ME.

WORKS CITED

American Psychiatric Association. 2013. *Diagnostic and Statistical Manual of Mental Disorders*, 5th ed. Washington, DC: American Psychiatric Association.

Barker, Kristin K. 2005. *The Fibromyalgia Story: Medical Authority and Women's Worlds of Pain*. Philadelphia: Temple University Press.

Brown, Phil, Mercedes Lyson, and Tania Jenkins. 2011. "From Diagnosis to Social Diagnosis." *Social Science & Medicine* 73 (6): 939–43. http://dx.doi.org/10.1016/j.socscimed.2011.05.031.

Brown, Phil, Rachel Morello-Frosch, Stephen Zavestoski, and the Contested Illnesses Research Group. 2012. *Contested Illnesses: Citizens, Science, and Health Social Movements*. Berkeley: University of California Press.

Carruthers, Bruce, M. 2012. "Diagnostic Criteria: The New International Consensus Criteria for ME – Content and Context." *Journal of IiME* 6 (1): 8–12.

Carruthers, Bruce M., Anil K. Jain, Kenny L. De Meirleir, Daniel L. Peterson, Nancy G. Klimas, A. Martin Lerner, Alison C. Bested, Pierre Flor-Henry, Pradip Joshi, A. C. Peter Powles, et al. 2003. "Myalgic Encephalomyelitis/Chronic Fatigue Syndrome: Clinical Working Case Definition, Diagnostic and Treatment Protocols." *Journal of Chronic Fatigue Syndrome* 11 (1): 7–115. http://dx.doi.org/10.1300/J092v11n01_02.

Carruthers, Bruce M., Marjorie I. van de Sande, Kenny L. De Meirleir, N.G. Klimas, G. Broderick, T. Mitchell, D. Staines, A.C.P. Powles, N. Speight, R. Vallings, et al. 2011. "Myalgic Encephalomyelitis: International Consensus Criteria." *Journal of Internal Medicine* 270 (4): 327–38. http://dx.doi.org/10.1111/j.1365-2796.2011.02428.x.

Clare, Eli. 1999. *Exile and Pride: Disability, Queerness and Liberation*. Boston: South End Press.

Conrad, Peter. 2005. "The Shifting Engines of Medicalization." *Journal of Health and Social Behavior* 46 (1): 3–14. http://dx.doi.org/10.1177/002214650504600102.

Conrad, Peter, and Kristin K. Barker. 2010. "The Social Construction of Illness: Key Insights and Policy Implications." *Journal of Health and Social Behavior* 51 (1): S67–79. http://dx.doi.org/10.1177/0022146510383495.

Evans, Pat, and Michael Smith Foundation for Health Research. 2010. *Report from the Fraser Health Primary Health Care Forum*. Report for Fraser Health and the British Columbia Ministry of Health Services. https://www.fraserhealth.ca/media/FH%20IHN%20Forum%20ReviewNov2010.pdf.

Foucault, Michel. 1979. *Discipline and Punish*. New York: Vintage.
—. 1980a. *Power/Knowledge: Selected Interviews and Other Writings, 1972–1977*. Edited by Colin Gordon. New York: Pantheon.
—. 1980b. "The Confession of the Flesh." In *Power/Knowledge: Selected Interviews and Other Writings, 1972–1977*, edited by Colin Gordon, 194–228. New York: Pantheon.
—. 1980c. "Truth and Power." In *Power/Knowledge: Selected Interviews and Other Writings, 1972–1977*, edited by Colin Gordon, 109–33. New York: Pantheon.
—. 2003. *Abnormal: Lectures at the Collège de France, 1974–1975*. London: Picador.
—. 2008. *Psychiatric Power: Lectures at the Collège de France, 1973–1974*. London: Picador.
Gilbert, Emilee, Jane Ussher, and Janette Perz. 2012. "Embodying Sexual Subjectivity after Cancer: A Qualitative Study of People with Cancer and Intimate Partners." *Psychology & Health* 28 (6): 606–19.
Goodley, Dan, Bill Hughes, and Lennard Davis, eds. 2012. *Disability and Social Theory: New Developments and Directions*. London: Palgrave. http://dx.doi.org/10.1057/9781137023001.
Greener, Ian. 2008. "Expert Patients and Human Agency: Long-Term Conditions and Giddens' Structuration Theory." *Social Theory & Health* 6 (4): 273–90. http://dx.doi.org/10.1057/sth.2008.11.
Hall, Kim Q. 2011. *Feminist Disability Studies*. Bloomington: Indiana University Press.
Hansen, Nancy, and Chris Philo. 2009. "The Normality of Doing Things Differently: Bodies, Space and Disability Geographies." In *Rethinking Normalcy: A Disability Studies Reader*, edited by Tanya Titchkosky and Rod Michalko, 251–69. Toronto: Canadian Scholars' Press.
Horwitz, Allan V. 2002. *Creating Mental Illness*. Chicago: Chicago University Press.
Jason, Leonard A., Meredyth Evans, Nicole Porter, Molly Brown, Abigail Brown, Jessica Hunnell, Valerie Anderson, Athena Lerch, Kenny De Meirleir, and Fred Friedberg. 2010. "The Development of a Revised Canadian Myalgic Encephalomyelitis Chronic Fatigue Syndrome Case Definition." *American Journal of Biochemistry and Biotechnology* 6 (2): 120–35. http://dx.doi.org/10.3844/ajbbsp.2010.120.135.
Jutel, Annemarie Goldstein. 2014. *Putting Name to It: Diagnosis in Contemporary Society*. Baltimore: Johns Hopkins University Press.
Klawiter, Maren. 2008. "Moving from Settled to Contested: Transformations in the Anatomo-Politics of Breast Cancer, 1970–1990." In *Contesting Illness: Processes and Practices*, edited by Pamela Moss and Katherine Teghtsoonian, 281–303. Toronto: University of Toronto Press.
Longhurst, Robyn. 2012. "Becoming Smaller: Autobiographical Spaces of Weight Loss." *Antipode* 44 (3): 871–88. http://dx.doi.org/10.1111/j.1467-8330.2011.00895.x.
McGann, P.J. 2011. "Troubling Diagnoses." In *Advances in Medical Sociology: Sociology of Diagnosis*, vol. 12, edited by P.J. McGann and David J. Hutson,

331–62. Bingley, UK: Emerald. http://dx.doi.org/10.1108/S1057-6290(2011) 0000012019.

Mol, Annemarie. 2002. *The Body Multiple: Ontology in Medical Practice*. Durham: Duke University Press. http://dx.doi.org/10.1215/9780822384151.

Morgan, Kathryn Pauly. 2011. "Foucault, Ugly Ducklings, and Technoswans: Analyzing Fat Hatred, Weight-Loss Surgery, and Compulsory Biomedicalized Aesthetics in America." *International Journal of Feminist Approaches to Bioethics* 4 (1): 188–220. http://dx.doi.org/10.2979/intjfemappbio.4.1.188.

Moss, Pamela. 2003. "Re-Reading Ill Bodies as Healthy Bodies: Positive Ontology in Practice." *Chimera* 18: 111–15.

–. 2008. "Edging Embodiment and Embodying Categories: Reading Bodies Marked with Myalgic Encephalomyelitis." In *Contesting Illness: Processes and Practices*, edited by Pamela Moss and Katherine Teghtsoonian, 158–80. Toronto: University of Toronto Press.

Moss, Pamela, and Isabel Dyck. 2002. *Women, Body, Illness: Space and Identity in the Everyday Lives of Women with Chronic Illness*. Lanham, MD: Rowman & Littlefield.

Moss, Pamela, and Michael J. Prince. 2014. *Weary Warriors: Power, Knowledge, and the Invisible Wounds of Soldiers*. New York: Berghahn.

Moss, Pamela, and Katherine Teghtsoonian, eds. 2008a. *Contesting Illness: Processes and Practices*. Toronto: University of Toronto Press.

–. 2008b. "Power and Illness: Authority, Bodies and Context." In *Contesting Illness: Processes and Practices*, edited by Pamela Moss and Katherine Teghtsoonian, 1–27. Toronto: University of Toronto Press.

Pall, Martin L. 2007. *Explaining Unexplained Illnesses*. New York: Harrington Park Press.

Pescosolido, Bernice A. 2006. "Professional Dominance and the Limits of Erosion." *Society* 43 (6): 21–29. http://dx.doi.org/10.1007/BF02698481.

Prince, Michael J. 2009. *Absent Citizens: Disability Politics and Policy in Canada*. Toronto: University of Toronto Press.

Roets, Griet, and Rosi Braidotti. 2012. "Nomadology and Subjectivity: Deleuze, Guattari and Disability Studies." In *Disability and Social Theory: New Developments and Directions*, edited by Dan Goodley, Bill Hughes, and Lennard Davis, 161–78. London: Palgrave. http://dx.doi.org/10.1057/9781137023001.0015.

Segal, Judy Z. 2005. *Health and the Rhetoric of Medicine*. Carbondale, IL: Southern Illinois University Press.

Shildrick, Margrit, and Janet Price. 1996. "Breaking the Boundaries of the Broken Body." *Body & Society* 2 (4): 93–113. http://dx.doi.org/10.1177/1357034X9600 2004006.

Stone, Sharon Dale. 2008. "Resisting an Illness Label: Disability, Impairment, and Illness." In *Contesting Illness: Processes and Practices*, edited by Pamela Moss and Katherine Teghtsoonian, 201–17. Toronto: University of Toronto Press.

Tremain, Shelley, ed. 2005. *Foucault and the Government of Disability*. Ann Arbor: University of Michigan Press.

–. 2015. "New Work on Foucault and Disability: An Introductory Note." *Foucault Studies*, no. 19: 4–6.

Wendell, Susan. 1996. *The Rejected Body: Feminist Philosophical Reflections on Disability*. New York: Routledge.

World Health Organization. 2001. *International Classification of Functioning, Disability, and Health*. http://apps.who.int/classifications/icfbrowser/.

–. 2011. *International Statistical Classification of Diseases and Related Health Problems*. http://apps.who.int/classifications/icd10/browse/2010/en.

Zavestoski, Stephen, Phil Brown, Sabrina McCormick, Brian Mayer, Maryhelen D'Ottavi, and Jaime C. Lucove. 2004. "Patient Activism and the Struggle for Diagnosis: Gulf War Illnesses and Other Medically Unexplained Physical Symptoms in the US." *Social Science & Medicine* 58 (1): 161–75. http://dx.doi.org/10.1016/S0277-9536(03)00157-6.

12

Challenging Rhetorical Indifference with a Cripped Poetry of Witness

JEN RINALDI and nancy viva davis halifax

> *If people knew what we went through surely they would do something.*
>
> *— Anonymous woman*

Suffering on a mass scale is an everyday, ordinary occurrence within Canada despite instruments of governance such as the Canadian Charter of Rights and Freedoms. Hunger, poverty, and homelessness lack social or political audience. Canadians remain indifferent.

Inscribed in the wording of the Charter is a particular framework that endorses the distribution of civic rights to individual rights-bearers. What go unacknowledged in the text are the socio-economic conditions that produce inequalities between and among citizens. This dearth in constitutional protections means very little has been done to address poverty that especially affects disabled Canadians. When we lack the vocabulary to call oppression by name, we lack the proper tools and legal recourse to seek redress. Reform necessitates that we heed the rhetorical constructions used in Charter jurisprudence and that we reframe and reorient our words.

In this chapter, we use language in the service of social justice and equity. Using the text of the Charter and the challenges raised in regard to disability and homelessness, we will situate a response to Canadian indifference in a

feminist political, theoretical, and poetic space. In its post-structural posi-
tioning and its accompanying valuing of difference, this work will encompass
an ethical and empathically unsettled response that is non-linear, frag-
mented, and oblique. Understanding disability as "undecidability" (Shildrick
2005a, 763), we think through a radical immanence of embodiment using
cripped poetry that "centers in bodies which are themselves off-center" and
"rejects views of disability as ... shameful, pitiable, tragic, and individual"
(Ferris 2007, unpaginated), alongside a poetry of witness (Forché 1993).

 We begin with the socio-legal and historical context within which consti-
tutional law and its languages were developed. We then unpack theory work
on the legal and philosophical activity of recognition, given that, historic-
ally, disability activisms sought and accomplished recognition of disability
categories under law, and we develop a critique of recognition drawing
from Derridean and feminist scholarship. Finally, we offer crip poetry – an
arts-based address to the wounded and wounding shapes that break from
the texts of legal language. Our intention is to use poetics as a rhetorical
strategy despite the solidity of indifference and as a practice through which
we might bear witness to the injustices that abound notwithstanding, and
sometimes because of, law.

Jen: An Investigation of Our Grounds

Socio-legal Context

The inclusion of mental and physical disabilities as enumerated prohibited
grounds for discrimination under section 15 of the Canadian Charter of
Rights and Freedoms was not a foregone conclusion. In their original draft-
ing, Charter equality provisions restricted prohibited grounds to race,
national or ethnic origin, colour, religion, age, and sex (Peters 2004). The
Council of Canadians with Disabilities, then called the Coalition of Prov-
incial Organizations of the Handicapped (COPOH), objected to the exclu-
sion of disability language and took action to see its incorporation (Lepofsky
and Bickenbach 1985). In an initial response, the Ministry of Justice refused
COPOH's demands, arguing that only identity markers that have long hist-
ories of disadvantage would be recognized:

> It was ultimately decided to limit the grounds of non discrimination to
> those few which have long been recognized and which do not require sub-
> stantial qualification. Unfortunately such is not yet the case with respect to
> those who suffer physical handicaps and consequently provision has not
> been made in the *Charter* for this ground. (Demers 1980)

This position did not hold, perhaps due to COPOH intensifying its campaigns, and disability was included in Charter drafts by 1981, marking what the Council of Canadians with Disabilities has called "the coming of age for the [Canadian] disability rights movement" (quoted in Peters 2004, part II). Legal recognition has its benefits: recourse now exists to challenge ableist legislation. The Charter functions as a tool for those who have the wherewithal and grounds to issue constitutional challenges. Further, subsequent legislation would incorporate disability, creating a history that can be traced through law without need for substantial qualification (Prince 2009).

Nevertheless, the Charter predominantly emphasizes civic rights. Equality provisions under section 15 do not protect citizens from economic disparity, nor do they recognize poverty as an equality matter. Ena Chadha and C. Tess Sheldon (2004) point out that the socio-economic rights that international law recommends may be reflected elsewhere in explicit, implied, or interpreted terms. Whether or not this is the case – that is, whether or not we see legal rhetoric about socio-economic rights to welfare, healthcare, and the like surface in court decisions, statutory law, or even the generous interpretation of subtext – socio-economic conditions continue to fall below par, especially for people already disadvantaged by ableism.

According to the 1997 *Maastricht Guidelines on Violations of Economic, Social and Cultural Rights* (International Commission of Jurists 1997, article 1), "The impact of [global socio-economic] disparities on the lives of people – especially the poor – is dramatic and renders the enjoyment of economic, social and cultural rights illusory for a significant portion of humanity." Specifically pertaining to Canada, the 1998 UN Committee on Economic, Social and Cultural Rights criticized federal and provincial powers for policies that "exacerbated poverty and homelessness among vulnerable groups" (51) and recommended the integration of socio-economic rights into Canadian law to ameliorate what was fast becoming a crisis. David Lepofsky (1997) argues that disabled Canadians disproportionately experience socio-economic disadvantage in contrast with non-disabled Canadians, given the overrepresentation of the former in poverty statistics, underrepresentation in post-secondary education, and dependence on government, charity, and healthcare services for basic needs. Though disability is now found and enshrined in law, this evidence suggests that disabled persons continue to encounter obstacles that fall outside of law's purview. We might then do philosophical work to understand what it has meant for disability to fall within the scope of law and to be recognized under law.

That is, we mean to develop a theoretical framework that can ferret out the limitations to formal legal consideration and serve as a foundation to our response.

Modern Musings

Recognition is the confirmation of belonging to the category of personhood, or having membership in a legal or moral community. There is a component of mutuality to the activity, at least in recognition theories that would understand the self to be constituted through relationships. Patchen Markell (2003, 12) argues that the ideal of recognition "anchors sovereignty in knowledge; that is, in the prospect of arriving at a clear understanding of who you are and of the nature of the larger groups and communities to which you belong." Central to regarding oneself as a person, to becoming conscious of one's membership in a moral community, one must be taken into this community, regarded and treated as a person. Or one must find motivation to force one's way into such a community that fails or refuses to offer regard.

Recognition theory is largely grounded in the work of Georg Hegel (1977), who explains that self-consciousness, that which exists for itself and through "the exclusion from itself of everything else" (186), develops through dialectical confrontation and struggle. He tells the story of a master and a slave, who "are opposed to one another, one being only recognized, the other only recognizing" (185). Persons become self-conscious by seeing themselves in and sublated by others. Those experiencing sublation may react by either annihilating or subordinating the other. This is a decidedly violent way of developing and preserving consciousness of self, which guarantees the status of subjectivity or mastery, and the privilege of deciding who will be recognized – who will be affirmed and accorded respect. If self-consciousness is "the pure negation of its objective mode" (187), the slave remains an object outside the bounds of recognition until it too presents as a being-for-self, abstracted from material, instrumental being. The arrangement is unstable, so in lieu of a life-or-death struggle, Hegel recommends instead a framework of rights that can be expanded to include groups coming to develop and present their self-consciousness, without need of violence.

Engaging such a framework, identity politics consists of political campaigns interested in advancing social change, from civil rights to the women's movement to LGBT activisms. Renee Anspach (1979, 773) calls this work "phenomenological warfare" or "a struggle over the social meanings attached

to attributes." Charles Taylor envisions identity politics as a struggle for recognition – "that is, as attempts to secure forms of respect and esteem that are grounded in, and expressive of, the accurate knowledge of particular identities borne by people and social groups" (quoted in Markell 2003, 39). For Taylor (1994), recognition entails the affirmation of something previously forgotten or absent – a way of being that had once been distorted, but upon inclusion marks a transformation in social, political, or legal systems. This inclusion does not necessitate the sharing of commonalities with other members of the moral community, but it does require respect for their differences. Nevertheless, identity politics have been critiqued (Heyes 2000; Spelman 1988) for essentializing identity classifications by supposing that there is an authentic way of being at the heart of any particular identity. This forced authenticity may result in pressure to take up an identity in particular ways to fall within the bounds of recognition.

Furthermore, identity politics prioritizes a kind of recognition that does not require redistribution of resources (Fraser 2003; Rorty 1999). Critical of this limitation, Nancy Fraser calls for transformative politics that redress material deprivation instead of expanding empty legal rhetoric. Disability studies scholar Michael Prince (2009) understands identity politics to encompass socio-economic redistribution, for he argues that "struggles of the disability movement are not to the exclusion of material issues of employment, accessible education, and income security or of governmental issues of public participation and policy making" (121).

Robert McRuer's (2006, 71) work on crip theory has an ambivalent relationship of "claiming disability and a disability identity politics while nonetheless nurturing a necessary contestatory relationship to that identity politics" – contestatory because identity is a fixed state, but he seeks to crip or destabilize categories of meaning. In conversation with McRuer, Melisa Brittain characterizes his theory work: "While you [McRuer] see usefulness in political movements grounded in identity, you are also trying to get at something that is in excess of identity categories" (quoted in Peers, Brittain, and McRuer 2012, 152). It would seem, then, that recognition is not enough, that there is further work to be done in a legal system – and to a legal system – to protect and provide for disabled persons. To make sense of what a theoretical framework would look like should it contest identity and do more than recognize (at least more than recognition in the modern sense would allow), we might turn to crip theory's philosophical antecedent, post-structural critique.

Post-structural Reflections

Jacques Derrida is critical of identity thinking, holding that "the rapport of self-identity is itself always a rapport of violence with the other; so that the notions of property, appropriation and self-presence, so central to logo-centric metaphysics, are essentially dependent on an oppositional relation with otherness" (quoted in Kearney 1984, 117). The Hegelian presentation of self-consciousness requires opposition to alterity, and Hegel would even agree that this opposition can be violent and forceful. A precondition for identity thinking, for the assertion of identity, is that someone be othered from or outside of the limits being carved out.

For Derrida (1974), language functions as a system of signification that represents, classifies, and makes sense of reality. Subjectivity is a discursive product, then – born within and bound by language. To self-identify is to present or bring to presence a self that is constituted by language. But absence functions as a prerequisite for presence to hold, like the spaces on a page are necessary for words to hold form. He explains, "Spacing as writing is the becoming-absent and the becoming-unconscious of the subject. By the movement of the drift/derivation the emancipation of the sign constitutes in return the desire of presence" (Derrida 1974, 69). So self-consciousness drifts to the becoming-present of signifiers from the liminal spacing in between.

That which is other to or different from identity both stands outside conceptual boundaries and functions within our systems of signification. That which has not been recognized haunts the in-between, phasing in and out of presence: "The outside bears with the inside a relationship that is, as usual, anything but simple exteriority. The meaning of the outside was always present within the inside, imprisoned outside the outside" (35). The unnamed is a sort of spectral reality, not fully manifest as long as there are no words to describe it or accord it meaning – not brought to life, not fully formed, instead cast in shadow. Derrida (1994) calls these others our ghosts, comparing them to the revenant in Shakespeare's *Hamlet:*

> I am thy Father's Spirit,
> Doom'd for a certaine terme to walk the night,
> ... But that I am forbid
> To tell the secrets of my Prison-House;
> I could a Tale unfold. (quoted in Derrida 1994, 93)

These ghosts are foundational to our legal and political systems, for legal authority requires a violent rapport with otherness – a violence without

logical justification – yet functions as the cornerstone for building a system of logocentric and hyperrational, indifferent, and impartial law: "Since the origin of authority, the foundation or ground, the position of the law can't by definition rest on anything but themselves [those who have authority], they are themselves a violence without ground" (Derrida 1989, 943). E.B. Elliott (2002, 184–85) describes Derrida's position: "The law is a disciplinary regime arbitrarily instituted by acts of founding violence. That violence is legitimated by the newly inaugurated system that retrospectively rationalizes its brutal birth."

To find our revenants, then, to bear witness to the hidden and the forgotten, is to challenge the very structure of a legal system for its "glaring hypocrisy in its formal or juridicist rhetoric of human rights" (Derrida 1994, 80). And to find them is to enact justice, which Derrida would not equate with law inasmuch as legal recognition is inadequate, linguistically bound, built not on the ideal of justice but on the unsteady ground of asserting self-identity at the expense of otherness. As he says, "Law *(droit)* is not justice. Law is the element of calculation, and it is just that there be law, but justice is incalculable, it requires us to calculate the incalculable" (1989, 947). Or, as Elliott (2002, 186) interprets, "Law is a frustrated approximation of justice. Law is a phenomenon earnestly yearning to answer the call to enforcement essayed by justice, yet locked and imprisoned by its own foundation and nature into desperate inadequacy."

Margrit Shildrick (2005b, 41) describes the Derridean position on recognition: "the legal recognition of the other is both an urgent need ... and a move that entails normalization and domestication." As a response to the problematics of legal rhetoric, Derrida may advocate instead that we bear witness, that we approach with an openness and willingness those who stand other to our textual and juridical constraints. This openness calls for an interruption of subjectivity, for subjectivity is originally predicated on violence done to the other. Says Elliott (2002, 191), "It is the awakening to alterity that ushers in an impetus to the re-conceptualization of the self. The re-conceptualization is based upon the primary care of the other, and structurally incorporates responsibility to the other into every self that it touches." Identity – and by extension our institutional frameworks – would therefore not be an assertion, a forcing into the world of becoming present, but a reaction or response to need, shaped and constituted in relation. Thomas McMorrow (2007, 27) illustrates this point by considering his responsibility and response to an embodied other:

Edgardo with the rough beard and angry eyes who has asked me for change on Rue St. Laurent is real as lice or thirst. He is one of the living, breathing human beings on this planet, in this city with whom my relations are governed by laws. That guy – with his vulnerability and loneliness, resentment and chattiness, desperation and hunger – has some pretty practical problems – that can only begin to have an impact on the way I think about him, myself and the world, if I recognize him and seek to know his problems.

Recognition, then, if we are to understand it to be recognition at all, necessitates an affirmation of the infinite value of another person that displaces the priority of self. It ought not be a framework that despite repeated expansions inevitably results in some form of social exclusion, because it has yet to accord meaning to the forgotten history and absent realities of our revenants. Recognition should not involve the dignity of being-in-itself, because becoming-present always occurs in relation – it is the orientation of the relation that matters. This reorientation is a responsibility that may not be satisfied with rhetoric alone, for it may call for adjustments in distribution patterns, may require an amelioration of disadvantage and resource deprivation, and may demand shifts in attitudes and expectations. For just as justice is always irreducible to law and an impossible ideal yet to come, not entirely captured within the confines of our systems of signification, so too is the other irreducible and undecidable, exceeding and transgressing the closures around meaning that our legal and linguistic systems impose; we are left to adjust to it.

Poetic Response
How might we begin the work of bearing witness and opening up to our forgotten others? How do we pay heed to the ghosts haunting us when they lack language to frame their injustice, inasmuch as the limits to juridical language do not reach justice? Derrida (1972) advocates play – an approach to language that loosens our boundaries by not taking any of them too seriously. He calls the play of differences *différance*, the word itself reflecting play in its deliberate misspelling that cannot be heard, but can only be seen. *Différance* "makes possible the presentation of the being-present" (Derrida 1972, 6). To engage in wordplay is to manipulate language to find those preconditions to presence and to use their productive force in deconstructing systems of meaning. To find *différance* is to mark "a relation to alterity, to the singularity of the other" (Derrida 2002, 93). It binds us to others, and in so doing breaks apart the walls within and outside which they were locked.

Poetry can serve as a strategy for engaging in wordplay, and indeed, we propose to use poetry to close this chapter in order to play with the language we have heretofore had at our disposal to frame issues of social justice. Patricia Leavy (2009) describes poetry as a kind of lyric narrative that "can help us access the *subtext* that helps shape our experience, perception, and understanding of social reality" (162). The form of poetic writing itself accesses subtext by saturating the empty space and the in-between with meaning: "Poems, surrounded by space and weighted by silence, break through the noise to present an essence. Sensory scenes created with skillfully placed words and purposeful pauses, poems push feelings to the forefront capturing heightened moments of social reality as if under a magnifying glass" (Leavy 2009, 141).

Audre Lorde (2007) frames the latent meaning embedded in poetry as a quality of light otherwise impossible to capture in prose. She claims that poetry sheds a new sort of light on experiences and feelings that have been rendered invisible. Traditional rhetoric erases experience and emotion, so much so that "within the structures defined by profit, by linear power, by institutional dehumanization, our feelings were not meant to survive" (Lorde 2007, 38). But language need not be so rigid, nor dictate our limits, not when we can tap into its fluidity and play with meaning, for "poetry is the way we help give name to the nameless so it can be thought" (Lorde 2007, 37). So we exchange one voice for another, distancing ourselves from legalist language and applying a poetic response, one that attests to the reality of material deprivation and critically contests the language that occasions law's indifference.

nancy: Light at the Threshold

What is said

"Well, they are liars."

nos voisines
For the past seven years I, nancy, have been part of an arts collective, the Red Wagon Collective, which perseveres with and alongside a group of women, *nos voisines*, who experience and are subject to the immiserating conditions of poverty, homelessness, disability, and chronic illness. As a collective member, I am committed to acknowledging our labours as enacted in conversations held over years, on historically contested lands, across multiple categories of identity and difference.

and indifference. oh canada.

It is through the repetition of days into years that we find ourselves existing as neighbours, attuned to how and where we live and labour and to the precarities of difference and variable embodiedness. The praxis of Red Wagon with *nos voisines* thinks through, feels, is touched by, touches, and at times clumsily senses as it grasps what is of consequence. Over years, the same act(ion)s are practised: cookies baked and eaten, stories told and retold, the pouring of water over aromatic leaves, and the gestures that are shared across embodiments as our history(ies) becomes manifest in quilts, tents, poems, drawings, songs. These cultural artifacts embody our "exchange of energy, [our] system of relationships" (Rukeseyer quoted in Rich 2001, 124). Together we exist in relation to what are often named conditions, which may better be understood as shadows cast from curves of bodies against which is formed a horizon of late-capitalist economies that clamour for progress and productivity (Stewart 2011). The Red Wagon Collective is part of a social project that has not yet achieved its existence – it flickers at the limin (Povinelli 2011). This flickering occurs and leaks into a sense that something is coming into existence even while it trembles, fades. What is coming forward coheres along the lines of body. I return to the apparitions of feeling, the felt, to what I could and still could disregard. But the liveliness of this current orients me, pulls me in. I write that which makes its tenancy within – what presents as light at the threshold.

thought lies close to body

What presents as I lie on my couch, computer propped, dog and kitten sleeping, is what I name the socially disavowed, those unbound revenants that wander, erasing, rewriting, unchanged (Gordon 2008). On this couch, in this body, sensations, gestures, and moments accumulate – what arrives matters, will not quit, will not admit my escape. My orientation is to that which abides and drifts. The theory is mostly *weak* (Kosofsky Sedgwick 1997; Stewart 2011) and at best facilitates a general direction. If we recognize in the substance of our direction that there is no *true* north (Bringhurst 2008), we still recall that north as culturally constituted has an influence. Its line inclines until it yields "to follow the objects it encounters, becomes undone by its attention to things that don't just add up but take on a life of their own" (Stewart 2008, 72). North undone. There are threads that entangle *nos voisines* and me that undo us. These threads are energies, phrases, scents

that have taken on their own lives, to which I am not indifferent. I attend to these resolute and ephemeral bodies through the sensuous practice of body writing.

Sensuous language, sensuous knowing is intimate, asymmetrical; it is that thing through which we do not think for meaning but through which meaning arrives – language snuggles – or as "Adorno reminds us ...[,] in Benjamin's writings thought presses close to its object, as if through touching, smelling, tasting, it wanted to transform itself" (Taussig 1992, 145). This is such a beautiful sentence – thought wants to transform itself ... through touch, taste, through the senses ... Poetry as body writing, as sensuous language, is an immanent practice of writing (Braidotti 2002).

a poem is not a law or a promise
Poems have less reliance on the propositional, different beliefs about facts and figures, and the flush of the sensuous. I write as audience to "the human costs of a system that is utterly dependent on the repression of a knowledge of *social* injustice" (Gordon 2008, ix; emphasis in original). I do not suggest that propositional knowledge is dispensed with or displaced – for it wraps itself around us and our world and we around it and there are moments when we depend on it – just that we admit (to) other forms of knowledge. *I write in response to the Charter's revenants, clothed in its scraps.* In so doing we acknowledge that each language form relies on different constructions of attention or practices of regard, or being apprehended. *I write as ear, skin, listener.* The poems are written because there is always something waiting – in the corner, at the curb – that seeks attention even as it is still without form, or as its form sparks and tumbles.

poetry is a call to the unnamed
Poetry allows for "the thing to rise up through the writing on the page as itself" (Finley 2006, 19). In this rising, the germ of the felt is enfleshed, constituted by the bones of language – vowels and consonants congregate, dive from doubt into recognition. Poetry proposes a particular regard for the gestures of the world, performs the sensuous (e)motion of language "without closing the experience in the trap of the name" (Finley 2006, 20). Affect under skin discerns heat, touch of iron, rose, or ice. Senses, attuned to glimmers from the multiple realms of the felt, disclose the emergent event of the as-yet-unthought. A poem is an accumulation of moments, imaginaries, is part of a social and aesthetic

practice in which light and shadow, sound and silence co-produce ways of attuning to and writing that which is rising and sinking and glimmering.

Poems, as Lorna Crozier (2006) notes, happen in moments of intense perception. They bear sense impressions across subjectivity(ies) and as such can act as a call to the other (Forché 1993). The poem does not explain but presents multiple narrative truths, not facts, in which our lives are immersed. Through poems we attend to intensities and stirrings, "the resonance of nascent forms quickening or sloughing off" (Stewart 2011, 446). We watch and wait upon the unknown, the immanent, the "materialities pressing into the expressivity of something coming into existence" (Stewart 2011, 446). The poem is not simply a container or object (Richardson 1994) filled with words – it is structure, desire and act embodied (Vernon 1979). A "poem 'shows' another person how it is to feel something ... It is felt" (Richardson 1994, 9).

Felt. Filled with feeling. The world arrives in a poem, touches us. Feeling becomes at times grasping or groping – there is hesitation; faltering through time, it arrives. This feelingtouch can be haptic, interoceptive – is under skin – subcutaneous. The world presents not only through the social, the political, but through the unnamed felt revenants, which the poem gathers.

a poetry of witness
The poet Carolyn Forché initiated the use of the phrase "poetry of witness" upon her return from El Salvador in the late 1970s. In 1981 she wrote, "It is my feeling that the twentieth-century human condition demands a poetry of witness" (quoted in Forché 2011). Forché (2011) suggests even now that a poetics of witness "remains to be set forth," and yet as such allows for a provisional indicator as to what might be included within this category. A poetics of witness requires "that the poet bear witness to extremity" (2011). "Extremity" suggests that the poet is inclined to attend upon all that emerges within the farthest regions, places where life is preoccupied with frailty, precarity, its own slender existence. Much of the published poetry of witness – as much as it could be said to have a canon – draws upon the witnessing of extreme suffering. In Forché's *Against Forgetting*, the table of contents headings include genocide, holocaust, revolution, repression, war, struggle. Each word a multitude.

Scanning the headings further locates the witness in a political and social space at a great distance both temporally and geographically. There is a single Canadian entry, well known by many Canadian schoolchildren. "In

Flanders Fields" (McCrae 2014) is writing borne from extremity; McCrae was both a soldier and a doctor. His poem "bears the trace of extremity ... [and is], as such, evidence of what occurred" (Forché 1993, 30).

In contemporary Canada, the scale of extremity – suffering borne collectively and related to poverty, homelessness, hunger, chronic illness, and disability – the colossal social injustice to which I/we/you bear witness, is largely unwritten and unacknowledged, despite instruments of governance such as the Canadian Charter of Rights and Freedoms. Witnessing is resisted; beds crammed into every space are evidence of what is occurring and yet simultaneously denied: people with bags, and chaos, and desire, and fear, who walk too many hours and are burdened by fatigue. And somehow we seem content with this state – Canadians seem indifferent. Many of our elected officials ignore the daily counts of hunger and death. There is a lack of a cultural or political audience.

I am present for decades, witnessing the ordinary, iterative, neglected suffering – the lack in the amount and nutritional value of food over days and months extends into years; the inability to purchase tampons, deodorant, or tokens for travelling is not a Charter concern. I am witness to testimonies of ordinary violence and occasional sweetness (which *nos voisines* insist upon – the complexity of their lives) that have yet to find a dedicated audience. I write my witness to be read by others as "'co-witness' – propelling forward a politics of reading. Reading, listening to these poems implicates us – we become those who know and in knowing can orient ourselves in an ethical turn" (Forché 2011). There is hope that the trace of extremity under which *nos voisines* live "remains legible in these poems" (Forché 2011).

a canadian poetry of witness – cripped

The poems that close this chapter are both a response to section 15 of the Charter and an excerpt from a series of poems written alongside my witnessing of homelessness, poverty, disability, and chronic illness on the streets and within women's emergency shelters of Canada. They imagine not only the historic and structural violence that persons who are excluded endure, but also the beyond of their lives as objects of charity as they are exchanged through and across institutions. They form a weft across which is woven my understandings of the politics of disability/poverty and the complexity of un/housing across the Canadian landscape. The weft supports the shadowed memories of my history of rough living. In these poems there is evidence – they become a site for and of memory with all of its failures.

What to do if your country stops breathing

Hold her in your arms.

Call her best friend
while you gather courage
 to breathe
 small breaths into rivers compress

 hills, two three

Call her thirty-six fathers from the grave.

On Monday night, Jenny

slips onto the couch
spills herself into a cuppa tea.

Exhausted by here here Here and here
I watch her stained fingers smooth

wrinkles on her skirt
touch ear then

teacup, return to skirt,
to hair. No motion stranded.

She plucks out
evidence –

ivory, moon,
drywall, shortbread,

picket fences, bone, maggot –
colours, the tired lines of days.

Housing studies

Information tells us little that is useful:
fourteen nights
eighty-two beds

seven women
forty years
three thousand
thirty nine years.

Do not imagine gathered facts as complete sets.
A fact is ill-equipped
language starved
does not sing the bone curve of pine
has never stooped to hear grass
had no illiterate childhood.

Normed and damned – ill-equipped,
ill with reason. Equipped with truth:
seal cubs, the Stanley Cup, the Saskatchewan cobalt bomb –
can never remember the joke's end, the one about
the zamboni, the Newfoundland premier and the codfish.

Approaching sorrow

While I sleep
the memorial to the homeless dead sleeps
harnessed to an injury

of names (johndoejuanitadoejohndoejohn
doejuandoejohndoejohndoejanedoejohn
doejane). Under the heat of yellow linen

sweat stitched by needle workers
I dream an alphabet –
names of men, closed doors,

acts of violence
in legislative houses. Gyrating
maple keys navigate

ground and water,
emerald lawns chafe under
silent alarms.

Three strikes

No-one ever told me that. No-one.
If they told me that that
it was three
 well if they told me that
I would not have been shoved to this curb's shoulder.

The first nudge – I complained. One of the women – turns
out there was something monkeying with her insides so she
could not turn the light off squaring
off about cudgels and hastening all night losing
sleep – turns out
 she complained.

The second screw,
missed curfew by like five minutes
the worker didn't
understand
we had cracked
the dark and just
one more
buttery vanilla bean
praline
reach mattered.

Last knock, tips me
outta here. I had needle and thread
In my room

and maybe I got mouthy
had a word swap with staff
who found 'em. That's
the third.

Toronto, c. 2013

the full significance thirty-nine years unclaimed
 sentimentality

 change averages expectancy statistics


 dangerous savesafe

 streets
 episodes occupied empty discussion reject

 criminal lost commonplace heart body

 do not talktake life brutal expectancy merciless


ACKNOWLEDGMENTS

This work is not done in isolation. As such, nancy would like to acknowledge the women, *nos voisines*, and the conversations over the years with *nos voisines* as well as friends and colleagues. She would also like to acknowledge the other half of the Red Wagon Collective, Kim Jackson, for her persistence at the threshold.

WORKS CITED

Anspach, Renee R. 1979. "From Stigma to Identity Politics: Political Activism among the Physically Disabled and Former Mental Patients." *Social Science & Medicine*, no. 13: 765–73.

Braidotti, Rosi. 2002. *Metamorphoses: Towards a Materialist Theory of Becoming.* Cambridge: Polity.

Bringhurst, Robert. 2008. *Everywhere Being Is Dancing: Twenty Pieces of Thinking.* Kentville, NS: Gaspereau Press.

Canadian Charter of Rights and Freedoms. Part 1 of the *Constitution Act, 1982,* being Schedule B to the Canada Act 1982 (UK), 1982, c 11.

Chadha, Ena, and C. Tess Sheldon. 2004. "Promoting Equality: Economic and Social Rights for Persons with Disabilities under Section 15." *National Journal of Constitutional Law* 16: 27–102.

Crozier, Lorna. 2006. "From 'Who's Listening?'" In *20th-Century Poetry and Poetics,* edited by Gary Geddes, 964–66. Don Mills, ON: Oxford University Press.

Demers, Jacques A. 1980. Letter to Mr. Allan Simpson, National Chairman of COPOH, written on behalf of Jean Chrétien. Office of the Minister of Justice and Attorney General of Canada, Government of Manitoba Archives.

Derrida, Jacques. 1972. *Margins of Philosophy.* Translated by Alan Bass. Chicago: University of Chicago Press.

–. 1974. *Of Grammatology.* Translated by Gayatri Chakravorty Spivak. Baltimore: John Hopkins University Press.

–. 1989. "Force of Law: The Mystical Foundations of Authority." Translated by Mary Quaintance. *Cardozo Law Review* 11: 919–1045.

–. 1994. *Specters of Marx: The State of the Debt, the Work of Mourning, and the New International.* Translated by Peggy Kamuf. New York: Routledge.

–. 2002. "The Deconstruction of Actuality." In *Negotiations,* edited and translated by Elizabeth Rottenberg, 85–116. Stanford: Stanford University Press.

Elliott, E.B. 2002. "Beautiful Day: Awakening to Responsibility." *Law and Critique* 13 (2): 173–95. http://dx.doi.org/10.1023/A:1019965608303.

Ferris, Jim. 2007. "Crip Poetry, or How I Learned to Love the Limp." *Wordgathering* 1 (2). http://www.wordgathering.com/past_issues/issue2/essay/ferris.html.

Finley, Robert. 2006. "readingwritinglistening." In *A Ragged Pen: Essays on Poetry and Memory*, 15–23. Kentville, NS: Gaspereau Press.

Forché, Carolyn. 1993. *Against Forgetting: Toward a Poetics of Witness*. New York: W.W. Norton.

–. 2011. "Reading the Living Archives: The Witness of Literary Art to Hell and Back, with Poetry." *Poetry Magazine*, May. http://www.poetryfoundation.org/poetry magazine/article/241858.

Fraser, Nancy. 2003. "Social Justice in the Age of Identity Politics: Redistribution, Recognition, and Participation." In *Redistribution or Recognition? A Political-Philosophical Exchange*, edited by Nancy Fraser and Axel Honneth, 7–109. New York: Verso.

Gordon, Avery. 2008. *Ghostly Matters: Haunting and the Sociological Imagination*. Minneapolis: University of Minnesota Press.

Hegel, Georg. 1977. *Phenomenology of Spirit*. Translated by A.V. Miller. New York: Oxford University Press.

Heyes, Cressida J. 2000. *Line Drawings: Defining Women through Feminist Practice*. Ithaca, NY: Cornell University Press.

International Commission of Jurists. 1997. *Maastricht Guidelines on Violations of Economic, Social and Cultural Rights*. http://www.refworld.org/docid/48abd 5730.html.

Kearney, Richard. 1984. *Dialogues with Contemporary Continental Thinkers*. Dover, NH: Manchester University Press.

Kosofsky Sedgwick, Eve. 1997. "Paranoid Reading and Reparative Reading: Or, You're So Paranoid, You Probably Think This Introduction Is about You." In *Novel Gazing: Queer Readings in Fiction*, edited by Eve Kosofsky Sedgwick, 1–38. Durham: Duke University Press. http://dx.doi.org/10.1215/978082238 2478-001.

Leavy, Patricia. 2009. *Method Meets Art: Arts-Based Research Practice*. New York: Guilford Press.

Lepofsky, David. 1997. "A Report Card on the Charter's Guarantee of Equality to Persons with Disabilities after 10 Years – What Progress? What Prospects?" *National Journal of Constitutional Law* 7 (3): 263–431.

Lepofsky, David, and Jerome E. Bickenbach. 1985. "Equality Rights and the Physically Handicapped." In *Equality Rights and the Canadian Charter of Rights and Freedoms*, edited by Anne Bayefsky and Mary Eberts, 323–76. Toronto: Carswell.

Lorde, Audre. 2007. "Poetry Is Not a Luxury." In *Feminist Literary Theory and Criticism: A Norton Reader*, edited by Sandra Gilbert and Susan Gubar, 222–28. New York: W.W. Norton.

Markell, Patchen. 2003. *Bound by Recognition*. Princeton: Princeton University Press.

McCrae, John. 2014. "In Flanders Fields." In *The Poetry of Witness: The Tradition in English 1500–2001*, edited by Carolyn Forché and Duncan Wu, 529. New York: W.W. Norton.

McMorrow, Thomas. 2007. "Law at L'Arche: Reflections from a Critical Legal Pluralist Perspective." Master's thesis, McGill University.

McRuer, Robert. 2006. *Crip Theory: Cultural Signs of Queerness and Disability*. New York: NYU Press.

Peers, Danielle, Melisa Brittain, and Robert McRuer. 2012. "Crip Excess, Art and Politics: A Conversation with Robert McRuer." *Review of Education, Pedagogy & Cultural Studies* 34 (3–4): 148–55. http://dx.doi.org/10.1080/10714413.2012.687284.

Peters, Yvonne. 2004. *Twenty Years of Litigating for Disability Equality Rights: Has It Made a Difference? An Assessment by the Council of Canadians with Disabilities.* Report for the Council of Canadians with Disabilities. *http://www.ccdonline.ca/en/humanrights/promoting/20years.*

Povinelli, Elizabeth. 2011. *Economies of Abandonment*. Durham: Duke University Press. http://dx.doi.org/10.1215/9780822394570.

Prince, Michael. 2009. *Absent Citizens: Disability Politics and Policy in Canada.* Toronto: University of Toronto Press.

Rich, Adrienne. 2001. *Arts of the Possible*. New York: W.W. Norton.

Richardson, Laurel. 1994. "Nine Poems: Marriage and the Family." *Journal of Contemporary Ethnography* 23 (1): 3–13. http://dx.doi.org/10.1177/089124194023001001.

Rorty, Richard. 1999. *Contingency, Irony, and Solidarity.* Cambridge: Cambridge University Press.

Shildrick, Margrit. 2005a. "The Disabled Body, Genealogy and Undecidability." *Cultural studies* 19 (6): 755–70.

–. 2005b. "Transgressing the Law with Foucault and Derrida: Some Reflections on Anomalous Embodiment." *Critical Quarterly* 47 (3): 30–46. http://dx.doi.org/10.1111/j.1467-8705.2005.00648.x.

Spelman, Elizabeth V. 1988. *Inessential Woman: Problems of Exclusion in Feminist Thought*. Boston: Beacon.

Stewart, Kathleen. 2008. "Weak Theory in an Unfinished World." *Journal of Folklore Research* 45 (1): 71–82.

–. 2011. "Atmospheric Attunements." *Society and Space* 29 (3): 445–53.

Taussig, Michael. 1992. *The Nervous System*. New York: Routledge.

Taylor, Charles. 1994. "The Politics of Recognition." In *Multiculturalism: Examining the Politics of Recognition*, edited by Amy Gutmann, 25–74. Princeton: Princeton University Press.

UN Committee on Economic, Social and Cultural Rights. 1998. Concluding Observations on Canada. *UN General Assembly Official Records, 8th Session, E/C.12/1/Add.31.*

Vernon, John. 1979. *Poetry and the Body*. Urbana, IL: University of Illinois Press.

13

The Body as Resistance Art/ifact
Disability Activism during the 2012
Quebec Student Movement

GABRIEL BLOUIN GENEST

The 2012 Quebec student movement is one of the largest social movements in recent Canadian history (Al-Saji 2012; Sorochan 2012).[1] Under the umbrella of protest against the rise of university tuition fees, groups representing different segments of society, with sometimes conflicting interests, united in anger against the Liberal government led by Premier Jean Charest. Students from different educational institutions (French- and English-speaking high schools, colleges, and universities), along with unions, environmental groups, and other organizations, mobilized against what was seen as a threat to Quebec's affordable education system inherited from the 1960s and '70s. This movement was concerned primarily with accessibility to education (Ayotte-Thomson and Freeman 2012) as well as broader critiques of neoliberalism and privatization (Ayotte-Thomson and Freeman 2012; Julien 2013; Lamoureux 2012; Langlois 2013; Solty 2012).

Among the different groups and organizations who stood up against the tuition fee hike and in favour of the overarching social movement, disability groups (Barnes 2007; Kitchin and Wilton 2003; Lewis 2006) played a significant role during the protests, mainly through the Quebec Association of Postsecondary Students with Disabilities (QAPSD[2]), but also at the individual level or through other organizations that were involved informally (like Ex aequo).

The involvement of disability groups during the Quebec student movement echoes the long history of disability activism (Barnes 2007; Kitchin

and Wilton 2003; Lewis 2006). The 2012 student movement represents, I argue, a "critical" moment when political, social, and biological constructs intertwined and overlapped regarding uses of the biological body, challenging the meaning of what constitutes normality. This phenomenon appears underanalyzed, both in the specific context of the 2012 Quebec student movement and in the overall fields of activism and social movements. The main objective of this text is to analyze this bio-political construct of normality within a social movement itself.

Disability rights movements (Fleischer and Zames 2001; McNeese 2013; Shaw 2008; Stroman 2003) and independent living movements (DeJong 1979a, 1979b; Williams 1983) have been crucial to the recognition and application of rights for disabled people. Especially important are issues of accessibility and safety, autonomy, equal opportunity, and freedom from violence and abuse that are (re)produced through the interaction of disabilities and disabling environments (Amundson 1992; Freund 2001; Kitchin 1998), which together shape the reality experienced by people living with disabilities. Disability rights movements emerged through fierce battles regarding claims for equals rights and opportunities in everyday life for people living with disabilities. Actions from these movements range from direct, rights-based claims (right to work, right to access public spaces, right to parenting, patients' rights, etc.) to criticizing the socially constructed/produced nature of disabilities themselves. They remind us that disability is always the product of biological *and* social factors (Liachowitz 2011; Rapley 2004).

The expansive nature of disability rights movements also lays the groundwork for intersectional analyses. From this perspective, disability activism sometimes appears as intertwined with other social issues: racism, feminism, poverty, social exclusion, etc. (Block, Balcazar, and Keys 2001), creating a productive space for the interactions of different groups, interests, and issues. For example, Chelsea Whitney (2006) and Robert McRuer (2006) explore the intersection between sexual identities and disabilities, while Christopher Bell (2011) and Josh Lukin (2013) challenge the exclusion process through a re-articulation of blackness and disability. Gender-, colour-, or disability-based forms of marginalization present themselves as being actively intertwined, opening an interesting space for analysis and offering new ways to "explore the problem of speaking/thinking/feeling about the other" (Campbell 2009, 3). By exploring the intersections of disabilities with other forms of oppressions and marginalization, these works challenge the dominant approach of exclusion and social marginalization. However, little research has explored the production of (bio) normality and/or

exclusionary practices within a social movement itself, which this text seeks to analyze. One important exception is Lena Palacios et al.'s study (2013) of the involvement of students of colour during the 2012 Quebec student movement. As in the work of Rosalind Hampton (2012), Palacios et al. highlight how racial and segregated processes structured the genesis and evolution of this social movement.

Building on these findings and experiences, my objective is to understand the nature of disability activism in the student movement, what their specific claims were, and how disability activists interpreted their own mobilization and involvement. I thus suggest that the mobilization of disability groups during the Quebec student protest provoked innovative modes of mobilization and organization that created alternative understandings of health and/or bodily characteristics as sites for resistance and politics. From this perspective, the 2012 Quebec student movement represents a "critical moment" when contesting and conflicting uses of the biological body were made, challenging the meaning of what constitutes a normal body as well as a legitimate social movement or claims. I argue that through artistic performances and framing, these specific understandings of the body and of disability challenged normalized and accepted identities, roles, and responsibilities within the social movement.

This chapter highlights two aspects that are missing from many social movement analyses of disability activism:

- the uses of specific health or body characteristics as a tool and/or medium for social engagement and mobilization (the body as a site of resistance or a site of politics); and
- the targets of disability activism during a social movement, both regarding the overall claims of the movement (students against a tuition fee increase in this case), but also within the movement (tensions/conflicts/interactions of the different actors).

Recognizing these gaps in both the academic and activist understandings of the body as a tool for social movement and the tensions they generate, this chapter analyzes the participation of disability activists during the 2012 Quebec student movement through the use of bodies as a site of contestation and resistance. I analyze the ways in which disability groups and people living with disabilities articulated the rationale for their actions during the Quebec student movement in order to understand the extent to which their lived experiences played a role in their mobilization and how it

affected the nature of their activities. I also examine how the mobilization of people living with disabilities challenged the concept of accessibility, specifically access to education. This is done by exploring the social and political recognition processes between governmental/institutional actors and student/societal actors experienced by disability groups. Finally, I examine the disabled body as a site of politics/resistance through artistic performances and how the naturalized and performed image of the "normal" body was shaped.

On a methodological note, I conducted ten interviews with persons with disabilities who took part in the 2012 Quebec student protests. These persons were contacted mainly through QAPSD, but also from personal contacts using snowball sampling. The people interviewed were generally not involved in other social movements and did not describe themselves as activists. They were, however, usually mobilized in social media and/or were generally involved in disability groups or organizations. For many of them, it was the first time they had participated in a social movement (especially demonstrations).

I also analyzed press releases, reports, and documents published by different organizations during the Quebec student movement (February–September 2012). Finally, I analyzed, as *artifacts* of the social movement, several artistic or cultural performances (e.g., posters, descriptions of performance, costumes) using a mixed methods approach (Dunne, Pryor, and Yates 2005; Hesse-Biber 2010; Tashakkori and Teddlie 2003). As a white, middle-class, able-bodied scholar, I sought to foreground the experiences and interpretations of people living with disabilities involved during the Quebec student movement. As Latour (1999, 19) points out,

> Actors know what they do and I have to learn from them not only what they do, but how and why they do it. It is us, the social scientists, who lack knowledge of what they do, and not they who are missing the explanation of why they are unwittingly manipulated by forces exterior to themselves and known to the social scientist's powerful gaze and methods.

The Quebec Student Movement: From "Political Bodies" to "Body Politics"

The Quebec student movement began as news spread of a proposed 81 to 88 percent increase in fees, from about $2,100 to between $3,793 and $3,946 a year. Tuition fees in Quebec before the rise were the lowest in Canada, but still among the highest in the OECD countries. Student groups organized a general strike that started in February 2012 and, at its peak, reached more

than 75 percent of the approximately 400,000 Quebec post-secondary student population, making this the largest student strike in Canadian history (Al-Saji 2012; Sorochan 2012). The social movement was also characterized by demonstrations on the twenty-second of each month (the date of the first demonstration organized by the student organizations), which brought crowds of up to 200,000 spilling onto the streets of Montreal, not to mention one hundred consecutive nights of protest events that took place during the height of this movement.

The 2012 Quebec student protest was also marked by several violent episodes, creating situations where the definition and framing of what constitutes "violence" were subject to competing interpretations by different actors (Blouin Genest 2012b). During the protests and demonstrations, hundreds of people were injured, from both the student and police forces sides, several quite severely. Police forces responded violently to the sometimes violent student demonstrations, provoking a vicious circle of violence and legitimization of violence by both camps. More than three thousand arrests were made and thousands of fines and statements of offence were given, which provoked, at the end, a juridical logjam (Government of Quebec 2014, 15). Drawing on collective paranoia and broader discourses of terror, authorities even arrested some protesters under the anti-terrorism provisions of the Criminal Code of Quebec.

The student conflict also foregrounded the legal and juridical sphere through a series of court orders, which allowed hundreds of students to attend their classes despite strike mandates that had been voted on democratically by student associations. Several commentators raised questions about the independence of the judicial system from politics and raised numerous issues about the legitimacy of legal orders during periods of social crisis (Sorochan 2012). Quebec's National Assembly also adopted Special Law 78, which later became Law 12. The legislation severely restricted the possibility of mobilization and protest by citizens. According to this law which was later amended, any gathering of more than fifty people in a public space would have required the organizer(s) to provide an itinerary eight hours in advance of the event. Failure to comply with this provision would have resulted in fines of $1,000 to $5,000 per day and up to $125,000 if a student organization or one of its representatives was found guilty. The amount doubled in cases of recidivism. Special Law 78 was strongly condemned by the United Nations, Amnesty International, and the Human Rights Council (Amnesty International 2012a, 2012b).

The student movement protest raised many issues beyond those related to education (CLASSE 2012), including the commodification of knowledge, privatization of post-secondary institutions, gender equality, the environment, accessibility to education, juridical neutrality, the economy and a fair tax system, corruption, neoliberalism, and so on (Ayotte-Thomson and Freeman 2012; Blouin Genest 2012a; Lamoureux 2012; Langlois 2013; Sorochan 2012). Some even termed this social movement an "ideological shock" or "ideological conflict," as it challenged two visions of society regarding the importance of knowledge and education as well as the legitimacy and value of social mobilization (Julien 2013; Paquerot 2013).

This movement also created a productive space for making claims and counterclaims about what constitutes the normal body. In a book on the philosophy of epidemics, Jean Lombard and Bernard Vandewalle (2006, 16) recalled that an epidemic is not "a moment like any other ... but a critical moment." The 2012 student movement represents, I believe, this type of critical moment, an epidemic of meanings, where political, social, and biological constructs intertwine and overlap in a multiplicity of meanings regarding bodies and normality.

For example, we witnessed the redefinition of the normal body during several nude protests that produced a large-scale confrontation regarding normalized bodies, as they publicly exposed different types of bodies that departed from dominant representations of embodiment (Bordo 2003; Cole 1993). The normalized biological body was challenged during these specific protests, enlarging the scope of bio-physical normalities and socially accepted corporeal nudity.

Images of these nude demonstrations were largely reproduced in mainstream media and thus played an important role in the advertising of the claims, demands, and interests of the different student groups who organized against the tuition fee hike. They used strategies employed by other actors such as FEMEN (a feminist group using nudity as one of its main modes of protest), creating fierce debates involving activists, scholars, and politicians over the (ab)uses of gendered and feminized women's bodies as a tool for public communications, militancy, and resistance (Fauré 2013; Selim and Querrien 2013; Zychowicz 2011).

Nonetheless, by explicitly questioning (and challenging) the assumptions about what types of bodies could publicly appear nude on TV and in newspapers, the nude protests during the Quebec student movement created a productive environment for the integration of debates about "normality."

This redefinition of normality was expressed through the multiple ways that the "normal" biological body was presented, acted upon, and performed during demonstrations. This aspect is central to the involvement of disability groups, as it is through this redefinition of normality, among other strategies, that disabled people sought to intervene in the movement.

Understanding Mobilization: Disabilities, Mobilizations, and Interactions among Social Actors

During the conflict, multiple claims were supported by different groups presented as (inter)acting together in their overall actions against the negative effects of tuition fee increases on accessibility to higher education. Disability groups took part directly in the student protests. One of the main groups representing people living with disabilities during the student-led movement was QAPSD. While this organization opposed the fee increase and supported the strike, its board of directors did not reach consensus about this position, which partly explains why it was late in taking a position in the movement (on March 21, 2012). It also received different requests from other organizations (primarily from the main student organizations) to support mobilization efforts. QAPSD took a position by creating blogs and websites, publishing reports and press releases, and participating directly in the protests.[3]

In a 2012 press release, QAPSD announced its support for this social movement and clearly emphasized that disability groups have specific interests in the movement:

> The QAPSD joins with our partners, the FEUQ, the FECQ, EX-AEQUO, and others in this mass-mobilization to raise awareness of the different groups to the realities of students living with disabilities. We also call on Québec society to reflect on the social contract, to which we are all linked through the Québec Charter of Human Rights and the Rights of Youth. Moreover, Canada ratified in 2010 the *Convention on the Rights of Persons with Disabilities*, which defends the right to education for all (article 24). (QAPSD 2012; author's translation)

My objective, as stated previously, was to understand why disability groups and individuals living with disabilities were involved in the student movement, what their claims were, and how they interpreted their own mobilization and involvement. The participants interviewed, as well as the documents analyzed, reveal the following three main lines of involvement:

* mobilizations centred on the concept of accessibility, specifically access to education;
* the negotiation processes among different government and societal actors to gain legitimacy; and
* the disabled body as a site of politics/resistance through artistic performances (embodiment).

Accessibility: Key Word for Mobilization and Contested Meanings
Even if the opinions expressed by interviewees differed, all agreed on one point: they mobilized for accessibility. The vast majority of claims and demands expressed by disability groups and people living with disabilities echoed the broader aims of disability organizing (Ayotte-Thomson and Freeman 2012). Demonstrations were organized against the tuition fee hike, which was framed as a threat to accessibility of education (Sorochan 2012).

For disabled persons, accessibility had a somewhat different meaning than for other groups and organizations participating in the social movement. From this perspective, I witnessed a form of translation process (Law 2009) regarding the concept of "accessibility," a translation that was modulated by and through the different groups involved, allowing for an inclusion of different and sometimes conflicting actors in social mobilization. In complex social and political settings, accessibility therefore acquired a specific meaning that served as a binding mechanism for the overall social movement as well as antagonism. This multiple meaning complicates the understanding and materialization of accessibility, as it embraces different realities, creating some tension around this concept. Accessibility, therefore, had a paradoxical role in the 2012 Quebec student movement as both a catalyst and an oppositional force, because the different groups that mobilized during the movement had different understandings and experiences of accessibility.

Disability groups and people living with disabilities had specific understandings of accessibility that derived from their own experiences with disabilities and the broader disabling environment. Even though the participants embraced an inclusive understanding of accessibility (through, for example, their support for the general meaning of accessibility of education), their reading of accessibility was clearly modulated and translated by disability issues, highlighting a "disability standpoint" that modified the meaning and understanding of the term.

For example, in terms of financial accessibility, all of the participants interviewed acknowledged the problem of financial strain faced by many

people living with disabilities. Many students with disabilities must attend school part-time, increasing the number of years they have to spend at university (or college), thus compounding their financial burden. Financial issues were also seen as central to accessibility, but not necessarily in their direct relationship with a tuition fee increase, stressing the tension identified previously. In fact, due to different governmental programs, the rise of tuition fees would not have equally affected able-bodied and disabled persons (those with a recognized disability have access to a conversion of their student loans into grants). Incidental expenses produced by the specific conditions of different participants, however, were seen as added financial burdens. As expressed by some participants, not all of these extra costs were covered by the financial aid accorded by governmental programs. For example, services such as accessible transportation, equipment, and specialized software were usually covered by various grants or financial programs, but secondary factors (e.g., parking, adaptive measures for vehicles, services outside of the university) were not included. For the participants interviewed, accessibility was about more than simply the rise of tuition fees.

Several participants also stressed the different problems they faced regarding accessibility of the labour market, both during and after their years of education. QAPSD (2012) emphasizes, for example, that "students with disabilities have more difficulty finding paid summer jobs and part-time courses." Even voluntary work, as stated by one participant, can be difficult to obtain. According to some participants, equity and accessibility, compared with other students, is highly contingent on their experiences of disability.

From my perspective, two distinctions must be made about disability groups' and disabled individuals' references to accessibility as one of the main motives for mobilization. First, they did not refer directly to the financial accessibility problems created by the tuition fee rise, but they did speak about financial accessibility problems produced by indirect factors associated with the social exclusion of disabled people. Second, they saw access reduced, not necessarily in the traditional sense (physical access to buildings or services), but more in terms of secondary access, especially regarding indirect financial constraints that produce specific access challenges for people living with disabilities. This double meaning of accessibility for disability groups versus other groups and organizations demonstrates a need for a more encompassing conceptual framing of accessibility (see, for example, Titchkosky 2011). This multilevel and multidimensional understanding of accessibility was not included in the general demands or

claims made by the main student organizations during the Quebec student movement.

(Re)claiming Spaces for Action: Social Recognition between Institutional and Societal Actors during the Student Movement

Disability groups during the student movement were mobilized not only against the tuition fee hike, forming a coalition with other groups against the Liberal government, but also for recognition inside the social movement itself. Disability activists thus faced another access concern during the 2012 Quebec student protest: access to the student movement. Participants interviewed identified two main issues with accessibility during the protests: (1) direct physical access to demonstrations and events, and (2) access to planning, organization, and decision making regarding the evolution of the social movement.

Many participants interviewed emphasized that it was difficult for them to get involved directly and be physically present in demonstrations due to the interaction between their physical limitations or disabilities and the organizational aspects of the movement, such as the unplanned nature of the demonstrations or the choice of location, which created disabling experiences for several participants. For example, one participant detailed how it was difficult for her to get involved in demonstrations without an advance schedule because it was impossible for her to book paratransit or organize individual transportation. Moreover, some of the places identified as meeting points for demonstrations were inaccessible for people with disabilities. One participant similarly identified the higher risk of being arrested by police, as she/he would have greater difficulty escaping police encirclement techniques and repression strategies.

These physical accessibility issues, according to some participants, were not taken into account by the other groups or organizations involved in the social movement, especially in the planning of the events. This situation directly affected the potential for mobilization by creating disabling social and physical environments and compounding disabling experiences. From this perspective, direct access to the protests, activities, and events during the social movement was seen as a major accessibility issue for many participants.

Many interviewees suggested that they also faced inclusion problems in the organization of, planning of, and decision making regarding the overall social movement. One member of QAPSD stressed that even if he/she received requests for public support from different student associations,

QAPSD was never directly involved in the planning of the protests or the different activities of the student mobilization. Interviewees also felt their specific demands or claims were excluded (directly or indirectly) in the general demands of the social movement, compared, for example, to feminist claims that were included by some organizations (CLASSE 2012).

Disability groups faced a recognition and legitimization problem, both regarding the government (through access to education) and inside the social movement, creating a double-sided exclusion that affected the potential for mobilization, organization, and the capacity to speak and be heard during the 2012 Quebec student protest. While not all participants interviewed underlined this issue or felt excluded by other groups involved in the social movement, none of the interviewees explicitly stated that they felt included by the main student organizations.

This form of exclusion was due, according to several participants, to a specific understanding of education itself by people living with disabilities and disability groups, an understanding that was largely ignored by other groups. For many participants interviewed, education was seen as a means of social recognition, especially regarding their disabilities. As they argued, education is a tool for inclusion, recognition, and involvement in society. Education, from their perspective, can help them, among other things, to obtain social recognition as well as some legitimacy in the social sphere. This understanding of education, directly linked with disability and the role that education can play for social recognition for people living with disabilities, was not included in the overall requests expressed by the main student groups and organizations in the social movement.

Several participants also emphasized their specific understandings of the concept of "fair share," which was frequently referred to during the student movement, both by the government and by student organizations.[4] "Fair share" was generally used by the government and other actors opposed to the student movement to emphasize the need for students to pay a larger share of the cost of their education, but it was also used by student organizations to underline that the main economic actors (banks, corporations, richer populations, etc.) do not pay their fair share of social costs (mainly due to tax exemptions). Several of the disabled participants highlighted a somewhat different understanding of fair share. Disability groups emphasized the need for a fair share of the resources (jobs, positions of authority, salaries, etc.) among the students themselves. This specific understanding of fair share among the different student populations was not discussed during the social movement, as it was seen as something trivial or less

important than the pressing need to contest the tuition fee rise. The dominant understanding of fair share during the social movement thus echoed a specific production of exclusionary practices and limitations within the social movement itself and not just in the overall social making of inequalities and normalities. Micro-sites of resistance and contestation, within the social movement and centred on the concept of fair share, emerged to underline how power is contested not only vertically (against macro-structures such as governments), but also horizontally (inside the social movement among the different groups).

Some participants also underlined the need to defend the specific right to education for people living with disabilities, a right that was, in a larger sense, also one of the main mottoes of the student movement. During the protests, arguments centred on protecting rights, defending rights, requesting rights, and contesting rights abuses. Disability groups and people living with disabilities, however, as interviewees mentioned, had a specific interpretation of this right to education, which, I argue, was more specific and explicitly linked with their disabling experiences in educational settings. In fact, the right to education, for several participants, was linked to other rights, especially disability rights (Stroman 2003).

Disability groups, as one participant specified during the interviews, invited the population to think about the right to education in terms of a social contract among different societal groups, suggesting that different groups involved in the student movement should defend one another, which was not necessarily perceived as taking place. Interestingly, and as recognized by one participant, this specific right to education for people living with disabilities was not included in the general demands of the student movement, leading some participants to argue that they were excluded from the framing of the claims of the 2012 student mobilization. As one participant explained, when faced with this exclusion inside the social movement, disability groups had to find unconventional ways to get involved, to be seen and heard, to be included in social protests and mobilizations: it is here that their disabilities and bodies, through performances and arts, played an important role.

The Disabled Body as a Site of Politics: Between Resistance and Artistic Performances

Even if disability groups participating in the social movement had specific understandings of some of the main issues or concepts raised during the 2012 Quebec student protest, they did not emphasize the issue of disability

as being the cornerstone of their mobilization, preferring to form coalitions with other groups against the proposed tuition fee hike. Nonetheless, their impairments and/or bodies played a significant role during the student movement as being a site of politics and resistance, shaping, through some forms of artistic performances, the embodiment of the experiences of the social movement. Bodies and disabilities were used to express ideas and values and to signify that disability groups and people living with disabilities were present and active in the social movement. The argument presented here was not shared by all of the participants interviewed, but some agreed that their voices expressed a legitimate, albeit contested, point of view.

First, being physically present in the different demonstrations, protests, and events was a means for several participants to reclaim social and political places. This was done, as acknowledged by some of the participants, by occupying the social space/place with their bodies, using their disabilities as tools to express both their physical presence and their differences (physically, but also regarding their demands and interests).

Even if it was sometimes difficult to participate in the demonstrations, just the act of being there, in the street, was seen by several participants as a reminder that the needs of people with disabilities should be recognized by the student movement as well as by the wider society and government. Several participants saw their physical presence during demonstrations as a strong statement that affirmed, using the words of one participant, that "we exist, we are here, and you have to recognize it and include our needs."

As another participant underscored, being in a wheelchair served as a sign, especially for others involved in the protest, that there are a range of actors, beyond those of the able-bodied, whose needs should be recognized as legitimate.

People living with disabilities who participated in the different demonstrations sometimes used their bodies as reminders of the debates and issues relevant to disability groups, creating a form of bio-physical disability activism and linking the embodied experiences with organizational aspects of the protest (Dale 2000). Interestingly, and as one participant indicated, they had to find innovative and inventive ways to be physically present in the demonstrations, using, as pointed out by this same participant, a form of staging of their bodies, a way to act on the scene of the student movement in order to be seen and heard. People living with disabilities and disability groups had to literally impose themselves in the public space, using their specific bodies as tools of political resistance, thereby challenging

accepted normalities and echoing some of the claims expressed during nude protests.

The presence of disabled bodies in the social landscape modified the normalization processes of accepted bodies and identities, a process that had major outcomes, both practical and symbolic. On the practical level, disability groups and people living with disabilities claimed that they needed to fight for the recognition of what counts as a "legitimate disability" by the Government of Quebec to gain access to specific loans and financial programs for education and other purposes. As suggested by one participant, sometimes disabled people have to fight hard to have their disabilities recognized as legitimate to access colleges and universities. As recalled by one participant, to have access to financial and material support, you have to be recognized as an "accepted disabled person" by the government, a process that, as we can imagine, is neither neutral nor value-free.

For example, QAPSD (2012) specifies that certain people "are not always considered to have a major functional disability: individuals with learning disabilities, dyslexia, chronic disease, cancer, rare disease, undiagnosed illness, psychosocial disability, etc., although these situations generate actual functional limitations, which create additional costs." As certain individuals are not taken into consideration by the government, neither were they recognized by other student organizations as having legitimate demands during the student movement.

As pointed out by some participants, the diagnosis (and the process leading up to it) of the disability is central to accessing necessary supports and services. It leads to a fundamental issue: what do we do when it is difficult or impossible to diagnose the disability? What are the effects of this reliance on "expert medical knowledge" for people living with disabilities? As one participant pointed out, this again presents a double burden for disabled people: "These people will pay higher fees in addition to the non-recognition of their disability by the educational and governmental system." There is a specific recognition problem here, even among people living with disabilities and disability groups themselves. What counts as a significant/accepted disability? How are normal disabilities (re)produced socially and individually? Why was this issue not included in the 2012 Quebec student movement?

On the one hand, being recognized as a legitimate disabled person is necessary to benefit from different grants and other financial and material support; on the other hand, being categorized as disabled can lead to certain

forms of exclusion. This situation creates a paradoxical context for disability groups, as they are caught between fighting for their disabilities to be recognized as legitimate and being partly excluded based on this acknowledged disability.

Some participants explained that they used their bodies and disabilities to express ideas and values, both directly by wearing slogans or posters on their bodies or wheelchairs and indirectly by using their presence in the protest as a means of communication with other actors. Disabilities were therefore used as artistic or cultural "performances," helping participants to be seen, understood, and taken into account by others. One participant emphasized that she had to "present and represent" her body/disability during the different events by emphasizing certain physical or material aspects (wheelchair, walking stick, etc.) with colours or posters/slogans so it would be seen by others, using art as a kind of cultural/social carrier for her ideas, values, identities, and requests.[5] Many people with disabilities also turned to more traditional forms of artistic performances such as dance, music, body painting, and poster making as forms of expression that allowed them to reclaim the social scene during the demonstrations. Many participants noted that they, voluntarily or not, included aspects of the disability experience in their artistic performances: dancing with their wheelchairs, painting using their disabled bodies or on their bodies, signing their slogans in LSQ (Langue des signes québécoise; Quebec Sign Language), etc. These innovative forms of mobilization of people living with disabilities, combined with artistic and cultural performances, disturbed and reconfigured the body as a space of resistance and created possibilities for disability groups and people living with disabilities to be heard and seen during the 2012 Quebec student movement.

Conclusion: Mobilizations, Performances, and Social Art/ifact

This chapter explored the involvement of disability groups and people living with disabilities in the 2012 Quebec student movement in order to analyze and understand their mobilization and the different social interactions that were produced. I sought to challenge and contribute to literature on social movements and disability studies to grasp the meaning and consequences of the participation of disability groups during the Quebec student movement. I underlined how these groups had their own understandings of concepts such as accessibility, fair share, and the right to education, and how they faced specific exclusions in the social movement itself. Further, I demonstrated how normality was (re)produced and

challenged during demonstrations, and how people living with disabilities used their bodies as tools of resistance.

When asked about her understanding of her mobilization in the Quebec student movement, one participant used a highly representative word. She explained that she felt like an "artifact" of the student mobilization. The definition of an artifact, even if different and varied, centres on some shared aspects: something made by a human, something artificial, an object that nonetheless reflects society; the issue of history and its materiality, something that modifies and affects things and perspectives.

The involvement of disability groups and people living with disabilities during the 2012 Quebec student movement challenged not only the Liberal government and its tuition fee rise, but also other groups and organizations involved. Disability groups had to create their own means of expression, their own articulations, understandings, and framing of the issues at stake. They had to modify, invent, and contest to reclaim their place in society and within the social movement. They sometimes used their disabilities and bodies to do so, framing and acting through artistic performances. In other words, they had to produce and to be their own artifacts, their own human-made subjects and objects of this social movement.

ACKNOWLEDGMENTS
The author thanks all of the participants who agreed to be interviewed for this exploratory research. A special thanks goes to QAPSD and to Ex aequo for their help in identifying interviewees. Many thanks also to Michael Orsini and Christine Kelly and to the wonderful participants of the workshop.

NOTES

1 This social movement has been termed differently by the actors involved (strike, lockout, protest, Maple Spring, etc.). I use the word "movement" to describe it in this chapter.

2 In French: AQEIPS, L'Association Québécoise des Étudiants ayant des Incapacités au Postsecondaire, http://www.aqeips.qc.ca/a-propos/.

3 See, for example, https://parlonsdaccessibilite.wordpress.com/about/.

4 "Fair share" is *la juste part* in French. For a critical analysis of this concept during the social movement, see Paquerot (2013).

5 This is referred to in French as *présenter et représenter notre corps et nos handicapes.*

WORKS CITED

Al-Saji, Alia. 2012. "Creating Possibility: The Time of the Québec Student Movement." *Theory and Event* 15 (3). http://muse.jhu.edu/journals/theory_and_event/v015/15.3S.al-saji.html.

Amnesty International. 2012a. "Conflit étudiant – Amnistie internationale Canada francophone est sérieusement préoccupée par les atteintes au droit de manifester pacifiquement." Press release, April 23.

–. 2012b. "Conflit étudiant – Amnistie internationale demande une enquête indépendante sur les interventions policières." Press release, May 14.

Amundson, Ron. 1992. "Disability, Handicap, and the Environment." *Journal of Social Philosophy* 23 (1): 105–19. http://dx.doi.org/10.1111/j.1467-9833.1992.tb00489.x.

Ayotte-Thomson, Megann, and Leah Freeman. 2012. "Accessibility and Privatization: The Québec Student Movement." *Social Policy* 42 (3): 3–6.

Barnes, Colin. 2007. "Disability Activism and the Struggle for Change: Disability, Policy and Politics in the UK." *Education, Citizenship and Social Justice* 2 (3): 203–21. http://dx.doi.org/10.1177/1746197907081259.

Bell, Christopher M., ed. 2011. *Blackness and Disability: Critical Examinations and Cultural Interventions*, vol. 21. East Lansing, MI: LIT Verlag Münster.

Block, Pamela, Fabricio Balcazar, and Christopher Keys. 2001. "From Pathology to Power: Rethinking Race, Poverty, and Disability." *Journal of Disability Policy Studies* 12 (1): 18–27. http://dx.doi.org/10.1177/104420730101200103.

Blouin Genest, Gabriel. 2012a. "Le conflit étudiant québécois: Une 'épidémie' de sens pour un Québec politiquement malade." *Cultures et Conflits* 87: 147–51. http://dx.doi.org/10.4000/conflits.18499.

–. 2012b. "Le (dé)goût d'un printemps: La construction sociale de la violence et de l'extrémisme politique lors du conflit étudiant québécois." *Cultures et Conflits* 87: 160–66. http://dx.doi.org/10.4000/conflits.18507.

Bordo, Susan. 2003. *Unbearable Weight: Feminism, Western Culture, and the Body.* Berkeley: University of California Press.

Campbell, Fiona K. 2009. *Contours of Ableism.* Basingstoke: Palgrave Macmillan. http://dx.doi.org/10.1057/9780230245181.

CLASSE. 2012. *Nous sommes avenir: Manifeste de la CLASSE.* Montreal: Coalition Large de L'Association pour une Solidarité Syndicale Étudiante.

Cole, Cheryl L. 1993. "Resisting the Canon: Feminist Cultural Studies, Sport, and Technologies of the Body." *Journal of Sport and Social Issues* 17 (2): 77–97. http://dx.doi.org/10.1177/019372359301700202.

Dale, Karen. 2000. *Anatomising Embodiment and Organization Theory.* New York: Palgrave Macmillan. http://dx.doi.org/10.1057/9780333993828.

DeJong, Gerben. 1979a. "Independent Living: From Social Movement to Analytic Paradigm." *Archives of Physical Medicine and Rehabilitation* 60 (10): 435–46.

–. 1979b. *The Movement for Independent Living: Origins, Ideology, and Implications for Disability Research.* East Lansing, MI: University Center for International Rehabilitation, Michigan State University.

Dunne, Máiréad, John Pryor, and Paul Yates. 2005. *Becoming a Researcher: A Research Companion for the Social Sciences.* Maidenhead, UK: McGraw-Hill International.

Fauré, Christine. 2013. "Le planisphère des Femen." *Les Temps Modernes* 674–675 (3): 377–88. http://dx.doi.org/10.3917/ltm.674.0377.

Fleischer, Doris Z., and Frieda Zames. 2001. *The Disability Rights Movement: From Charity to Confrontation*. East Lansing, MI: Temple University Press.

Freund, Peter. 2001. "Bodies, Disability and Spaces: The Social Model and Disabling Spatial Organisations." *Disability and Society* 16 (5): 689–706. http://dx.doi.org/ 10.1080/09687590120070079.

Government of Quebec. 2014. *Rapport: Commission spéciale d'examen des événements du printemps 2012*. http://www.securitepublique.gouv.qc.ca/fileadmin/ Documents/police/publications/rapport_CSEEP2012/rapport_CSEP2012. pdf.

Hampton, Rosalind. 2012. "Race, Racism and the Québec Student Movement." *New Socialist*, July 8. http://newsocialist.org/index.php/627-race-racism-and-the -quebec-student-movement.

Hesse-Biber, Sharlene N. 2010. *Mixed Methods Research: Merging Theory with Practice*. New York: Guilford Press.

Julien, Frédéric. 2013. "Le printemps érable comme choc idéologique." *Cultures et Conflits* 87: 152–59.

Kitchin, Rob. 1998. "'Out of Place,' 'Knowing One's Place': Space, Power and the Exclusion of Disabled People." *Disability and Society* 13 (3): 343–56. http://dx. doi.org/10.1080/09687599826678.

Kitchin, Rob, and Robert Wilton. 2003. "Disability Activism and the Politics of Scale." *Canadian Geographer/Géographe Canadien* 47 (2): 97–115. http://dx. doi.org/10.1111/1541-0064.00005.

Lamoureux, Diane. 2012. "La grève étudiante, un révélateur social." *Theory and Event* 15 (3). https://muse.jhu.edu/journals/theory_and_event/v015/15.3S. lamoureux.html.

Langlois, Philippe. 2013. "Révolte contre le néolibéralisme, riposte contre la liberté d'association." *Cultures et Conflits* 87: 167–73.

Latour, Bruno. 1999. "On Recalling ANT." *Sociological Review* 47 (S1): 15–25.

Law, John. 2009. "Actor Network Theory and Material Semiotics." In *The New Blackwell Companion to Social Theory*, edited by Bryan S. Turner, 141–58. http://dx.doi.org/10.1002/9781444304992.ch7.

Lewis, Bradley. 2006. "A Mad Fight: Psychiatry and Disability Activism." In *The Disability Studies Reader*, 2nd ed., edited by Lennard J. Davis, 3–16. New York: Routledge.

Liachowitz, Claire H. 2011. *Disability as a Social Construct: Legislative Roots*. Philadelphia: University of Pennsylvania Press.

Lombard, Jean, and Bernard Vandewalle. 2006. *Philosophie de l'épidémie*. Paris: l'Harmattan.

Lukin, Josh. 2013. "Disability and Blackness." In *The Disability Studies Reader*, 4th ed., edited by Lennard J. Davis, 308–15. New York: Routledge.

McNeese, Tim. 2013. *Disability Rights Movement*. North Mankato, MN: ABDO Publishing.

McRuer, Robert. 2006. "Compulsory Able-Bodiedness and Queer/Disabled Existence." In *The Disability Studies Reader*, 2nd ed., edited by Lennard J. Davis, 301–7. New York: Routledge.

Palacios, Lena, Rosalind Hampton, Ilyan Ferrer, Elma Moses, and Edward O.J. Lee. 2013. "Learning in Social Action: Students of Color and the Québec Student Movement." *Journal of Curriculum Theorizing* 29 (2): 6–25.

Paquerot, Sylvie. 2013. "L'angle mort du débat sur la 'juste part' dans le conflit étudiant au Québec: Les banques. Un conflit idéologique qui ne dit pas son nom." *Cultures et Conflits* 87: 174–80.

QAPSD. 2012. "L'AQEIPS est contre la hausse des frais de scolarité." Press release, March 28.

Rapley, Mark. 2004. *The Social Construction of Intellectual Disability*. Cambridge: Cambridge University Press. http://dx.doi.org/10.1017/CBO9780511489884.

Selim, Monique, and Anne Querrien. 2013. "Femen." *Multitudes* 2: 14–18.

Shaw, Katherine. 2008. "Disability Rights Movement." *Momentum*. http://pekd advocacy.com/documents/disabilities/DisabilitiesRightsMovement.pdf.

Solty, Ingar. 2012. "Canada's 'Maple Spring': From the Québec Student Strike to the Movement against Neoliberalism." *The Bullet*, December 31. http://www. socialistproject.ca/bullet/752.php.

Sorochan, Cayley. 2012. "The Québec Student Strike – A Chronology." *Theory and Event* 15 (3). http://muse.jhu.edu/journals/theory_and_event/v015/15.3S. sorochan.html.

Stroman, Duane F. 2003. *The Disability Rights Movement: From Deinstitutionalization to Self-Determination*. Lanham, MD: University Press of America.

Tashakkori, Abbas, and Charles Teddlie, eds. 2003. *Handbook of Mixed Methods in Social & Behavioral Research*. Thousand Oaks, CA: Sage Publications.

Titchkosky, Tanya. 2011. *The Question of Access: Disability, Space, Meaning*. Toronto: University of Toronto Press.

Whitney, Chelsea. 2006. "Intersections in Identity – Identity Development among Queer Women with Disabilities." *Sexuality and Disability* 24 (1): 39–52. http:// dx.doi.org/10.1007/s11195-005-9002-4.

Williams, Gareth H. 1983. "The Movement for Independent Living: An Evaluation and Critique." *Social Science and Medicine* 17 (15): 1003–10. http://dx.doi. org/10.1016/0277-9536(83)90403-3.

Zychowicz, Jessica. 2011. "Two Bad Words: FEMEN & Feminism in Independent Ukraine." *Anthropology of East Europe Review* 29 (2): 215–27.

14

Divided No More
The Toronto Disability Pride March and the Challenges of Inclusive Organizing

MELISSA GRAHAM and KEVIN JACKSON

The first time it happened, we were not expecting a crowd. After a week of organizing at the peak of the 2011 Occupy movement, we gathered in front of Toronto's city hall. It was a freezing cold day in late October, so when two people arrived, it was exciting; when a hundred people showed up, people took notice. When we took to the streets, they remembered us.

The Toronto Disability Pride March (TDPM) has taken place annually since that day. While we still march for many of the same reasons that brought us together in the beginning, much of how we organize has grown each time we take to the streets. The challenge is both exciting and daunting. Contemporary activist Mia Mingus (2011) describes it well by framing disability pride in terms of disability justice: "We are trying to understand how we can build organizing and community spaces that are mixed-ability, cultivating solidarity between people with different disabilities. We are working to move together, as disabled people, through a world that wants to divide us and keep us separate."

Much like the act of marching, the goal is not the conclusion of the event itself. TDPM has always been an intentional form of activism striving to address the intersectional nature of disability while reshaping the meaning of what disability rights and advocacy can be in Toronto and across Canada. This article addresses why TDPM activists have chosen to organize in this way by looking at the importance of such social organizing now, where it fits

in disability history, and what it could mean for the future of the Canadian disability movement.

Why We March

The first TDPM on October 26, 2011, seemed, on the surface, to be a spontaneous event, riding the coattails of other actions taking place that year. In reality, the events were building up to this moment for a long time. The spark was lit by other activists who were taking action against the historical oppression and austerity imposed upon disabled people. The Occupy movement and the marches against cuts to disability services happening in the United Kingdom highlighted the particular ways in which austerity was being used as a tool of oppression and how disabled people could fight back. This also resonated locally in the need to raise awareness about political decisions that were affecting the disability community in Toronto and Ontario, such as cuts to social housing and incidents with the Toronto Police Service.

Activists who are engaged in the movements over time know that struggle requires an ongoing process to create real change, and that a single event is only the beginning. There were people at the march who understood this as well; some of them came together to become our key organizers, and together we created objectives that form the basis for continuing to march. These objectives are to bring recognition of the struggles and value of people with disabilities as we fight against ableism and other forms of oppression; to be visible and show that we have a voice in our community and a right to be heard by taking to the streets; and to celebrate and take pride in ourselves as a community of people with disabilities (Toronto Disability Pride March 2013).

Building Cross-Disability Solidarity

A strong activist and cross-disability solidarity theme is apparent in the composition of organizers, speakers, and attendees of the march. The organizing committee works collaboratively to ensure that all speakers have diverse disability, cultural, class, sex/gender, academic, and professional experiences.

The serious tone and disability rights–themed topics are apparent in the guest speakers' and organizers' speeches. Previous speakers include some well-known and lesser-known activists from the disability and Mad movements such as Tanya Titchkosky (associate professor at the Ontario Institute for Studies in Education, University of Toronto), Ruth Ruth Stackhouse

(Friendly Spike Theatre Band), Charles Silverman (Ryerson University School of Disability Studies, OCAD University, inclusivemedia.ca), and Kathryn Church (director of Ryerson University's School of Disability Studies). Organizing members who have given speeches at the TDPM include Melissa Graham (Centre for Independent Living in Toronto), Kevin Jackson (Ryerson University/York University), and Janet Rodriguez (Continuing Education Students' Association of Ryerson). This high level of diversity is also reflected in the composition of the TDPM organizing committee. Founding and organizing members claim diverse cultural, class, gender/sex, and academic backgrounds, and all proudly self-identify as being disabled.

Due to the shared experiences of discrimination and oppression faced by disabled people, organizers of the TDPM agreed that there was a need for a highly recognizable annual march. The TDPM is intended to, as the name suggests, instill and promote pride among disabled people in Toronto; however, the march also seeks to highlight the political and organizational power that is possible within the cross-disability solidarity movement that the TDPM represents.

Disability does not exist in a vacuum, but is a result of "multiple oppressions together and in conjunction with each other" (Withers 2012, 99). As such, TDPM is based on the understanding that disability comprises many categories of human diversity, including race, class, and gender/sex, which combine to play "a role in examinations of complex political problems and processes such as persistent poverty, civil war, human rights abuses and democratic transitions" (Hancock 2007, 251). As a framework, intersectionality helps explain how diversity interacts with social institutions to create disabling physical and social environments and how these interactions restrict the level and type of civic and social participation of disabled people.

The march organizers strive to address the intersectional nature of disability by helping people to realize that disability and oppression are not categories of their own, but are systems made up of many interlocking factors. These factors create shared experiences of (dis)ableism, sanism, and other forms of what Ange-Marie Hancock (2005, 75) refers to as "discrimination, marginalization, and/or violence." As she adds, "political actors who shared the same racial, gender, or class identity logically envisioned these shared experiences as a bonding aspect of a collective politics" (Hancock 2005, 75).

As we state on our website, "[TDPM] aims to promote a cross-disability atmosphere that also recognizes other forms of oppression such as race,

class, gender, sexuality, sanism, etc. We believe the disability movement is strongest in a harmony of voices, not one homogeneous voice" (Toronto Disability Pride March 2013). It is important to recognize that other forms of oppression affect how individual communities experience disability and that experiences of disability can vary based on type of disability and level of engagement. The presence of factions within the overall movement is not a weakness. By simultaneously recognizing and making space for these differences, while providing a space for people to come together, we can move forward with greater strength.

As community organizers who work to fight oppression and respect diversity, we believe that people with disabilities are as diverse as the communities they come from and that this is a great strength for the disability movement. We know that organizing effectively means respecting the right for diverse groups of people with disabilities to organize in their own ways and to have diverse ideas about what disability pride looks like. Those of us who have experienced less oppression than others have a responsibility to work *with* these groups, not *for* them. By respecting this diversity and viewing it as an asset, we will emerge under many banners with a stronger voice.

After the first march in 2011, we became aware that our approach of acknowledging and bringing together the diverse factions of the disability community in a visible movement was setting us apart from others in the movement at the time. The appetite for the march itself marked a critical point in our history where it was no longer appropriate to work on disability rights in the silos of our specific issues. The time had come for "taking a cross-disability approach to disability rights, and building solidarity with other movements" (Graham 2011).

As TDPM grew, people who had been involved in the disability rights movement in Toronto began to share their opinions on how we should organize and act. Many of these views were supportive, but some wanted to see TDPM fit into the status quo by attracting sponsors, acquiring funding, and seeking charitable status. As organizers, we viewed these types of strategies as part of the problem that was leading to the stagnation of disability rights activism. We can see this through the local history of Toronto's disability movement.

History of Disability Activism in Toronto

There is a rich history of disability-related protests and marches that have all contributed to TDPM in one way or another. In this section, we discuss

some examples of disability activism to highlight the range of collective action in the name of disability.

The earliest of the Toronto disability-related marches occurred on May 18, 1988. The newly formed group AIDS ACTION NOW!, led mostly by participants attending a national AIDS conference in Toronto, organized "[a] demonstration which culminate[d] in the burning in effigy of federal Minister of Health Jake Epp" (AIDS ACTION NOW! n.d.). Activists sought "to protest treatment issues and a lack of overall policy commitment on AIDS" (AIDS ACTION NOW! n.d.). This protest resulted in AIDS ACTION NOW! acquiring much-needed national news coverage for its cause and organization. TDPM appreciates the power of protest marches to advance issues or gain political leverage on important disability issues.

The first Psychiatric Survivor Pride Day, which included a march, was held on September 18, 1993 (Reaume 1993, 5; Finkler 1997, 765–66). In attendance were people of varying disabilities who were involved in the first Psychiatric Survivor Pride Day events, including people from racialized backgrounds who spoke at the first pride day. After psychiatric survivor Edmond Yu was killed by police on February 20, 1997, disabled people from various communities protested the shooting (Geoffrey Reaume, personal communication, June 3, 2014). To protest the over-drugging and confinement of psychiatric patients a psychiatric survivor march was organized. It ran between the Parkdale Library and the Queen Street Mental Health Centre (Ehrkamp 1993).

Simply People began in 2004 and ran disability pride celebrations for eight years. In these events, "Torontonians with disabilities gathered at Nathan Phillips Square, to celebrate their achievements and uphold their pride through advocacy and entertainment" (Barrie 2004). In 2004, the organization "wanted a less political, 'let's all get together and have a bit of fun' atmosphere – while at the same time, of course, rais[ing] awareness" (Barrie 2004). Simply People's eighth and final annual disability pride celebration was in 2011 at Toronto's Nathan Phillips Square. The celebration had guest speakers and musical performances and was brought to the public by Canada-Wide Accessibility for Post-Secondary Students, LinkUp Employment Services, and many other supporters (Scadding Court Community Centre 2010). While the non-profit organization has not officially disbanded, its Facebook page notes that its last march was in 2011. The organization appears to still exist, but is largely inactive.

The Disability Action Movement Now (DAMN) is a cross-disability coalition that includes disabled people and people affected by ableism. In

2010, DAMN was near the forefront of an anti-G20 march in Toronto. Disability rights activists were present at the G20 protest march, which included speeches by activists who "emphasize the links between different forms of oppression and the G20" (Lindsay 2010). DAMN also works to create activist environments that are accessible to disabled people (OPIRG n.d.), which is an important issue to TDPM organizers. Charles Silverman, an Accessibility for Ontarians with Disabilities Act (AODA) critic, also assists us in addressing accessibility issues wherever possible within budgetary structures. DAMN's anti-G20 march prided itself on being "one of the first huge mobilizations ... that has had a coherent accessibility policy and has put accessibility on the agenda of all the marches" (Lindsay 2010).

The Professionalization of Disability Activism

Direct social actions like taking to the streets are not new phenomena for the disability rights movement, but a re-emergence of more visible tactics to create change. The disability rights movement has a strong history of people who chained themselves to buses and occupied legislative buildings (Graham 2011). This occurred in Canada and the United States as part of the independent living movement. Recently, a group of disabled Montrealers took to the streets in September 2014 to demand better living conditions (*CTV News Montreal* 2014). These actions not only increased awareness of the rights of disabled people, but also made disabled people visible.

The largest challenge for the organizers of TDPM is our lack of funding. Funding sources often put limitations on these types of actions, leading to disability organizations having to choose between resources and activity (Hutchinson et al. 2007; Kelly 2013, 3–6). Searching for funding often involves difficult choices. If we were to accept funding from the City of Toronto, we would likely be limited in our ability to criticize city policies that affect disabled people, and the same could be said for provincial funds. Groups who have funding are often forced to orient their goals toward those of their funder, and in many cases this is a government body. Currently, most levels of government are focused on independence and personal choice, which can create opportunities for some disabled people, but also opportunities for funding cuts and social discrimination.

For example, modern disability politics and mainstream disability organizations have put a great deal of time and energy into shaping policies such as AODA and the Convention on the Rights of Persons with Disabilities. These are good legislative footholds to have, but they will not ensure the rights and equality of disabled people (Graham 2011). The AODA legislation

is focused on getting disabled people in Ontario involved in the workforce and contributing to the local economy. These are welcome, but for a large group of disabled people, this legislation is little more than paper, making a greater distinction between disabled people with privilege and those without. By supporting the government's agenda and using it to advance our own rights, we distract from the idea of collective responsibility and undermine collective action (Slorach 2012, 10). This creates a misrepresentation of the disability rights movement. Those who get behind those doors are often from a position of privilege and do not represent the majority of people with disabilities, who often face multiple forms of oppression.

It is important to consider who has access to those politicians and whether they are representative of the disability community as a whole. When former federal finance minister Jim Flaherty passed away in 2014, many of the well-known disability organizations in Canada spoke up about his legacy to disabled people and his contribution to the Registered Disability Savings Plan, some even calling him a "champion for people with disabilities" (Bach and Beachall 2014). Flaherty's contribution to that program is unquestionable, and many who praised him had worked with him directly, but this kind of praise came from privileged people who have the resources to contribute to such plans and to be engaged politically. Would the former finance minister have championed the 14.4 percent of disabled Canadians who live in poverty and struggle to put food on the table (Stapleton 2013)?

The point of this example is to help spread the message that disabled people are as diverse as the communities from which they come. If they all are to benefit from the movement, then it too needs to be diverse. If people do not see how laws and politicians are relevant to them as disabled people, they will not connect to a movement with that focus. Connecting to a movement that gives them visibility and links them to their communities will strengthen disabled people and the broader movement. Without direct action that demonstrates our collective power, we risk becoming invisible. If we are made invisible, we can be further oppressed, especially when forces of austerity are in place (Slorach 2012, 6, 29). The organization ADAPT has taken this approach for the last thirty years, and it continues to be at the forefront of many disability issues across the United States (ADAPT n.d.).

Moving Forward

We are living in a time when many disabled people still see their disability identity in negative terms (Beckett 2006). There are many people whose

lives simply do not reflect the positive nature of disability or who don't see it as a cause for celebration. We live in a time in which social assistance recipients are facing great threats to their quality of life, parents with disabilities are fighting for the right to raise their own children, and the disability community is still grappling with racism, sexism, homophobia, and other forms of oppression. Celebration alone is not enough. If disabled people are going to find and use their power, they must have opportunities to collectively raise their voices and be heard by those in power.

By remoulding what it means to be a disabled person in society into a political identity, we can change the relationship between society and disabled people. It is time to stop seeing disabled people as a group left behind by barriers and start seeing ourselves as a socio-political force (Williams-Findlay 2011). The first approach allows a wedge to be driven between groups of disabled people and privileges some rights over others. The second approach gives us a stronger collective identity that can be used as a force for change. As we have continued marching over the years, we have noticed other individuals, groups, and movements taking up this second approach to disability activism. We are beginning to see this as part of a global shift toward a more inclusive, progressive disability movement.

The clearest and most recent example of this change is occurring right now in the United Kingdom, where disabled people are facing unimaginable levels of discrimination and austerity. During the process of writing this chapter, one of the authors had the opportunity to travel to the United Kingdom and speak on a panel with Ellen Clifford, from Disabled People Against Cuts (DPAC). She explained that "[disabled people] are facing an unprecedented level and scale of attack affecting every aspect of our lives ... Underlying the assaults on disabled people's ability to participate in day to day life and receive the support we need to survive is an ideological attack on disabled people's place in society" (Clifford 2014). DPAC has seen the front-line impact of austerity measures on disabled people in its country, and it understands that individualized and non-political activism will not change it. The organization has chosen to resist these attacks by creating some unlikely allies. Particularly important allies were the low-waged workers at Atos, the company hired by the UK government to move disabled people off social assistance and declare them "fit for work." That company has since backed out of its contract (Clifford 2014). It is also worth noting that during the time this chapter was written, the United Kingdom became the "first country to face [a] UN inquiry into disability rights violations" (*Disability News Service* 2014).

To organize inclusively, we must believe that "when disabled people collectivise, when we unite and fight we are formidable. In contrast to the traditional images society has of us as pitiful, tragic and vulnerable we can also be strong political leaders not only within the disability movement but at the forefront of the wider campaign against austerity" (Clifford 2014).

Being a disabled person has power. Over the years since deinstitutionalization, a lot of that power has been eroded by shame, doubt, striving for normalcy, and the idea that disabled people should either go to great lengths to hide their disability or see disability as all that they are.

Yet our power still exists. We can see it in the streets when disabled protesters are fighting for their dignity and equality. People with disabilities demonstrate to the world that there is no normal way; these conventional ways were created by human beings, and they can be unmade. This is our shared strength. We must keep this torch lit and visible to all who would challenge it. We can and we will reclaim our power. With that in mind, we march forward into a new chapter for the disability movement and a better world for all.

WORKS CITED

ADAPT. n.d. "ADAPT Is 30 Years Strong!" Accessed March 20, 2014. http://www.adapt.org/main.

AIDS ACTION NOW! n.d. "AAN History." Accessed March 9, 2014.. http://www.aidsactionnow.org/?page_id=38.

Bach, Michael, and Laurie Beachall. 2014. "Flaherty's Legacy for Canadians with Disabilities." *Ottawa Citizen,* April 14. http://www.ccdonline.ca/en/socialpolicy/access-inclusion/Flaherty.

Barrie, Don. 2004. "Simply People Event Marks New Chapter in Local Disability Movement." *CILT: In the Stream.* http://www.cilt.ca/Lists/Newsletter/AllItems.aspx.

Beckett, A. 2006. "Understanding Social Movements: Theorising the Disability Movement in Conditions of Late Modernity." *Sociological Review* 54 (4): 734–52. http://dx.doi.org/10.1111/j.1467-954X.2006.00669.x.

Clifford, Ellen. 2014. "Disabled People Against Austerity" presentation at Marxism 2014, London, United Kingdom, July 13.

CTV News Montreal. 2014. "Montrealers with Disabilities Protest to Demand Better Living Conditions." September 1. http://montreal.ctvnews.ca/montrealers-with-disabilities-protest-to-demand-better-living-conditions-1.1986069.

Disability News Service. 2014. "UK 'Is First Country to Face UN Inquiry into Disability Rights Violations.'" August 15. http://www.disabilitynewsservice.com/uk-is-first-country-to-face-un-inquiry-into-disability-rights-violations/.

Ehrkamp, Andrew. 1993. "Former Mental Patients Protest." *Toronto Sun.* September 19.

Finkler, Lilith. 1997. "Psychiatric Survivor Pride Day: Community Organizing with Psychiatric Survivors," *Osgoode Hall Law Journal* 35 (3–4): 763–72.

Graham, Melissa. 2011. "Free Radicals, Why the Disability Movement Must Take It to the Streets." *Abilities*, Spring. http://abilities.ca/free-radical/.

Hancock, Ange-Marie. 2005. "W.E.B. Du Bois: Intellectual Forefather of Intersectionality?" *Souls* 7 (3–4): 74–84. http://dx.doi.org/10.1080/1099994050026 5508.

–. 2007. "Intersectionality as a Normative and Empirical Paradigm." *Politics & Gender* 3 (2): 248–54. http://dx.doi.org/10.1017/S1743923X07000062.

Hutchinson, Peggy, Susan Arai, Alison Pedlar, John Lord, and Felice Yuen. 2007. "Role of Canadian User-Led Disability Organizations in the Non-Profit Sector." *Disability & Society* 22 (7): 701–16. http://dx.doi.org/10.1080/09687590701 659550.

Kelly, Christine. 2013. "Towards Renewed Descriptions of Canadian Disability Movements: Disability Activism outside of the Non-Profit Sector." *Canadian Journal of Disability Studies* 2 (1): 1–27. http://dx.doi.org/10.15353/cjds.v2i1.68.

Lindsay, Hillary Bain. 2010. *An Accessible Movement. Toronto Media Co-op*, June 26. http://toronto.mediacoop.ca/story/accessible-movement/3825

Mingus, Mia. 2011. "Changing the Framework: Disability Justice." *Leaving Evidence* (blog), February 12. https://leavingevidence.wordpress.com/2011/02/12/changing -the-framework-disability-justice/.

OPIRG. n.d. "Disability Action Movement Now." OPIRG Toronto. Accessed March 19, 2014. http://www.opirgtoronto.org/actiongroups/current/damn.

Reaume, Geoffrey. 1993. "Psychiatric Survivors Hold Pride Day." *People's Voice*, November.

Scadding Court Community Centre. 2010. "The 7th Annual Disability Pride Celebration in Toronto." *Scaddingcourt*, July 20. http://www.scaddingcourt.org/ pdflibrary/blogto_disabilitypride.pdf.

Slorach, Roddy. 2012. *Disability Austerity and Resistance*. London: Socialist Workers Party.

Stapleton, John. 2013. *The "Welfareization" of Disability Incomes in Ontario*. Report for the Metcalf Foundation. http://metcalffoundation.com/wp-content/uploads/ 2013/12/Welfareization-of-Disability-Incomes-in-Ontario.pdf.

Toronto Disability Pride March. 2013. "About the March." Accessed February 16, 2014. https://torontodisabilitypride.wordpress.com/.

Williams-Findlay, Robert. 2011. "Lifting the Lid on Disabled People against Cuts." *Disability & Society* 26 (6): 773–78. http://dx.doi.org/10.1080/09687599.2011.60 2868.

Withers, A.J. 2012. *Disability Politics and Theory*. Black Point, NS: Fernwood Publishing.

15

Accountability, Agency, and Absence
Embodying Radical Disability Values in Artistic Production

DREW DANIELLE BELSKY

The first time I met Anne, we talked about a performance that we both had seen called *The Book of Judith*. Ostensibly about Judith, a woman with a disability, the play was written by a non-disabled man who had become her friend. It was performed by him, Judith, and a chorus of people with disabilities. Although Judith participated, and indeed her words and participation were for me the most powerful moments, I was frustrated with how the male narrator seemed to make the story about *him*, consigning Judith, an accomplished activist and scholar, to the role of tragic saviour. Anne disagreed. She had enjoyed the performance, and she saw his over-the-top preaching and eventual vulnerability as a dramatization of his process of unlearning ableism. As a disabled person, one who had done graduate research in the field of social work and disability, she felt that the piece addressed issues that were rarely spoken of in mixed company: fear of disability and the loss of one's own (largely mythical) corporeal integrity, which translates into objectification, fear, and avoidance of people with disabilities.

Several months later, sitting in my kitchen, our conversation turned to my master's degree project. I had previously mentioned it only in passing, and Anne wanted to know more. I began awkwardly, as I often do, but she asked questions and I went deeper. I explained that I was interested in how bodies work and how they feel. Although I do not identify as disabled, critical disability frameworks such as the social model spoke to my artistic and academic interests in bodies, embodiment, and medicalization. Serious

engagement with these ideas and experiences is inherently politicizing, or so it was for me. Social models of disability emphasize the social factors that contribute to the exclusion of certain bodies and that create barriers to full participation in the social and political spheres. Radical activism and scholarship demand not just accommodation or tolerance, but changes to the very social frameworks that form divisions and hierarchies between bodies, including – but not limited to – disabled or non-disabled. Thus, I sought ways to engage with bodies in my work that would further the goals of disability activism and would speak to the relationships between oppressions grounded in embodiment, such as racism, sexism, and transphobia. Through my artistic practice, I wanted to rework the understandings of embodiment and normalcy that result in the social and political exclusion of certain kinds of bodies.

I planned to interview people who identified as disabled about how they experienced their bodies. While medical images and diagnoses are inextricably embedded in those understandings, I wanted to explore those bodily experiences without framing disabilities, or pain, as inherently a problem to be solved. In thinking about somatic experiences overlooked by Western medicine, I wanted to challenge the limitations that Western culture imposes on bodies that do not fit narrowly defined notions of normalcy and humanness. As a way of sharing the knowledge that was generated, I would produce artwork as a sort of portrait of each body, not based on the visual representations of medical imaging or the documentation of physical differences, but rather on specific lived experiences.

Halfway through a sentence during this conversation, Anne looked at me and said, with great intensity, "Will you please interview me for your research?" At the time, I was still formulating my proposal, and the thought of asking her had not crossed my mind. Surprised and bewildered by her enthusiasm, I agreed.

As the project took shape, I explored a number of methods of connecting with potential collaborators, conducting research, and producing artwork. The process of research and production for *Somatic Aesthetics* borrowed elements of several research and community arts approaches, as they were appropriate and applicable to the proposed work and how it unfolded. Following in-depth interviews as well as informal discussions, I formulated artworks to reflect on and respond to our conversations. These works took varied forms, including textile work, sound installation, and video installation. In this chapter, however, I will focus more on the research process than on the artwork itself. I explore the frictions and difficulties of collaborative

research and art production from a critical disability framework, the challenges of putting ideals into practice, and the limits of consent and collaboration in both academic and artistic work.

Accounting for Bodies

Because of the time- and labour-intensive nature of the research process, the limitations of the academic schedule, and my desire to work with individual experiences rather than seek any generalized conclusions, only three participants were involved in this project. All were women in their late twenties to early thirties with a range of visible and invisible disabilities. They had all completed master's degrees, including work connected to disability, and one was in the later years of a PhD program. One identified as Jewish; one identified as queer. Two were Canadian citizens; one was an American-born visa resident in Canada. All three were previously known to me socially for at least a year before the research began, and two explicitly volunteered without being formally asked. The research process included formal interviews, but much of it was woven into everyday interactions through friendship, attendant care work, political organizing, and sharing in each other's scholarly and creative work.

A range of literatures and practices informed the research process, including contemporary art, community arts and activism, science and technology studies, critical disability studies, and participatory research methodologies. Resonances among these disciplines, literatures, and practices produced new ways of relating with each other and relating to theory. Feminist and anti-colonial researchers have argued passionately for a shift not only in methods, but also in the fundamental epistemological assumptions of research. In her pivotal 1988 article "Situated Knowledges," feminist science studies scholar Donna Haraway challenges the supposed dichotomy between (positivist) objectivity and (constructivist) subjectivity by proposing that, while the ontological assumptions may be different, the epistemological position of the researcher remains the same: a vanishing point that sees, but is never seen. She proposes instead a shift in perspective that would bring the researcher into the frame and actively acknowledge the limitations of both objective and subjective accounts. Haraway emphasizes the performative aspects of knowledge production, exhorting a reflexivity that "allows us to become answerable for what we learn how to see" (1988, 583).

A feminist objectivity, according to Haraway (1988), is not a matter of omniscience but rather situated, limited, and contextual. Further, she suggests that as opposed to being fixed entities, bodies and boundaries are born

of the interactions between them, through which they "shift from within" (Haraway 1988, 595). She explains that "bodies as objects of knowledge are material-semiotic generative nodes. Their boundaries materialize in social interaction. Boundaries are drawn by mapping practices; objects do not pre-exist as such" and thus remain provisional, "generative, [and] productive of meanings and bodies" (595). In this context, the term "bodies" is not understood exclusively as human, or even living, organic bodies, but rather in the sense that physics applies it, acknowledging not only human bodies, but also non-human animal and machine bodies.

Science studies scholar Karen Barad (2003) builds on the active, performative implications of Haraway's work. Barad views reality as mutable and active and emphasizes the productive liminality of Haraway's meaning-generating object. Employing metaphors of diffraction and a Deleuzian conception of "becoming," Barad offers a theory of "intra-active agency" wherein "agency is the enactment of iterative changes to particular practices through the dynamics of intra-activity" (2003, 827).

> Agency is about the possibilities and accountability entailed in reconfiguring material-discursive apparatuses of bodily production, including the boundary articulations and exclusions that are marked by those practices in the enactment of a causal structure. Particular possibilities for acting exist at every moment, and these changing possibilities entail a responsibility to intervene in the world's becoming, to contest and rework what matters and what is excluded from mattering. (Barad 2003, 827)

Bodies, whether human or non-human, animal, technological, cosmological, or microscopic, are formed from generative, boundary-mapping relations between them and are thus neither stable nor separate from their intra-actions. In this sense, a body is always in transition and can be known only through its enactment – in relation to other bodies. Although these ideas are born of the meeting of science and feminism, they surface and propagate to other fields, where bodies meet and intervene in each other's becoming.

Accounting for Bodies in Art

Philosopher Tobin Siebers (2006, 67) asserts that "at a certain level, objects of art are bodies, and aesthetics is the science of discerning how some bodies make other bodies feel." If ontological emphasis is shifted from the truth of art as a singular and static object to the situated, embodied experiences

and affective relations between art objects, creators, and the myriad bodies that come into contact with them, it becomes possible to approach art as boundary-making intra-action between bodies, both human and non-human. But the enactment of boundary-shifting artwork is a complex undertaking that often reinforces existing boundaries instead.

The idea that art is, or ought to be, a relational practice has gained momentum in the last few decades. Often calling for the active participation of non-artists, these contemporary works are characterized by a preoccupation with interaction between artists, audiences, and the work; indeed, this orchestrated interaction is seen as inherently constitutive of the work itself. Some work is relational on the level of production: models or actors are integral to the creative process, non-artists are interviewed or solicited for their contributions, communities are engaged in the fabrication of works of art. Other works offer objects (like posters or candy) to be removed from the gallery space, or take place outside of the institutional space altogether, intervening in public spaces and shaping movement through them.

Nicolas Bourriaud and Claire Bishop argue that the distinguishing element of recent contemporary artwork is this "social turn" (Bishop 2004, 2006), which Bourriaud (2002) terms "relational aesthetics." A number of contemporary artists, including Marc Quinn, Santiago Sierra, Artur Żmijewski, and Sophie Calle, have engaged disabled and othered bodies as actors, models, and collaborators in their work. Unlike identity-based and politically motivated artwork of previous generations, these works – orchestrated by non-disabled artists – instrumentalize disabled bodies as metaphorical or uncanny objects, performing their otherness for an audience presumed to be non-disabled. While not all of these works and artists are strictly understood as examples of "relational aesthetics," each enacts a more relational approach to art – with bodies and subjectivity as a leitmotif – and each calls upon non-artist bodies in various ways to animate the work.

Discourses of participation and relational artwork tend to imply that the mere fact of inclusion of oppressed groups in a relational or performative art context is sufficient to reorganize the distribution of power and privilege. As performance theorist Peggy Phelan (1993) points out, however, increased power in the political field is hardly a simple matter of making visible the hitherto unseen or unrepresented. As long as embodied differences such as gender, sexuality, race, and disability are marked as deviations, The Body (assumed to be white, male, youthful, heterosexual, gender-normative, and non-disabled) remains "unremarkable" (Phelan 1993, 5).[1] While sympathetic to these arguments, Bishop also warns that community-based and social art

practices often run an equal risk of privileging certain progressive socio-political ideals to the extent that aesthetics are completely subsumed to questions of politics and ethics. What would it mean to create aesthetically engaging artwork from within a radical disability framework? As an artist who does not identify as disabled, how do I situate myself in that work? How can art by a non-disabled artist avoid objectification and fetishization of disability and instead prioritize the experiences and aesthetics of people with disabilities?

Haraway's (1988) argument for partiality is embedded in an allegory of vision, which ties it not only to the dominant epistemological practices of science and medicine, but also to visual arts practices. If the perspective that limits the range of perception is unacknowledged, the gaps in that vision also remain unacknowledged and therefore invisible and unknowable. But as Joseph Grigely (2000) and Phelan (1993) point out, reliance on allegories of vision risks reifying the dominance of the visual over other modes of perception and fixing representations of the Other. If allegories of vision are exchanged for Barad's (2003) performative understanding of reality, other modes of knowing can emerge from the blind spots of visuality. When the inherent partiality of knowledge is acknowledged, these spaces make themselves known, becoming sensible, seeable, and sayable. Agency and embodiment need no longer be anxiously proven through representations that fix them as singular and unchanging truths, but may be felt, heard, sensed, contested, and reworked through ongoing knowledge-making practices.

At their best, participatory and emancipatory paradigms reflect this intra-active agency: research, researcher, and researched are entwined and co-generative, and outcomes are measured according to their ability to rework and contest established knowledge and practices. Informants, participants, artists, and researchers act on each other, shaping and renegotiating those roles in the process. Intra-actions over the course of the research both complicate and enrich the process and product.

Situating Agency

In the year or so between the evening in my kitchen and Anne's interview, we went to each other's parties, did yoga, and cooked together. Before the official interview even began, we had several long conversations about the research, what I planned to do with it, and my methodology. As with other participants, most of these informal conversations were woven into discussions of our lives, our friends, dating, what to eat for lunch, and so on. As a

graduate student, Anne had done qualitative research with people with disabilities, and she had suggestions for how to make language and interactions more comfortable. We talked about methods, interviewing styles, writing questions, and consent forms. Many of these conversations were very difficult; she held me accountable. She reminded me that people with disabilities are often quite familiar with the experience of being a research subject and that it can be extremely objectifying and dehumanizing. It was important for me to be invested in the relationship and for the participants to have agency in the use and dissemination of their knowledge.

I sought to make the research process as collaborative as possible given the availability, time constraints, and prior commitments of those involved. Throughout the research, I remained in contact with the participants, checking in with them about ideas and conclusions and negotiating artwork with them. For example, some statements in Anne's interview seemed to support an undercurrent of anger, yet when I proposed a more confrontational interpretation of her experience, she shied away from it:

Throughout my whole life, I've had a perseverance or a resiliency or something that has enabled me to, to fight. And the word fight is key. It's not just to persevere and to try, it's to fight. And I think that, that type of, of anger, has fuelled me quite productively to sort of, to achieve, quite frankly. (Anne, interview, November 14, 2010)

When I mentioned this statement and asked how she felt about gestures like her emphatic "Fuck you!" from a previous conversation appearing in artwork, she was resistant to the mobilization of anger in the rendering of her experiences. She did not view herself as an outwardly angry person, but felt that the anger and resistance were positive forces driving her forward. At other times, she offered ideas and interpretations of her own responses: "I noticed that before the seizure I talked about loneliness and after the seizure I talked about loneliness. Maybe that's a theme."

It can be argued that a researcher should refrain from personal entanglements with research subjects or that such entanglements compromise the validity of research. I would argue that existing relationships were a vital component of this interdisciplinary and inherently political work. These entanglements were more than a matter of establishing the sort of "intimate familiarity" encouraged by Kathy Charmaz (2004, 984) and other anthropologists. The unfolding of the research had more in common with what

Lisa Tillmann-Healy (2003) describes as "friendship as method." While such approaches can and do include more traditional methodologies of qualitative research, "our primary procedures are those we use to build and sustain friendship: conversation, everyday involvement, compassion, giving, and vulnerability" (Tillmann-Healy 2003, 734). By placing myself in intimate relation to the participants, both physically and emotionally, I came to situate my own body and my perspective as a non-disabled researcher, activist, and artist. Like most friendships, our relationships were first established primarily along lines of commonality, but our differences, particularly those that cross lines of oppression such as disability, encourage those "bonds [to] take on political dimensions" (Tillmann-Healy 2003, 731).

My explicit goal was to produce a work that felt "true" for each participant. This could be possible only through feedback and open communication. In short, I wanted my collaborators to see the final work and say, "Yes! That is what I meant." I liken this to Dan Goodley's process of "getting to know," where research is a "gradual process of learning to know some things about informants" (1999, 28). As Goodley (1999, 42) explains,

> Non-disabled researchers will know next to nothing about the daily experience of disablement. However, in unison with disabled co-researchers, analytical conceptions of disabling society and active opposition to such oppression can be shaped and constructed. There is no room for the distant outsider in disability research. Moreover, it is acceptable and right to state where your loyalties lie.

Like Goodley, I do not have first-hand knowledge of the experience of disablement in the world. On the other hand, he asserts (albeit less emphatically than I would), even when researchers, such as feminist researchers, share some common traits with their research subjects, "the presumption that one can have a priori or ad hoc knowledge of another's culture is disputable" (Goodley 1999, 28). Although my collaborators and I are all young, educated white women, we each had different sets of experiences and ways of understanding those experiences. Their responses were sometimes contradictory and at other times they echoed each other profoundly. My challenge was to get to know each woman's experiences and ideas, to ask questions about what I did not understand, and to navigate the similarities and differences between our experiences without resorting to simplistic or totalizing interpretations.

Of course I worried that collaborators would disagree with me or my conclusions or that they might not feel accurately rendered in the works of art I produced. Those anxieties, in addition to our personal connections, kept me accountable. Activists, artists, and scholars all draw on, build upon, and critique the theories, actions, and works that have formed us, whether those relationships are textual or embodied. If the methodological framework asserts the value of participants' knowledge as such, then it follows that I can also learn from them and respectfully, generously, disagree without contradiction. Although I strove to be true to their experiences, I also acknowledged that we could disagree. I remain convinced that the foundations of friendship and collaboration include the possibility of respectful disagreement and that friction itself can be a useful outcome – as a renegotiation of "what matters, and what is excluded from mattering" (Barad 2003, 827).

Absence and Transformation

In late February, while I was out of town for a few weeks, I received an email from a mutual friend informing me that Anne had died in a tragic accident while she was on vacation. I had no prior experience of death or grief; no one close to me had ever passed away. I was entirely unprepared. For the first few weeks, I would say, almost flippantly, "She died." The word was as sudden, final, and absurd as the event. Euphemisms were insufficiently brutal. To say that she had passed away did not describe the violence of my loss. She had not slipped away slowly; it had happened in an instant and then she was gone. I resisted the idea of changing my language just to make other people feel comfortable.

I could not return to Toronto in time for the funeral. For those first weeks, far from our shared community, I had only Anne's interview. At first I clung to it, as if listening would keep her in my world. Even after my return, her recorded voice haunted me. We had intended to have a follow-up interview. There was so much more I wanted to ask her. What did she want me to do with what I had so far? Did she approve of my plans for artwork? Would she agree with my conclusions? The researcher in me was lost. I put away her interview. Working with her material reminded me of how much I missed her voice, the shape of her when we hugged, her eloquence, her joy in living. I started to avoid dealing with those parts of my project, burying myself in other aspects.

In short, I chose to manage grief like an academic: when faced with the unknown, I turned to research for answers and meanings. I looked to

methodology, ethics, and academic standards, because working with my own data was breaking my heart. I alerted my supervisors, contacted the Centre for Ethics, and looked for books, articles, words that would help me to make sense of a senseless situation.

The procedural research ethics issues of Anne's death were quickly resolved. I had a consent form. It read,

> All information you supply during the research will be held in confidence. Your name will not appear in any report, publication or public showing of the research and artwork, unless you specifically give your consent ... Unless you choose otherwise, audio and video recordings and any other data you may contribute will be rendered anonymous, including (but not limited to) removing your name, deleting or changing personal details, and altering or obscuring voice.

Unless you choose otherwise. She might have chosen otherwise, or not. She did not want to be a spectacle, but she was also proud of her life and her work. If she had somehow known she would soon die, would she have wanted that work to live as a memorial, available to her friends and family? Or was it me who wanted to offer that?[2] In any case, to the Centre for Ethics, the consent form was clear. Anne and I had never discussed it, so the work had to be anonymous. The name "Anne" is a pseudonym. The completion of my research was part of the grieving process, but I had to be very careful about what I said and to whom. I felt unsure about sharing large chunks of my process with our mutual friends or inviting them to see the work, even if her name was never published. It was not easy to avoid mentioning that part of our relationship or that continuing my work meant remembering her, over and over again. Ethically speaking, however, I could not thank, credit, or mourn her by name in my written work, nor in public exhibitions of the artwork she helped to create.[3]

Sometimes study participants die. It is an explicit risk in clinical research and not uncommon in social research, particularly on aging and illness (Dickson-Swift et al. 2008; Lawton 2001; Morse 2001). Nevertheless, it hadn't crossed my mind; my collaborators were healthy.[4] As I spoke with researchers around me, I found that many of them had lost research participants, yet few could recommend literature on dealing with a sudden, unrelated death and particularly the affective dimension of it. There is plenty of dry, impersonal literature about the ethics of participation in research, potential for harm, and the obligations of researchers in those circumstances,

but relatively little that addresses the emotional vulnerability of qualitative researchers.[5] Anne's death was unrelated to the research or her disability; it was a senseless accident and a personal loss. The repercussions were not merely academic.

Research ethics cannot easily encompass the complexities of embodied relationships. I set out to prioritize the agency and knowledge of research participants and to collaborate actively at every stage. If a participant is no longer available for consultation, however, then a different set of criteria must be invoked. If the original premise of the project saw benefits to the participants as a primary goal and social outcomes as a close second, under which rubric do friends and family fall? Should the will of her family stand in for her, as in strictly legal matters of property or medical records? Or does the very act of posing the question or pursuing the research harm them in a time of grief? If so, does the potential social benefit that I seek outweigh that harm? Who determines what is beneficial or harmful? For whom?

Medical interventions designed to "correct" or "cure" a body tend to frame as "beneficial" that which will enable a body to function (or appear to function) in a more normative way, thus simplifying life in a world that distrusts, devalues, and refuses entry to bodies that do not comply. In cases where a body cannot be made to fit, the social good has historically been evoked to justify institutionalization of people with physical and intellectual disabilities whose needs or behaviours are deemed incommensurate with social norms, although this is beginning to shift to more community-based models (Bogdan and Taylor 1989; Woodill and Centre for Independent Living in Toronto 1992).

In these and other cases, individual perceptions of one's body may be in conflict with those of family, medical staff, or society. While perhaps less substantively life-changing than surgical procedures or institutionalization, the question of whether research results and dissemination are beneficial or harmful is dependent on differing notions of individual agency and social good. For these reasons, socially defined "harms" and "benefits" have been vigorously contested by disability rights activists in the last few decades, and similar critiques are levelled against artistic and cultural productions that mobilize disabled bodies as symbolic objects while perpetuating or subtly reinforcing structural inequities (Crimp 1992; Grigely 2000; Gruson-Wood 2009).

Throughout our conversations, there was a tension between Anne's desire to share her experience and to see it rendered through my work and the desire to be in control of her story and its dissemination, not unlike the

tensions between my desire to be as faithful as possible to her experience and my desire to express my own artistic ideas. At one point in her interview, I asked her to describe a particular experience of her disability in greater detail. She responded, with some trepidation, "I sort of feel like this question is a little bit voyeuristic, sort of like, 'Look at the monkey in its natural habitat!' But we'll go with it." Later, she again wrestled with ideas of ownership of her own narrative:

> And uh, yeah, and then you have a seizure, and kinda, you miss that part, or I miss that part. To have a few seconds of your life where you're just like, you have no recollection. So the experience of other people living moments of your life where you were not there, that's kind of interesting, 'cause then, you know, you have to go back in order to find out if you did have a seizure, and ask. You know, was it like this, was it like that? It's like the process of having someone else, who is not disabled, know something more about you than you know about yourself, you know? That's the sort of disempowering part of it. 'Cause you sort of get attached to this idea that you have your own life's experience and that's yours, right? And then even if, disability in general, there's all sorts of portrayals about disability and you may disagree with what's in the media but you still have your own perception and experience of yourself. But with this, you're just out, you know. So for a few seconds, if you want to make up that time – which for medical purposes supposedly they say it's advantageous that you do, to find out what happened ... Maybe it's not, maybe that part of life was not yours to begin with and you should just let it go.
>
> But, I mean, then you have to go on other people's experience of you, without you having an experience of yourself. Unless you choose to accept that that moment of your life was absent and that absence was – belongs to you. That absence belongs to you as an experience of life. (Anne, interview, November 14, 2010)

As Anne's interviewer and her friend, I am left to report on the part of her life that is her absence. Although the project sought to provide a first-person account of embodied experience, I could no longer consult her. Her absence changed the work, yet it was the unanticipated extension of a shift that had to occur eventually. At some point, artistic and scholarly decisions must be made, even at the risk of friction or incompleteness. The interpretation of collaborators' data requires a careful negotiation of

contradictions: what is said and unsaid, dynamics of power, voice, and ownership of narratives.

Because the project includes artistic production intended for a broad audience, I increased the possibility of exposing collaborators not only to strangers but also to friends or family who might not have otherwise seen the written products of the research. In Anne's absence, these tensions were amplified. I was left with final control over what is shared and what remains private.

> *As part of an installation that incorporates video, multi-layered sound, and a textile sculpture,* This Is the Order of my Body *attempts to reconstitute Anne's body from the resonances of her own words, ordering images and words in space, while also making evident the gaps and absences in that rendering. She sought to find meaningful ways to make sense of absence: as a part of her experience and as connection to those whose narratives and experiences of her are necessary in order to reconstitute missing moments. Projected over a textile sculpture that evokes a body, video follows the three-part narrative of her seizures in a kind of temporal triptych. A layered monologue in two simultaneous parts emanates separately from left and right speakers, loud enough to intermingle in the space. Taken from our interviews, the text addresses Anne's social and sensory experiences with disablement and her sense of both bodily division and unity. Finally, the video element is blocked from reaching the opposite wall by a sculptural textile figure suspended in the centre of the projection, disrupting its two-dimensionality. This central figure accepts and curves the video projection across its form while casting its shadow onto the centre of the video image as it hits the wall. Constructed from an article of clothing that belonged to Anne, the figure evokes the shape of my own embodied memory of her, while its shadow references her absence. The absence that she recounted in her experience of a seizure takes on double meanings: the interruption in her memory echoed by the interruption in the lives of those who knew her. Although her body never appears in the video, its absence becomes presence in the shadow cast by the central figure. Once again, others are left to reconstitute a body that is no longer present.*
>
> This Is the Order of my Body *offers multiple points of entry and experiences of a single body. Sound and light resonate and define the space of her body, intra-actively enacted by the presence of viewing*

*bodies that both enter and disrupt the space. Time-based media allow
these experiences to develop, overlap, and intra-act not only with each
other but also with viewing and listening bodies. Bodies cast shadows as
they move through space, sounds emerge, reflect, and resonate through
them. The textile figure exists in relation to other bodies in the space and
the possibility of an embodied sensory relationship. Shadows and blank
spots in the video and the text recall not only the absence of memory in
her experience, but also the mourning process that pervades the work.
Anne's absence complicates the piece not only in resonance with her own
words but also in terms of an absence of feedback – I cannot know if she
would feel herself accurately reflected – and the dimension of loss in my
own relationship to the piece. It functions as a rendering of her body,
but it also functions as my own attempt to keep her body in the world.*

I was loath to see myself as an ethnographer whose interpretation of
the underlying meanings of a narrative is more authoritative than that of
its intelligent and very self-aware narrator. The alternative, however, is not
silence. As Charmaz (2004, 979) asserts, "Silences are significant." Haraway
(1988) and others have emphasized that to disavow the control that the
researcher has over the final interpretations and dissemination of partici-
pants' knowledge is to unmoor ourselves from the partiality of both per-
spectives. Estroff (1995, 83) encapsulates this shift in voice in terms of the
research process: "Something important happens in the transformation
from conversation to interview, and from spoken word to published text ...
there is another audience and a different purpose for the text, the ownership
and authority of the author is established, and the commodification process
is actual and irreversible."

The process of moving from interview, to informal conversation about
the interview, to writing and making, to dissemination was ongoing and
intra-active. The artworks I produced evolved not only out of the intra-
action of my collaborators' experiences with my own interests, research,
and artistic proclivities, but also as my interpretations changed as we
continued to discuss ideas of embodiment and artwork. Even so, and in
spite of every good intention, the production was as much mine as theirs,
and I can never be sure I did it *right*.

Vulnerable Bodies
Anthropologist Renato Rosaldo (1993) points out that while social sciences
frequently examine the rituals and apparatuses of death, they tend to elide

the emotional forces at work and the processes of bereavement that are not contained in funerary ritual. Rosaldo's account titled "Grief and a Headhunter's Rage" explicitly draws on his own experience of losing his wife and fellow researcher in the field and instrumentalizes that experience as a mode of understanding aspects of their ethnographic work that had previously been unfathomable: the sheer rage and depth of emotion possible in grief. "All interpretations are provisional," he explains; "they are made by positioned subjects who are prepared to know certain things and not others" (Rosaldo 1993, 8). Rosaldo acknowledges that while developments in the theoretical framing of social research have opened up more space for personal narrative engagement with research, particularly in ethnographic practices, such work always runs the risk of being dismissed as too personal, not academic enough. Still, academics, artists, and activists do take our work personally, in particular when we choose to include and situate our own bodies as active agents. Affective states and embodied relations *matter*.

In the opening pages of her book chapter, "Beside Oneself: On the Limits of Sexual Autonomy," Judith Butler (2004) weaves the experience of grief into her analysis of the social interrelatedness of bodies. "Many people think that grief is privatizing, that it returns us to a solitary situation," she writes, "but I think it exposes the constitutive sociality of the self, a basis for thinking a political community of a complex order" (19). The social relations from which I emerge as a researcher, an activist, and an artist and that tied me to all of my collaborators, were exposed through the process of grieving one of them. The reality of losing a collaborator materially changed the outcome, but the questions of autonomy and voice that came to light in this situation were applicable across the whole of the project as I negotiated participant authority and my own agency as artist.

Relationships with parents, friends, partners, strangers, medical staff, and caregivers, as well as non-human bodies like medical images and physical barriers, were ever-present in my conversations with all of the respondents, shaping and interacting with experiences of disability and embodiment:

> I spend a lot of my life thinking about how my body appears to others, right, like instead of thinking about like how my body is to me, partly because I'm always responding to this world that's always trying to tell me how I should be, and what I should think and how I should feel about my body, and so I spend a lot of my time just being like, "Hey!" You know like, pushing back against it. (Loree, interview, February 7, 2011)

It didn't really matter to me if people understood that there was this specific pain in this part of my body and it really hurt, but if they understood the distress I'd been in over such a period of time, that's when I really felt understood. So, it was like, it was actual doctors, like a specialist who ... was really concerned about whether I was coping and these types of questions that other specialists had never asked me. I felt implicitly that he understood my illness so much better. (Janet, interview, November 10, 2010)

Medically speaking they say that the muscles are contracted, like they're tighter. But they kind of feel looser, in a way. Except for when I'm shaking other people's hands, or making out with somebody and then they feel kind of like stiff and rigid. But um, maybe that's how, medically speaking when they're writing about this, maybe it's like how it feels for other people to experience somebody with disability, with cerebral palsy, I mean. (Anne, interview, November 14, 2010)

In very different ways, each woman made sense of her body and her experience of disability through these relations, as resistance, validation, friction, or support. Somatic experiences were never divorced from interactions with other bodies. In some cases, experiences of pain must await certain kinds of sensing bodies – like doctors or medical imaging devices – to be validated and treated. In others, bodies come together in what Loree called "cultivating spaces of shared vulnerability," where the question of bodies is no longer unidirectional, but rather, "How do our bodies work together in this moment? And just having a conversation around that ... 'cause then it's not just my body that's the one that needs attending to, you know?" (Loree, interview, February 7, 2011)

Butler (2004, 18) suggests that "one mourns when one accepts the fact that the loss one undergoes will be one that changes you, changes you possibly forever, and that mourning has nothing to do with agreeing to undergo a transformation the full result of which you cannot know in advance." The loss of Anne changed the relationships possible between our bodies. While it foreclosed certain relations, it opened new ones as I shared memories and sorrow with others who knew her. My grief does not define her life and her body, which remained the focus of the project; however, the lens of grief brought into focus the ways in which Anne was, as Butler insinuates, constituted by and constitutive of a political community. Despite our efforts to prioritize her experiences, her understanding and experiences of her body were

always already produced within a social context that accepted or questioned her embodiment.

Conventional academic wisdom encourages detachment from one's research. We are taught to write out the personal: avoid the first person, speak in passive voice, avoid equivocating, speak with authority, and remain at an objective distance from our subjects. On the other hand, modernist artistic practice has tended to emphasize the individual genius of artists, a habit that persists even in an era of social, collaborative, and interactive art. It is no more honest or feasible to absent one's own perspective in the work than it is radical to ignore the perspectives and needs of those whose experiences and bodies are the matter of the work.

Thinking about methodology and doing research are not discrete activities. I read about other people's ways of working, and I come to some decisions about how I would like to enact research; I *do* research, and I look for some literature that will help me to make sense of that experience; as I speak with a particular collaborator, an article enters our conversation, bringing the literature into the research in a different way, and so forth. The process, the literature, and their praxis are inextricable from the social relations of research; the bodies that relate their stories also form a literature. In this case, theory, methodology, and practice were deeply informed and troubled by embodied social relations, including – but in no way limited to – the death of a participant. Thus, it is necessary not only to address how the research was done (and why), but also – and perhaps most importantly – to situate myself as one body among many that generate knowledge and knowledge-making practices.

Changing material and social relations around disability research and artistic production entails a responsibility not only to literature or a transcribed interview, but also to each other. It is a question of not only who contributes to the formation of knowledge, but how. When we take on generative possibilities of co-created knowledges, the many bodies that come together to form the work become implicated in each other's lives, sometimes far beyond the scope of the project. These relations are not easily contained by research ethics, theory, or methodology. In taking on these modes of research, I was committed to treating my collaborators as embodied actors in knowledge production. At the same time, my bodily knowledge of each woman, of how she moved and spoke, informed my understanding of her words and her experiences of embodiment. As an artist, a researcher, and a friend, my bodily memory informed the work. After Anne's death, it

became clear that much of what is at stake in such an extreme case is always an integral part of both art and social research. This transformation allowed me to situate my own agency more explicitly and to address more fully the vulnerability that embodied and participatory research entails, as knowledge generated where bodies meet, engage, and come to matter.

NOTES

1 I use the capitalized, definite term "The Body" to refer to the singular and totalizing object that is constituted through the aesthetic and discursive patterns of Western art, science, and medicine. Elsewhere, I privilege the terms "a body" or "bodies" as dynamic, multiple, and locally iterated forms of experience.

2 Even in cases where consent has been given, questions of autonomy and privacy can arise. See, for example, Lawton (2001) for an account of some of the ethical dilemmas of ongoing consent and participant observation in a palliative hospice setting.

3 After much discussion, her name has been associated with other aspects of the project with permission from her parents. However, my hesitation to use her name in published material remains.

4 There is a great deal of literature that attempts to define and distinguish between concepts of impairment, disability, illness, sickness, and disease on the basis of cultural connotations, social models of disability, political expediency, and questions of visibility (see, for example, Oliver 1996; Samuels 2003; Shakespeare 2006; Wendell 2001). Wendell (2001) in particular problematizes the ways in which social models of disability have tended to emphasize "healthy people with disabilities" in contrast and to the detriment of supporting those "whose bodies are highly medicalized because of their suffering, their deteriorating health, or the threat of death" (18). With this in mind, I use the term "healthy" here to indicate that none of the participants was experiencing any unusual or notable distress, suffering, or sickness at the time; each was in the normal state of health for her particular body.

5 For further exploration of friendship and emotional risk in qualitative health research, see also Watson, Irwin, and Michalske (1991) and especially Dickson-Swift et al. (2006). For additional reflections and references on researcher vulnerability in qualitative health research, see Woodby et al. (2011). For some anthropological reflections on vulnerability as a researcher, see Behar (1996) and Gibb (2005).

WORKS CITED

Barad, Karen. 2003. "Posthumanist Performativity: Toward an Understanding of How Matter Comes to Matter." *Signs: Journal of Women in Culture and Society* 28 (3): 801–31. http://dx.doi.org/10.1086/345321.

Behar, Ruth. 1996. *The Vulnerable Observer*. Boston: Beacon Press.

Bishop, Claire. 2004. "Antagonism and Relational Aesthetics." *October*, no. 110: 51–79. http://dx.doi.org/10.1162/0162287042379810.

–. 2006. "The Social Turn: Collaboration and Its Discontents." *Artforum*, February: 178–83.

Bogdan, Robert, and Steven J. Taylor. 1989. "Relationships with Severely Disabled People: The Social Construction of Humanness." *Social Problems* 36 (2): 135–48. http://dx.doi.org/10.2307/800804.

Bourriaud, Nicolas. 2002. *Relational Aesthetics*. Dijon: Les Presses du réel.

Butler, Judith. 2004. "Beside Oneself: On the Limits of Sexual Autonomy." In *Undoing Gender*, 17–39. New York: Routledge.

Charmaz, Kathy. 2004. "Premises, Principles, and Practices in Qualitative Research: Revisiting the Foundations." *Qualitative Health Research* 14 (7): 976–93. http:// dx.doi.org/10.1177/1049732304266795.

Crimp, Douglas. 1992. "Portraits of People with AIDS." In *Cultural Studies*, edited by Lawrence Grossberg, Cary Nelson, and Paula Treichler, 117–33. New York: Routledge.

Dickson-Swift, Virginia, Erica L. James, Sandra Kippen, and Pranee Liamputtong. 2006. "Blurring Boundaries in Qualitative Health Research on Sensitive Topics." *Qualitative Health Research* 16 (6): 853–71. http://dx.doi.org/10.1177/104973 2306287526.

–. 2008. "Risk to Researchers in Qualitative Research on Sensitive Topics: Issues and Strategies." *Qualitative Health Research* 18 (1): 133–44. http://dx.doi.org/ 10.1177/1049732307309007.

Estroff, Sue E. 1995. "Whose Story Is It Anyway? Authority, Voice, and Responsibility in Narratives of Chronic Illness." In *Chronic Illness: From Experience to Policy*, edited by S. Kay Toombs, David Barnard, and Ronald A. Carson, 77–102. Bloomington: Indiana University Press.

Gibb, Camilla. 2005. "An Anthropologist Undone." In *Auto-ethnographies: The Anthropology of Academic Practices*, edited by Anne Meneley and Donna J. Young, 216–28. Peterborough, ON: Broadview Press.

Goodley, Dan. 1999. "Disability Research and the 'Researcher Template': Reflections on Grounded Subjectivity in Ethnographic Research." *Qualitative Inquiry* 5 (1): 24–46. http://dx.doi.org/10.1177/107780049900500102.

Grigely, Joseph. 2000. "Postcards to Sophie Calle." In *Points of Contact: Disability, Art, and Culture*, edited by Susan Crutchfield and Marcy Epstein, 31–58. Ann Arbor: University of Michigan Press.

Gruson-Wood, Julia Frances. 2009. "Ableism Kitsch: The Aesthetics of Disability-Related Ethics." *Critical Disability Discourse/Discours Critiques dans le Champ du Handicap* 1. http://cdd.journals.yorku.ca/index.php/cdd/article/view/23387.

Haraway, Donna J. 1988. "Situated Knowledges: The Science Question in Feminism and the Privilege of Partial Perspective." *Feminist Studies* 14 (3): 575–99. http:// dx.doi.org/10.2307/3178066.

Lawton, J. 2001. "Gaining and Maintaining Consent: Ethical Concerns Raised in a Study of Dying Patients." *Qualitative Health Research* 11 (5): 693–705. http:// dx.doi.org/10.1177/104973201129119389.

Morse, J.M. 2001. "Are There Risks in Qualitative Research?" *Qualitative Health Research* 11 (1): 3–4. http://dx.doi.org/10.1177/104973201129118867.

Oliver, Michael. 1996. *Understanding Disability: From Theory to Practice*. New York: St. Martin's Press. http://dx.doi.org/10.1007/978-1-349-24269-6.

Phelan, Peggy. 1993. *Unmarked: The Politics of Performance*. London: Routledge. http://dx.doi.org/10.4324/9780203359433.

Rosaldo, Renato. 1993. *Culture & Truth: The Remaking of Social Analysis*. Boston: Beacon Press.

Samuels, Ellen. 2003. "My Body, My Closet: Invisible Disability and the Limits of Coming-Out Discourse." *GLQ: A Journal of Lesbian and Gay Studies* 9 (1–2): 233–55. http://dx.doi.org/10.1215/10642684-9-1-2-233.

Shakespeare, Tom. 2006. *Disability Rights and Wrongs*. London: Routledge.

Siebers, Tobin. 2006. "Disability Aesthetics." *Journal for Cultural and Religious Theory* 7 (2): 63–73.

Tillmann-Healy, Lisa M. 2003. "Friendship as Method." *Qualitative Inquiry* 9 (5): 729–49. http://dx.doi.org/10.1177/1077800403254894.

Watson, Lynn, Jeanette Irwin, and Sharon Michalske. 1991. "Researcher as Friend: Methods of the Interviewer in a Longitudinal Study." *Qualitative Health Research* 1 (4): 497–514. http://dx.doi.org/10.1177/104973239100100406.

Wendell, Susan. 2001. "Unhealthy Disabled: Treating Chronic Illness as Disabilities." *Hypatia* 16 (4): 17–33. http://dx.doi.org/10.1111/j.1527-2001.2001.tb00751.x.

Woodby, L.L., B.R. Williams, A.R. Wittich, and K.L. Burgio. 2011. "Expanding the Notion of Researcher Distress: The Cumulative Effects of Coding." *Qualitative Health Research* 21 (6): 830–38. http://dx.doi.org/10.1177/1049732311402095.

Woodill, Gary, and the Centre for Independent Living in Toronto. 1992. *Independent Living & Participation in Research: A Critical Analysis: A Discussion Paper*. Toronto: Centre for Independent Living in Toronto.

Conclusion
The Politics of Embracing Disability Metaphor

TANYA TITCHKOSKY

I.

She hadn't performed on stage since then, since she fell. The fall wasn't exactly painful, but it was devastating. Everything about her now seemed bent and bungled with its humiliation. And, months later, she was still waking up to its memory. Her big body, big shoes, her big voice in a big performance, she was on the brink of becoming a big name when it all came crashing down. Legs akimbo, dress split, all of it, all of *her* really, fell in front of everyone.

"A fallen woman," she said without laughing to her mom, "that's what I am now." That she was drinking didn't soothe the pain. This was the beginning of discovering what was wrong, but this didn't block out the memory. Instead of moving on with the fall in tow, the raw weight of the fall tumbled on her again and again. She would never forget it.

She knew it would probably happen again. Given the diagnosis that followed her fall ... yes, it would happen again.

Her mom began a quirky speaking version of an old Sinatra song, "That's Life":

> Each time I find myself flat on my face
> I pick myself up and get back in the race.

"You know," her mother said, "life gave you this as a metaphor."

What? To pick myself up like a worn-out Sinatra song? She refused to treat this, her life, this fall, her devastation, as some sort of positive-thinking moment. But metaphor – what did that mean? What? For overcoming? *Oh, my body.* "Mom, what do you mean?" she groaned.

II.

This remarkable collection can be read as asking us to fall completely into a fuller understanding of disability metaphor in art, culture, and activism. Editors Christine Kelly and Michael Orsini have assembled this book of art, culture, disability activism, and theory to marshal us to consider what sort of action we can take with disability as metaphor. The metaphors of embodiment used in this collection are as vast as they are diverse ... stairbombing, visual activism, revisioning, inoculation against our fear of disability, ephemeral spaces of envisioning, cripped poetry of witness, body as resistance and as "art/ifact," and more.

Mobilizing Metaphor depicts disability as a life, to borrow from Diane Driedger (chapter 10), lived in broad strokes, including that of pain. Moreover, many of the authors paint themselves into the picture of disability through a variety of arts-based practices. The metaphoric range of the work collected here is astonishing when juxtaposed with the customary use of disability as a stand-in for unwanted fall and decline.

But what does understanding the importance of metaphor mean for our aesthetic and political consciousness regarding disability in Canada? Insofar as life gives us metaphor, what is this life of disability like? In the following discussion, I aim to draw out the social and political significance of embracing disability as a mobilized as well as a mobilizing metaphor. I turn now to falling in with disability metaphor.

III.

Of the metaphor of falling, Ann Cooper Albright (2013, 36) says that it

> carries a pretty heavy symbolism in the West. Whether we are talking about the hubris of Icarus or the evil of Satan, the collapse of stock markets or the public stumbling of the latest politician to have lost his integrity on the Internet, falling is generally seen as a failure, a defeat, a loss or a decline. In short, a fall charts a passage from the lofty heavens of stardom to the grit of the earth.

While disability can be used to naturalize a fall by lending it a sensible cause, disability is also a metaphor for a fall, and fall is a metaphor for disability, and both are made to count for life changes cast as undesirable departures from normalcy. Disability is a readily available term to metaphorically express collapse, loss, failure, defeat, decline, or an unwanted and unwelcomed state of affairs. As in the story above and as can be found in almost any account of lack or loss, "disability" is a term often used to naturalize metaphoric falls. Perhaps the mother in the story is right: "Life" has given us disability as a metaphor, but it is one whose negativity is often assumed, since who wants to or aims to engage disability as an experience? This is part of the heavy symbolism that not only the term but also disabled people are made to carry.

With disability, and its many associated terms (e.g., impairment, injury), we almost always fall into loss, limit, lack – at least initially. These conventional meanings of disability threaten to transform it into a dead metaphor whose hauntings run rampant through daily life – disabled streetcars, blind alleys, lame arguments, crippled economies, the news of any of these falling on deaf ears, and you must be blind if you do not see what I mean. In discussing disability metaphor as a "narrative prosthesis" and as that which lends material sense to expressions of individual and social collapse, David Mitchell and Sharon Snyder (2000, 47) say, "Nearly every culture views disability as a problem in need of a solution ... [and this] situates people with disabilities in a profoundly ambivalent relationship to the cultures and stories they inhabit."

In the face of this profound ambivalence, there is still the task of finding a way to respond to a life filled with disability metaphor (dead or alive), which is a political, cultural, and aesthetic issue as well as a difficult task.

Part of the difficulty is that there are few practices, artistic or otherwise, that attempt to help people attend to our relations with disability metaphor. But as Carla Rice, Eliza Chandler, and Nadine Changfoot argue in their chapter, the non-didactic, non-predictive, and non-prescriptive retelling of the stories that we already are can be read as a new practice of living and being. Returning to scenes of disability metaphor with some uncertainty and letting their meaning fall a little closer to us is such a practice. Overall, this book contains many retellings of metaphors of embodied difference that invite the reader to revisit the place of metaphor in the Life of disability.

IV.

In the face of disability metaphor deployed as a taken-for-granted indicator of a *big unwanted problem,* some have suggested that we should simply say "Stop!" Since at least the International Year of Disabled Persons (1981), the World Health Organization and many governments, including Canada's, have attempted this stop order. They have issued the order by, for example, circulating word-choice pamphlets that recommend disability terms be used only to refer to impairments, that impairment terms be used only to refer to lack of function, and even that these non-metaphoric uses of impairment be employed only if absolutely necessary. Yet the work of Joseph Grigely (2006), David Bolt (2006), Deborah Gallagher (2006), and others serves as a stark reminder that the pejorative use of disability metaphor has not stopped even as the stop orders proliferate (Titchkosky 2001, 2015).

In this collection, Jen Rinaldi and nancy viva davis halifax and many others challenge the notion that government-sponsored rhetorical indifference is a solution to pejorative uses of disability terms. They do this not so much by suggesting a politics of recognition but more by suggesting artistic and cultural practices that reframe how we talk about and act on disability. The chapters included in the section "Artistic Paths to Disability Activism" can enable the reader to resist indifference. At the same time, these chapters ask us to re-engage metaphor through practices such as "Crip the Light Fantastic: Art as Liminal Emancipatory Practice in the Twenty-First Century" (sachse); artistically rendering disabled bodies and prosthetics as a moving art installation (Driedger); staging disability presence as a place where the hardest things about disability metaphors are danced (Eales); or interrupting the broadcast of stereotypical renderings of disability (Preston) by making, for example, deaf stereotypical metaphoric put-downs into Deaf art discourses and practices (Bath) inclusive of Deaf space. In these ways, disability metaphor comes to life as something other than a broken rule or a disturbance of a politically correct expression.

Other scholars have suggested that metaphor be replaced with a return to the Real of bodies, a kind of non-metaphoric space where pain as pain or impairment as impairment appear as brute asocial facts (Vehmas and Mäkelä 2008). The Real, in this case, refers to a belief in a body untouched by social life. Implicit in some realist arguments is that there should be no fall into a life with disability metaphor, since pain, violence, impairment, and death, as well as the power of the norm, simply *are.* They suggest that any metaphoric grappling with such matters will fall short. But again, Life has no space for an acultural or direct experience of our bodies, minds, senses,

emotions, or comportments (for a fuller discussion, see Goodley 2011, 116). Approaches that resist the realist impulse to regard embodied experiences as transcending culture offer instead the "productive potential of dis/ability to crip a whole host of norms ... playing with ideas around what it might mean to live non/normative lives extends what we might understand as being human" (Goodley 2014, 158).

Through *Mobilizing Metaphor*, it is possible to imagine that all impairment experiences, including the cut-off lines between the "real" and the "imaginary," are already mediated by a host of symbolic differences and distinctions. In this volume, the question of inclusion is pursued in Kristin Nelson's chapter, "Deaf and Disability Arts: Insiders, Outsiders, and the Potential of Progressive Studios," as well as Catherine Frazee, Kathryn Church, and Melanie Panitch's "Fixing: The Claiming and Reclaiming of Disability History" as this relates to their fight for the full inclusion of all aspects of their *Out from Under* installation (now permanently installed in the Canadian Museum for Human Rights). In Alexander McClelland and Jessica Whitbread's chapter, "PosterVirus: Claiming Sexual Autonomy for People with HIV through Collective Action," public health questions regarding AIDS are engaged through artistic practices that are virtually and literally viral. These chapters can be read as radical counterpoints to the notion of an unmediated Real as a solution to the problem of disability metaphor, since every act of inclusion battles with previous notions of what inclusion was to look like, and explicitly address what disability has been made to stand in for. In the face of art, culture, and disability activism we can thus find ourselves "in the world ... *condemned to meaning*" (Merleau-Ponty 1945, xxii; emphasis in original) and wrapped in and transported by metaphorical meaning making. Perhaps this is the Real of our embodied experience with which we must grapple.

This collection neither suggests that we should purge disability from linguistic expression nor attempts to express impairment as if it appears somewhere other than in and as culture. Insofar as metaphor is a part of our material reality as interpretive beings, these chapters suggest ways to relate to disability metaphor that may invite us to be something other than estranged to the movement of metaphor. Neither refused nor resisted, disability metaphor can call for a more imaginative response to our embodied expressions linking "life and limb," envisioning new ways of "seeing" (Rice, Chandler, and Changfoot, this volume) as a way to make new meaning while actively taking into account the meanings already made of our embodied existence (Belsky, this volume).

V.

"Embodiment," then, is not just a fancy word for bodies. Instead, embodiment manifests as a reflection of the Real of metaphor in our daily lives. The cultural turn within queer theory, anti-racism, feminist, black, and disability studies has shown us that it is, in fact, difficult to attend to embodiment of any sort in a non-metaphorical fashion. In theorizing post-colonial cultural relations, Paul Gilroy (2005, 39) reminds us that "by 'race' I do not mean physical variations or differences, commonsensically coded in, on, or around the body. For me, 'race' refers primarily to an impersonal, discursive arrangement." Gilroy goes on to suggest that such a conception calls on us to commit "acts of imagination and invention that are adequate to the depth" (53) of the predicaments of our times. "Embodiment" is a term that should remind us that the experience of any body is a mediated one. As a discursive arrangement, embodiment is of the world in which it makes an appearance (and if not in and of the world, then this body is likely long dead and gone, or functioning as a fallacy of personal sovereignty). While the heart does not easily stand in for the head, the body does seem to occasion endless metaphorical twists, making what it means to live this life as embodied beings an open question.

The call to fall into acts of imagination via embodied metaphor is answered throughout the collection's section entitled "Rethinking Agency in Canadian Disability Movements." Here we encounter resistance embodied as an "art/ifact" during the 2012 Quebec student movement (Blouin Genest, this volume) as well as during the Toronto Disability Pride March (Graham and Jackson, this volume). Embodiment variously mediated (as participant, as excluded type, as place for and of protest) is further addressed by Pamela Moss's chapter, "Perching as a Strategy for Seeking Legitimacy for Broken Embodiments," where she considers what is at play in biomedical descriptions of undefined illness.

Throughout this section on pushing the boundaries, the reader encounters the cliché "disability as broken body." The "broken body," however, is depicted as something more than, or other than, a straightforward derogatory phrase – "broken" represents the depths of the complexity of medical and political regulatory regimes of oppression. Disability as broken body is shown to be socially organized. Through medical discursive practices and other political practices, broken is represented as a long commotion of ambiguous effects that engages with established ways to articulate the problem body (Moss, this volume). Embodiment, as that which can flirt with established meanings of the body, whether at political protests or in the doctor's

office, trips us into diagnostic uncertainty that nonetheless is bent and bungled with meaning after meaning. Without the capacity to halt or simply dismiss articulations of the body, we forge the possibility of learning to attend to the movement of meaning that disability metaphor releases on or in, or maybe even *as,* our lives.

Given the social nature of embodiment, of disability, and of metaphor, we might trip once more into the idea that disability metaphor is where we can imagine that new meanings may arise when we embrace disability as a "fall into life" (Kriegel 1988). After all, in the midst of the dead weight of disability customarily used to express unwanted negative change, there is still the work of artists, activists, cultural critics, and theorists carrying on in an unexpected fashion. The truth of this, perhaps a radical one, lies in the sense of what both disability and metaphor share: namely, the possibility to release unexpected meanings, since the body, like the language that bares us, is both vulnerable and responsive to change.

VI.

For those who study the movement of language, metaphor represents one of the fundamental issues in need of understanding. Through metaphor, we meet contexts within which established meanings reside and are repeated, reproduced, recycled. But through the movement of metaphor, these established meanings are made part of a comparison, and this makes for a combination that potentially releases new meanings. As prevalent and provocative, disability metaphor needs to be understood as a form of materiality that is *doing* something. Editors Kelly and Orsini suggest this at the beginning of the book when they implore us "to challenge the idea that disability is a stand-in, a placeholder." Disability metaphor can be read as an invitation to figure out what is being done within the context of its appearance, especially if we suspend a belief that "disabled" can signify only a condition of fallen hero or villain, fallen from the ever-ephemeral realm of normalcy.

A theorist of metaphor, Paul Ricoeur (1975, 225) suggests that the truth of metaphor is one that says "it was and it was not." Metaphor, to be metaphoric, is a linguistic trope that addresses itself to a present context of meaning by referencing something that "it is not." This *it-was-and-it-was-not* structure makes metaphoric truths difficult to grasp, yet easy to kill. And dead metaphors abound! For example, when every fall "stands in for" the need to rise again, where a decline is a crash and a crash is disabling, or where a shift in one register of events always comes to point at the customary meaning of disability as something to overcome, then we have a dead

metaphor wielding its normative power. While disability is overused as a dead metaphor, a clichéd reference to unwanted lack, this is not the only possibility – there is more.

The *more* of metaphor, according to Ricoeur (1978, 147), is that it shows that *"mimesis* [repetition] is *poiesis,* that is, fabrication, construction, creation"* and can occur from what we already say and already do. There is, in other words, the potential to make *(poiesis)* new worlds out of the repetitive return *(mimesis)* to the words that already constitute our worlds. The "structure of metaphor, as transposing the meaning of ordinary language into strange uses" (Ricoeur 1978, 148) is a power, but not the power of generating more and more images. Instead, metaphor is tied to the potential power of releasing the imagination within a world already built, already oppressive. Metaphor, in this sense, can be read as the occasion for Gilroy's (2005, 53) *acts of imagination,* acts that might forge new meaning and self-understanding. This can also be framed as a "politics of wonder" (Titchkosky 2011, 129), where we return to *what is* in order to encounter it anew.

Focusing on a single example should enable us to continue to consider the matter of metaphors and how they mobilize imagination. Consider Véro Leduc's chapter, "'It Fell on Deaf Ears': Deafhood through the Graphic Signed Novel as a Form of Artivism." Following Baynton's (2008) suggestion that "to be deaf is not to not hear ... but a social relation," Leduc theorizes her production of comic books that play with the cliché "it fell on deaf ears." Of course, "it fell on deaf ears" is a worn-out set of words reflective of a world that does not mind grasping deafness as simply not-hearing. Such a world ordinarily uses the body to express the equally worn-out notion that inappropriate attention can be likened to deafness. But through comic renderings, deafness becomes a fall into various and competing relations to these "deaf ears." There are, after all, multiple uses of deafness in daily life falling on multiple "deaf ears." Leduc deploys this clichéd use of deafness as a metaphoric expression of her own coming into Deafhood, where the boom of a put-down is made to show how it touches the movement of Deafness in her life. Leduc writes:

> All of a sudden I don't want to be "hard" of hearing anymore;
> Am I Deaf if sign language isn't my first language?
> Am I hearing if I hear anyway, but not like hearing people?
> Where are we going when we leave behind the words
> (and the worldviews they carry) we don't want anymore?
> Reeling in the "in-between" says Brenda Brueggemann

> You say to me: I am "Deafian"
> It sounds like "Martian," but I like it.
> (Leduc 2012, 2; LeBlanc's translation)

Deafian sounds like Martian and neither are simply "hard" of hearing, yet hard of hearing is what Leduc is called and what she is not or, at least, is no longer. In between, Leduc's art and activism (artivism) produce meanings that arise between her many and various experiences of being something other than not-hearing. In her poem, Leduc reveals many different moments of deafness – "hard of hearing" is distinguished from "hearing not like hearing people," which is distinguished from the Deaf culture and "sign language," which is not her first language. Yet all of these expressions of deafness are part of being Deafian and reeling between something far more significant than "not-hearing." From this in-between space, hard of hearing does fall on deaf ears, and even though deafness is used to reference not attending or not attending properly, Leduc ironically shows hearing others that they still need to attend to deafness as *not* not-hearing.

The cliché of deafness as lack of attention is mobilized to show what Leduc is attending to, and she is attentive to how she attends "not like hearing people." Falling on deaf ears is falling into Deafian perception, a way of being in between various normative orders and at one with none. Through her comic books, her theorizing, and her own life-with-disability cliché where *mimesis* is *poiesis*, what falls with her deafness and on all who live with disability metaphorically *is always already a poetic relation to what it is via what it is not.*

Such "artivism" can mobilize a kind of agentive awareness; that is, an insistent gesture toward the "question – and the affective labour – of critical agency, in its entwinement with multiple forms of doing, undoing, being undone, and becoming, as well as multiple forms of giving and giving up" (Butler and Athanasiou 2013, 193). Or, as Leduc has suggested when first presenting this work, "For me, comics have the ability not only to evoke the politics, affect, and art of a sociocultural reality larger than the stories they tell, but also to transform ways of perceiving and living this reality."

Throughout this collection there are a variety of expressions of critical agency that we may find ourselves falling for. Belsky's chapter, for example, suggests that we might pursue a form of agentive accountability by asking how we become answerable to what we see. Here, visual activism is not the proliferation of images, nor is it pointing out "blind spots," but is instead a return to visual culture to uncover what organizes perception itself. Visual

activism addresses how we perceive, so that gaps in vision are not regarded as blindness but a form of sight for which we might take responsibility. Likewise, deafness is *not* not-hearing, but a way to fall into a kind of attentiveness that is not at one with ordinary depictions of deafness as not-hearing, and so on. Falling into living with the metaphors of embodiment that we are said to be and not be is one way to read this collection.

VII.

The politics of embracing disability metaphor and what this understanding means for our aesthetic and political consciousness regarding disability in Canada is tied, at least in part, with how people relate to metaphor. It is very easy to shut down imagination, to kill metaphoric power, by showing how metaphor is nothing but the repetition of the same. Moreover, repetition *is* part of the truth of metaphor; every metaphor does indeed repeat established understandings, many of which are horrible. Testimony to this is the prevalence of disability clichés ordinarily used to indicate an undesired fall from the good graces of the normally expected. This is only part of the truth of disability metaphor, however.

"What is" can also be agentively – or poetically, that is – self-reflectively engaged so as to repeat the same Real but toward a different end than sheer repetition of what is. Mobilizing disability metaphor turns out to be a way to express art, culture, and disability activism as part of the larger ongoing move toward what Butler and Athanasiou (2013) are calling "critical agency" and what Ricoeur (1975, 1978) and Gilroy (2005) might simply call *imagination*. Conscious of the injustices of the current normative orders of daily life, critical agency can be imagined as that wide-awake state that is busy doing something other than mapping these injustices, since it is also making something of the injustices that have already made something of us. Critical agency moves with metaphor (not only against it), since metaphor necessarily involves attending to our own complicity, perhaps necessary for survival itself, in strange and unexpected ways. The powers that say how we matter as legitimate or sensible beings can be made to matter differently via metaphoric deployment of the terms and conditions already expected by the worlds in which we find ourselves. As Nancy Mairs (1996, 59) suggests, disability is made to "occupy a physical space literally outside the field of vision of those in the centre, so that the latter trip unawares and fall into the laps of those they have banished from consciousness." Art, culture, and disability activism are those trippy practices that embody metaphor in unexpected and even yet-to-be imagined ways.

Clearly, representations of disabled people have been made to "stand in for" something that we are not; that it is not. One thing that disability is not is the not-yet world of justice – a world where unexpected embodied differences might thrive. The language of disability, impairment, madness, illness, injury, pain, and basic embodied differences do not escape this fate of metaphoric use, but maybe this can be done differently when we keep the lessons from *Mobilizing Metaphor* in mind. Perhaps the mobility of metaphor is its materiality; perhaps the materiality of metaphor is that it moves us. In this way, these metaphoric matters are even more pressing, since it is through our bodies that world and meaning coalesce, flow, and find their expressions (Merleau-Ponty 1945, xxiii, 202). Since we cannot fall out of it, we may as well fall into it – such is metaphor! *Mobilizing Metaphor* can be read as a way to actualize this promise – it is a way to get into a world that is not yet what it should be.

VIII.

Again, she falls.

"Life gave you this as a metaphor," the words ring.

It must be true. Still, it is difficult to know how to live them.

ACKNOWLEDGMENTS

This is dedicated to Austin Clarke, who I also thank for helping me with the opening story. I thank also Heather Berkeley for inspiration; Rod Michalko for his ongoing conversations and editing; and Fiona Cheuk, Tracey Edelist, and Sona Kazemi, graduate research assistants working with me at OISE, for their editorial suggestions on my work.

WORKS CITED

Baynton, Douglas C. 2008. "Beyond Culture: Deaf Studies and the Deaf Body." In *Open Your Eyes: Deaf Studies Talking*, edited by H-Dirksen L. Bauman, 293–313. Minneapolis: University of Minnesota Press.

Bolt, David. 2006. "Beneficial Blindness: Literary Representation and the So-Called Positive Stereotyping of People with Impaired Vision." *New Zealand Journal of Disability Studies* 12: 80–100.

Butler, Judith, and Athena Athanasiou. 2013. *Dispossession: The Performative in the Political*. Cambridge: Polity.

Cooper Albright, Ann. 2013. "Falling." *Performance Research: A Journal of the Performing Arts* 18 (4): 36–41. http://dx.doi.org/10.1080/13528165.2013.814333.

Gallagher, Deborah J. 2006. "On Using Blindness as Metaphor and Difficult Questions: A Response to Ben-Moshe." *Disability Studies Quarterly* 26 (2). http://dsq-sds.org/article/view/690/867.

Gilroy, Paul. 2005. *Postcolonial Melancholia*. New York: Columbia University Press.

Goodley, Dan. 2011. *Disability Studies: An Interdisciplinary Introduction*. London: Sage.

–. 2014. *Dis/Ability Studies: Theorising Disablism and Ableism*. London: Routledge.

Grigely, Joseph. 2006. "Blindness and Deafness as Metaphors: An Anthological Essay." *Journal of Visual Culture* 5 (2): 227–41. http://dx.doi.org/10.1177/1470412906066908.

Kriegel, Leonard. 1988. "Falling into Life." *American Scholar* 57 (3): 407–18.

Leduc, Véro. 2012. *C'est tombé dans l'oreille d'une Sourde*. http://media.wix.com/ugd/1e875f_1afdecebad86438980291bd97b001d9f.pdf.

Mairs, Nancy. 1996. *Waist-High in the World: A Life among the Nondisabled*. Boston: Beacon Press.

Merleau-Ponty, Maurice. 1945. *Phenomenology of Perception*. London: Routledge.

Mitchell, David T., and Sharon L. Snyder. 2000. *Narrative Prosthesis: Disability and the Dependencies of Discourse*. Ann Arbor: University of Michigan Press.

Ricoeur, Paul. 1975. *The Rule of Metaphor: Multi-Disciplinary Studies of the Creation of Meaning in Language*. Toronto: University of Toronto Press.

–. 1978. "Metaphor and the Main Problem of Hermeneutics." In *The Philosophy of Paul Ricoeur: An Anthology of His Work*, edited by Charles E. Regan and David Stewart, 134–48. Boston: Beacon Press.

Titchkosky, Tanya. 2001. "Disability: A Rose by Any Other Name? 'People-First' Language in Canadian Society." *Canadian Review of Sociology/Revue canadienne de sociologie* 38 (2): 125–40. http://dx.doi.org/10.1111/j.1755-618X.2001.tb00967.x.

–. 2011. *The Question of Access: Disability, Space, Meaning*. Toronto: University of Toronto Press.

–. 2015. "Life with Dead Metaphors: Impairment Rhetoric in Social Justice Praxis." *JLCDS Journal of Literary and Cultural Disability Studies* 9 (1): 1–18. http://dx.doi.org/10.3828/jlcds.2015.1.

Vehmas, Simo, and P. Mäkelä. 2008. "A Realist Account of the Ontology of Impairment." *Journal of Medical Ethics* 34 (2): 93–95. http://dx.doi.org/10.1136/jme.2006.019042.

Contributors

Paula Bath is a PhD student in Applied Linguistics and Discourse Studies at Carleton University and holds BA and MA degrees in communications from the University of Ottawa. She enjoys writing academic and creative non-fiction pieces, and she plays with blending the two genres. Her current research efforts focus on the cultural and linguistic representations of sign language and Deaf people in the media and the arts. Bath is married to a Deaf person and uses Langue des signes québécoise (Quebec Sign Language) and American Sign Language at home and with her two children.

Drew Danielle Belsky is interested in the relationship between artistic and biomedical rendering practices and the creation, maintenance, and possibilities for the contestation of canonical bodies. She is a doctoral student in the Science and Technology Studies (STS) Department at York University focusing on the professionalization, pedagogy, and practices of biomedical illustrators from the twentieth century to the present. Ongoing projects address questions of consent in the mobilization of disabled bodies in contemporary art production. She holds a degree in studio art (DNSEP) from the Haute École des Arts du Rhin (formerly ESAD, Strasbourg, France) and an MA in interdisciplinary studies (fine arts, critical disability studies, and STS) from York University.

Gabriel Blouin Genest is assistant professor in the Department of Political Science at Virginia Tech. His research interests include health politics and policies, health security and pandemics, global health institutions and practices, water politics, and complexity theory. His work has been published in *Health: An Interdisciplinary Journal for the Social Study of Health, Illness and Medicine, Études internationales, Cultures et Conflits,* and *Dynamiques internationales.* Blouin Genest is also the author of *L'eau en commun* (PUQ, 2012) as well as several chapters in edited volumes.

Having earned her PhD from the Department of Social Justice Education at the Ontario Institute for Studies in Education, University of Toronto, **Eliza Chandler** is assistant professor in Ryerson University's School of Disability Studies, where she researches the development of disability arts in Canada. She is also the former artistic director at Tangled Art + Disability, an organization in Toronto dedicated to the cultivation of disability arts. Chandler is the current president of the Canadian Disability Studies Association, the co-director of the disability arts community group Project Creative Users, and a practising artist.

Nadine Changfoot is associate professor and chair of the Political Studies Department at Trent University. She works with Drs. Carla Rice and Eliza Chandler on Project Re•Vision, welcoming and bringing previously unheard and hidden stories of embodied difference to light. Her research explores the multi-faceted relationship between art, politics, and social and political change at the local level. She is also involved in community-based research focused on community–campus partnerships for local sustainability and stronger, healthier communities.

Kathryn Church is director and associate professor in the School of Disability Studies at Ryerson University. Since 2002, she has been part of key initiatives that have brought the school's "vision, passion, action" message to life across the university and in the public eye. An arts-informed ethnographer, Church is the author of *Forbidden Narratives: Critical Autobiography as Social Science,* curator of the exhibit *Fabrications: Stitching Ourselves Together,* and co-curator of *Out from Under: Disability, History and Things to Remember,* now in the permanent collection of the Canadian Museum for Human Rights. An award-winning instructor, in 2015 she received a Woman of Distinction award from the Ontario Confederation of University Faculty

Associations and a David C. Onley Award for Leadership in Accessibility. Allied to the Mad movement for twenty-five years, Church is a foundational contributor to the emerging field of Mad studies.

Diane Driedger is a visual artist, a poet, a writer, an activist, and an educator. She has written or edited nine books, including *The Last Civil Rights Movement: Disabled People's International* (Hurst, 1989). Her book, *Red with Living: Poems and Art*, was published by Inanna Publications and Education in 2016. She has been involved in the disability rights movement locally, nationally and internationally for thirty-five years. Driedger was awarded the inaugural Tanis Doe Award for Distinction in Canadian Disability Art and Culture in 2009. She is assistant professor in the Interdisciplinary Master's Program in Disability Studies at the University of Manitoba.

Lindsay Eales is a choreographer, an instructor, a performer, and a scholar who explores integrated dance, disability, Madness, and social justice. She is currently a PhD student in the Faculty of Physical Education and Recreation at the University of Alberta. Her work has been published in journals such as *Adapted Physical Activity Quarterly, Leisure/Loisir,* and *Emotions, Space, and Society.* Her PhD work uses research-creation to explore Mad politics, aesthetics, and Mad-accessible practices through dance. She is supported by the Vanier Canada Graduate Scholarship (SSHRC). Eales is also a co-founder and co-artistic director of CRIPSiE, the Collaborative Radically Integrated Performers Society, in Edmonton.

Catherine Frazee is a professor emerita at Ryerson University's School of Disability Studies and is now pursuing all the pleasures of activist retirement. She blogs intermittently at http://fragileandwild.com when riled or beguiled. When not consumed by the demands of persistent decrepitude, she spends her spare time worrying about autonomy run amok and holding out for kinder, gentler understandings of vulnerability and dependence. When discouraged, she reaches for fresh air, the rustle of natural worlds, and the dazzlements of artful resistance from the likes of this book's contributors.

Melissa Graham is the founder and one of the key organizers for the Toronto Disability Pride March, which began in October 2011. Graham is

an activist involved in disability issues and other social justice concerns. She has written for publications such as *Abilities* magazine and on her own blog, https://exposingableism.wordpress.com. Graham holds a Master of Social Work with a concentration in social justice and is currently working for the Direct Funding Program at the Centre for Independent Living in Toronto. She can be seen often at social justice events or enjoying the occasional wheelchair bungee jump.

nancy viva davis halifax teaches in the Graduate Program in Critical Disability Studies at York University. Originally trained as a conceptual artist, her praxis is grounded in that history. She is a feminist, a critical disability scholar, and an artist who finds usefulness and pleasure within crip theory, poststructuralism, feminisms, and new materialisms. In her commitment toward the articulation of that which lies under/beyond language, she allies herself with intradisciplinary theoretical and methodological modes of inquiry.

Kevin Jackson is one of the key co-organizers of the Toronto Disability Pride March, executive board member of the Ethno-Racial People with Disabilities Coalition of Ontario, and board member of the Canadian Disability Studies Association. Formerly, Jackson was chair of the Psychiatric Survivor Archives of Toronto, a member of the Lakeshore Asylum Cemetery Project, and a Mad Pride 2011 organizer. Jackson's primary focus is on freeing Mad narratives and histories concealed within Ontario psychiatric institutions. He is currently completing a master's degree in the Graduate Program in Critical Disability Studies at York University.

Christine Kelly is assistant professor in Community Health Sciences at the University of Manitoba and a former Banting postdoctoral fellow in the Institute of Feminist and Gender Studies at the University of Ottawa. Informed by feminist and disability scholarship, Kelly's research explores politics of care and the evolving nature of Canadian disability movements. She is the author of *Disability Politics and Care: The Challenge of Direct Funding* (UBC Press, 2016), which considers what it might mean to incorporate a rejection of care into the core of our theorizing, policies, and practices of support. For more information, see www.christinekelly.ca.

An artist, activist and community organizer, **Véro Leduc** is the executive manager of the Quebec Network for the Social Inclusion of Deaf and Hard-

of-Hearing Persons. Born and living in Montreal on unceded Mohawk territory, she has been involved in various activist communities for the last fifteen years, especially in Deaf, queer, sex worker, feminist, and video-activist collectives/community organizations. Holding a PhD in communication and a Master's degree in social work, she produced a graphic novel as part of her research-creation thesis, titled *C'est tombé dans l'oreille d'une Sourde* (It Fell on Deaf Ears). It is the first bilingual digital graphic novel in Quebec Sign Language (LSQ) and French, and it is based on excerpts from interviews conducted with deaf and hearing people.

Alexander McClelland is an academic, a writer, and an activist who is working on a doctorate at the Centre for Interdisciplinary Studies in Society and Culture, Concordia University. His work focuses on the intersections of life, law, and disease. He has developed a range of collaborative writing, academic, artistic, and curatorial projects that cross disciplinary bounds to address issues of criminalization, sexual autonomy, drug liberation, and the construction of knowledge on HIV and AIDS. His doctoral work is examining the lives of people who have been criminally charged and/or prosecuted in relation to not disclosing their HIV-positive status to sex partners in Canada. His work is supported through a range of awards, including the Canadian Institutes of Health Research doctoral HIV/AIDS Community-Based Research Award.

Pamela Moss is a full professor in the Faculty of Human and Social Development, University of Victoria. Her research coalesces around themes of bodies, power, and knowledge production in numerous contexts. She locates her interdisciplinary work in disability studies, social and cultural geography, feminist methodology, and autobiographical writing. She uses feminist and posthuman theories to explore the social and cultural dimensions of the practice of power across a set of diverse sites: women with chronic fatigue, soldiers with post-traumatic stress, intimacy and joy, veterans' rights, and Bruce Springsteen's lyrics. Her most recent book, co-authored with Michael J. Prince, is *Weary Warriors* (Berghahn, 2014).

Kristin Nelson is a Canadian visual artist born in Ajax, Ontario. Through a process of examination and re-contextualization, she transforms mundane subjects into larger social concerns. Nelson received her BFA from Emily Carr Institute of Art and Design (2003) and MFA from Concordia University (2014). She has completed residencies at the Banff Centre (2008) and

through the Canada Council for the Arts International Residency program (2015). She is currently serving on the board of directors of the Winnipeg Arts Council and has served on the boards of the Manitoba Craft Council and the Manitoba Printmakers Association. Nelson has been awarded grants through the Winnipeg Arts Council and the Manitoba Arts Council and has exhibited work across Canada and in Mexico. Her work is included in the collections of BMO, the Province of Manitoba, and the Winnipeg Art Gallery.

Michael Orsini is a professor in the School of Political Studies and vice-dean of graduate studies in the Faculty of Social Sciences at the University of Ottawa. Informed by interpretive, feminist, and disability scholarship, he is interested in the role of social movements and interest groups in policy processes. He has co-edited a number of edited collections, including the *Handbook of Critical Policy Studies* (Edward Elgar Publishing, 2016), *Worlds of Autism: Across the Spectrum of Neurological Difference* (University of Minnesota Press, 2013), and *Critical Policy Studies* (UBC Press, 2007).

Melanie Panitch is an associate professor in Ryerson University's School of Disability Studies and its founding director. Throughout her career, she has been an activist, an advocate, a researcher, and an educator. She was a co-curator of the groundbreaking exhibit *Out from Under: Disability, History and Things to Remember,* now exhibited in the Canadian Museum for Human Rights. Her book *Disability, Mothers and Organization: Accidental Activists* (Routledge, 2008) is a gendered history of activist mothering in the Canadian Association for Community Living. Currently, she spearheads Access Ryerson's response to the Accessibility for Ontarians with Disabilities Act and is the Faculty of Community Service's academic lead for social innovation and strategic outreach.

Jeffrey Preston is a professor of digital marketing at Fanshawe College in London, Ontario, and a disability and culture correspondent on AMI Accessible Media Inc. A long-time advocate and motivational speaker, Preston's work focuses on the intersection of disability, subjectivity, and culture.

Carla Rice is professor and Canada Research Chair at the University of Guelph. A leader in the field of embodiment studies in Canada, she explores cultural representations and stories of body and identity in her research. She founded Project Re•Vision, a media lab that works with misrepresented and

aggrieved communities to challenge stereotypes. Her books include *Gender and Women's Studies in Canada: Critical Terrain* (co-editor, Women's Press, 2013), and *Becoming Women: The Embodied Self in Image Culture* (University of Toronto Press, 2014).

Jen Rinaldi is an assistant professor in the Legal Studies Program at the University of Ontario Institute of Technology. Funded by the Women's College Hospital, her current work engages with narrative and arts-based methodologies to deconstruct eating disorder recovery and to reimagine recovery in relation to queer community. Rinaldi also works in collaboration with Recounting Huronia, a SSHRC-funded arts-based collective that explores traumatic histories of institutionalization.

jes sachse is a visual artist, writer, and curator. Through the use of an interdisciplinary array of media, sachse has presented work on the international stage, including their recent curating of the unique disability arts program Criptonite for Artsweek Peterborough in 2011 and 2012. They have also been working closely with other Toronto-based disabled artists, facilitating a Canadian Institutes of Health Research–funded digital storytelling initiative, Project Re•Vision, since 2011. sachse is also a storyteller whose work has been featured in a number of publications, including the *Toronto Star*, *Abilities* magazine, and *NOW* magazine.

Tanya Titchkosky is a professor at the Ontario Institute for Studies in Education, University of Toronto. Her teaching and research areas are based in interpretive approaches to disability studies informed by post-colonial and queer theory as well as cultural studies. Titchkosky has authored three books – *The Question of Access* (University of Toronto Press, 2011), *Reading and Writing Disability Differently* (University of Toronto Press, 2007), and *Disability, Self and Society* (University of Toronto Press, 2003) – and was co-editor with Rod Michalko of *Rethinking Normalcy: A Disability Studies Reader* (Canadian Scholars' Press, 2009). Her current work explores disability imaginaries in the (re)constitution of normalcy.

Jessica Whitbread has a Master's in environmental studies and works in the realm of social practice and community art, often merging art and activism to engage a diversity of audiences in critical dialogue. Whitbread often uses her own body and experience as a queer woman living with HIV as the primary site of her work. In her head, the entire world is a pantless tea party,

full of awkward yet playful interactions that challenge heteronormative and mainstream assumptions about bodies, sexuality, and desire. Her ongoing projects include LOVE POSITIVE WOMEN: Romance Starts at Home, No Pants No Problem, Tea Time, and PosterVirus (AIDS ACTION NOW!).

Index

Printed and bound in Canada by Friesens

Set in Futura Condensed and Warnock by Artegraphica Design Co. Ltd.

Copy editor: Lana Okerlund

Proofreader: Helen Godolphin

Indexer: Judy Dunlop

Cover designer: Martyn Schmoll

Cover image: *Freedom Tube,* courtesy of jes sachse